A Divided World

To Kate, love of my life, and whose idea it was in the first place.

A Divided World

Hollywood Cinema and Émigré Directors in the Era of Roosevelt and Hitler, 1933-1948

Nick Smedley

intellect Bristol, UK / Chicago, USA

First published in the UK in 2011 by
Intellect, The Mill, Parnall Road, Fishponds, Bristol, BS16 3JG, UK

First published in the USA in 2011 by
Intellect, The University of Chicago Press, 1427 E. 60th Street,
Chicago, IL 60637, USA

Copyright © 2011 Intellect Ltd

All rights reserved. No part of this publication may be reproduced,
stored in a retrieval system, or transmitted, in any form or by
any means, electronic, mechanical, photocopying, recording, or
otherwise, without written permission.

A catalogue record for this book is available from the British Library.

 Library of Congress Cataloging-in-Publication Data

Smedley, Nicholas.
 A divided world : Hollywood cinema and emigré directors in the era of
Roosevelt and Hitler, 1933-1948 / Nicholas Smedley.
 p. cm.
 Includes bibliographical references.
 ISBN 978-1-84150-402-5 (alk. paper)
1. Motion picture industry--California--Los Angeles--History--20th century.
2. Expatriate motion picture producers and directors--United States.
3. Lubitsch, Ernst, 1892-1947--Criticism and interpretation. 4. Lang, Fritz,
1890-1976--Criticism and interpretation. 5. Wilder, Billy, 1906-2002--Criticism
and interpretation. 6. Motion pictures--Political aspects--United States.
7. United States--Politics and government--1933-1953. 8. Germans--
California--Los Angeles. 9. Sex role in motion pictures. 10. Immigrants--
California--Los Angeles. I. Title.
 PN1993.5.U65S545 2011
 791.43'658--dc22
 2010041838

Cover designer: Holly Rose
Copy-editor: Danielle Styles
Typesetting: Mac Style, Beverley, E. Yorkshire

ISBN 978-1-84150-402-5

Printed and bound by Gutenberg Press, Malta.

Part of Case Study 1 appeared in a slightly different form in a volume of *Film History*
(March, 1993). I am grateful to the editors of the journal for permission to reproduce it here.

Contents

Introduction	7
Chapter 1: Once Upon a Time in America: American Society and Culture, 1933–1948	17
Chapter 2: The Keeper of the Flame: Hollywood and the Cinema of Liberal Idealism	45
Chapter 3: Trouble in Paradise: Hollywood Films and American Social Change	67
Case Study 1: 'Everything That Happens Must Be Strictly American': Fritz Lang and Hollywood Idealism	88
Case Study 2: Sex, Violence and Alcohol: Billy Wilder in the 1940s	121
Chapter 4: The Devil is a Woman: Hollywood Films and the American Woman	137
Case Study 3: 'Definitely Bawdy and Offensively Suggestive': Lubitsch and the American Woman	155
Case Study 4: 'Love Cures the Wounds it Makes': Lang and Wilder: Conventional Portraits of the American Woman	186
Chapter 5 The World Changes: Hollywood and International Affairs	195
Case Study 5: 'World Political Theater': Lubitsch and Foreign Affairs	205
Case Study 6: 'As Corruptible as the Others': Wilder on America and Europe	216
Case Study 7: 'Propaganda Can be Art': Lang and International Affairs	225
Conclusion	245
Bibliography	249
Index	269

Acknowledgements

I would like to thank Richard Paterson at the British Film Institute and Melvyn Stokes at University College London, both of whom encouraged me to write the book and offered invaluable advice. Dorothy Haley provided me with a base for my research in Los Angeles, and became a great friend in the process. Loulou Brown was enormously generous with her time, if not very generous with her compliments, as she helped me turn the early verbose draft into something much tighter and readable. Her advice was well worth the two lunches she made me buy her. Melanie at Intellect was the ideal publisher, efficient, friendly and helpful at all times. My gratitude also goes to the anonymous peer reviewer, whose comments on the structure of the book have, in my view, improved it no end. I would also like to thank Danielle Styles for a superb job in editing my manuscript, and Denise Derbyshire for producing the index.

Introduction

In January 1933 the world divided. Two men in different parts of the world took office in their respective countries. Franklin D. Roosevelt, having been elected the previous year, was formally inaugurated in Washington DC as president of the United States of America. He would embark on a programme of social reconstruction that would introduce to America the ideas and values of a welfare society, and active state benevolence and intervention. He would go on to end America's isolation from world affairs and pave the way for the foundation of American global imperialism.

In Berlin, over 7000 miles away, Adolf Hitler took the oath of office as Chancellor of the German Reich in the presence of the venerable World War I veteran, President Hindenburg. In marked contrast to his American contemporary, Hitler was about to destroy the structures and institutions of democracy in Germany and to introduce terror and repression, at first in the domestic sphere and eventually across the whole of Europe. His international intentions would express themselves in war, conquest, devastation and death. The two leaders' destinies would come together in late 1941, their countries locked in conflict – a conflict which would determine the future of the Western world for the second half of the twentieth century.

By 1948, when the period examined by this book ends, both men were dead. The United States emerged from World War II stronger and more globally dominant than before, while Europe lay in ruins. The superpower of the Soviet Union faced the newly triumphant America, and the Cold War began in earnest, ushering in an almost hysterical anti-communist paranoia and persecution in the United States. The fifteen years from 1933 to 1948 were a momentous time in American and world history.

This book is a history of Hollywood cinema and American social change between 1933 and 1948. It looks at how mainstream cinema in this period responded to, commented on and contributed to three major aspects of American life: first, the reconstruction of American values after the ravages of the Great Depression; second, the changes in the roles and perceptions of women in the United States; and third, the growing international role played by America, including its gradual commitment to involvement in the Second World War, and the emergence of the Cold War after 1945.

Methodology

Because I wish to make general observations about the relationship between Hollywood films and American society, I base my analysis on a very broad range of mainstream Hollywood product from these years. I do not confine myself to just those fewer, more famous films, whose popularity has endured to our own time.

In order to give depth as well as breadth to the study I punctuate this analysis with some detailed case studies and production histories drawn from the works of three influential German film-makers who worked in Hollywood at this time – Fritz Lang, Ernst Lubitsch and Billy Wilder. I do this for two reasons. Partly, it is to demonstrate some of the key voices in the Hollywood film industry of this time who challenged American conformity and articulated dissent from the moral consensus of the New Deal. These are three film-makers who, in their different ways, profoundly influenced the direction of American cinema. Hollywood's films certainly do betray distinct patterns and themes at this time, despite its huge output, and I draw these out in the main chapters which follow. But this is not to say that Hollywood cinema was an entirely homogenous industry. The three European directors I have chosen to study in depth illustrate how the presence of dissenting voices acted as a spur to development and innovation in the American film industry.

The other reason for the inclusion of these case studies is to help to deepen our knowledge of Hollywood production history in this era and to enrich our understanding of the works of these three huge figures in film history. I hope that in offering both a broad survey of many Hollywood movies *and* an in-depth analysis of a few key films I can shed light on the industry at large, as well as these three individuals in particular and their interaction with American social change.

Hollywood film-makers, as a rule, embraced wholeheartedly the coming of Roosevelt and the New Deal. During the 1930s the Hollywood community developed a cinema of liberal idealism, the influence of which is still felt in many of the films America produces today. During the 1940s, as the philosophical and social tenets of the New Deal came under attack from a resurgent Republican Party, Hollywood responded with a cinema of alienation and anxiety. In both decades American films were unrelenting in their hostility towards women and female self-determination. On the international front, Hollywood was an early and vociferous advocate of intervention in the fight against fascism in Europe, despite the unpopularity of this position in domestic politics. After the war, the onset of the Cold War found the liberal community in Hollywood silenced. Film-makers were mostly too frightened of being labelled 'communist' or 'unpatriotic' to mount any criticism of the clumsy nature of American diplomacy during the post-war reconstruction.

Within this community of largely American-born film directors, Lubitsch, Lang and Wilder made films which, in certain important respects, were profoundly different. These three European émigré directors produced a body of work which dissented at times from Hollywood's brand of celebratory liberal idealism. Lang and Wilder articulated criticisms of American society left unsaid by their contemporaries. Lubitsch formulated a programme of

dissent from the endemic cultural subjugation of women in American cinema and society. All three challenged the assumptions underlying American foreign policy and sought to broaden their audience's understanding of European issues. In addition, they mounted an important challenge to Hollywood's moral conservatism and the restrictions of the censorship code operated by the Production Code Administration (PCA). These three directors thus deepened and enriched the cultural commentary of American cinema in this formative period of the country's growth.

To avoid any possible distortion in my comparison of the work of these three émigré directors to what I label 'mainstream' Hollywood products, I have deliberately omitted from the latter category any film directed by an émigré director. Thus, the reader will find no analysis of films by such luminaries as Chaplin, Hitchcock, Renoir or Wyler, for example, and – by the same token – no study of such classics as *The Great Dictator* (Chaplin, 1940), *Casablanca* (Curtiz, 1942) or *Laura* (Preminger, 1944), for example. This is irrespective of whether or not these films can be said to be the 'voice' of the émigré director – for the avoidance of doubt and to maintain my control group I have left out of consideration all films directed by Europeans (other than my chosen three) who migrated to America at some point during their adulthood.

The time frame

There are reasons why the apparently arbitrary period of 1933–1948 is, in fact, a coherent choice. It marks clearly the era of Roosevelt, beginning with his inauguration and continuing to the end of his final term of election. While FDR died in 1945, Truman can be said to have completed the Roosevelt era in those last three years, before he stood for election in his own right. It is always a subjective decision where to draw a line in history between the end of one era and the beginning of the next – but I would make a case for 1948 being a dividing line in the history of the United States. It divides the Roosevelt era, including its decline under Truman after 1945, from the post-Roosevelt settlement and the abandonment of FDR's experiment with social liberalism.

The Roosevelt era clearly began with his first presidential election victory, and the years from 1933 to 1940 may be seen as the period of the 'high New Deal', when FDR's popularity remained buoyant and there was a sense of unity as the American nation grappled with recession. There was a strong consensus in this decade around Roosevelt's programme of liberal social reform. After the interlude of World War II, when international pressures meant that domestic disputes were sidelined, the reaction to the dominance of Roosevelt and the Democrats surfaced. Faced with the seemingly unstoppable expansion in Europe and elsewhere of Soviet-backed communism, the Republicans – who by now dominated both Houses in Washington – began a fight-back. Domestic liberalism, along the lines mapped out by FDR, was now conflated with left-wing dissent, even a lack of patriotism, and eventually, when Senator McCarthy came to prominence in the early 1950s, with treachery.

The year 1948, when Truman won his own presidential victory, thus marked the final collapse of the New Deal consensus and its brand of social liberalism in the most powerful capitalist country in the world. The preoccupation with international affairs and the spread of communism marked the beginning of American global imperialism. This too was a key difference from the Roosevelt era, and it had intense domestic ramifications. The post-war era of domestic prosperity, conservatism and the defence of 'Americanism' began in earnest in 1948. It was truly the end of an era.

Structure of the book

Chapter 1 is a historical essay covering the years 1933–1948 in the United States, which aims to provide the context for a study of American cinema in this period. In particular, I highlight the three thematic concerns, mentioned above, which seem to me to be key to understanding American culture and history in the 1930s and 1940s. My analysis and interpretation of the cinema of this period is assembled around these three themes.

The first theme examines the significant reconstruction and reappraisal of American values that followed the loss of faith in capitalism and individualism after the Wall Street Crash of 1929. It was a very different cultural emphasis from the 1920s. In that decade of rampant capitalism, the trinity of self-interest, individualism and materialism dominated American thought. In contrast, the values of the New Deal programme in the 1930s emphasized self-denial, community and earning the respect of one's fellows. The election of Franklin Delano Roosevelt gave political leadership to the reconstruction of American society and inaugurated a period of modified capitalism in the United States. This in turn saw an artistic and intellectual emphasis on communal values, self-sacrifice and higher ideals, rather than mere moneymaking. But, with hindsight, this reconstruction of American values appears to have been more an interlude than an enduring cultural change. As the decade of the 1930s wore on, the inability of Roosevelt to end the recession led to a resurgence of Republican authority and right-wing thinking.

These emerging tensions were temporarily suppressed by the necessity of communal endeavour when the United States joined World War II. As soon as the conflict was over, however, a fiercely conservative reaction set in. The New Deal was now seen by many political leaders as a dangerous flirtation with left-wing philosophy. The celebratory liberalism and idealism of the 1930s was replaced by an anxious, defensive climate. American values were no longer proclaimed with confidence, but defined in opposition to communism. During the years from 1945 to 1948 – the end of the fifteen-year period examined in this book – Hollywood looked increasingly beleaguered. The film community was no longer in harmony with the political values of Washington, but rather defending the values of the 1930s against the post-New Deal political settlement. In its most extreme form, this conflict was to come to fruition in the purges and persecution of the Hollywood community under the McCarthy investigations of the 1950s. The New Deal decades were

to have a profound impact on how Hollywood films portrayed and discussed what made America the country it was.

The second theme I draw out is the changing social and cultural status of women in America during this period. The recession years of the 1930s presented America with a series of conundrums about how to present the image of womanhood. With ever more women going out to work to support unemployed husbands, one might have expected to see a more subtle and complex portrayal of women in Hollywood films. But, on the contrary, the further American women moved away from the idealized housewife figure, the more American women were urged in the movies to 'recapture' their true, feminine values. After World War II, the return of American servicemen to jobs now occupied by women led to further tensions. Again, these tensions were reflected in the visions of American women offered by Hollywood films. There was still no attempt to accommodate or accept a wider role for the American woman. In the later part of the period covered by this book, women in the cinema were as likely to be portrayed as scheming murderers as they were immoral adulterers. Once more, Hollywood films played an important part in articulating the values which underlay the treatment of women in America.

The third and final theme relates to foreign affairs. A distinct change in approach was introduced by Roosevelt's arrival in 1933 compared to that of the previous decade; and then again, there was a further change after his death in 1945. Prior to Roosevelt's election, American foreign policy was marked by isolationism and an unwillingness to engage in European affairs. The increasing instability of Europe in the 1930s began to challenge this stand-offish posture: the rise of Stalin in the Soviet Union, the rise of Hitler in Germany, Franco's seizure of power in Spain. All these developments suggested to Roosevelt and his supporters that American intervention in Europe was necessary. But there was strong opposition at home to such international engagement. The country still remembered the death toll of World War I and the failure of the League of Nations. The benefits for the American people of foreign intervention were not immediately apparent. Roosevelt proceeded carefully. Many Hollywood film-makers tried to influence the debate. Films depicting strife-riven Europe became more and more frequent. More often than not, such films would include one or more American characters whose detachment from world events and whose lack of commitment to supporting the wider global struggle for freedom seemed a throwback to the discredited values of self-interest.

The attack on Pearl Harbor, of course, brought this debate to a sudden end. Hollywood was immediately able to express unqualified support for foreign engagement during a period of united national backing for the war effort. From 1945 onwards, the major foreign issue was the attempt to deal with the spread of communism in Europe and elsewhere. This was a sensitive and complex issue, fraught with pitfalls for the American governing classes. Hollywood film-makers found this a difficult period and usually avoided any comment on American foreign policy for fear of appearing unpatriotic. There are parallels here with the first theme outlined above: Hollywood's liberalism could be – indeed, would be – interpreted by some as supporting communism. The politics of the Cold War after 1945

raised new issues. Politicians of the Right viewed the internationalism of the previous decade as suspiciously close to communism. Many of Hollywood's artists were caught up in this tense and oppressive climate – they had been articulate opinion-formers in the late 1930s, advocating anti-Nazi policies and intervention in the war. Many had indeed flirted with left-wing thinking and had seen Stalin and Soviet communism as an attractive alternative model for American society. The conflation of New Deal internationalism with post-war communist sympathizers merely added weight to those who, like Senator McCarthy, called for a purge of the left-wing elements in the Hollywood community.

In Chapter 2, I outline my arguments about how a mass-market, populist and 'escapist' cinema such as Hollywood can yet be said to be politically relevant and to offer commentary on its contemporary society. I explain my interpretation of how Hollywood as a cultural institution responded to the political and social changes described in Chapter 1. I argue that the film industry occupied the role of cultural leader and mouthpiece for the New Deal at its height in the 1930s. It formulated a cinema of liberal idealism in tune with Roosevelt's social reforms. As the 1940s introduced a period of conservative reaction, those self-same Hollywood artists and executives became alienated and disillusioned. Anxious about the collapse of Roosevelt's consensus politics, Hollywood liberals were no longer the voice of a united nation. They came to be seen as unpatriotic by the resurgent Republican political leaders. Hollywood's films reflected these tense times, with darker films and marginalized heroes, or with fantasy resolutions for society's ills. Finally, at the end of Chapter 2, I review the major milestones in the earlier film scholarship about this period.

Next, the book analyses in more detail how mainstream American cinema engaged with the three themes identified in Chapter 1. Thus Chapters 3 to 5 survey over 250 Hollywood films from this period. Each chapter focuses on one of the three themes – the New Deal and post-New Deal political culture (Chapter 3); the position of women in America (Chapter 4); and foreign affairs (Chapter 5).

Woven into this analysis is a series of detailed case studies of films by the émigré directors Lang, Wilder and Lubitsch. The case studies draw extensively on archival sources in the United States. I argue that, in a number of respects, these three directors were radical, dissenting voices. They engaged with the issues of American social change, the position of women and international affairs in different ways from those of the mainstream Hollywood film-makers. The Europeans' contribution, therefore, enriches and deepens our understanding today of American culture in this period. Case Study 1 looks at Fritz Lang's works of searching social criticism, after providing an introductory biographical overview of the director and his philosophy and approach to cinema. Case Study 2 provides a similar introduction to Billy Wilder and his films, before considering two of his works which provide influential and controversial insights into American society in the 1940s. Case Study 3 introduces Ernst Lubitsch and his unique contribution to the depiction of women in American society. Case Study 4 looks at the more conventional portraits of women offered by his two compatriots. Case Study 5 turns to foreign affairs and the observations of Lubitsch on communism and Nazism. Case Study 6 looks at Wilder's highly contentious and boldly cynical commentary

on post-war American internationalism. Case Study 7 considers two important films by Lang, the first about the Nazis and the second on the consequences of the atomic bomb for the post-war era.

The Conclusion briefly summarizes my arguments and conclusions, and completes the stories of the lives of the three extraordinary émigré film directors on whom the case studies have centred.

The case studies

It might be asked why I have chosen these three particular individuals for the case studies. There are a number of possible individuals on whom I could have chosen to focus, but I have selected these three men for a number of reasons. First, as 'outsiders' in the sense of coming from a different culture, I believe that they offer interesting and unusual perspectives on the significant social changes which were occurring in America at this time and that their films often display values and attitudes noticeably different from those of the dominant culture. Second, being German (or Germanic to be strictly accurate, as Lang was born in Austria and Wilder in Polish Silesia), they have particular interest for today's film scholars, given the way in which events in their homeland began to have a major impact on affairs in their adopted land. Third, these three were all important and influential directors at the time covered by this book, albeit with varying reputations and success. All three operated in America, either consistently or, in Lang's case, sporadically, with significant creative autonomy in a commercial and highly structured industry which sought to contain artistic freedoms. I do not subscribe to the 'auteur theory' (discussed in more detail in Chapter 2), in which the director is automatically to be seen as the sole creative voice in a film. In what follows in this book, I use archival evidence to analyse when any one of my chosen three directors was in full, or partial, control over the content and production of any specific film and when they had little or no control, in cases where the producer or screenwriter, for example, was more the 'author' of the work. But I have selected these three particular directors because, as I say above, in many cases they *were* able to exercise full control over their works in an industry where this was not the norm. I have, accordingly, concentrated on those films in which one *can* interpret the content as a reflection of what Lubitsch, Lang or Wilder wanted to say.

Finally, all three, while served by some excellent film scholarship, have left us important and extensive archival material not hitherto fully explored. This book, through the case studies, brings much of these precious resources into print for the first time. Fritz Lang has attracted the attention of numerous film theorists, but very little has been written about him using primary sources.[1] Long regarded as the authoritative account of his career, Lotte Eisner's *Fritz Lang* has more recently been seen as limited in key respects. Eisner was a personal friend of the director and perhaps contributed more to Lang's self-conscious myth-making than to objective historical analysis.[2] As with all Hollywood figures, the many interviews which Lang gave have to be treated with caution: much of the mythology that

surrounds his name does not stand up to scrutiny.[3] Patrick McGilligan's biography is the best of recent scholarship: it is well researched and maintains a refreshing objectivity when assessing Lang's numerous self-publicizing stories.[4]

Lubitsch has attracted some serious study, although very little based on archival research.[5] As with Eisner's book on Lang, Herman Weinberg's *The Lubitsch Touch*, written by a personal friend of the director, was for a time regarded with perhaps more reverence than it deserved.[6] There is an excellent guide to sources for Lubitsch scholars by Carringer and Sabath.[7] Wilder has prompted much journalistic writing over the years. He, too, has been much interviewed. Similar caution needs to be exercised in using this material.[8] In addition to these works on the three individual directors, there is a useful body of secondary literature which looks at the Weimar culture in which the three men nurtured their artistic leanings.[9] There are also some readable studies of the generic subject of émigré directors in Hollywood.[10] I hope that this book, through its case studies, offers new insights and fresh information on these three directors and stimulates further research and debate.

Notes

1. One of the earliest, in addition to my own work, is Matthew Bernstein, 'Fritz Lang, Incorporated', *Velvet Light Trap*, 22 (1986), 33–52. For an introduction to some of the theoretical approaches to Lang, see Stephen Jenkins (ed.), *Fritz Lang: the Image and the Look* (London, 1984).
2. Lotte Eisner, *Fritz Lang* (London, 1976). Eisner apparently had access to Lang's personal copies of his film-scripts, but she does not use references, so her research has not been easy to assess critically.
3. An excellent source for assembling a bibliography on Lang is E. Ann Kaplan, *Fritz Lang: a Guide to References and Resources* (Boston, Mass., 1981), a comprehensive guide to writings by and about the director, as well as to scores of the interviews he gave throughout his life. Peter Bogdanovich, *Fritz Lang in America* (London, 1967) is a much-quoted long interview with Lang. See also Charles Higham and Joel Greenberg, *The Celluloid Muse: Hollywood Directors Speak* (London, 1969).
4. Patrick McGilligan, *Fritz Lang: the Nature of the Beast* (London, 1997).
5. See, for example, William Paul, *Ernst Lubitsch's American Comedy* (New York, 1983). More recent, and very useful, is Scott Eyman, *Ernst Lubitsch: Laughter in Paradise* (New York, 1993).
6. Herman G. Weinberg, *The Lubitsch Touch: a Critical Study* (New York, 1968). It does, however, reprint a useful letter from Lubitsch. See also Leland A. Poague, *The Cinema of Ernst Lubitsch: the Hollywood Films* (Cranbury, NJ, 1978).
7. Robert Carringer and Barry Sabath, *Ernst Lubitsch: A Guide to References and Resources* (Boston, Mass., 1978), a pioneering guide for scholars to writings by and about Lubitsch.
8. No fully adequate study of Wilder yet exists, although Ed Sikov, *On Sunset Boulevard: the Life and Times of Billy Wilder* (New York, 1988) is a good introduction, despite quoting extensively from Wilder's treasure chest of yarns. Steve Seidman, *The Film Career of Billy Wilder* (Boston, Mass., 1977) is in the same series as Carringer and Sabath's, and Kaplan's *Guide to References and Resources*, on Lubitsch and Lang respectively, but inferior to those two works. Apart from this, there are a number of journalistic writings on Wilder – see among many Axel Madsen,

Billy Wilder (Bloomington, Ind., 1969); Tom Wood, *The Bright Side of Billy Wilder, Primarily* (New York, 1970); Neil Sinyard and Adrian Turner, *Journey Down Sunset Boulevard: the Films of Billy Wilder* (Ryde, Isle of Wight, 1979); Bernard K. Dick, *Billy Wilder* (Boston, Mass., 1980); Maurice Zolotow, *Billy Wilder in Hollywood* (London, 1988); and Gerd Gemünden, *A Foreign Affair: Billy Wilder's American Films* (New York, 2008). Higham and Greenberg, in *The Celluloid Muse*, include Wilder in their collection of interviews.

9. See John Willett, *The New Sobriety 1917–1933: Art and Politics in the Weimar Period* (London, 1978) and Willett, *The Weimar Years: a Culture Cut Short* (London, 1984) for an excellent introduction to this period. Other works include Peter Gay, *Weimar Culture: the Outsider as Insider* (New York, 1968) and Walter Laqueur, *Weimar: a Cultural History 1918–1933* (London, 1974). For the history of early German cinema, Siegfried Kracauer, *From Caligari to Hitler: a Psychological History of the German Film* (New edn, Princeton, NJ, 1974) is of interest, although written from a very distinct perspective (see Chapter 2). See also Lotte Eisner, *The Haunted Screen: Expressionism in the German Cinema and the Influence of Max Reinhardt* (London, 1969); H. H. Wollenberg, *Fifty Years of German Film* (London, 1948), an unpretentious and useful introduction to the period; and Peter Manvell and Heinrich Fraenkel, *The German Cinema* (London, 1971).

10. For general works which deal with émigré directors and producers (and others) in Hollywood, see, among others, John Russell Taylor, *Strangers in Paradise: the Hollywood Émigrés, 1933–1950* (London, 1983); John Baxter, *The Hollywood Exiles* (London, 1976); and Graham Petrie, *Hollywood Destinies: European Directors in America, 1922–1931* (London, 1985).

Chapter 1

Once Upon a Time in America: American Society and Culture, 1933-1948

This chapter explores the political, social and cultural context in which Hollywood films were made between 1933 and 1948. Hollywood, contrary to widely held notions of its supposed escapism and political evasions, was and remains a vital part of contemporary American culture. Between 1933 and 1948, the Hollywood film industry attempted to come to terms with the changes that were taking place in American society. The creative and executive personnel of Hollywood were not isolated from that process of change. They helped to articulate a response to the reformulation of values in American life at this time. The way in which Hollywood contributed to the cultural and political regroupings of the 1930s and 1940s was not, in my view, overtly political. Nevertheless, in its celebration of American ideals in the 1930s and its subsequent defence of these ideals during the conservative retrenchment of the ensuing decade, Hollywood manifested an explicit and identifiable cultural programme. That programme had direct parallels with the changes in attitudes, ideals and social values that marked the New Deal era. In the remainder of this chapter, I provide a synopsis of the social and cultural changes that took place in America during this period, grouped into the three main themes summarized in the introduction.

The reconstruction of American values: part one, 1933–38

A tension shared by all modern capitalist countries is that between self-interest and social responsibility. The imperative towards self-enrichment is a basic motivating force in most, if not all, market economies. The freedom to amass personal wealth drives individuals to provide products and services at a profit. This, it is argued, leads to a more general prosperity as jobs are created and wealth is distributed, albeit unevenly. This model of capitalism prevailed in Europe and America in the nineteenth century. In the following century, under the pressures of urbanism and population growth, capitalist economies incorporated to varying degrees a 'socialist' element. Beginning with the introduction of a form of social security in Germany in the 1890s and further advanced in Britain at the start of the twentieth century, the European model of capitalism was modified. Some state-directed redistribution of private wealth took place, funded through increasing levels of income tax, to introduce welfare payments, national insurance, pensions, health care and social housing. There was a parallel recognition of the role of trade unions in collective bargaining and the protection of workers' rights. This approach to modern capitalism gave birth in England, via the post-war Labour Government of 1945, to the introduction of a fully fledged welfare system. Increased

levels of taxation and state regulation – including, for instance, a minimum wage, controlled working hours, stringent health and safety controls and anti-discrimination laws – have since become standard packages in twenty-first century Europe.

This modified form of capitalism was not, in the early twentieth century, embraced as enthusiastically in the United States as it was across the Atlantic. But there was an inherent contradiction, or at least conflict, in American philosophy. America was the nation which best came to typify the model of individualist wealth creation in the 'Gilded Age' of the late nineteenth century. Yet America was also the nation that had been formed in the eighteenth century in a spirit of high-minded idealism and commitment to equality, human happiness and freedom of opportunity. Thus the American liberal urge to pursue social justice and equality came increasingly into conflict with the competitive economic urge and the goal of limitless personal wealth. This clash of values – between self-interest and self-sacrifice, between materialism and altruism, and between individual achievement and social welfare – was to reach a watershed in the 1930s. The first stirrings of this American political liberalism arose in the late nineteenth century in the form of Progressivism.[1]

Progressivism's first great political leader was William Jennings Bryan, and the movement's goals were carried forward by, amongst others, such significant presidents as Theodore Roosevelt and Woodrow Wilson. The Progressives aspired to give governmental expression to the American liberal tradition, which had been part of the vocabulary of the Founding Fathers. As a political movement, it grew out of the United States' transition from a primarily agrarian to a more urban-industrial society, which was accompanied by a rapid development in technology. The movement was middle-class and philanthropic. Because it was primarily an urban phenomenon, Progressivism concentrated on humanizing industrial life for the working classes in the cities and correcting the corruption, waste and inefficiency of hitherto unmanaged urban growth. Fears that the individual entrepreneur was being swamped by the huge monopolies of industrialists such as Carnegie and Rockefeller led the Progressives to challenge the power of big business. Democracy, they argued, was based upon the individual's free exercise of will. Once that individual was excluded from effective participation in the economic life of the country, the very basis of American democracy was threatened. The conduct of business was inseparable from the ordering of political life in America. This philosophy led the Progressives to tackle corruption and the social abuses that they believed resulted from unregulated capitalism and mass immigration. Many of those involved in the movement shared a sense of their own culpability in what had gone wrong with American development. America had lost its moral purpose in pursuit of materialism.[2]

The 1920s then appeared to reject completely the philosophy and political programme of the Progressives, emphasizing instead the intrinsic virtue of materialism and promoting the image of the self-made millionaire. This decade of Republican rule saw an alliance of government and business in an orgy of speculation, ending in the spectacular Crash of 1929. Over the following three years, President Hoover's administration seemed incapable of acting to deal with acute economic and social problems. In part, this reflected the Republican belief that the government should not intervene and that the market would remedy its own defects.

The arrival of Franklin D. Roosevelt as president at the end of 1932, however, demonstrated that Progressive beliefs remained pertinent to American life.[3] But his programme of social and economic reform went much further. The Progressives had merely sought to contain the abuses of monopolies to protect the small businessman. The government's role had been no more than to police a fairer system. It was not actively to intervene or to plan the economy. In contrast, Roosevelt altered the whole notion of a non-interventionist federal government.

From the moment of his inauguration, Roosevelt introduced a comprehensive programme of social and economic reform, including social security and welfare relief for the unemployed, as well as housing and employment programmes. He reformed the banking and fiscal structures and instituted a programme of public works; he also regulated labour relations and the conduct of private enterprise, bringing the unions into discussions about the economy, workers' rights and employment. In all of this, Roosevelt's style was pragmatic rather than ideological: far from attempting to dismantle the capitalist system in the United States, Roosevelt worked within its structures, seeking only to moderate its excesses. His intention was to import elements of a welfare system into the existing private profit system. His political tradition lay with the policies of the early twentieth-century British Liberal Party. Roosevelt instituted 'broker' politics, under which he and his advisers would strike deals and agree compromises with the powerful interest groups of labour and capital. His aim was to construct a non-partisan, non-class, non-party alliance in the national interest. Roosevelt was supported in his programme by a group of young intellectuals known as the 'Brains Trust', who were at the forefront of the new thinking. These men believed that competition could no longer protect essential social interests; the formula for stability in the realigned society of the 1930s was combination and cooperation, planned and managed by an invigorated central government. Popular support for the New Deal came from a heterogeneous coalition of urban blue-collar workers in the North, ethnic and religious minorities, farmers, intellectuals and the black population. Roosevelt's experiment with the American liberal tradition was the start of a sporadic journey in American politics: his heirs would be Kennedy and Johnson in the 1960s, and Carter and Clinton after that.[4]

This moderate liberal reformism at first yielded great political success. The Republicans were routed in the 1934 congressional elections, and Roosevelt returned in 1936 with a substantially increased share of the national vote. In his second term, he adopted a rather more radical programme, which became more hostile to business. His power, however, was undermined by the formation of a congressional coalition between the Northern Republicans and the hitherto loyal Southern Democrats, the latter in particular feeling alienated from Roosevelt's interventionist and centralist government. In 1938 the Republicans made some gains in Congress, while the president's second re-election in 1940 showed that his support was slipping. The Depression lasted throughout the 1930s. A major recession in 1937 clearly demonstrated that the difficulties had not yet gone away. Although by 1939 Roosevelt's economic policies were able to restore levels of production to 1929 levels, this was not enough to take the country out of recession. The New Deal had restored confidence and had made significant changes to America's social and cultural life, but it had not solved cyclical

economic problems. America was, in fact, able to escape from recession only when World War II brought a boom in production and employment, financed by government spending on an unprecedented scale.

During the years of Roosevelt's unchallenged ascendancy – from 1932 to 1938 – a significant cultural shift took place in America. The New Deal's move away from naked competition towards industrial planning and business–labour cooperation was paralleled by a movement in American thought. The rise of federal relief programmes challenged the old orthodoxy that each individual had to look out for his or her own interests and could expect no assistance from outside agencies. The appearance of the federal government in previously private concerns undermined the American idea of self-help and personal responsibility (and hence personal failure and personal guilt). The new legitimacy of organized labour was a further moderating force in American social thought, showing that the less well off had status and rights in a democracy. The rise of neighbourliness and concern for one's fellow citizen – key themes repeated over and over in Hollywood's films of the New Deal – were cultural offshoots of this political realignment.

This cultural shift was in dramatic contrast to the dominant ideology of the 1920s. In that period of unbridled materialism, the underlying philosophy was the ethos of success. Rooted in Puritan work ethic traditions, the prevailing morality saw success as God-given. The worthy would always succeed because they possessed the necessary virtues: hard work, honesty and competitive individualism. Businessmen, the producers of the nation's wealth, were idolized. Any interference with, or regulation of, business practices could only inhibit the ambitious from succeeding and impede the creation of wealth. Those who could not participate in the dream of success were not worthy of its rewards. Poverty would either instil the virtues required to escape it and find success, or it was the proper fate for the lazy, wasteful and unambitious.[5] Intellectuals and artists had reacted against the spiritual emptiness of this society by depicting a world without values – a hopeless, pointless existence. They wrote about individuals who pursued a 'separate peace', who avowed a private disaffiliation from the world. Writers such as F. Scott Fitzgerald and Ernest Hemingway shouldered the burden of providing readers with a code of values lacking in their own daily lives.[6]

The devastating social and economic consequences of the market collapse in 1929 precipitated a crisis of belief in America. Hitherto held certainties suddenly seemed flawed. It was startlingly evident that the capitalist market system was not infallible. A huge increase in unemployment and homelessness followed the Crash. The ethic of self-help was quite obviously inadequate to deal with the resulting scale of social turmoil. In reappraising the economic system which had led to this upheaval, the values which had supported individual wealth creation came under scrutiny too. Perhaps, people began to say, America had lost touch with its founding principles. In essence, the cultural voyage of the 1930s 'discovered' that American ideals were not those of power, wealth and personal gratification. These were, it transpired, mere surface manifestations of a deeper purpose in American life. People began to argue that the true greatness of the nation lay in America's commitment to freedom, equality and individual happiness. Capitalism was the system which best preserved those

values, but without this underpinning of a higher morality, wealth and materialism meant little. This thematic shift was to be the bread and butter of Hollywood's films in the 1930s.

Robert McElvaine has argued that the United States in the 1930s saw a rise of 'working class and female values'. Such values emphasized compassion, sharing, sacrifice, social justice and community help, in contrast to 'middle class, masculine values' of personal power, self-help, self-improvement and individual achievement.[7] The sheer numbers of those hit by unemployment and associated deprivations meant that the ethos of 'go-it-alone' individualism had to be moderated; problems were bound to be shared, and solved through communal endeavour. The guilt and shame of unemployment, when it touched so many lives, needed an explanation other than that of personal failings.[8] The philosophy of social Darwinism in American thought saw failure as a product of personal weakness or indolence. In the 1930s, this thinking gave way to social realism and environmental determinism, which recognized that external factors such as housing were important in influencing human opportunities.[9] The development of social and natural sciences helped to underpin the rational strain in American thought, stressing that problems are soluble through creative experimentation.[10]

Intellectuals advocated a tempered form of capitalism, a social market philosophy influenced by the writings in the previous decade of John Dewey, the architect of pragmatism. He had challenged the accepted view that 'instinct' governed human behaviour, that the struggle for life was competitive and selfish and that only the fittest could survive. Dewey believed that humans had a capacity to adapt in order to achieve desired social goals. His thinking laid the foundations for 1930s intellectual radicalism. For Dewey, there was nothing immutable about either human nature or economic, legal, social and political behaviour. Psychology and sociology showed how individual and social behaviour were both explicable and malleable. The aim of social, rather than autonomous, individuality was prescribed.[11] By 1929 Dewey was writing, in *Individualism Old and New*, that 'the collective age' had arrived, the choice now lying between anarchic capitalism and democratic planning. Only the latter could create the conditions for a new individualism in the United States.[12] His heirs found these values readily applicable in the changed circumstances of the Depression era. Charles Beard, writing in 1935, saw the goal of Americans as 'the subordination of personal ambition and greed to common plans and purposes'.[13] As Clarke Chambers wrote in 1958, Americans had come to expect 'infinite progress in the improvement of human life … ever-richer life and ever-larger satisfaction to the individual'.[14] Many contemporaries saw new opportunities for the enrichment of the human spirit in New Deal America. Frederick Lewis Allen, writing in 1940, registered a major change in the social climate of the country and dated it from 1933. He believed that the days of pioneer values were over, bringing to an end the plundering of the land and ushering in a more settled, mature era.[15] This clearly paralleled the decline of capitalist profiteering and the beginning of a new, quieter phase in American life. Robert Lynd, a leading social scientist of the time, reflected at the end of the decade on the liberal ethos that had characterized the 1930s. He found that the ideals of the 1930s had included a sense of common purpose, a wish to be a good citizen, belief in the importance of the finer things in life, and cooperation.[16] Lynd's assessment of the

New Deal's cultural reorientation is consistent with that of many other observers. Michael Gold, a Marxist writer of the 1930s, observed that, 'It is the first time that America has ever examined itself'.[17] As Chapter 3 will demonstrate, Hollywood was to be prominent in this examination in the 1930s.

Although there were some dissenting voices in this intellectual and cultural ferment, they were in a minority. Conservative critics of the New Deal could find solace in those few populist writings which perpetuated the idea of unlimited success, despite the evidence of the Depression. Luck and opportunism were indeed added to the earlier values of virtue and hard work as factors for success in life, but a handful of writers refused to acknowledge that the dream was over.[18] The majority of popular literature, however, in such publications as *Liberty* or the *Saturday Morning Post*, evinced sympathy for the 'little man', and accorded heroic status to the ordinary American from the small town.[19] A man's success was measured not in terms of material wealth, but by his reputation with the community and neighbours, and advances in his moral stature. These stories gave a compensating sense of individual worth and independence to ordinary American people, who could transcend their circumstances by carrying out acts of charity or social service.[20] Wealth and ambition were often depicted as destructive desires, bringing unhappiness to the rich or the socially aspiring. The moral of many books and magazine stories was that it was wrong to denigrate failure and praise success.[21] Other stories began to stress the search for inner contentment: the love and security of a family replacing the outright pursuit of ambition and success.[22] There was an emphasis on the essential integrity and goodness of humankind.[23] It was a time of 'remoralization'; there was a growth in collectivist thought.[24] Anthropologists, sociologists and psychologists became more sensitive to society rather than the individual.[25]

Hollywood too provided numerous classic expositions of this style of storytelling in the 1930s. Its films were self-confident expressions of American values – good-natured people conquering vice and corruption, working in harmony with others, and exposing greed and selfishness. The ordinary citizens, the 'John and Jane Does', were the heroes and heroines of the hour, and they always triumphed. This cultural reappraisal was often presented not as a new set of values but, instead, as the 'discovery' of a long-standing American tradition. In reality, American values were moving along an intermittently travelled path towards late twentieth-century liberal capitalism. But a reluctance to criticize the culture meant that change was presented as a return to 'old values' – a conservative presentation of radical change.[26] Under this interpretation, the Great Crash was not the inevitable culmination of American expansion. Rather, the disaster had occurred because the nation had departed from its appointed course, as laid down by the Founding Fathers in the eighteenth century.[27] A key component of this interest in America's past was the 'agrarian myth'. A homage to America's fancied innocence of origin, the myth reconstructed American history to portray a nation made up of self-sufficient farming communities, tranquil, virtuous and at one with nature. This bore little relation to the actual history of American farming. The pattern of land exploitation in the nineteenth and early twentieth centuries was one of careless cultivation, speculation and soil exhaustion. The overriding motive was rapid commercial gain. The

farmer was more an individualist businessman than a self-sufficient labourer in a coherent agricultural community. But the function of the myth was not to reflect reality. It was a cultural defence against the decline of agriculture and the rapid rise of industrial wealth. One of its early tenets, therefore, was the virtue of the land and the corruption and vice of the city.[28]

In the 1930s it thus became fashionable for intellectuals and exponents of popular culture to 'rediscover' American virtue and innocence in a mythical rural past. The New Deal gave tangible credence to these reflections of Eden in its Tennessee Valley Project and its creation of a Civilian Conservation Corps. The back-to-the-land movement grew in popularity, supported by the Division of Subsistence Homesteads, part of the Works Progress Administration. This Division administered a scheme to resettle urban overspill tenants on the land. The model of a Scandinavian lifestyle became fashionable, emphasizing clean air, gardening, digging and exercise.[29] The agrarian myth had cultural, as well as practical, manifestations. Writers, film-makers, artists, and photographers such as Ansell Adams, sought a mythic definition of American values in the Western landscape. They portrayed individuals free from social pressures, history and family, self-reliant and ready to confront whatever awaited him or her. It was a landscape both savage and lawless, and yet abundant and free. Rejecting industrialization and technology, these myth-makers found a radical alternative to American progress in America's poetic past.[30] American liberalism at this time thus identified itself with the agrarian tradition, departing from the traditional association of agrarianism with conservative thought.[31] Hollywood was to endorse this cultural programme enthusiastically. One of the most consistent and convincing advocates was John Ford (his films, and those of others which look at the agrarian myth, are discussed in Chapter 3).

The reconstruction of American values: part two, 1938–1948

The height of the New Deal had passed by 1938.[32] Francis Merrill, writing in 1948, looked back at the war years in the United States and concluded optimistically that there had been an acceleration and development of the 1930s spirit of national cooperation.[33] Later commentators have been inclined to argue otherwise. Modern historians are more likely to argue that, as conservative opposition grew in Congress from 1936 onwards, aggravated by the 1937 recession, a brake on reform was enforced.[34] Roosevelt's preoccupation with foreign affairs and defence policy meant that he concentrated less on domestic matters, and the energy of the social programmes of his early presidency dissipated. The onset of the war reinforced this trend towards inertia at home, an inertia exacerbated by the lack of any ideological blueprint for the New Deal. The president's brokerage style of politics made him more likely to seek an accommodation with the hostile and obstructive coalition of Northern Republicans and Southern Democrats. During the war the liberal cause took a back seat to the military effort; business experts were brought back into the government

to supervise war production, a symbol, perhaps, of the passing of the New Deal. 1942 saw further Republican gains in the congressional elections, as memories of the 1929 recession faded and unpopular wartime restrictions were blamed on the government. Roosevelt's third and final re-election in 1944 saw his most slender majority, defeat being averted largely by the imminence of military victory in Europe.[35]

The full wrath of the Right was reserved, however, for the post-war years. By 1945 an alliance of business with the conservative coalition in Congress meant an end to any continuation of the New Deal ideas of business regulation, the promotion of labour rights, the provision of social security and subsidized public works projects. The 1946 congressional elections, conducted in an atmosphere of Red scaremongering, brought landslide victories for the Republicans. The Right gained control of both houses for the first time since 1928. Truman, now president following FDR's death in office in 1945, moved to the right to accommodate the new political mood. His early attempts to introduce the Fair Deal legislation were blocked by the Eightieth Congress, which introduced conservative measures of its own. Loyalty tests were brought in to root out communist sympathizers in the civil service and elsewhere. The Taft-Hartley anti-union law was passed in 1947. Congress, in what became known as the 'soak-the-poor' taxes, lowered the tax burden on business, reversing the New Deal emphasis on redistributing wealth.[36]

The Republicans needed an issue to help break the Democrats' long hold on the White House, and they lighted on anti-communism. The end of the war had seen Russia expand its control across eastern Europe, and America seemed helpless to prevent it. These foreign travails provided the Republicans with the basis for an assault on its enemies at home. Those values which had seemed irrefutable at the height of Roosevelt's power in the 1930s – community-based support, helping the weak and the poor, moderating and controlling the activities of big business – were now presented as dangerously left wing, 'un-American', unpatriotic – even treacherous. It suited Republicans to use these epithets to cast aspersions on the once popular Rooseveltians. Even orthodox politicians of the Right attached themselves to this cause in their scramble to recover the lost ground of fifteen years in the wilderness. As a result, ordinary conservatives embraced hysterical anti-communism, while any defence by the Left was silenced for fear of being labelled un-American. The search for impossible cures to the problems of America (and, in the emergent Cold War, the problems of America in the world) led inevitably to frustration and disappointment.[37] In what Richard Hofstadter dubbed 'the paranoid style' of American politics, a cyclical reaction to the liberal achievements of the previous decade ensued.[38] The achievement of elevated ideals and unrealistic goals was seen as the country's appointed destiny. Unable to accept that simplistic American solutions might not be sufficient for the realities of the Cold War world, politicians and populace alike sought an explanation in conspiracy. A scapegoat was needed. As Hofstadter put it, the nation launched itself upon another of those periodic, 'psychic sprees that purport to be moral crusades'.[39] The era of conservatism began in earnest.

The cultural response to this conservative reaction was in stark contrast to the celebratory and optimistic idealism of the 1930s. Robert Lynd was a typical example of the anxious

intellectual, alienated from the direction of social change in the country and unable to understand how the ideals of the 1930s had left no permanent effect on the American people. His assessment in 1939 of the ultimate achievement of the 1930s was profoundly pessimistic. The commitment to aggressive competitiveness had endured. The individual had become highly mobile and thus rootless, alone, shifting; free in one sense, but only free to suffer without help or companionship and ultimately to fail, alone. The progress made in the 1930s towards a more humane society had seen insufficient adjustment by social agencies to ensure that the change was permanent. The weak and helpless in American society were cast adrift by the continuation of unfettered American capitalist values. Lynd concluded, 'the elephants are dancing among the chickens'.[40] Could the mentality which had enabled the wilderness to be conquered now be used to live in the United States at peace, he asked? The frontier values of aggression, dominance and individual competitiveness had served the nation well in the conquest and exploitation of America. But now that the time had come to settle the land and use the resources, those same values were destructive and outdated.[41] For later writers, the confidence in American progress that so characterized 1930s thinking had been shattered by the horrors of the war, particularly the exploding of the atom bomb and the revelations about the concentration camps. Even science, formerly perceived as the key to mankind's rational understanding of the world, was seen to be a destructive pursuit.[42]

The failure of New Deal liberalism left a vacuum in moral values as writers, thinkers and artists attempted to make sense of the confusion in post-war America. Faith in communism was now discredited and, indeed, positively dangerous to espouse; faith in science was gone; faith in mankind's ultimate intention to do good seemed utterly unsuited to the atmosphere of the Cold War. Hortense Powdermaker, an anthropologist, wrote of the anxiety, uncertainty and loneliness of life in the United States after the war, and the fear that the American dream was over; the subjects of her study were the artists and executives of Hollywood.[43] Leo Lowenthal, a historian, sees a 'lack of definitive cultural and moral solutions' at this time.[44] Hollywood was to respond to this breakdown in moral certainty by making many films which depicted the seediness and corruption of American life. Social and cultural malaise is challenged in these films by an isolated male hero trying to salvage a personal moral code out of the cultural wasteland around him. (The role of women, which is discussed below, was markedly different.)

Novelists and playwrights had begun to express anxiety about American morality in the late 1930s and early 1940s. Steinbeck had written about success as a delusion, a notion that destroyed rather than ennobled its victims. Other writers showed the dream of success as an inescapable nightmare, neither dignified nor avoidable. Nathanael West burlesqued and mocked the success myth; Clifford Odets believed that the pursuit of American dreams subverted and destroyed the valuable ideals present in the culture. Yet there was no alternative, these writers argued; the pursuit had to be made, even though a once uplifting goal had been perverted and contorted into a cynical ambition.[45] Popular authors such as Raymond Chandler, Dashiel Hammett and James M. Cain reacted to the drift away from liberalism with their 'tough guy' literature. Disillusioned with the tradition of idealistic and

successful heroes, these writers fashioned stories around lonely individuals in the brutal world of a dark urban jungle. This approximated to a 'cult of failure', as if the virtues of American life resided only in failures and losses. These populist writers, however, did allow their rugged heroes at least some kind of triumph, even if their successes were isolated rather than social. Hemingway's 'decline of the individual' went further, to the length of having the loner fight, but ultimately lose.[46] These fables of virtue struggling to maintain itself in a hostile environment reflect a profound disillusionment with American idealism and the prospects for the American dream.

These stories were to prove a fruitful source for Hollywood's own cultural response to the conservative triumph in 1940s America. The rise of the 'film noir' was one such expression of Hollywood's disillusionment – a dark, bleak setting for a lonely exploration of murder and violence. Other films ran away from reality through the use of ghost stories, in which New Deal values were embodied in – and realized by – a phantom from the past. It was a very different collection of films from those celebratory, optimistic 1930s movies, in which the values of Roosevelt's America were confidently trumpeted to the rest of the world. The movies were different because the times had changed.

The American woman, 1933–1948

The high point of feminist thinking in America prior to the 1960s was in 1920, when the suffragist movement obtained its goal of winning the vote for women. This was a natural climax to more than two decades of active public life on the part of middle-class women in philanthropy and voluntarism.[47] With the extension of the franchise came expectations of a more developed role for women in American society. Suffragists saw the winning of the vote as merely the catalyst for a widespread social liberation for American women. The entry of women, as equals of men, into the workforce and prominent public positions was anticipated. Yet by 1940, as William Chafe, a women's historian, has written, the women's rights movement 'had ceased to exist as a powerful force in American society'.[48] Thus American feminism reached its first peak in 1920. Subsequent decades – lasting right up to the mid-1960s – saw significant cultural and social pressures on women to restrict themselves to domestic roles and not to challenge male economic and political supremacy. The expectations of the early suffragettes were to be disappointed across the whole range of American life. The 1930s and 1940s were decades of feminism in retreat, a period of American history in which women were discriminated against and oppressed. Hollywood actively participated in this comprehensive cultural oppression, producing hundreds of films that ridiculed or criticized the aspirations of women to assert themselves economically or socially. These films are discussed in Chapter 4. It is no accident that the vast bulk of Hollywood films in this period oppose female independence. The American film industry was, again, in perfect harmony with the wider cultural and social goals of the country at large.

In the 1930s female employment became a vital source of income for hard-pressed families struggling to survive the Depression. Women expanded their traditional roles as farm labourers, factory workers and servants, slowly beginning to take on white-collar jobs. Yet throughout the decade, economic discrimination against women at work intensified, while cultural expectations demanded that married women confine themselves to the home. The existence of greater numbers of women in the workforce in the early years of the Depression did not itself signify economic or cultural equality. Indeed, the economic necessity of female labour brought with it renewed efforts to maintain a male dominance that was under threat. Women in industry in the 1930s were economically deprived, ignored by the male-centred labour unions, their rights not recognized in legislation or by the courts. The Depression may have precipitated an expansion in female employment, but it allowed no progress towards equality for women.[49] Although female unemployment fell more slowly than male unemployment at the start of the 1930s, by 1939 females were losing work more rapidly than men.

Married women in the United States took jobs only in those sectors of the economy where men did not traditionally work and where wages were comparatively low. Women's work was underpaid and menial as a rule. Although middle-class women did begin to take white-collar jobs, over the decade as a whole the proportion of professional women fell from 14.2 per cent to 12.3 per cent. Moreover, married women in America at this time worked only when their husband's income was low. In 1940, for example, only 5.6 per cent of wives worked in marriages where the husband earned over $3000 a year; that figure rose to 24.2 per cent where the husband's salary was less than $400. In other words, married women did not work to free themselves from domesticity, nor did they work because they had achieved a new parity with men. Married women worked out of necessity, not choice. They were accordingly victims of discriminatory pay, promotion and retention policies in American industry. Women's work was segregated from men's and restricted to subordinate tasks; they were not promoted to supervisory positions, and they were paid less than men for jobs of equal worth.

In the sphere of politics, there were apparent advances made by women. Under the dynamic influence of Eleanor Roosevelt, women participated in Democratic Party campaigns and New Deal policies. Frances Perkins was the first woman member of Cabinet. For the first time in American history, there was a female Appeals Judge and a number of women were appointed as junior ministers. Women activists such as Mary Dewson transcended the private philanthropy of earlier American feminists, crossing from social work into political life. This was facilitated by the way in which New Deal policies brought previously private matters, such as welfare, mortgages and school lunches, into the domain of public politics. Yet the activities of a few prominent women in political life did not in itself advance the cause of women's issues; neither did it signify recognition of women's rights. Indeed, there was virtually no interest on the part of the New Dealers in helping women to realize their social and political goals. Women did not vote as a united constituency and did not organize themselves around women's issues. Reforms which could have helped women

secure equality were resisted. Unequal pay continued, assisted by government equivocation on the issue. No progress was made towards establishing state childcare facilities. This was partly due to financial considerations but, more importantly, there was a dominant belief that it was wrong to facilitate mothers working instead of looking after their children at home.[50] The urgent preoccupation with the economic problems of the country militated against any concerted action on behalf of a feminist programme. As Lois Scharf, another women's historian, has put it, 'In a decade during which economic recovery and social stability monopolized public attention, and intellectuals toyed with economic but not social revolution, feminism retreated'.[51]

There were cultural counterparts to the institutionalized economic discrimination against women. Indeed, the two were inseparable. For men, suffering loss of status from widespread unemployment, women in employment presented an unpleasant challenge. Many opposed their wives working, even while in desperate economic straits themselves.[52] As working wives became a symbol of hard times, so the goal of returning women to the home became synonymous with the goal of a general return to prosperity. For the average American, both male and female, a wife at work was a sign of poverty and failure. The aspiration was to restore women to domesticity, as if to mount a display of the returning economic supremacy of the male.[53] Magazines such as the *Ladies' Home Journal* and *McCall's* put forward an ever more strident advocacy of female domesticity. The former proclaimed the rejection of 'Smartness', that is, intelligence, as the motif for 1930s women and advocated the rise of 'Charm'. An elaborate ideology of domesticity was constructed over the years in magazines such as these, emphasizing the separation of gender roles – wife and mother for women, wage-earner and provider for men. Women, particularly married women, were discouraged from taking jobs at a time when, it was argued, men could not find work. Popular journals alleged that wives who worked were abandoning their domestic responsibilities and losing their femininity. The popular conception of working single women was that they worked only for 'pin money', rather than from economic necessity – a selfish, irresponsible act of frivolity that denied men work.[54]

This disjunction between popular culture and social reality – in which Hollywood cinema played an active part – is instructive. Rather than reflecting the new circumstances of increased female economic importance, the cultural industries sought to neutralize unwanted social change by criticizing its manifestations. Women who worked were alienated, ridiculed and attacked, even though in the main their decision to work was born of economic necessity. The intention was to dissuade women from interpreting positively their participation in the economy. Although economic imperatives had brought about their presence in the market, a wife who worked was judged a failure as a woman, or socially irresponsible. This cultural pressure on women, when conjoined with contrary economic pressures, was bound to be confusing. Margaret Mead complained about the narrowness of permissible definitions of American womanhood. American society would not allow a woman to achieve without sacrificing her femininity: either one could be, 'a woman and therefore less an achieving individual, or an achieving individual and therefore less a woman'.[55] Robert Lynd in 1939

observed the clash between the values of home and workplace, and noted the increasing tension between the sexes as women started to broaden their lives.[56]

The – overwhelmingly male – social and cultural leaders of American life attempted to order the American woman back into the home. Hollywood's films of the 1930s relentlessly ridiculed women who sought to assert themselves in the conduct of a romance. Women who put their careers before marriage were not just ridiculed, but shown to be unacceptably selfish. Economic independence might buy a woman freedom from male control. Writing about American saleswomen in 1929, Frances Donovan had observed that: 'the saleswoman … was influenced in her attitude toward marriage by the comforting knowledge that she did not have to get married. She was economically independent and could, therefore, make a careful decision when a suitor presented himself'.[57] This degree of female independence was not acceptable to the opinion-leaders of 1930s America. It was certainly not an image promoted by the American film industry. Middle-class married women in this period did not embrace feminist philosophy and readily acceded to the social and cultural pressures to remain in the domestic sphere. They abandoned moves towards paid work. They chose to embrace the ornamental and emotional elements of domesticity, using servants to perform the menial work and sparing husbands from any domestic responsibilities. This transaction, it has been argued, reinforced the dominance of male control over women in this period.[58]

America's entry into World War II caused a temporary disruption in the steady erosion of women's status in the United States. Over six million women took jobs; the female labour force increased by more than 50 per cent; wages leapt up; the number of working wives doubled; not only the manufacturing industry but the tertiary sector welcomed women (over two million office jobs were taken by women during the war). Women became occupationally mobile, changing jobs for better pay; unions accepted women into their membership. Older women and married women joined the workforce in significant numbers. This added a new permanence to the notion of the employed woman. She was no longer synonymous with the young, unwed girl waiting for marriage to 'free' her from employment. Some women predicted that never again would they be dependent on men.[59] However, there was in fact very little permanent change effected by the exigencies of war. The advent of older, married women into the economy would endure, signalling the start of a slow process of feminist advance. But, in terms of immediate goals, the wartime employment boom actually yielded American women little. Discrimination against women in the professions continued unabated during the war, with universities, law practices and hospitals either refusing to employ women, or refusing to promote them or offer them equal pay. Opposition to public institutions taking on 'women's' roles in the home inhibited progress towards women achieving equality at work. As mentioned above, the provision of childcare was discouraged in case it prompted women to abandon their domestic responsibilities. Such attitudes endured throughout the 1940s. Women could not hope to compete with men for better jobs and promotions when they had to carry the burden of family care on top of full-time employment.[60] There were additional pressures. Social scientists such as Francis Merrill saw a link between working

wives and the rising divorce and desertion rates, as well as the rise in juvenile delinquency and increased promiscuity among girls.[61]

Thus the economic position of women changed in the war but traditional conceptions of women's role did not. Hostility towards women broadening their experiences outside the confines of the home continued after the war. The immediate post-war period was one of intense speculation by social scientists and others about the position of women in American society and about marriage, the family and morals. Men and women sought to determine the boundaries of women's sphere of activity. The two sexes jockeyed to establish new roles after the disruptive effects of the war. For women, the issue was how much of their wartime gains they could retain and consolidate. They were not ready to give up their gains when the soldiers returned. The widely predicted recession did not happen after the war. Although many women were laid off, redundancies and dismissals were lower than expected. By 1947 the period of immediate adjustment was over and women workers had stabilized at numbers far higher than in 1940. In California, for example, the number of women in work doubled between 1940 and 1949.[62]

The increased tensions led observers to speak out more starkly. 'The home is the basic American institution', declared Frederick Crawford, head of the National Association of Manufacturers. 'Women must bear and rear children; husbands must support them', Willard Waller, an eminent sociologist, stated baldly.[63] These sentiments were reinforced by a new generation of social scientists, such as Talcott Parsons, Ashley Montagu and Agnes Meyer, who added ideological underpinnings to the prejudice against women. Less interested than their New Deal-inspired predecessors in social change, Parsons and his contemporaries preached that women should return to the home and stay there.[64] Others, like Lundberg and Farnham, argued that women had lost their direction through misconceived efforts to imitate men; they had rejected their natural instincts, under the malign influence of feminism, and had been cast adrift. If these women were to be rescued, the prestige of the home, of child-rearing and housekeeping had urgently to be restored.[65] Their views were shared and supported by the *Ladies' Home Journal* and *McCall's*. Similar sentiments appeared in writings about women's education and employment. Hollywood films also contributed to these negative perceptions of women, albeit in a more dramatic and overstated fashion. Women became, in the films noirs of the 1940s, murderers and evil seducers – a threat to the confused and easily misguided male.

Public opinion shared these denunciations of female participation in the economy and public life. Working wives were opposed by 63 per cent of respondents in a *Fortune* survey in August 1946 and by 86 per cent in a Gallup poll of the following year.[66] A married woman over 35 was more likely to be in work than at home, but most people believed that she *should* be at home.[67] Further questioning revealed that attitudes to women taking jobs became less hostile if it did not threaten traditional sex roles. Women could work without fear of social opprobrium if they had finished their child-rearing; alternatively, they could work in areas where men were unlikely to seek employment, or when their husband's income had to be supplemented.

Margaret Mead, writing in late 1946, argued that women were placed under severe constraints by having to maintain sole responsibility for housework while trying to nurture a career. On any criteria one cared to use, she wrote, 'the answer is the same: women – and men – are confused, uncertain and discontented with the present definition of woman's place in America'. She criticized the 'semivoluntary slavery to housekeeping that we now impose on married women in the U.S.' and pleaded for men to do more in the home.[68] Feminists all over America agreed with her; the problem was the unrelentingly narrow definition of feminine roles insisted upon by American society. *Life* magazine carried an editorial at around the same time as Mead's article was published, in which the continuing inequality faced by American women was criticized. The American woman was 'still not a full partner in the national scheme of things', largely because of 'the way that Americans divide up their spheres of interest too sharply after marriage'. Men had to offer women a more balanced distribution of labour: 'Our urban industrial society, which rests on a division of labour, even tends to freeze women in their subservient social role'.[69] Less than a year later, in 1947, *Life* devoted thirteen pages to a special feature on the 'American Woman's Dilemma', examining the conflict faced by women over how to be a housewife and yet still participate in the wider world. Women, the article concluded, were confused about their identity and their role in post-war America.[70]

A significant change in women's roles had occurred during this period, even if the cultural acceptance of it was yet to come. The cost had been a prolonged conflict of values that involved the repeated denigration of women's aspirations and qualities. The insistent hostility towards women found many outlets, from the learned writings of sociologists to popular magazines and advice journals. Hollywood participated in this cultural trend as an influential mouthpiece for sustained criticism of women's rights. In the 1930s its films reflected the revival of the Victorian cult of domesticity; in the 1940s the films expressed much harsher abuse of women, characteristic of the increased sexual tensions in that decade. In this, Hollywood was responding to a wider social trend. It would be left to Ernst Lubitsch to dissent from this virtually unbroken wall of hostility to the issue of women's rights in 1930s and 1940s America. His extraordinary contribution to the debate is explored fully in Case Study 3.

America and the world, 1933–1948

The first years of the New Deal were the years of American isolationism. A historic disengagement from the affairs of Europe was given added imperative by the need to tackle America's pressing domestic problems. Roosevelt's personal preference for a more active foreign policy, particularly as Europe moved towards war, had to give way to the widespread political and public desire to remain detached from global affairs. The President passed the Neutrality Laws, forbidding American assistance to the anti-Nazi coalition in Europe, from characteristically pragmatic motives rather than from any great conviction. Yet Roosevelt did

try to establish an American presence on the world stage by influencing foreign leaders to imitate the example of his domestic policies. This satisfied Roosevelt's desire to see America assume a measure of international leadership without alienating the isolationist instincts of the country. He hoped that the United States would serve as a symbol of democracy and liberty, a source of inspiration in international affairs. Roosevelt himself became, in the 1930s, a powerful figurehead for the cause of social reform and liberal democracy. A Montevideo newspaper reported that, under Roosevelt, the USA had again become, 'the victorious emblem around which may rally the multitudes thirsting for social justice and human fraternity'.[71]

This inspirational role found a clear echo in Hollywood's films of the 1930s. European and Asian countries were depicted only to demonstrate how much they owed to American democratic values or how far behind America these other nations lagged. America was proclaimed in the cinema the first and best hope for democracy and individual freedom. One product of isolationism was a film industry that trumpeted the superiority of American values at a time when Europe was sliding into dictatorship. As the 1930s drew to a close, many of Hollywood's film-makers produced films which called for American intervention in European affairs. There was an increasing urgency to these calls, both in the number of such films being made and in the directness of the message. This overtly political commentary from the film industry was highly unusual and thus not uncontroversial. It led to the establishment in 1938 of a committee, under Texan Senator Martin Dies, to look into left-wing infiltration of Hollywood – a precursor to the more famous McCarthy Commission which was established at the start of the 1950s.

Roosevelt had to battle with Congress, from the late 1930s until Pearl Harbor, to secure support for a more active foreign policy in support of the European democracies. The contradictory impulses in America – to avoid war and yet to see the Nazi menace to freedom stopped – were eventually welded together by the president into a homogeneous foreign policy. Roosevelt argued that lend-lease arrangements (whereby the United States would provide arms, supplies and financial assistance, mainly to the United Kingdom) were the best means of helping the democratic nations to resist the Nazis. If they were successful, he continued, then world peace would be secured and American involvement in a global war would be rendered unnecessary. He offered a proposal which appeared to keep America out of any European war and yet which took positive steps to limit the Nazi advance. Between the years 1938 and 1941, the president manoeuvred delicately towards greater American commitment, balancing carefully the demands of isolationists and his own desire to participate actively in the struggle for democratic values.

The Japanese attack on Pearl Harbor in 1941 put paid to isolationist opposition to the war. The nation united around the flag of anti-fascism and supported the American war effort. Beneath the unity of purpose, however, lay the roots of later domestic conflict. Uncertainties about the Soviet Union, and in particular the totalitarian tendencies of Stalin, had been an issue among American liberals for much of the 1930s. Many pro-Soviets had been disillusioned with the show trials of the Old Bolsheviks and alarmed by the Nazi–Soviet

Pact of 1939. The war ushered in a brief period of Soviet–American cooperation. For a while there was a hint of euphoria about the prospect of a post-war rapprochement of capitalism and communism. Stalin was *Time* magazine's 'Man of the Year' in 1943. Roosevelt was not naive about the Soviet leader's domestic or foreign policies, and he pinned his hopes on securing a pragmatic accord with the USSR after the war. He ensured that his ambassadors to Moscow were a mixture of pro-Soviet idealists and anti-Stalin sceptics. After the war, the professional anti-communists in the United States were able to make great play out of the association between the Democratic Party and the Soviet dictatorship.[72]

The post-war period was, as already noted, one of declining optimism in America, a time when the idealism and moral certainty of the 1930s appeared to have evaporated. This mood of resignation, anxiety and even despair was attributable largely to international developments.[73] The single most important influence over American thought in this respect was the figure of Hitler. Although dead, he served as the nightmare role model for future dictators with a lust for world conquest. Stalin's ambitions, although largely connected with his quest for security and some approximation of parity with the United States, seemed uncomfortably reminiscent of his erstwhile foe. Moreover, new technology in rocket-launched missiles meant that America was, for the first time, physically as well as economically threatened by a foreign power. This insecurity was overlaid by American politicians' opposition to the tenets of communism. They saw the need for a counterweight to Soviet ambitions in Europe. This was not purely a military concern. Access to markets in Europe was a key plank of American economic strategy, too. The result of this coalition of economic interest, defence considerations and ideological conflict was a new American imperialism. American interests, it was argued, could best be maintained by the proliferation across Europe of capitalist states opposed to Stalinism and looking to America for economic, military and political leadership. A commitment to secure free, democratic nations open to American enterprise became the guiding light of Truman's foreign policy. This sharpened the existing conflict of ideologies between American individual enterprise and democracy, and Soviet-style collectivism and autocracy. Moreover, many Americans now believed that their country's isolationism had been directly responsible for the war. Therefore, America's urgent duty was to manage international affairs and keep the world safe from dictators like Hitler. Stalin appeared to many to be just such a leader.[74]

Hopes of a Soviet–American rapprochement were quickly dashed in the first years after the war. The two superpowers had strikingly different perceptions of European politics. Stalin was not prepared to countenance American expansion into eastern Europe, with the inevitable political, economic and military dominance it would bring. The Western allies had shown no enthusiasm for maintaining the Soviet Union's borders at the time of Hitler's expansion eastward. Indeed, there was abundant evidence that Hitler had been seen as a useful anti-communist counterweight to Soviet power. Stalin's fears of a revitalized Germany and the threat of a future invasion of Russia can hardly be exaggerated. The influence of America in Central and South America was unchecked. Its tacit support for Nazis to be given a refuge in these countries seemed sinister to Stalin, to say the least. Western Europe

was already looking to the United States for support. From the Soviet perspective, it seemed only fair, as well as militarily, economically and politically essential, that the Soviet Union should control eastern Europe.

The American people saw things differently. They hoped that eastern Europe could be part of the Soviet sphere of influence, yet operate as democratic and free-market nations. This was impossibly naive. Yet it was thought inconceivable that the eastern Europeans did not want a democratic, private enterprise culture run along American lines. The Americans' own confidence that their system was the envy of the world permitted no other interpretation. But what they saw was an apparent military conquest of eastern Europe by Stalin, all too reminiscent of Hitler in 1939. The collapse of Poland in 1946 started the American panic. Up until then, American power was felt to be insuperable. Sole possession of atomic bomb technology had seemed to assure American superiority over Soviet military might. The case of Poland immediately demonstrated that the power of the atom bomb was more apparent than real. No American president was going to drop the bomb on Europe. There was little the United States could do to prevent Stalin from controlling what he saw as his legitimate sphere of influence. The American public, however, was angry and confused about the inability of the most powerful nation on earth to stop the communist 'conquest' of eastern Europe. This mismatch between unrealistic American expectations and the limits of American power had as an immediate consequence the search for a scapegoat. Paranoid fantasies of a worldwide communist conspiracy, with cells in America itself, led frustrated anti-communists to conclude that American failures abroad resulted from subversion at home. Even if there was no direct link between the two, there was at least some compensation in attacking communism at home for the inability to halt its expansion abroad.[75]

Unintentionally, this hysteria was given support by Truman. He had to find a means of resisting Soviet influence and maintaining American interests around the world. This implied an active foreign policy, in which American soldiers and money would be employed to oppose communist forces wherever they arose. Yet the will, both of the American public and of Congress, was lacking for such a novel enterprise. For the populace, rapid demobilization was the pressing issue; the hostile Republican Congress wanted reductions in taxation. Neither of these pressures helped Truman's new policy. He therefore sought to distract domestic opposition by deliberately overdramatizing international events. Poland had fallen to Stalin; by March 1947 Greece was apparently succumbing to communist rule. Truman went to Congress to demand support for military intervention. The result was the Truman Doctrine and the policy of 'containment'. America would intervene in the world wherever free peoples were resisting armed subjugation. (Truman meant by this only communism, rather than the military dictatorships in South America, which the United States continued to support.) Democracy and private enterprise were to be preserved and Soviet influence 'contained'. His speech, said a supporter, was designed to 'scare the hell out of the American people'.[76] Truman's execution of this new American internationalism inaugurated a decade of hysterical Red scares and the total eclipse of American liberalism.

The issue was presented not as one of American economic interests, nor even of political influence. Rather, it was a battle between dark and light, between the fundamental forces of good and evil: it was a crusade. Truman dramatized a pragmatic political conflict in terms more in keeping with the national mood. It was a universal struggle. The 'domino theory' of communism was first outlined at this time: if Greece fell, so went Turkey; then the Dardanelles would pass into Stalin's control and hence the Middle East would fall; after that, Stalin would be powerful enough to conquer Europe. This time, appeasement would not occur. So began an extraordinary shift in American foreign policy, from isolationism to imperialism and global intervention in times of peace. By the end of 1948, Truman's doctrine had been implemented in spectacular fashion, with the Marshall Plan for European aid, and the airlift over the Berlin blockade. But the communist-inspired *coup d'état* in Czechoslovakia had been a setback; Mao Tse Dung's communists were clearly going to triumph in China; tension was mounting in Palestine and Korea. The Cold War had begun.

Hollywood was not to dwell upon these international events. It had trumpeted American values to foreign nations during the early period of American isolationism. It had championed the liberal cause of intervention from 1938 to 1941. It had supported the war effort from Pearl Harbor to VJ Day. From 1945 onwards, alienated from the anti-liberal culture at home created by the tension abroad, Hollywood film-makers beat a gloomy retreat. A wave of fear passed through the post-war film community, as the American public and political institutions closed their minds to rational debate. The predominantly left-wing artists in Hollywood were particularly vulnerable to charges of communist subversion. There was thus no attempt by the film-makers to engage the public in alternative interpretations of the Cold War. Wilder and Lang were notable exceptions to this rule, as discussed in Case Studies 6 and 7 respectively. They each produced a film which probed beneath the surface and dared to criticize American foreign policy. Hollywood films of the mid- and late-1940s were dominated by a mood of bleak pessimism and a depiction of idealism in retreat. This malaise and moral uncertainty was in no small measure a reflection of how events abroad were having domestic repercussions. The American film industry started to look in on itself, in stark contrast to its self-confident global advocacy of American values in the 1930s. This period of gloomy introspection showed how far Hollywood – and the nation – had moved away from the optimism and high ideals of New Deal America.

Notes

1. Progressivism has its own extensive bibliography. An excellent analysis is Richard Hofstadter, *The Age of Reform: from Bryan to F.D.R.* (New York, 1955). An introductory account can be found in Arthur M. Schlesinger Jnr, *The Crisis of the Old Order, 1919–1933* (Boston, Mass. 1957). Other interpretations include Christopher Lasch, *The New Radicalism in America (1889–1963): the Intellectual as a Social Type* (New York, 1965); Gabriel Kolko, *The Triumph of Conservatism: a Reinterpretation of American History, 1900–1916* (New York, 1963); Robert Wiebe, *The Search for*

Order, 1877–1920 (London, 1967); and Arthur A. Ekirch Jnr, *Progressivism in America: a Study of the Era From Theodore Roosevelt to Woodrow Wilson* (New York, 1974).
2. A good introduction to Progressive thought is David W. Noble, *The Progressive Mind, 1890–1917* (Rev. edn, Minneapolis, 1981); Morton G. White, *Social Thought in America: the Revolt Against Formalism* (New York, 1949) is also useful. I am grateful too to Professor Melvyn Stokes for his observations on this period of American history during his series of lectures at University College London.
3. The literature on the New Deal is impressive in size and scope. My summary of the politics of the period is derived principally from Schlesinger Jnr, *The Crisis of the Old Order* and its succeeding two volumes, *The Coming of the New Deal* (Boston, Mass. 1958) and *The Politics of Upheaval* (Boston, Mass. 1960) (collectively known as *The Age of Roosevelt*); William E. Leuchtenburg, *Franklin D. Roosevelt and the New Deal, 1932–1940* (New York, 1963); and Robert S. McElvaine, *The Great Depression: America, 1929–1941* (New York, 1984) (whose section on Hollywood and the New Deal is, incidentally, quite sound). Also useful are Stephen W. Baskerville and Ralph Willett (eds), *Nothing Else to Fear: New Perspectives on America in the Thirties* (Manchester, 1985); John Braeman et al. (eds), *The New Deal: Vol. 1 – The National Level* (Columbus, O., 1975); Jim Potter, *The American Economy between the World Wars* (London, 1974); and Harvard Sitkoff (ed.), *Fifty Years Later: the New Deal Evaluated* (New York, 1985). See also Mario Enaudi, *The Roosevelt Revolution* (London, 1959) and Albert U. Romasco, *The Politics of Recovery: Roosevelt's New Deal* (New York, 1983).
4. The debate over the radicalism of the New Deal has produced a number of works. Leuchtenburg, *Franklin D. Roosevelt and the New Deal* and Leuchtenburg, 'The Achievement of the New Deal', in Sitkoff (ed.), *Fifty Years Later*, 211–231, are written by the key proponent of the New Deal as radical and enduring; McElvaine, *The Great Depression*, has a well balanced assessment. The New Left reappraisal in the 1960s, which saw the New Deal as failing to implement the necessary structural reform of capitalism, is stated by Barton J. Bernstein, 'The New Deal: the Conservative Achievements of Liberal Reform', in Barton Bernstein (ed.), *Towards a New Past: Dissenting Essays in American History* (New York, 1968), 263–288. Romasco, *The Politics of Recovery*, shares this assessment of the New Deal achievements as 'conservative'. The essays in Braeman et al. (eds), *The New Deal*, accord grudging approval to the New Deal. My interpretation is supported by the assessment in Braeman et al. given by James Holt, 'The New Deal and the American Anti-Statist Tradition', 27–49.
5. Charles R. Hearn, *The American Dream in the Great Depression* (Westport, Conn., 1977), 3–17.
6. Irving Howe, 'American Moderns', in Arthur M. Schlesinger and Morton White (eds), *Paths of American Thought* (London, 1964), 309–325. F. Scott Fitzgerald, *The Beautiful and Damned* (1922) successfully evokes the absence of values or purpose among America's leading classes.
7. McElvaine, *The Great Depression*.
8. Richard Sennett and Jonathan Cobb, *The Hidden Injuries of Class* (Cambridge, 1977) uses interviews with 150 American workers in 1969–1970 to explore the indignities and shame of economic failure in the United States. The difference between the experience of the Depression, when failure was felt to be outside a person's control, and that of more recent years, is one of the themes of the interviews.
9. Richard Hofstadter, *Social Darwinism in American Thought* (Philadelphia, 1944).
10. Ralph Gabriel, 'Ideas and Culture in the Twentieth Century', in William H. Cartwright and Richard L. Watson Jnr (eds), *Interpreting and Teaching American History* (Washington DC, 1961), 312–328.

11. Merle Curti, 'Human Nature in American Thought: Retreat from Reason in the Age of Science', *Political Science Quarterly*, 68 (December 1953), 492–505, 507–8, reprinted in Wilson Smith (ed.), *Essays in American Intellectual History* (Hinsdale, Ill., 1975), 463–472. See also the following essays (all reprinted in the same volume) for the influence of John Dewey's pragmatism: Charles Frankel, 'John Dewey's Legacy', from Frankel, *The Love of Anxiety and Other Essays* (New York, 1960), reprinted at 389–401; Robert Goedecke, 'Holmes, Brandeis and Frankfurter: Differences in Pragmatic Jurisprudence', *Ethics*, 74 (January 1964), 83–96, reprinted at 402–414; and John E. Smith, 'The Spirit of American Philosophy', from J. E. Smith, *The Spirit of American Philosophy* (New York, 1963), 187–197, reprinted at 473–79.
12. Arthur M. Schlesinger Jnr, 'Sources of the New Deal', in Schlesinger and White (eds), *Paths of American Thought*, 372–391.
13. Charles Beard, 'The Educator in the Quest for National Security', *Social Frontier*, 1 (April 1935), 14; quoted in McElvaine, *The Great Depression*, 205.
14. Clarke A. Chambers, 'The Belief in Progress in Twentieth-Century America', *Journal of the History of Ideas*, 19 (April 1958), 197–224, reprinted in Smith (ed.), *Essays in American Intellectual History*, 422–437.
15. Frederick Lewis Allen, *Since Yesterday: the Nineteen-Thirties in America* (New York, 1940); see, for example, 212–14.
16. Robert S. Lynd, *Knowledge for What? The Place of Social Science in American Culture* (Princeton, NJ, 1939), 60–62.
17. In *New Masses*; quoted in Richard H. Pells, *Radical Visions and American Dreams: Culture and Social Thought in the Depression Years* (New York, 1973), 52.
18. Hearn, *The American Dream in the Great Depression*, 59–80. See also R. S. Lynd and Helen Merrell Lynd, *Middletown in Transition* (New York, 1937), whose survey of an American mid-Western town found that underlying attitudes towards the American capitalist system remained largely unchanged by the Depression. Pells, *Radical Visions and American Dreams*, 292–329, also concludes that the radical change of the first years of the New Deal lapsed into conservatism after 1935.
19. Popular journals which published such stories also included *American Magazine* and *Ladies' Home Journal*; see Hearn *The American Dream in the Great Depression*, in particular 109–164.
20. Hearn, *The American Dream in the Great Depression*, 138–163.
21. Patrick Johns-Heine and Hans Gerth, 'Values in Mass Periodical Fiction, 1921–1940', in Bernard Rosenberg and David Manning White (eds), *Mass Culture: the Popular Arts in America* (n.p., 1957), 226–234.
22. Hearn, *The American Dream in the Great Depression*, 109–112; Johns-Heine and Gerth, 'Values', *passim*.
23. Warren Susman, 'The Thirties', in Stanley Coben and Lorman Ratner (eds), *The Development of an American Culture* (Englewood Cliffs, NJ, 1970), 217–18.
24. McElvaine, *The Great Depression*, 223.
25. Thomas L. Hartshorne, *The Distorted Image: Changing Perceptions of American Character since Turner* (Cleveland, 1968), 101–117; Pells, *Radical Visions and American Dreams*, 96–150. For further observations on the changes in 1930s values, see Irving Kristol, 'Ten Years in a Tunnel', in Morton J. Frisch and Martin Diamond (eds), *The Thirties: a Reconsideration in the Light of the American Political Tradition* (DeKalb, Ill., 1968), 6–26; Alan Lawson, 'The Cultural Legacy of the New Deal', in Sitkoff (ed.), *Fifty Years Later*, 155–186; and William Stott, *Documentary Expression and Thirties America* (New York, 1973).

26. Susman, 'The Thirties', in Coben and Ratner (eds), *The Development of an American Culture*, 179–218; Pells, *Radical Visions and American Dreams*.
27. This idea of an unbroken line in political thought stretching from the revolutionary philosophy of the Founding Fathers to modern America is well explored in Daniel Boorstin, *The Genius of American Politics* (Chicago, 1953).
28. For an exposition and critique of the agrarian myth, see Hofstadter, *The Age of Reform*, 23–59. See also Patricia Nelson Limerick, *The Legacy of Conquest: the Unbroken Past of the American West* (New York, 1987) for a more recent reappraisal of the 'conquest of the West' and the terms on which it was carried out. For the related issue of the conflict between rural virtue and urban vice, see Morton and Lucia White, *The Intellectual Versus the City: from Thomas Jefferson to Frank Lloyd Wright* (Cambridge, Mass., 1962); and Leo Marx, *The Machine in the Garden: Technology and the Pastoral Idea in America* (New York, 1964).
29. See, for example, Twelve Southerners, *I'll Take my Stand* (New York, 1930); Stuart Chase, *Mexico, a Study of Two Americas* (no place, 1931); Ralph Borsodi, *Flight from the City: an Experiment in Creative Living on the Land* (New York, 1933); Philip Curtiss, 'They Are Moving to the Country', *Harper's*, 171 (1935), 67–79; Pells, *Radical Visions and American Dreams*, 96–150. Novelists such as John Steinbeck contributed to the movement with *The Grapes of Wrath* (1939) and *Tortilla Flat* (1941), both later filmed. See also Leuchtenburg, *Franklin D. Roosevelt and the New Deal*, 345 and Schlesinger Jnr, *The Coming of the New Deal*, 319–381.
30. Pells, *Radical Visions and American Dreams*, 194–251; Susman, in 'The Thirties', writes of the discovery of American 'culture' in the landscape and in documenting the experiences of the nation; see also Ray Allen Billington, *America's Frontier Culture: Three Essays* (Texas, 1977), particularly 'Cowboys, Indians and the Land of Promise', 74–97; Christopher Brookeman, *American Culture and Society since the 1930s* (London, 1984), 1–7; Merle Curti, *The Growth of American Thought* (New York, 1943); Ralph Willett and John White, 'The Thirties', in Malcolm Bradbury and Howard Temperley (eds), *Introduction to American Studies* (London, 1981), 220–242; Henry Nash Smith, *Virgin Land: the American West as Symbol and Myth* (Cambridge, Mass., 1970); and Roderick Nash, *Wilderness and the American Mind* (3rd edn, n.p., 1982).
31. Hartshorne, *The Distorted Image*.
32. Neither Schlesinger Jnr, *The Age of Roosevelt* nor Leuchtenburg, *Franklin D. Roosevelt and the New Deal* goes much beyond 1938 in their account of the New Deal. My summary of political and social developments after 1938 is derived mainly from Richard Polenberg, *War and Society: The United States 1941–1945* (Philadelphia, 1972); William E. Leuchtenburg, *A Troubled Feast: American Society since 1945* (Rev. edn, Boston, Mass. 1979); Godfrey Hodgson, *In our Time: America from World War II to Nixon* (London, 1976); and Robert J. Donovan, *Conflict and Crisis: the Presidency of Harry S. Truman 1945–1948* (New York, 1977). See also John Morton Blum, *V Was for Victory: Politics and American Culture During World War II* (New York, 1976); and Malcolm Bradbury and Howard Temperley, 'War and Cold War', in Bradbury and Temperley (eds), *Introduction to American Studies*, 243–266.
33. Francis E. Merrill, *Social Problems on the Home Front: a Study of War-Time Influences* (New York, 1948), 233–34.
34. See, for example, Richard Polenberg, 'The Decline of the New Deal', and David Brody, 'The New Deal and World War II', both in Braeman et al. (eds), *The New Deal*, 246–266 and 267–309.
35. Polenberg, *War and Society*, 184–214.
36. Donovan, *Conflict and Crisis*, 107–126; Leuchtenburg, *A Troubled Feast*, 9–11, 15–16, 19–20; Alonzo L. Hamby, *Beyond the New Deal: Harry S. Truman and American Liberalism* (New York,

1973). John Higham, in 'Hanging Together: Divergent Unities in American History', *Journal of American History*, 61 (June 1974), 5–28, argues that there has been a long-term decline in American ideology and idealism, with Progressivism and the New Deal standing as aberrations in American political thought, rather than as part of any trend. He was, of course, writing before the time of Bill Clinton's presidency in the 1990s.
37. Hodgson, *In our Time*, 17–18.
38. Richard Hofstadter, *The Paranoid Style in American Politics and Other Essays* (London, 1966).
39. Hofstadter, *The Age of Reform*, 17. See also Alistair Cooke, *A Generation on Trial: USA v. Alger Hiss* (London, 1950), 3–42, for an account of the immense value changes regarding communism that took place in the United States between 1938 and 1948.
40. Lynd, *Knowledge for What?*, 111. For other anxious meditations on American destiny, see Charles A. and Mary R. Beard, *America in Midpassage* (London, 1939) and Margaret Mead, *The American Character* (Harmondsworth, NY, 1944) (reprinted in expanded form as *And Keep your Powder Dry: an Anthropologist Looks at The American Character* (New York, 1965)).
41. Hartshorne, *The Distorted Image*, 135–149, has an excellent analysis of this classic 1940s American dilemma.
42. Chambers, 'The Belief in Progress in Twentieth-Century America', 430–31.
43. Hortense Powdermaker, *Hollywood the Dream Factory: an Anthropologist Looks at the Movie-Makers* (Boston, Mass., 1950), 307–8. She goes on to record her own anxieties about Hollywood's 'democratic responsibilities' in the coming years of increasing autocracy – see 308–332.
44. Leo Lowenthal, 'Historical Perspectives of Popular Culture', in Rosenberg and Manning White (eds), *Mass Culture*, 51. Arthur Miller recalls this moral confusion illuminatingly in *After the Fall* (1964).
45. Hearn, *The American Dream in the Great Depression*, 82–107, 165–190. See such examples of disillusion with American values as: Steinbeck, *Of Mice and Men* (1937), *The Grapes of Wrath* (1939) and *The Moon is Down* (1942); Clifford Odets, *Paradise Lost* (1935) *Waiting for Lefty* (1935) and *Golden Boy* (1937); and Nathaneal West, *Day of the Locust* (1939).
46. Hearn, *The American Dream in the Great Depression*, 109–136; David Madden (ed.), *Tough Guy Writers of the Thirties* (Carbondale, Ill., 1968). Representative examples of writing include Raymond Chandler, *The Big Sleep* (1939), *Farewell my Lovely* (1940), and *The Lady in the Lake* (1944); James M. Cain, *Double Indemnity* (1935); and Ernest Hemingway, *To Have and Have Not* (1937) and *For Whom the Bell Tolls* (1940) (all filmed in the 1940s by Hollywood). See also Eric Homberger, 'The American War Novel and the Defeated Liberal', in Ian Higgins (ed.), *The Second World War in Literature: Eight Essays* (Edinburgh, 1986), 32–44. Homberger finds parallels in the experiences of novelists with my account of Hollywood's response to post-war America, in particular the struggle between 'liberals and reactionaries' as the New Deal waned.
47. Lasch, *The New Radicalism in America (1889–1963)*, 3–37, gives a biographical account of Jane Addams' middle-class, religious motivation for social welfare, and her corresponding political naivety. His subsequent chapter on American feminism in the 1920s (38–68) charts the cultural confusion about the changing expectations of women – the roots of the later overt anti-feminism.
48. William H. Chafe, *The American Woman: her Changing Social, Economic, and Political Roles, 1920–1970* (New York, 1972), 132. My summary of the broad trends in women's history during this period is derived principally from Chafe, supported by William L. O'Neill, *Everyone Was Brave: the Rise and Fall of Feminism in America* (Chicago, 1969). See also Lois Banner, *Women in Modern America: a Brief History* (New York, 1974) and Julie A. Matthaei, *An Economic History*

of *Women in America: Women's Work, the Sexual Division of Labor, and the Development of Capitalism* (New York, 1982). Other supplementary sources are cited in the notes below.
49. Chafe, *The American Woman*, 56–65, 81–88; Lois Scharf, *To Work and To Wed: Female Employment, Feminism and the Great Depression* (Westport, Conn., 1980), 110–138.
50. Chafe, *The American Woman* (see, for example, 151–158, 163–170).
51. Scharf, *To Work and To Wed*, 158. O'Neill, *Everyone Was Brave*, argues that the feminist movement's preoccupation with politics meant that the key issues for women – division of sexual roles, and social structures – were neglected.
52. 80 per cent according to Gallup; Scharf, *To Work and To Wed*, 141.
53. McElvaine, *The Great Depression*, 180–84.
54. Chafe, *The American Woman*, 56–65, 100–111; Scharf, *To Work and To Wed*, 139, 143–45. O'Neill, in *Everyone Was Brave*, argues that the social feminists played into the hands of institutionalized anti-feminism by supporting women's family and domestic responsibilities, the very instruments of female oppression.
55. Margaret Mead, 'Sex and Achievement', *Forum*, 94, (1935), quoted in Chafe, *The American Woman*, 100.
56. Lynd, *Knowledge for What?*, 110.
57. Frances R. Donovan, *The Saleslady* (Chicago, 1929), quoted in Winifred D. Wandersee, *Women's Work and Family Values 1920–1940* (Cambridge, Mass., 1981), 104.
58. Phyliss Palmer, *Domesticity and Dirt: Housewives and Domestic Servants in the United States, 1920–1945* (Philadelphia, 1989).
59. Chafe, *The American Woman*, 135–149.
60. Chafe, *The American Woman*, 151–170. See also Clyde Kluckhohn, 'The Evolution of Contemporary American Values', *Daedalus*, 87 (Spring 1958), 102–3.
61. Merrill, *Social Problems on the Home Front*, 145–168. See also Polenberg, *War and Society*, 145–150.
62. Chafe, *The American Woman*, 181.
63. Chafe, *The American Woman*, 176.
64. Scharf, *To Work and To Wed*, 163.
65. Ferdinand Lunberg and Marynia Farnham, *Modern Woman: the Lost Sex* (New York, 1947), summarized in Chafe, *The American Woman*, 202–7. A certain amount of the anxiety about women can perhaps be attributed to fears of female sexual demands following the heightened awareness of this issue in the light of Freudian thought: see Alfred Kazin, 'The Freudian Revolution Analyzed', *New York Times Magazine* (6 May 1956), reprinted in Smith (ed.), *Essays in American Intellectual History*, 383–88.
66. Hadley Cantril (ed.), *Public Opinion 1935–1946* (Princeton, NJ, 1951), 1047; Chafe, *The American Woman*, 178.
67. Chafe, *The American Woman*, 188–195.
68. Margaret Mead, 'What Women Want', *Fortune*, 34 (December 1946), 172–75, 218–224; see 173 and 224.
69. 'The American Woman', *Life*, 21 (21 October 1946), 36.
70. 'American Woman's Dilemma', *Life*, 22 (16 June 1947), 101–112.
71. Quoted in Robert Dallek, *Franklin D. Roosevelt and American Foreign Policy, 1932–1945* (New York, 1979), 530. On the drift from isolationism to war, see 23–168, 171–313. See also Stephen E. Ambrose, *Rise to Globalism: American Foreign Policy, 1938–1976* (Rev. edn, New York, 1979); and Robert A. Divine, *The Illusion of Neutrality* (Chicago, 1962) and *The Reluctant Belligerent: American Entry into World War II* (New York, 1965).

72. Dallek, *Franklin D. Roosevelt and American Foreign Policy*, 317–528, 533–34; Donovan, *Conflict and Crisis*, 257–265; Ambrose, *Rise to Globalism*, 104–5.
73. My summary of post-war American internationalism takes account of the reappraisal of American foreign policy led by William Appleman Williams, *The Tragedy of American Diplomacy* (New York, 1952), which drew attention to Soviet caution and weakness, and American aggression and power in the immediate post-war years. See in particular David Horowitz, *The Free World Colossus: a Critique of American Foreign Policy in the Cold War* (Rev. edn, New York, 1971), especially his 'Reassessment', 81–90, where he argues that Stalin's decision to control eastern Europe was in *response* to Truman's doctrine and the economic counteroffensive of the Marshall Plan. See also Walter Lafeber, *America, Russia, and the Cold War 1945–1980* (4th edn, New York, 1980); and Joyce and Gabriel Kolko, *The Limits of Power: the World and United States Foreign Policy, 1945–1954* (New York, 1972). Ambrose, *Rise to Globalism*, 11–22, 102–174, is in keeping with this interpretation. Also valuable are Denna Frank Fleming, *The Cold War and its Origins, 1917–1960: vol. 1: 1917–1950* (London, 1961); Richard Freeland, *The Truman Doctrine and the Origins of McCarthyism: Foreign Policy, Domestic Politics, and Internal Security, 1946–1948* (New York, 1985); and Daniel Yergin, *Shattered Peace: the Origins of the Cold War and the National Security State* (Boston, Mass., 1977).
74. Ambrose, *Rise to Globalism*, 11–22.
75. Ambrose, *Rise to Globalism*, 102–135; Horowitz, *The Free World Colossus*, 25–80; Hodgson, *In our Time* 22–33; see also Leuchtenburg, *A Troubled Feast*, 20, for an account of the 'chastening' of American liberalism by the atom bomb, the horrors of Stalin's and Hitler's personal power and the failure of British socialism to realize aspirations for a 'New Jerusalem'.
76. Senator Arthur Vandenberg, quoted in Ambrose, *Rise to Globalism*, 151.

Chapter 2

The Keeper of the Flame: Hollywood and the Cinema of Liberal Idealism

This chapter sets out my view of Hollywood and its relationship with American politics and culture. I argue that Hollywood formed a close relationship with the political and cultural programme of Roosevelt in the 1930s and was able to assume a position of cultural leadership. It was foremost in articulating the values and ideals that underpinned the New Deal. The close identification of Hollywood cinema with New Deal politics changed in the 1940s. At first many commentators predicted an intensification of American liberalism after the war and foresaw an increasingly confident Hollywood industry. Writers, journalists and film practitioners anticipated a liberalization of censorship, and films which tackled difficult social issues. The reality, however, was different. After the war, America's drift to the right created a rift between the dominant Republicans on the one hand and, on the other, a cultural industry that preached liberal idealism. The result was a cinema which no longer articulated American optimism, but instead became pessimistic, detached and nostalgic for the past. Hollywood thus remained an index of liberalism, reflecting the decline of social harmony and the rise of anxiety and tension in post-war America.

In this chapter I also examine the relationship between Hollywood cinema and its audience, including the mediating role of the censorship office. Chroniclers of this period more often than not assume an oppositional relationship between Hollywood and the censors at the Production Code Administration (PCA). I will contend that, in fact, there was a cosy accommodation between the two bodies, particularly in the 1930s. The high moral tone of the New Deal as proclaimed in Hollywood films found a perfect partner in the preachy, regulatory and interventionist PCA. They worked together to create a picture of a perfect American society, family-based and upholding Christian values. In one sense, however, those contemporaries who had predicted a change in censorship after the war were right. The breakdown in the alliance between Hollywood idealism and American politics in the 1940s did sow the seeds for the eventual dismantling of the PCA and censorship in the 1960s. This too supports the proposition that Hollywood's liberalism was partnered by a highly moral censorship code. The high moral tone of Hollywood films was anachronistic and unsuited to American life after 1945. As Hollywood's films became darker and more equivocal, so the moral values of the 1930s ceased to be appropriate. The Production Code would fade away from the 1950s onwards.

Finally in this chapter, I review the major milestones in the earlier literature on New Deal Hollywood cinema, to illustrate how a settled position was first reached by film historians on how to interpret Hollywood's relation to the political, social and cultural change of this era. Although our knowledge of the period has been enriched by more recent research,

and some aspects of the orthodox interpretation have been refined, broadly speaking the position reached by these first film historians has changed very little in the past 40 years. I believe that it needs to shift quite a lot further.

Hollywood and politics, 1933–1948: the cinema of liberal idealism

What was the relationship between the populist, mass culture industry that was Hollywood in the 1930s and 1940s, and the political and social developments of the time? Ideology in American cinema in the 1930s was not overtly political, but it was extremely topical. Hollywood films entertained audiences and engaged their attention, evoking not an intellectual, but rather an intuitive, response. In many of its comedies of the period, for instance, Hollywood found opportunities to explore relations between the sexes and hence the social role of women. For the men and women in the audience who lived with the changing status of women in the Depression era, this experience would be cathartic. Complex issues were presented in simplified and exaggerated forms and given a clear narrative structure. In this way, American populist cinema strove to make life understandable and its problems capable of resolution. The films, in other words, showed order in the chaos of human existence.

Hollywood provided a manual of ideals upon which life in America should be based. Hollywood did not offer 'realistic' solutions to life's problems. No one could be expected to be blessed with the virtues of an average Hollywood hero or heroine. But, if people needed ideals upon which to structure their world view and with which to cope with the mundane experiences of everyday life, then Hollywood could provide them. The film industry was influential in reconstructing American values after the 1929 Crash. The American people, as described in the previous chapter, were striving to articulate new social and individual codes. At this time of cultural, social and political ferment, Hollywood offered viewers a clear indication of codes of conduct, value systems and ideals appropriate to the changing times. It is in this sense that Hollywood cinema might be judged to have a 'political' dimension. It was a cinema of liberal idealism.[1]

When Lloyd Morris, in 1949, reflected on the cinema of the previous two decades, he alluded to this relationship between the American audience and the apparent fantasy of the films:

> Few adult Americans, in all probability, accepted the stories told on screen as literal substitutes for reality. Yet they participated in them, imaginatively. And it seemed that their participation was likely to be most active and intense when the stories in some way gave meaning to their own lives – expressed their interests, problems and aspirations. In so far as the movies thus recorded the inarticulate, or unacknowledged, private experience of Americans, they furnished a relevant commentary on certain aspects of the national civilisation.[2]

Otis Ferguson put this another way, writing in 1941 that Hollywood's philosophy might be 'eyewash', but that, 'a national hero is some sort of national index after all, and it is not so much how miserably short we fall of being an ideal as what ideal we choose to dream of'.[3] Raymond Carney, writing in more recent times about Frank Capra, questions whether realism is an appropriate yardstick with which to measure Hollywood films:

> The reality that [Hollywood directors of the 1930s and 1940s] are engaged in depicting in their works is a state of imagination and desire that may have little or no social form of expression ... Capra's movies measure the distance between ordinary life and the moments of vision or idealism within them.[4]

If Hollywood had one vital function, it was to provide America with the textbook of idealism that could not be captured in ordinary life. Such idealism helped people understand that life and gave meaning and value to it.[5]

Hollywood and the high New Deal

The radical reorientation in 1930s America towards a more communal, less competitive, social ideology prompted a response from the Hollywood community.[6] Writing for the *Hollywood Reporter* in 1941, Jack Moffitt wryly reminded his readers of the way in which Hollywood's portrayal of financiers had changed since the coming of the New Deal. George Arliss had portrayed Baron Rothschild in *The House of Rothschild* (Werker, 1934), a film still reflective of the spirit of Hoover's America rather than the early New Deal:

> The public is so fed up with the cold screen worship of industrial prowess and money ... the day is past when George Arliss ... can stand up in Lloyds and bring out gooseflesh by saying, 'Men, we must heroically sacrifice five pounds, eight shillings and nine pence for the sake of the good lads who are fighting the battle of Trafalgar out there!' Today we'd rather see Nelson losing his arm, than admire the tycoons who finance the amputation.[7]

Lewis Jacobs' influential study of the film industry, published in 1939, looked back over a decade of film-making. He took for granted an association between Hollywood and public attitudes. He found that Hollywood had 'matured' during the 1930s. At the start of the decade, he argued, Hollywood had an ill-formed suspicion that something was wrong in American society. As the decade wore on, films began to expose corruption, injustice and social inequalities. Finally, by the late 1930s, Hollywood film-makers were articulating new codes in life, both individual and social.[8] Thus there was a close fit in the high New Deal of 1933–1940 between Roosevelt's political programme and Hollywood's brand of liberal idealism. The political imperatives of FDR fostered cultural change throughout American society. Hollywood was able to assume a position of cultural leadership.

Hollywood and the decline of liberalism

At first, it seemed that the 1940s would build on this experience and develop further the way in which Hollywood articulated American idealism. Independent producer Walter Wanger, writing in 1939, argued for the liberalization of censorship as a means of promoting a more serious picture of American life to Europe.[9] This, he argued, would allow opportunities 'to expound, emphasize and proclaim the virtues of the true American Way'.[10] He drew attention to a system of censorship that forced Americans 'to see on the screen **the least common denominator of what the least broad-minded groups** at home will approve' (original emphasis).[11] Lewis Jacobs anticipated that Hollywood would in future need to appeal more carefully to discerning audiences, rather than concentrate on sure-fire hits. For Jacobs, American culture and thought had become more 'social minded' during the 1930s, replacing the irresponsibility of the 1920s. Writing in 1939, he could detect the beginnings of Hollywood's 'earnest search for moral norms'.[12]

The experiences of World War II developed these expectations further. After 1941 many practitioners in the industry foresaw the dawning of a new age of adult movies. Darryl Zanuck, production head of Twentieth Century Fox, espoused the importance of messages in films when he addressed the Writer's Congress in 1943:

> [W]e must play our part in the solution of the problems that torture the world. We must begin to deal realistically in film with the causes of wars and panics, with social upheavals and depression, with starvation and want and injustice and barbarism.[13]

A left-wing screenwriter, Robert Rosen, writing in 1943, anticipated a need for less pessimistic stories once the war was over. He expected a resurgence of hope following the conquest of evil.[14] Dorothy Jones, an Office of War Information official with a professional interest in the cinema, reflected Zanuck's optimism when, in 1945, she asked, 'Is Hollywood Growing Up?'[15] She felt sure that Hollywood in the future, 'will not be content to produce exclusively escapist films which recognise no social or political responsibility'.[16] She shared with others the hope that Hollywood's new maturity would usher in a sense of social purpose.

As it turned out, this confidence in a more politically committed and socially engaged Hollywood was misplaced. By the end of World War II, as shown in Chapter 1, America had reached a turning point in its social history. This change had profound implications for Hollywood's celebration of American idealism. The political reaction to FDR's monopoly of power and his social reform programme; the fear of Russian expansion, and the resulting anti-communist hysteria; the disappointment that the end of the war had not ushered in an era of peace and brotherhood; all these factors combined to occlude the liberal idealism of the 1930s. The 1940s were to see a very different relationship between Hollywood, as the repository of liberal ideals, and a society that had ceased to believe in those ideals. From being an integral part of the process of American political and social change – a leading exponent of the dominant ideology – Hollywood moved during the 1940s to a more

marginal position. A cinema of ideals could no longer offer the necessary cultural leadership in post-war America. Hollywood had to seek a new role: it found it as the representative of forgotten idealism in an amoral world.

Fritz Lang seemed to detect this changing relationship. In an article of 1947, he demanded the right to examine the social and economic conditions that create 'crime, disease and poverty', in order 'to throw light on the pressing problem of our time and society'.[17] He wanted to make more serious, politically engaged films, freed from the constraints of censorship. His comments reflected a growing unease among the film community about the relationship between Hollywood and the political establishment. Lang saw that the American film industry was no longer at the centre of American political thought. That same year, screenwriter and producer John Houseman expressed his vexation at Hollywood's new heroes, 'utterly lacking in ideals and ambition'. Houseman's grasp of the moral malaise then gripping America was remarkably clear for one so close to the events. For him, the key difference in the new films was the lack of any moral solutions: 'The moral of our present "tough" picture, if any can be discerned, is that life in the United States of America in the year 1947 is hardly worth living at all'. He concluded that, 'It almost looks as if the American people, turning from the anxiety and shock of war, were afraid to face their personal problems and the painful situations of their national life'.[18]

The divorce of Hollywood from the dominant political ideology in the United States in the 1940s caused a reappraisal of the film industry's role. Those who expressed a desire for Hollywood to produce more 'meaningful' films betrayed a sense of urgency about the direction of American social change. It was no longer enough to celebrate the most idealistic and progressive elements of American political and cultural traditions. Those traditions now had to be defended against the enemy. The complacent assurance that moral order and rectitude could triumph if mankind preserved those ideals had to be jettisoned in the era of the Cold War and the atomic bomb. Hollywood's executives and workers were compelled to search for new means of expression to describe the function of American idealism. The various ways in which they solved this dilemma are discussed in Chapter 3.

Hollywood cinema and the audience

The exact nature of the relationship between a national cinema and its audience is a complex issue. Writers have disagreed about the extent to which popular cinema reflects the values of the audience and the society of which it is a part, and the extent to which popular cinema influences and shapes the values of that society. Siegfried Kracauer's famous study of German cinema in the 1920s and early 1930s argued that the films of that period were an index of the national collective unconscious. They reflected the underlying anxieties of the German people and the nation's predisposition towards wanting to be led by a dictator.[19] Paul Monaco adopted a very similar approach, writing in the 1970s. He used only popular films, to avoid the criticism that had been levelled at Kracauer, namely that the German

historian had chosen artistically significant films, which were unrepresentative of the mass mentality.[20] But, if films do no more than reflect mass audience feelings, how does one factor in the autonomous creative ideas of the film-makers? How were these film-makers able to access the unconscious feelings of the audience? Monaco argues that the films were often tailored to perceived audience desires. Other writers have developed this view that films 'reflect' popular attitudes. Norman Friedman concludes that, in Hollywood's case, the films, 'reinforced, extolled, illustrated, and transmitted existing cultural orientations; they portrayed and justified dominant cultural conceptions of the nature and the necessities of the nation'.[21] William Hughes argues that, while film producers controlled the films' content, they were aiming to appeal to what audiences desired.[22]

Others have taken the opposite view. Norman Woelfel, a sociologist writing in 1947, argued that,

> To excuse a bad movie … by saying that it is only what American men and women want, is a slander on the American character … the average American has no real choice in the matter. He takes what is given him.[23]

Similarly, Franklin Fearing, also writing in 1947, argued that what an audience derives from watching a film is unknowable. It may or may not be the same as what the film-maker intended. And the film-maker's intent may or may not be the same as what Fearing (or anyone else) understands it to be.[24] Clayton Koppes and Gregory Black, two more recent historians of Hollywood in World War II, conclude that the film industry gave the public what the industry itself decided the public were going to get. It had a monopoly of supply, it functioned as an oligopoly rather than in competition and the audience had no choice over what it saw. The content of the films could not be influenced by the powerless audience.[25]

It may be possible to identify some middle ground in this debate. Those in charge of Hollywood films were, I would suggest, creators and purveyors of American cultural values, not just passive reflectors. Yet there was clearly a dialogue between those who worked in Hollywood and their audience – an interchange of values and attitudes. The personnel of Hollywood were as influenced by the cultural forces in American society as were their audience. Nevertheless, identifiable people created these films, and these people can be assumed to have had views and ideas of their own. Those who worked in Hollywood offered cultural leadership to those who consumed their products. The former attempted to communicate ideas about society in terms which the latter would understand and, it was hoped, accept. In a commercial, mass culture industry, film-makers will often wish to produce films which they believe the public will want to see and whose values the public will share. Therein lie greater audience figures and more profit. Yet there was also a cultural identity within the industry itself, which helped formulate and develop the nation's values.[26]

This is not to imply that Hollywood films 'reflected' the dominant political ideology in every respect. Hollywood dealt with the imagery of American idealism. As a result, when idealism was a strong force in American life at the height of the New Deal – roughly between

1933 and 1940 – there was a conjunction of values between society and Hollywood films. In the 1940s, the decline of idealism altered Hollywood's relationship with the cultural opinion-formers. If the cinema were simply a reflector of social trends, one would have seen an increased conservatism in the cinema of the post-war years. Rather, the Hollywood community produced films that encapsulated the sense of moral decay felt most keenly by liberals. There was thus more of a disjunctive relationship between Hollywood films and dominant social values in the years after the war. Hollywood reflected the mood of the country only in the sense that there was a greater moral ambivalence in American life in the post-war period.

My contention is that Hollywood comprised an artistic–commercial community, which shared liberal values. Individuals working within this community had, of course, different personal views. Sometimes – where an individual had considerable autonomy over what went on to the screen – this is reflected in specific films. Hence, certain directors and producers (and, occasionally, writers) expressed clearly identifiable personal views – Capra, Lubitsch, Ford, Wilder, on occasion Lang, De Mille, Zanuck, on occasion Welles, Preston Sturges, Chaplin, and so on. Nearly all of these individuals subscribed to a left-of-centre liberalism that was given free expression in the 1930s and which had a close fit with the dominant political ideology of the high New Deal. (De Mille is the conservative exception.) In the 1940s, this liberalism was *not* in kilter with the prevailing political ideology, and the Hollywood community (including these and other individuals) expressed a critique, rather than a celebration, of American society. This critique was not overtly political, but was manifest in a cinema of alienation, pessimism and fantasy, rather than a cinema of idealism located in a real-world setting.

Hollywood and the role of the censors

Many previous writings about Hollywood cinema in the 1930s have seen an oppositional relationship between Hollywood film-makers and an oppressive, morally conservative censorship system: the Production Code Administration.[27] A number of historians have perceived a conspiracy between the censors and the studio heads to impose a restrictive moral code on the film industry, thereby preventing any social criticism in Hollywood films. A preliminary word of caution is that American morality should not automatically be conflated with American conservatism. In the *conservative* Republican decade of the 1920s, film censorship was relatively inactive under the chief censor, Will Hays, head of the Hays Office (the forerunner of the PCA). During the first decade of FDR's *liberal* regime, this relaxed system of censorship became more assertive. Power passed to the censors' West Coast head, Joseph Breen, and the system developed teeth via a new Production Code (hence the office is generally referred to from 1934 onwards as the Production Code Administration, or PCA). The period of the high New Deal is not usually regarded as a 'conservative' era, but it rode on the crest of a very high moral wave. The PCA itself fell into

decline and then desuetude in the 1950s, a decade dominated by *conservative*, Republican administrations. The codes of conduct in the Production Code governed, among other things, criminal wrongdoing and pre- or extramarital sexual activities. The Code overall reflected the Roman Catholic morality of the men who composed it and who occupied senior positions in the Hays Office – Hays himself, Joseph Breen and Martin Quigley. The interventionist and regulatory nature of the PCA during the 1930s and 1940s chimed well with the interventionist and regulatory tendencies of the New Dealers in Washington.

There was thus a three-cornered alliance of the New Deal architects in Washington, the liberal film-makers in Hollywood and the moral guardians at the PCA. This helps to explain one of the conundrums in the traditional interpretation of an oppositional Hollywood–PCA relationship. How was such an apparently unrepresentative cadre of moral reactionaries in the PCA and among the Hollywood executives able to exercise such awesome power over Hollywood and its audience? Why, in a competitive world, did one or more studios not simply abandon the (voluntary) Code regulation and take its products to the audience which, we are led to believe, opposed the strictures of the PCA? This did not happen, because the Code accurately reflected the prevailing moral atmosphere. The Code did not function *in spite* of the will of the American people. It could hardly have continued without the virtually universal support it commanded for its underlying moral precepts. When the high moral tone of the New Deal's liberal consensus gave way to the post-war crisis of moral purpose, the Code became less relevant. It was subjected to increasing criticism and challenge in the 1940s, was flouted successfully in the 1950s and then finally abandoned. There is no evidence that audiences in the 1930s wanted more explicit treatment of sex on screen; neither is it self-evident that covert treatments of sex are necessarily more 'conservative' than graphic ones. The Code's requirement that villains had to get their comeuppance should not be seen as running counter to the moral code of the time. Again, there is no evidence – and indeed it is intuitively implausible – that 1930s and 1940s audiences wanted to see bad men triumph, or adulterous women find true happiness, or immorality bring rewards to the non-virtuous.

American cinema and American society shared a belief in the triumph of virtue and in moral absolutes, at least until the mid-1940s. The fervent moral tone of American films at this time was less the result of the Production Code and more a product of the moral consensus of the period. A 1949 survey of Californians, for example, found that 31 per cent of people thought that censorship was 'not strict enough' and 46 per cent thought that it was 'just right'.[28] Moreover, one must differentiate between the practical, as distinct from the rhetorical, effect of the Code. Exactly how did it operate to turn otherwise subversive material into harmless conservative films? Study of the PCA archives reveals that, in fact, the PCA often advised film-makers on how to avoid censorship difficulties in the seven states which had their own censor boards and the seven cities which likewise operated their own boards.[29] The PCA also helped Hollywood producers avoid trouble with censorship offices abroad and, indeed, with the PCA itself – much of the advice given related to ways in which film companies could skirt the Code's restrictions. Joseph Breen repeatedly made

suggestions to facilitate the inclusion in a script, in an acceptably coded way, of sexual liaisons, prostitution and pre-marital sex.[30]

In any event, the PCA could not control what audiences understood from frequent exposure to the conventions of the day. Harold Salemson, writing in 1946, drew attention to the signs that audiences were expected to understand:

> [A] whole symbolism has been developed: a hand-shake or a glance have become propositions of illicit love; a kiss has become an overt sex act; almost any fadeout on two characters of opposite sexes … has become almost a flat statement of the fact that from there they retired together, to put it politely.[31]

The PCA officials worked on the basis of script drafts, making it hard to foresee visual jokes or sly deliveries of innocent-looking lines. Lubitsch was notorious at the PCA for employing this strategy, making his films very hard to control without seeing the final cut.[32]

As Hortense Powdermaker observed in her 'anthropological' survey of the movie colony, the Code-enforcers tended to focus on individual details in the script rather than on the moral values of the film as a whole, thus rendering the moral policing of Hollywood product negligible.[33] Salemson knew that obeying the detailed rules did not prevent overall subversion of any aspect of the Code that film-makers wanted to explore further. In discussing comedies that revolved around uncertainty about the status of a couple's marriage, he remarked:

> [These films] followed the letter of the Production Code. Nothing could be done about prohibiting the films. Yet the hour and a half of bedroom farce that was extra-marital was never overcome by the final couple of minutes which revealed that it was all really quite all right. Thus, the protection afforded by the letter of the law covered a license [sic] which became much greater than almost anything seen in similar comedies of the preceding few years.[34]

Hollywood was not a 'conservative' institution. Neither was there an artificially restrictive morality which prevented American cinema from launching radical strategies. Hollywood embodied liberal values throughout this period and, more often than not, was content to enshrine the lofty morality of the New Deal. There was nothing incompatible about a high moral tone and a liberal political direction. The role of the PCA was certainly influential in the style of Hollywood films of this period; but to credit the censors with stifling American cinematic radicalism is a misconception.

Interpretations of Hollywood's politics

Modern film scholarship might be said to begin with the group of French intellectuals and film journalists centred around the influential magazine *Cahiers du Cinéma* in the 1960s. These writers developed an approach to films in which the film director was elevated to the

same status as other creative artists, such as painters and writers. This became known as the 'auteur theory' and was later imported into American writing by Andrew Sarris.[35] These writers credited the director with sole 'authorship' of a film because he (very occasionally she) controlled the structure of the assembled film. The role of writers and producers – and, strangely, editors – was ignored. There was no attempt to unravel the complex processes of a film's production or to research the precise history of a film's evolution from script to screen. These writers also drew a direct parallel between the circumstances of film-making in France (and Europe), where the film director often *was* a controlling force, and those of Hollywood, where the studio system of the 1930s and 1940s meant that power was often concentrated in the hands of the studio executives.

Subsequent scholars, including Christian Metz, Roland Barthes and Andre Bazin, sought to add to this early and rather primitive 'theory' a more scientific underpinning. This came to be known as 'structuralism'. They imported into film studies ideas from literary analysis and semiotics, explaining how meaning is conveyed through the structure of language and linguistics. They argued that a film's meaning was understood entirely through the construction of the images – the signs and symbols of cinema. These scholars tended to focus on such things as camera angles, set design and lighting. Any extra-textual information was considered invalid, subjective and thus potentially misleading.[36] This style of film scholarship remained dominant throughout the 1980s and into the 1990s, supplemented by borrowings from psychology. Often couched in impenetrable jargon, these writings struggled at times to justify the absence of socio-historical context. Annette Kuhn, for example, in *Women's Pictures: Feminism and Cinema*, acknowledges that there must be some relationship between film and society, but rejects 'a simple relationship of reflection'. She offers instead a rather oblique notion of a search for 'recurrent structures of enigma-resolution'.[37]

The necessity of conducting a very detailed study of a particular 'text' (that is, a film) has meant that film theorists usually concentrate on only a handful of films. Yet these authors make generalizations about the wider political and social meanings of the films. Feminist theorists, for example, havefelt able to make sweeping conclusions about the political nature of women in American society on the basis of just one or two of the more famous films.[38] The reluctance to engage with information contained outside the 'text' also meant that film theory ignored archival sources. Thus film theorists were able to carry on for some years a debate about the auteur theory and the extent to which a director can be said to be the sole creative voice in a film. Could one person, they asked each other, be said to be in control of the signs, symbols and meanings contained in a film? Was there an alternative case for the controlling nature of the screenwriter, the producer or the studio, instead of the director?[39] In fact, archival evidence can often demonstrate whether or not a director, producer or writer actually did exercise control over a given film.

A challenge to structuralist theory came in the late 1980s from the school of 'cultural materialism'. This approach is well defined by Jonathan Dollimore and Alan Sinfield in their 'Foreword: Cultural Materialism', reprinted in each volume of their *Cultural Politics* series:

> [C]ulture does not (cannot) transcend the material forces and relations of production … texts [are] inseparable from the conditions of their production and reception in history; and [are] involved, necessarily, in the making of cultural meanings which are always, finally, political meanings.[40]

David Buxton, writing in *From 'The Avengers' to 'Miami Vice'*, offered a critique of semiology's 'flight from content' and the limitations of 'descriptive theory'. Without socio-historical analysis, he argues, film theorists are unable to explain 'why "bourgeois culture" is manifested in one form and not another'.[41] In other words, the interpretation of a 'text' by a structuralist film scholar is no more objective than anything else. It is based on a subjective construct of what the series of images might be said to mean. The advent of the influential 'neo-formalists', led by David Bordwell in the mid-1980s, further challenged the pure theorists. Bordwell and his collaborators focused on the industrial structures of Hollywood film-making, broadening the boundaries of discussion beyond textual analysis.[42] Janet Staiger went on to write about the reception histories of films, again broadening the definition of how films can be understood and interpreted.[43] Increasingly, historians have become interested in film studies, bringing to the debate the disciplines of archival research and detailed understanding of film production histories.

Writing about film has not always been in the context of dense film theory. Many other surveys of cinema history dispense with historical research for a different reason, namely that the authors are having too much fun watching the films or hanging on the words of celebrities from the industry. Many an author has had privileged access to a famous film personality, whose anecdotes, while often entertaining, seldom bear much relation to the truth. These populist books are often personal assessments and reactions to films, a collection of film reviews supplemented by unreliable memoirs.[44] There are also numerous opportunities for the reader to go straight to the horse's mouth and read biographies and autobiographies.[45] The books can be highly entertaining and readable, but are seldom of much value to the serious historian.

The evolution of the 'conservative' interpretation of New Deal Hollywood

More scholarly works on Hollywood and the New Deal began to appear in the 1970s. They focused mainly on the period between Roosevelt's election and the beginning of the New Deal's decline, around 1938–39. In 1971 Andrew Bergman's *We're in the Money* set the tone of the debate, arguing that Hollywood cinema was 'conservative'.[46] In the film-makers' desire to amuse and entertain the masses, his argument runs, Hollywood's films avoided all discussion of reality and social ills. The films did no more than show the audience a world in which everything was fair and justice always triumphed. In so doing, Hollywood took the collective mind of the American people off the traumas of the Depression era. Hollywood films of the high New Deal are not 'about' anything; they are escapist entertainments, designed to avoid discussion of American society.

This thesis was advanced and developed in the writings of a number of film historians over the following years. They were led by Robert Sklar in 1975, with *Movie-Made America*, followed by Richard Maltby's *Harmless Entertainment* in 1983 and Nick Roddick's *A New Deal in Entertainment* of the same year.[47] These books – discussed in detail below – broadly followed Bergman's thesis. They argued that for a brief period at the start of the 1930s, Hollywood cinema was radical and questioning. It was anarchic in its humour, grim in its social dramas, explicit in its discussion of sex. This reflected the breakdown of accepted American values and morals in the confusion of the 1929 Crash and its aftermath. In 1934 this came to an end, and Hollywood returned to 'safe' film-making.[48] There were, it is suggested, two reasons for this retreat from radicalism. First, the election of Franklin D. Roosevelt and the inauguration of the New Deal restored the middle-class order and the nation's faith in American institutions. The effects of the Depression were tackled. Second, pressure from Roman Catholic groups such as the Legion of Decency led to the imposition of a formidable and restrictive censorship. This prevented serious discussion of social issues, modified the earlier anarchic humour into comedies of reconciliation and forbade anything to do with sex. The combination of these twin influences allegedly created the 'conservative' nature of Hollywood cinema in this period. Films merely celebrated American greatness, failed to criticize American institutions and generally endorsed middle-class complacency. Thus the period of 'harmless entertainment' was ushered in.[49]

It is worth reviewing this line of argument in detail. Bergman laid down the foundations. He argued that as the New Deal wore on, Hollywood films became increasingly conservative and supportive of established institutions. Mae West's sexual innuendos and the Marx Brothers' anarchic zaniness gave way to the comedies of reconciliation made by Capra and others. The heroic gangsters of *Little Caesar* (LeRoy, 1930) and *Public Enemy* (Wellman, 1931) were superseded by heroic policemen and G-men instead. After 1934, Bergman concluded, a cautious endorsement of the American success model was all that Hollywood offered its audiences. Federal benevolence, social concern, law and social unity were the key themes of Hollywood films, all of which testify to their basic conservatism.[50] Bergman's work may be said to be flawed in some respects. He reaches his conclusions on Hollywood having analysed only a tiny sample of the best known films of the period. His socio-historical analysis can at times seem too schematic. Edward Buscombe amusingly remarks on this tendency in his essay, 'Notes on Columbia Pictures Corporation 1926–41', in Paul Kerr (ed.), *The Hollywood Film Industry*:

> The social comment can simply be read off as if the films were so many sociologists' reports. Here is an admittedly rather extreme example: 'Tod Browning's 1932 MGM film, *Freaks*, had a cast made up of pinheads, human torsos, midgets, and dwarfs, like nothing ever in the movies. And what more stunted a year than 1932 for such a film?'[51]

Bergman's book perhaps reflects late-1960s American radicalism, loftily critical of the New Deal's failure to implement decisive reform of the country's social structures – a failure in which, Bergman concludes, Hollywood was complicit.

Robert Sklar provided an ambitious and subtle account of American cinema's relationship to American culture, although his conclusions are not significantly different from Bergman's.[52] For Sklar, the films of the 1930s engaged in deliberate 'cultural myth-making', a reaffirmation of American values and cultural mythology at a time when they seemed under threat. Sklar argues that this reaffirmation was a product of the collaboration between Hollywood producers and the censors to produce movies that reassured the American people of the essential soundness of American social systems. Thus the values adumbrated by Hollywood films at this time were unrepresentative of the national mood, imposed upon a passive audience by the movie moguls and the censors. For Sklar, this cinema of reassurance was not communicating positive, new values, but transmitting outdated values in order to 're-assure' audiences. Accordingly, Sklar sees the works of both Disney and Capra as developing from 'fantasy' to 'idealized reality', a progression in his view that is conservative, reinforcing 'the old values'. Here he summarizes this transition from radicalism to conservatism as a result of the collaboration between the PCA and the studio heads:

> In the first half decade of the Great Depression, Hollywood's movie-makers perpetrated one of the most remarkable challenges to traditional values in the history of mass commercial entertainment. The movies called into question sexual propriety, social decorum and the institutions of law and order. The founding of the Breen Office [i.e. the giving of teeth to the Hays Office] in 1934 seriously curtailed the permissible range and depth of Hollywood films for years to come … The movie moguls gave up their adversary [*sic*] stance because they suddenly found greater opportunities for profit and prestige in supporting traditional American culture …[53]

Another writer who lent his support to the conservative interpretation of Hollywood films was Richard Maltby.[54] Maltby is a serious historian who utilizes archival sources to support his thesis. He argues in essence that the movie moguls who ran the studios collaborated with the PCA to produce harmless entertainment for the masses. In pursuit of profits, the all-powerful studio heads fed a docile public socially conservative material. The films celebrated the values of harmony, neighbourliness and the pursuit of prosperity and happiness, America's 'most persistent tradition of political thought'. For Maltby, Hollywood was purely an entertainment industry, the products of which lacked any 'socially or politically significant meaning'.[55] Nick Roddick also supported this analysis.[56] He concludes (rather schematically) that Warner Bros. films moved from a problem-solving approach in the early 1930s to a celebration later in that decade of American values. He sees this transition as paralleling Roosevelt's move from grappling with the problems of the Depression to the more orthodox endorsement of capitalism in the later New Deal. Roddick draws unduly reductionist parallels between political events and contemporaneous film content. So too does Mark Roth, writing about Warner Bros. musicals of the 1930s.[57] He explains how *42nd Street* (Bacon, 1933), made before Roosevelt's inauguration, differs from the post-inauguration *Footlight Parade* (Bacon, 1933). The dance producer in the latter film is closely involved in mounting the show,

whereas the parallel character in the former film is a weary outsider, dependent on sordid financiers. Hence, *Footlight Parade* displays 'the spirit of the New Deal' (that is, participation in a communal endeavour) while *42nd Street* does not. This fundamental shift in ideology is supposed to have occurred in a matter of weeks. The process of cultural change, which undoubtedly did take place in 1930s America and in which Hollywood played a part, was not so fine-tuned as to reflect the political changes from month to month.[58]

Much film scholarship has been devoted to the era of the high New Deal in the 1930s. Less has been written about the films of the 1940s. As I argue in Chapter 1, there was a marked shift away from the liberal politics of the 1930s after World War II. The cinema which resulted from this significant change in mood has often been described as 'dark', the term 'film noir' being coined by later writers to describe films of the 1940s. Ralph Willett writes about the emphasis in American films of the 1940s on the loner. He sees this as part of the characters' 'nihilism' – these are people committed neither to the war effort nor to democratic values. Willett sees these films as challenges to the concept of individualism, portraying the pressures towards conformity. The individual must not be exceptional, but instead must subscribe to timid, middle-class values.[59] A valuable, near-contemporary account of the mood of these films is Barbara Deming's *Running Away from Myself* (although written in the 1940s, it was not published for twenty years).[60] She reflects on the 'obsessive patterns that underlie' the cinema of the 1940s, highlighting the trends that reveal and repeat themselves. The book is an instructive meditation on the alienated atmosphere of many films of this time. She describes the 'bleakly stoical' nature of many of the heroes in American films of the 1940s; she identifies a recurring theme, of women helping men to recover their self-esteem and nurturing them back into society; she analyses how the traditional American success story is given a new interpretation, in which achievement seems undermined by the concomitant loss of humanity; and how the detective hero must meet a challenge to his values and survive in a world of disorder and chaos. Her conclusion draws attention to the elusive or worthless nature of success in post-war American cinema and to the parade of film characters with nothing to fight for, and to whom the possibility of starting anew is denied.[61] Deming's account is not intended as a scholarly work, but it is nevertheless a valuable source, a contemporary's recollections of an era of moral emptiness and disillusion.

Conclusion

This chapter has offered a framework for approaching Hollywood films and their relationship to American society, politics and culture. In the next three chapters, I will set out my arguments for understanding Hollywood cinema of this period as one of liberal idealism and a significant supporter of Roosevelt's New Deal. I will illustrate this thesis, first with plentiful references to a wide survey of films from the period and then second in a series of detailed case studies drawing on the works of the three émigré directors.

Notes

1. This political 'idealism' has been seen by some as conservative, rather than liberal. The literature on Frank Capra, perhaps the greatest exponent of American liberal idealism, often applies the term 'conservative' to his work and does not associate (as I do) the images of communality in his films with New Deal liberalism. See Jeffrey Richards, *Visions of Yesterday* (London, 1973), in which Capra is considered, along with Nazi cinema and British imperialist cinema, as part of 'the cinema of the Right', (xvi) and anti-New Deal; Robert Sklar, 'The Imagination of Stability: the Depression Films of Frank Capra', in Richard Glatzer and John Raeburn (eds) *Frank Capra: the Man and his Films* (Ann Arbor, Mich., 1975), 121–138 and Richard Griffith, *Frank Capra* (London, 1950) both see Capra as old-fashioned and anachronistic; Glenn Alan Phelps, 'The Populist Films of Frank Capra', *Journal of American Studies*, 13 (December 1979), 377–392, fails to understand the idealistic morality of Capra and finds his films perplexing and ludicrously unrealistic; while Donald C. Willis, *The Films of Frank Capra* (Metuchen, NJ, 1974) sees Capra as a pessimistic and negative film-maker.
2. Lloyd Morris, *Not So Long Ago* (New York, 1949), 195.
3. Otis Ferguson, 'Democracy at the Box Office', *New Republic* (24 March 1941), in Robert Wilson (ed.), *The Film Criticism of Otis Ferguson* (Philadelphia, 1971), 349–351. The comment relates to Frank Capra's *Meet John Doe* (1941).
4. Raymond Carney, *American Vision: the films of Frank Capra* (London, 1986); see 3–29.
5. For other valuable appraisals of Capra's place in New Deal culture, see Robert Willson, 'Capra's Comic Sense', in Glatzer and Raeburn (eds), *Frank Capra*, 83–98; William S. Pechter, 'American Madness', in Glatzer and Raeburn (eds), *Frank Capra*, 177–185; Charles J. Maland, *Frank Capra* (Boston, 1980); and Leonard J. Quart, 'Frank Capra and the Popular Front', *Cineaste*, 8 (Summer 1977), 4–7. See also Joseph McBride, *Frank Capra: the Catastrophe of Success* (New York, 2000). For a contemporary insight into Capra's use of ideal types to represent liberal American values, see Richard Griffith, *National Board of Review* (November 1939), in Anthony Slide (ed.), *Selected Film Criticism: 1931–1940* (Metuchen, NJ, 1982), 159–161.
6. Looking more widely than Capra, other writers have analysed Hollywood as a purveyor of myths. This approach has the benefit of recognizing that the 'politics' of American cinema is not overt. For interesting examples of this school of thought, see Will Wright, *Sixguns and Society: a Structural Study of the Western* (Berkeley, Cal., 1975) and Edward Countryman, 'John Ford's "Drums along the Mohawk": the Making of an American Myth', *Radical History Review*, 24 (Fall 1980), 93–112.
7. Jack Moffitt, *Hollywood Reporter* (12 February 1941), 9.
8. Lewis Jacobs, *The Rise of the American Film: a Critical History* (New edn, New York, 1969), 506–7. One can readily detect the inspiration for the arguments – discussed later in this chapter – used by Andrew Bergman, *We're in the Money: Depression America and its Films* (New York, 1971), albeit without the lamentations for Hollywood's conservatism.
9. Walter Wanger, '120,000 American Ambassadors', *Foreign Affairs*, 18 (October 1939), 45–59.
10. Wanger, '120,000 American Ambassadors', 57.
11. Wanger, '120,000 American Ambassadors', 54.
12. Jacobs, *The Rise of the American Film*, 506.
13. Darryl Zanuck, 'The Responsibility of the Industry', in (no author) *Writer's Congress: the Proceedings of the Conference Held in October 1943 under the Sponsorship of the Hollywood Writers' Mobilization and the University of California* (Berkeley, Cal., 1944), 34–5.

14. Robert Rosen, 'An Approach to Character 1943', in *Writer's Congress*, 61–67; reprinted as 'New Characters for the Screen', in Richard Koszarski (ed.), *Hollywood Directors 1941–1976* (New York, 1977), 48–54. For other contributions to the debate about Hollywood's 'seriousness', see John Howard Lawson, 'Hollywood – Illusion and Reality', *Hollywood Quarterly*, 1 (January 1946), 231–33 and Arnold Hauser, 'Can Movies Be Profound?', *Partisan Review*, 15 (January 1948), 69–73.
15. Dorothy B. Jones, 'Is Hollywood Growing Up?', *The Nation* (3 February 1945), in Gerald Mast (ed.), *The Movies in our Midst: Documents in the Cultural History of Film in America* (Chicago, 1982), 470–76.
16. Jones, 'Is Hollywood Growing Up?', in Gerald Mast (ed.), *The Movies in our Midst*, 475.
17. Fritz Lang, 'The Freedom of the Screen', *Theater Arts* (December 1947), in Koszarski, *Hollywood Directors 1941–1976*, 137–38.
18. John Houseman, 'Today's Hero: a Review', *Hollywood Quarterly*, 2 (January 1947), 161–63. See also Bosley Crowther, *New York Times* (24 August 1946), 6, for his review of *The Big Sleep* (1946), in which he remarks that the daughters in the film are 'quite obviously ... bums' and that 'it has a not very lofty moral tone'.
19. Kracauer, *From Caligari to Hitler*.
20. Paul Monaco, *Cinema and Society: France and Germany during the Twenties* (New York, 1976).
21. Norman L. Friedman, 'American Movies and American Culture', *Journal of Popular Culture*, 3 (Spring 1970), 816. The article looks at Hollywood films from 1946 to 1970.
22. William Hughes, 'The Evaluation of Film as Evidence', in Paul Smith (ed.), *The Historian and Film* (Cambridge, 1976), 49–79. P. H. Melling, 'The Mind of the Mob: Hollywood and Popular Culture in the 1930s', in Philip Davies and Brian Neve (eds), *Cinema, Politics and Society in America* (Manchester, 1981), 19–41, agrees that Hollywood films reflected what the American people felt.
23. Norman Woelfel, 'The American Mind and the Motion Picture', *Annals of the American Academy of Political and Social Sciences*, 254 (November 1947), 93.
24. Franklin Fearing, 'Films as History', *Hollywood Quarterly*, 11 (July 1947), 422–27.
25. Clayton R. Koppes and Gregory D. Black, *Hollywood Goes to War: How Politics, Profits and Propaganda Shaped World War II Movies* (New York, 1987), 328.
26. See Franklin Fearing, 'Influence of the Movies on Attitudes and Behavior', *Annals of the American Academy of Political and Social Sciences*, 254 (November 1947), 78 and Fearing, 'A Word of Caution for the Intelligent Consumer of Motion Pictures', *Quarterly of Film, Radio and Television*, 6 (1951), 129–142, supplemented by I. C. Jarvie, *Towards a Sociology of the Cinema: a Comparative Essay on the Structure and Functioning of a Major Entertainment Industry* (London, 1970).
27. The Production Code Administration was run by Will Hays, and its West Coast head was Joseph Breen. The Code was enforced rigidly from 1934, following agitation from organizations like the Legion of Decency about the level of violence and immorality in Hollywood films. Films had to be granted a certificate of approval to gain release in the United States, although the system worked by mutual consent rather than draconian enforcement powers. Hence, in the 1950s film-makers like Otto Preminger and Elia Kazan were able to break ranks and release uncertificated films with impunity. This foreshadowed the demise of the operation of the PCA. The PCA's archives are in the Margaret Herrick Library in Los Angeles. The Code itself is reprinted in Mast (ed.), *The Movies in our Midst*, 321–333. For partisan accounts of the workings of the PCA, see Raymond Moley, *The Hays Office* (New York, 1945) and Will Hays, *The Memoirs of Will H. Hays* (Garden City, NY, 1955); for more neutral accounts, see Gerald C. Gardner, *The Censorship Papers: Movie Censorship Letters from the Hays Office, 1934–1968* (New York, 1987); Leonard J. Leff and Jerold L. Simmons, *The Dame in the Kimono: Hollywood, Censorship and the Production Code from the 1920s to the 1960s* (New York, 1990); and, more recent, Matthew Bernstein (ed.) *Controlling Hollywood: Censorship*

and Regulation in the Studio Era (New Brunswick, NJ, 1999) and Thomas Doherty, *Hollywood's Censor: Joseph I. Breen and the Production Code Administration* (New York, 2007).
28. Leo A. Handel, *Hollywood Looks at its Audience: a Report of Film Audience Research* (Urbana, Ill., 1950); only 10 per cent thought it 'too strict'. See also Gilbert Seldes, *Movies for the Millions: an Account of Motion Pictures, Principally in America* (London, 1937), 54; Seldes argued that the censors were 'protecting the accepted sexual morality'; George Cukor told Higham and Greenberg, as reported in *The Celluloid Muse*, 64–65, that 'we were more or less representing – via the Production Code – what did in fact happen'.
29. The seven state censor boards were: New York; Pennsylvania; Ohio; Kansas; Maryland; Virginia; and Massachussets. The seven city boards were: Atlanta; Chicago; Memphis; Kansas City, Missouri; Detroit; Portland, Oregon and Milwaukee. In addition, pressure groups such as the Legion of Decency exerted considerable influence over the Hays Office.
30. I have studied the PCA archives only in respect of the three European directors. Many examples will be found in the case studies.
31. Harold J. Salemson, 'A Question of Morals', *The Screen Writer*, 4 (April 1946).
32. There are numerous examples to be found in the case studies dealing with Lubitsch's work.
33. Powdermaker, *Hollywood the Dream Factory*, 58.
34. Salemson, 'A Question of Morals', *The Screen Writer*, 4 (April 1946), 2.
35. For an excellent introduction and guide to the evolution of film theory, its main arguments and the main literature, see the relevant chapters in Pam Cook (ed.) *The Cinema Book* (3rd edn, London, 2007). Gerald Mast and Marshall Cohen (eds), *Film Theory and Criticism: Introductory Readings* (2nd edn, New York, 1979) provides a good supplementary collection of representative theoretical and other writings. See also V. F. Perkins, *Film as Film: Understanding and Judging Movies* (Harmondsworth, 1972); Peter Wollen, *Signs and Meaning in the Cinema* (London, 1972); Andrew Tudor, *Theories of Film* (London, 1974); J. Dudley Andrew, *The Major Film Theories: an Introduction* (London, 1976) and *Concepts in Film Theory* (Oxford, 1984); and James Monaco, *How to Read a Film: the Art, Technology, Language, History and Theory of Film and Media* (New York, 1977). See, for a good introduction to different ways of approaching Hollywood film history, Charles F. Altman, 'Towards a Historiography of American Film', in Richard Dyer MacCann and Jack C. Ellis (eds), *Cinema Examined: Selections from 'Cinema Journal'* (New York, 1982), 105–129.
36. For particular and influential examples of theoretical works, see Andre Bazin, *What is Cinema? Vol. 1* (Berkeley, Cal., 1967); Christian Metz, *Film Language: a Semiotics of the Cinema* (New York, 1974); and Roland Barthes, *Mythologies* (St Albans, 1973) and *Image-Music-Text* (London, 1977). See also Richard and Fernande De George (eds), *The Structuralists from Marx to Levi-Strauss* (New York, 1972).
37. Annette Kuhn, *Women's Pictures: Feminism and Cinema* (London, 1982), 33–34.
38. Kuhn, *Women's Pictures*, 32, again furnishes a good example. Rejecting the empiricism of a wide sample of films, she writes: 'It may be considered sufficient … to examine a single narrative in terms of its expression of underlying structures', although her reasons for believing this approach to be sufficient are unclear.
39. See Pam Cook (ed.), *The Cinema Book* (1st edn, London, 1993), 114–206, for a comprehensive account of the evolution of the debate, together with a full bibliography and filmography. James Narmore provides a brief overview of the history of the auteur debate in his essay, 'Authorship', in Toby Miller and Robert Stam (eds), *A Companion to Film Theory* (Malden, Mass., 1999), 9–24.
40. Jonathan Dollimore and Alan Sinfield, 'Foreword: Cultural Materialism', in Dollimore and Sinfield (eds), *Cultural Politics* series (Manchester, 1988 onwards).
41. David Buxton, *From the Avengers to Miami Vice: Form and Ideology in Television Series* (Manchester, 1990), 5, 13. The introductory essay, 1–20, is well worth reading in its entirety.

42. David Bordwell, Janet Staiger and Kristin Thompson, *The Classical Hollywood Cinema: Film Style and Mode of Production to 1960* (London, 1985). See also Bordwell and Noel Carroll (eds), *Post Theory: Reconstructing Film Studies* (Madison, 1996); and Bordwell and Thompson, *Film Art: an Introduction* (6th edn, New York, 2001).
43. Janet Staiger, *Interpreting Films: Studies in the Historical Reception of American Cinema* (Princeton, 1992). See also Robert Allen and Douglas Gomery, *Film History: Theory and Practice* (New York, 1985).
44. See, for example, John Baxter, *Hollywood in the Thirties* (London, 1968); and Charles Higham and Joel Greenberg, *Hollywood in the Forties* (London, 1968). Both are entertaining surveys, but do not use archival sources. See also Colin Shindler, *Hollywood Goes to War: Films and American Society 1939–1952* (London, 1979); Michael Wood, *America in the Movies: or, 'Santa Maria, it Had Slipped my Mind'* (London, 1975). See also David Manning White and Richard Averson, *The Celluloid Weapon: Social Comment in the American Film* (Boston, Mass., 1972); Bosley Crowther, *The Lion's Share: the Story of an Entertainment Empire* (New York, 1957); Otto Friedrich, *City of Nets: a Portrait of Hollywood in the 1940s* (New York, 1986); John Izod, *Hollywood and the Box Office 1895–1986* (London, 1988); Stephen Louis Karpf, *The Gangster Film: Emergence, Variation and Decay of a Genre, 1930–1940* (New York, 1973); Arthur Knight, *The Liveliest Art: a Panoramic History of the Movies* (New York, 1957); Betty Lasky, *RKO: the Biggest Little Major of Them All* (Englewood Cliffs, NJ, 1984); Ann Lloyd and David Robinson (eds), *Films of the Thirties* (London, 1983) and *Films of the Forties* (London, 1982); Andrew Sarris, *The American Cinema: Directors and Directions 1929–1968* (New York, 1968); and Jack Shadoian, *Dreams and Dead Ends: the American Gangster/Crime Film* (Cambridge, Mass., 1977). There are many other such works which might be cited.
45. For biographies which draw on untested memoirs, see Mel Gussow, *Zanuck: Don't Say Yes until I Finish Talking* (London, 1971); Arthur Marx, *Goldwyn: a Biography of the Man behind the Myth* (New York, 1976); Samuel Marx, *Mayer and Thalberg: the Make-Believe Saints* (London, 1976); Leonard Mosley, *Zanuck: the Rise and Fall of Hollywood's Last Tycoon* (London, 1984); Bob Thomas, *King Cohn: the life and times of Harry Cohn* (New York, 1967), *Thalberg: life and legend* (Garden City, NY, 1969) and *Selznick* (Garden City, NY, 1970); and Norman Zierold, *The Hollywood Tycoons* (London, 1969). For examples of autobiographies, see Jesse L. Lasky (with Don Weldon), *I Blow my Own Horn* (London, 1957); Joseph McBride (ed.), *Hawks on Hawks* (Berkeley, Cal., 1982); Andrew Sarris (ed.), *Hollywood Voices: Interviews with Film Directors* (London, 1971); Jack L. Warner (and Dean Jennings), *My First Hundred Years in Hollywood* (New York, 1964); and Adolph Zukor (with Dale Kramer), *The Public is Never Wrong: the autobiography of Adolph Zukor* (New York, 1953). More recent scholarship has provided more reliable histories of some of the great moguls, including Mark Vieira, *Hollywood's Dreams Made Real: Irving Thalberg and the Rise of MGM* (New York, 2008) and Scott Eyman, *Lion of Hollywood: the Life and Legend of Louis B. Mayer* (New York, 2005).
46. Bergman, *We're in the Money*. What follows in the text is not intended as a comprehensive bibliographical guide to New Deal Hollywood, but an account of the major milestones in earlier scholarship, which laid the foundations for what is still a fairly unchallenged interpretation of this period. Both Giuliana Muscio, *Hollywood's New Deal* (Philadelphia, 1997) and Saverio Giovacchini, *Hollywood Modernism: Film and Politics in the Age of the New Deal* (Philadelphia, 2001), for example, add interesting insights into the period and expand the accepted definition of Hollywood's political standpoint, but remain broadly within the accepted consensus. Both Tino Balio, *Grand Design: Hollywood as Modern Business Enterprise* (New York, 1993) and, even more so, Thomas Schatz, *Boom and Bust: American Cinema in the 1940s* (Los Angeles, 1997)

add significant depth to our understanding of the socio-economic structures of the Hollywood studios, including very useful information on production styles and box office trends, and a broad ranging survey of films from the period. Richard Maltby, *Hollywood Cinema* (2nd edn, Oxford, 2003) has an excellent series of reading guides throughout this first-class introductory textbook, for the reader who wishes to assemble a fuller bibliography.

47. Robert Sklar, *Movie-Made America: a Cultural History of American Movies* (New York, 1975); Richard Maltby, *Harmless Entertainment: Hollywood and the Ideology of Consensus* (London, 1983); Nick Roddick, *A New Deal in Entertainment* (London, 1983).
48. See also Ralph Willett, 'The Nation in Crisis: Hollywood's Response to the 1940s', in Davies and Neve, *Cinema, Politics and Society*, (Manchester, 1981), 59–75; Robert Reiner, 'Keystone to Kojak: the Hollywood Cop', in Davies and Neve, *Cinema, Politics and Society*, 195–220; Koppes and Black, *Hollywood Goes to War*; Terry Christensen, *Reel Politics: American Political Movies from 'Birth of a Nation' to 'Platoon'* (Oxford, 1987); Robert B. Ray, *A Certain Tendency of the Hollywood Cinema, 1930–1980* (Princeton, NJ, 1985); Peter Roffman and Jim Purdy, *The Hollywood Social Problem Film: Madness, Despair, and Politics from the Depression to the Fifties* (Bloomington, Ind., 1981); and John E. O'Connor and Martin A. Jackson (eds), *American History/American Film: Interpreting the Hollywood Image* (New York, 1979). See further, R. D. Marcus, 'Moviegoing and American Culture', *Journal of Popular Culture* (Spring 1970), 3, 755–766.
49. The phrase is from Maltby, *Harmless Entertainment*.
50. Bergman, *We're in the Money*, passim; his conclusions are at 167–173.
51. Edward Buscombe, 'Notes on Columbia Pictures Corporation 1926–41', in Paul Kerr (ed.), *The Hollywood Film Industry* (London, 1986), 44–63, 49.
52. Sklar, *Movie-Made America*.
53. Sklar, *Movie-Made America*, 175. See 195–214 on Disney and Capra, and 161–192 for Sklar's thesis on 1930s Hollywood and American values.
54. Maltby, *Harmless Entertainment*. He alters his stance slightly in later writings – see in particular *Hollywood Cinema*, where he writes that after World War II, when Hollywood took an overtly political position, it 'belonged to the liberal center' (306). Note that this does not apply in Maltby's view to the bulk of the period studied by me, and applies only when Hollywood is overtly political, rather than as the underlying and consistent stance for which I argue in the text. In his chapter in Balio, *Grand Design*, 37–72, Maltby argues that the film industry did a deal with the PCA, whereby the former admitted moral lapses and agreed to adopt the Code, in exchange for which the PCA and the 'Catholic hierarchy' agreed not to press for federal regulation of Hollywood.
55. Maltby, *Harmless Entertainment*, 151–52; 14.
56. Roddick, *A New Deal in Entertainment*.
57. Mark Roth, 'Some Warners Musicals and the Spirit of the New Deal', *Velvet Light Trap*, 1 (Winter 1971), 20–25; reprinted in *Velvet Light Trap*, 17 (Winter 1977), 1–7.
58. On this point, see, for example, Frans Nieuwenhof, 'On the Method of Filmanalysis', in K. R. M. Short and Karsten Fledelius (eds), *History and Film: Methodology, Research and Education* (Copenhagen, 1980), 33–38.
59. Willett, 'The Nation in Crisis'.
60. Barbara Deming, *Running Away from Myself: a Dream Portrait of America Drawn from the Films of the Forties* (New York, 1969), 6.
61. Deming, *Running Away from Myself*. See, in particular, 8–38 on the stoical hero; 39–71 on the hero's rediscovery of self-esteem; 72–105 on the success story; 140–186 on the detective/noir hero; and 201–2 for her concluding remarks.

Chapter 3

Trouble in Paradise: Hollywood Films and American Social Change

In Chapter 1 I surveyed the major political and cultural trends in American society between 1933 and 1948. In this and the next two chapters, I analyse over 250 films from the same period to demonstrate how Hollywood's films responded to the changing social landscape. I use the same three themes as I did in Chapter 1. In all three chapters, I will argue that Hollywood forged a close partnership with the values of New Deal liberalism. This chapter looks at the relationship between Hollywood films and American domestic social change. In Chapter 4 I examine American cinema's refusal to accept a wider definition of women's role in American life – a refusal mirrored by the New Deal's absence of support for female rights. And in Chapter 5 I highlight Hollywood's espousal of FDR's policies in international affairs: the film industry's support for a more interventionist foreign policy in the 1930s and its anxiety after the war about the threats to liberalism at home in an internationally strained environment.

These next three chapters draw widely on Hollywood's output during this period. I will comment on some films in depth and on others only in brief outline. Many more references to support my arguments will be found in the relevant notes. In using such a wide sample of films, I hope to show the consistent patterns of thought which permeate the films of these two decades. The case studies which supplement each chapter provide a detailed exposition of some key works from the individual émigré directors.

Hollywood and the reconstruction of American values, 1933–1940

Hollywood actively articulated the major cultural reorientation of the New Deal. Films of the 1930s portrayed most enthusiastically the new values of liberalism, self-sacrifice, neighbourliness, communal responsibilities and achievements of character, rather than material success. Hollywood's strong endorsement of Roosevelt's policy innovations bears testament to the liberal values harboured by the majority of the industry's creative community, as well as many of its executives. Those liberal views did not suddenly disappear in the 1940s when American politicians and voters began to disown the legacy of the New Deal. So, as Americans moved to the right, Hollywood moved to occupy the position of a marginalized repository of New Deal values. Those values were now in retreat, and the films of the post-war years reflect that.

As Roosevelt's administration gathered steam in the 1930s, the values that had underlaid American society in the decades of prosperity and expansion changed. From the 1890s

through to the Great Crash of 1929, American success had been defined in terms of personal wealth, material gain and individualism. But this creed of unashamed capitalism was severely shaken when the stock market plummeted in 1929 and America entered the Great Depression. The onset of unemployment, homelessness and widespread rural and urban poverty suggested that the American success story might need rethinking. New values became prominent in the years that followed FDR's election. These foregrounded the benefits of community, self-sacrifice and helping one's fellow citizens. Personal achievement was no longer defined by personal wealth and power; now the dominant cultural norms stressed concern for others, reputation among one's peer group, compassion, humanity and self-effacement. Hollywood cinema contributed significantly to this change of values. The films of the 1930s found a ready accord with the idea of a more tolerant, gentler society. The liberal community that made up a large proportion of Hollywood – writers, directors, producers and actors – responded to the challenges of the Depression enthusiastically. They were keen to show that there was more to American life than greed and the accumulation of wealth. They reminded audiences of America's founding principles in the Declaration of Independence: a belief in equality, humanity and enlightened thinking. Hollywood films in the 1930s were in harmony with the principles behind Roosevelt's programmes of social reform. Collectively, these films were an articulate and influential voice in the reconstruction of American values.

The final courtroom speech of Edmond Dantes in *The Count of Monte Cristo* (Lee, 1934) introduces Hollywood's New Deal values. The film is concerned with materialism and moral corruption, and it illustrates what happens when the ruling classes behave irresponsibly. Dantes reminds us of 'criminals who profit by the suffering of others'. Although the film is set in nineteenth-century France, Dantes' attack on those who had lined their pockets at the expense of the people while claiming to have acted 'for the good of the country', is a thinly disguised assessment of the 1920s Republican leaders. His passionate speech denounces the powers behind the banking houses, who have 'abused the privilege of public office [and] corrupted every face of Government'. He, Dantes, alone cannot condemn such people – it is a matter for the nation's conscience and judgement. This early indictment of the Republican age of selfish greed pointed a finger at America's political and business leaders, who had presided over an era of national irresponsibility.

The mistakes of the 1920s – the pursuit of wealth and the absence of a clear moral purpose to American life – were consistently challenged by Hollywood film-makers. Even such early films as *Dinner at Eight* (Cukor, 1933) and *The House of Rothschild* (Werker, 1934), while presenting bankers sympathetically, proposed the use of financial power for socially worthwhile ends. *The World Changes* (LeRoy, 1933) offered a panoramic survey of four generations of Swedish-Americans. It contained a frank acknowledgement that yesterday's mistakes should be purged. Industrial wealth had been bought at the cost of America's pioneer values: morality and simple self-sufficiency. The new generation of Americans shown in the film would start afresh, on a sounder moral footing. The portrayal of success in Hollywood cinema changed during the early years of the New Deal. Greater

significance was attached to personal integrity than to material success. Hence, in *The Mighty Barnum* (W. Lang, 1934), although the famous circus impresario achieves greater and greater material wealth, it does not bring him happiness. His relentless ambition destroys his domestic life, and he loses his innocence and virtue. This was a far cry from the previous decade's celebration of American entrepreneurs. In the same year, *Success at Any Price* (Ruben, 1934) also illustrated the emptiness of success and the terrible price paid to achieve it. Joe Martin, a greedy, unscrupulous gangster, rises to legitimate business success. His personal achievement is, however, undermined by a loveless and childless marriage to a woman of loose morals. There is a moral charge to the film's condemnation of Joe's personal enrichment. Businessmen are equated with criminals and immorality. The New Deal values challenged Americans to find a moral, rather than a material, purpose to their lives.

Later in the decade, film-makers became more adept at formulating alternative values, rather than merely criticizing the mistakes of the past. Films began to promote the benefits of cooperation and the importance of reputation. *Alice Adams* (Stevens, 1935), for example, offered a two-tiered assault on materialism and ambition. Alice aims to marry above her station, foregoing love for social aspirations. Her father, Vergil, mirrors his daughter's misguided ambition in his relentless struggle to build up his business. The film depicts the urge to better oneself as destructive. In classic New Deal spirit, however, cooperation and harmony finally triumph over competition and disunity. Vergil's arch-rival enters into partnership with him instead of bankrupting him, while Alice drops her snobbish romantic aims and marries her true love instead.

The increasingly confident formulation of New Deal liberal values was taken a step further in Gregory La Cava's *My Man Godfrey* (La Cava, 1936). This told the story of a 'forgotten man' of the Depression, who is adopted as a butler by a family of Park Avenue socialites. The film shows the emptiness of materialism, and the need to reconnect with a deeper moral purpose. Godfrey is soon revealed to the viewer as a man from a wealthy background who has fallen into poverty. This detachment from money has enabled him to discover where his class – and his country – have gone wrong. Although Godfrey has lost his position in society, he has gained a better understanding of what one should value in humanity. His calm, meditative manner is contrasted with the chaotic, drunken and irresponsible lives of the dysfunctional family to which he is now a servant. Godfrey's new horizons give him a political awareness. The young ladies of the household run a frivolous competition to find a 'forgotten man', as though such people were playthings. Godfrey remarks, 'the only difference between a derelict and a man is a job'. What he has discovered is not presented as a new social philosophy, however. It is a relearning of values which, while integral to American life, have somehow been lost in the 1920s. This, as discussed in Chapter 1, was a common response to the Depression in the 1930s. Rather than seeing the Crash as a result of unwise speculation in a country living beyond its means, it was perceived as an aberration. Thus, Americans did not need to change their national character or direction. They simply had to rediscover their essential values, recently mislaid.

The greatest exponent of Hollywood's new idealism was perhaps Frank Capra. He formulated the prototype of his New Deal liberal hero in *It Happened One Night* (Capra, 1934) and, more explicitly, in *Mr Deeds Goes to Town* (Capra, 1936). Capra's *You Can't Take It with You* (Capra, 1938) broadened the discussion and allowed the director to sum up America's change of direction in the 1930s. In this film Capra shows how the traditional pursuit of power and wealth has been superseded by the celebration of love, friendship and kindness. The conflict of values is presented clearly and simply. A. P. Kirby is a wealthy and powerful banker who plans to destroy an entire neighbourhood in order to build a giant munitions factory. He can then become the sole supplier of arms to the government. Facing him is Martin Vanderhof, who heads a household of eccentric characters, each of whom has rejected the conventions of the American race for wealth. Vanderhof is the centre of the community now threatened with destruction by Kirby and is beloved of all its residents. The two protagonists confront each other in two ways. First, Vanderhof's daughter, Alice, intends to marry Anthony Kirby Jnr. The Kirby parents oppose Anthony's plans to marry a mere secretary. Second, Kirby needs Vanderhof to sell out to him if the factory is to be built. All the other residents are Kirby's tenants, and he plans to evict them. Vanderhof could take the very generous offer Kirby makes but, in so doing, he would enable Kirby to destroy the entire community. Vanderhof refuses to sell.

It is in microcosm a clash between the conservative values of the Republican decade and the liberal values of the New Deal period: materialism versus altruism; self-interest versus self-sacrifice; personal greed versus communal sufficiency; snobbism versus egalitarianism; power versus love. In one scene, a character called Poppins renounces his job as a bank clerk, taking up residence in the Vanderhof house to pursue his real love, designing toys. Capra has Vanderhof deliver a speech, which relates how he too gave up his career because it was not making him happy. He explains to Kirby that making more money than a man can ever spend is a pointless pursuit – 'You can't take it with you', he says, so why pursue wealth so tirelessly? For Vanderhof, life has no greater reward than 'the warm love of your fellow human being'. Capra builds up his oppositional themes in many ways. The centrepiece comes with a confrontation between Vanderhof and Kirby in a police cell. Imprisoned by mistake, Kirby at first reacts with indifference to his cellmates, even as they scramble and fight over his cigar butt. Eventually, he shouts at these disadvantaged people, contemptuously labelling them 'scum' who deserve to be in the gutter. Vanderhof rounds on him, calling him an 'idiot', a man with no friends. No one will cry at Kirby's funeral; 'good riddance' is all that will be said, a pitiful legacy for a lifetime spent 'sweating over coin'. The importance of reputation and the respect of the community are stressed here. In the ensuing courtroom scene, the entire neighbourhood turns up to support Vanderhof at his trial: the residents club together to pay his fine, and the trial judge makes up the final sum from his own pocket.

In the occasional speech, Capra's political philosophy is direct. Vanderhof delivers a telling commentary on the modern search for meaning in American life. He comments on how everyone must have an 'ism' today. For him, neither communism nor fascism is

as meaningful as 'Americanism'; his creed is based on Lincoln's 'with malice toward none and charity to all'. Vanderhof contrasts this with today's values: 'Think the way I do or I'll bomb the daylights out of you'. His faith in good-natured American values over rampant self-assertion is reflected too in his prayer at dinner, when he asks God simply for the chance 'to go along as we are [and] to keep our health … as far as anything else is concerned, we leave that up to You'. Capra thus imparts a philosophy, not of ambition nor of self-assertion, but of belief in the simple benefits of human cooperation and love. He rejects any kind of politics – Vanderhof does not even believe in income tax – putting his trust in the ability of humanity to live according to our higher ideals. Capra's philosophy may not be any more realistic than is Vanderhof's carefree existence during the height of the Depression. Yet the values he espouses in this film were as valid and topical for 1930s American audiences as Kirby's commitment to capitalism, profit and personal power was to 1920s America. In the film's final scenes of communal celebrations, involving the now-reconciled Kirbys and Vanderhofs, we see the triumph of New Deal liberalism over Hooverite conservatism. The community is saved, the marriage will happen and the munitions factory will not be built. Success in business is an empty and destructive pursuit compared to the richness, warmth and love found in belonging to an American community.[1]

By the end of the decade, the debate about American values had become almost clichéd. In *Tom, Dick and Harry* (Kanin, 1941), Jane has to choose her partner from three lovers – Tom, a wildly rich 1920s-style playboy; Dick, a dynamic, hard-working car salesman; and Harry, an ordinary, idealistic poor man who has rejected the destructive success ethos (it drove his boss to suicide). She, of course, marries Harry.[2]

The agrarian myth: finding the future in the past

In Chapter 1 I discussed how the shock of the Depression led many writers and cultural commentators to find solace in recourse to America's past. An important aspect of this stream of thought was the agrarian myth. This invoked a rural ideal and a sense that urbanism and technological progress had corrupted the essentially innocent nature of America. These thinkers argued that the nation had been founded on correct principles at the very start. Nothing was fundamentally wrong; the ship had simply been temporarily blown off course. The task now was to discover what that original course had been. This involved almost by definition a romantic view of the past and a nostalgic sense of American history. Through such yearning, many film-makers sought to locate the modern New Deal values of communality and neighbourliness in a long historical tradition of 'true' American thought. The search for a usable past placed a premium on finding links between American history and the present. In *Bombshell* (Fleming, 1933), representatives of two families compete to determine who has the more respectable American credentials. The socially pretentious Middletons claim to go right back to Bunker Hill. The ill-at-ease Mr Burns attempts to go one better: 'my ancestors stood with Columbus on the poop deck of the *Mayflower*'.

Mr Burns' history may be in need of a little brushing up, but the desire to find roots in the past was shared by many Americans in the 1930s.

One way in which Hollywood deployed the agrarian myth was in a simple celebration of rural life. This was contrasted with the perils of modern urban living, and the films depicted the pleasures of life without ambition, and the opportunity for personal fulfilment without wealth and luxury. An unusual and early contribution to this genre is *Four Frightened People* (DeMille, 1934), in which a demure schoolteacher, Miss Jones, and a submissive chemist, Arnold Ainger, become stranded in the jungle. Their enforced sojourn with nature allows them to return to the roots of mankind itself. Miss Jones discards her spectacles and lets down her hair: she is next glimpsed by a waterfall, clad only in a fig leaf. She has become the modern Eve in a tropical Eden. Ainger and Miss Jones have a primitive marriage ceremony and live together. He begins hunting for food, while she wears a leopard-skin loincloth and stays in a tree, making dresses. Their rural idyll is shattered when the forces of civilization finally rescue them from the jungle and return them to the humdrum existence of their ordinary lives.

Similarly, films such as *Anne of Green Gables* (Nichols Jr., 1934), *Ah! Wilderness* (Brown, 1935) and *The Adventures of Huckleberry Finn* (Thorpe, 1939) celebrated the qualities of rural life and rejected the supposed benefits of civilization. *The Good Earth* (Franklin, 1937) offered a classic exposition of a virtuous agricultural past and the threat posed by the pursuit of wealth in the city. It tells the story of a Chinese family who prosper on the soil and almost lose everything when they leave the life of farming they know so well. *Hudson's Bay* (Pichel, 1940) used the story of seventeenth-century trapper Pierre Radisson to demonstrate the importance of humanity's relation with the natural world. The film also showed how modern Americans had inherited a legacy of tranquil pastoralism from the early pioneers. *The Wizard of Oz* (Fleming, 1939) also rejected the trappings of the modern world for the simple virtues of agrarian life. Nowhere is this encapsulated more succinctly than in the magic words which enable Dorothy to return to her simple farm in Kansas: 'There's no place like home'. This location of innocence in the rural heartland of the country was a classic statement of American agrarian populism.

One of the most sustained and thorough evocations of the search for the rural idyll is *Brigham Young* (Hathaway, 1940). The film is about the titular Mormon preacher leading his people from oppression to the Promised Land. It provided the perfect framework for the symbolism and imagery of America's rural origins. Early in the film, Brigham Young visits the Mormon leader Joseph Smith for spiritual guidance. Smith is shown as a farmer, in a glade by a lake, chopping wood. Smith tells Young that a utopian land based on egalitarian principles must be searched for: 'we had it once but we lost it; we must find it again'. In this classic statement of nostalgic pastoralism, it seems that America has lost its innocence, but it can – must – be rediscovered and reclaimed. The depiction of the trek itself allows for a deeper consideration of the values that will inform this rural Arcadia. Men, women and children, old and young – all cooperate on the perilous journey and contribute what they can offer to the communal enterprise. 'If we all pull together,' says Young, 'we'll get

somewhere.' On arriving at their destination, the film stresses the revelatory nature of the discovery – Young has seen it in a vision – investing the land with divine providence, making it a Garden of Paradise.

The film does not end with the arrival in Eden; instead, it goes on to stress the struggle to establish a community/nation from the wilderness. The communal nature of the endeavour is shown, based on 'labour, love and fellowship'. Food is pooled and distributed evenly among the settlers. Neighbours help one another with land exploitation. A harsh winter almost destroys the community, and then a plague of crickets threatens to eat the crop in the summer. Nevertheless, with communal efforts to battle these enemies – sharing the potatoes in the winter, organizing into groups to fight the crickets – and with God's help – a flock of seagulls flies by and eats the crickets – the community prospers. The final shot shows Salt Lake City in 1940, forging a link between yesterday's communal farming paradise and the present. This was the pastoral image of America to which many Americans would turn. Depressed by the direction their country had taken in the twentieth century, people saw in this rural idyll a reminder of the nation's roots, when the values of community and individual freedom had apparently prevailed.

Among the most influential film-makers involved in raising America's rural past to mythic status is John Ford.[3] In the final shot of *Stagecoach* (Ford, 1939), the Ringo Kid rides off into the spectacular landscape with his lover, Dallas. Philosopher-drunkard Doc Boone pronounces a fitting epitaph: 'that saves them the blessings of civilization'. It could have been Ford's manifesto. He followed this with a series of movies which charted the destruction of America's agrarian innocence and provided an equivocal response to the coming of industrialization and urbanism. In Ford's films the director seems unsure of the prospects for individual freedom in a more organized and technologically sophisticated society. His masterpiece in this genre is *The Grapes of Wrath* (Ford, 1940). The film blends a powerful indictment of the cruelty of capitalism with a moving tribute to the mystical spirit of America, captured in the landscape. The film charts the destruction of the rural way of life in America, portraying the country now as harsh and poverty-stricken, captured by heartless capitalists who have no sense of community. By the end the rural ideal exists only as a phantom, a mystical presence – perhaps no more than a memory. Ford endorses the New Deal's shift towards welfare capitalism, but depicts at the same time the price to be paid: agricultural virtue destroyed by industrial progress. The film's final acceptance of the hope afforded by governmental reforms, and the enduring rural spirit of freedom and justice redeem to some extent the film's overall mood of pessimism.

It begins with a graphic depiction of the destruction of agricultural communities by callous landowners. Bulldozers level the Joad house; the tracks cut across the shadows of the watching family – impotent, hopeless, reduced to mere outlines of the people they once were. 'The wind … blew away the crops, the land – and now us', someone tells Tom Joad. When the Joads set out in search of a new life in California, there is an ironic parallel with the pioneers who had crossed the desert before them, seeking and finding opportunities for participation in the American dream. Now, with the faces of the Joads reflected back on

themselves in their car windscreen, they remember those first travellers, and we see how the dream has soured for later generations. It is a bitter comment on the passing of the rural ideal. The family unit symbolizes the solidity of agricultural life, rooted in an attachment to the land. When Tom is forced to go on the run, the family breaks up, destroyed by the ravages of America's progress. Tom himself is merged into the landscape to become part of the 'one big soul' which is humanity, justice and simple happiness. This mystical union of Tom and the spirit of American ideals is arguably a product – perhaps the apotheosis – of the agrarian myth: that American rural innocence, unvanquished by the remorseless march of progress, the Depression and the meanness of human beings. Tom will be present wherever injustice or oppression is perpetrated – a cop beating up a guy – and in the celebration of simple values – a child laughing when supper is ready. Ever present 'in the darkness', a remote figure glimpsed in a huge, dominant landscape, this is the spirit of human endurance – mythical, vast, spiritual. Ma has the last word: 'we're the people … we'll go on forever … [we] can't be licked'.

Ford developed this ambivalence towards industrial progress in three subsequent films. In *The Long Voyage Home* (Ford, 1940), his evocation of a rural paradise is replaced by a more abstract lament for 'home', however defined. Lacking Ford's customary nostalgia and romantic sentiment, this tragic, despairing film offered a unique complement to his explicitly pastoral meditations on Man's communion with the land. In *How Green Was my Valley* (Ford, 1941), Ford presented a moving, sentimental portrait of a tight-knit community whose values were dying. The story is told through the voice of a young man, Huw Morgan, looking back on his childhood in a Welsh mining community. By the film's end, the valley has lost its greenness. Industrial despair is advancing across it, just as the boy has lost his innocence and become a man. The sense of what has gone is overwhelming at the film's melancholy conclusion, even as the inevitability of progress is acknowledged. Ford's *Tobacco Road* (Ford, 1941) offered a lament for the doomed Southern way of life on the land. A quieter companion piece to *The Grapes of Wrath*, this film portrays the struggles of Jeeter Lester to retain his hold on the land as a poor sharecropper during the Depression. It opens with Jeeter's imminent eviction from his farm. He is not angry, but confused, unable to comprehend how his world can so suddenly have been made irrelevant. Jeeter and his wife are evicted from their property by the anonymous forces of the world of finance. Faced with the prospect of working in an urban mill, Jeeter turns down a secure income in the city. He prefers the poverty of rural life, where he can be 'on the ground'. Ford once again composes a shot of two people framed against the skyline in the enormity of the landscape. It is an eloquent image of the enduring power of nature and the inconsequentiality of human endeavours. The final shot of the film – unfortunately undermined by inappropriately jaunty music – shows Jeeter, on the porch with his dog in the twilight – a symbol of the doomed agrarian way of life, crushed by the progress of modern culture. There exist few more affecting portraits of the end of the rural ideal.[4]

Hollywood and the decline of the New Deal: 1940–48

With the passing of the New Deal, the idealism and liberalism of Roosevelt's first two terms of office faded. Republican gains in both Houses signalled a political shift, and the New Deal ran out of steam. As soon as the war was over, a tangible shift in American culture became apparent. New Deal liberalism, including intervention in business affairs, social housing and unemployment relief programmes, became identified with communist leanings. There was soon no room for those fictional Hollywood characters who, in the 1930s, had denounced big business and the profit motive. But Hollywood film-makers did not simply switch their affiliations and start making movies that denounced the liberal idealism of the previous decade. Instead, many film-makers began to deny the probability of moral triumph in society – a stark contrast to the complacent, celebratory optimism of the 1930s. Films of the 1940s offered a frank recognition of a crisis of faith, portraying American ideals as now alien to ordinary life. Unable any longer to present the nation with images of triumphant idealism, the film industry had to find new methods to promote its liberal values. Four themes can be identified.

The first theme was the depiction of the dream of American success as more akin to a nightmare. The pursuit of success had destroyed deeper values of democracy, justice and communal help – so much had been acknowledged by Hollywood films at the height of the New Deal. But in the 1930s, New Deal values were reinstated by the conclusion of the films. In the 1940s the nightmare was simply shown as the new reality. It might be criticized, but it could not be vanquished. The second theme introduced a fundamental change in the status of the New Deal idealist hero opposed to materialism. In the 1940s this character became isolated. No longer was he able to dominate the film's narrative, determine its outcome and be included at the centre of a celebratory and optimistic finale. Instead, these characters occupied the margins of society and often ended up alienated and alone when the film finished. In such films, participation in society was not an option for the male hero of ideals, because society no longer shared his values.

A third theme was the use of mysticism and fantasy to escape from the horrors of modern life. In a fairy-tale world, populated by ghosts, the old ideals might still hold sway. Film-makers who adopted this strategy filled the moral vacuum of the 1940s with a pseudo-mystical centre. They felt unable to ground their moral solutions in 'real' life, as had been possible at the height of the New Deal. Instead, they relied on elements of fantasy or divine intervention to solve society's problems. Such fantasizing would have been seen in the 1930s as pessimistic escapism and defeatism. There was no need in that confident decade to ground solutions to social ills in fantasy. Morality would triumph sure enough in everyday life. No such confidence permeated the films of the 1940s. The fourth and final response to the moral crisis was simply to deny reality, to insist on an optimistic assessment of the prospect of a return to the New Deal's consensus society. Each of these four themes is considered below.

The American dream as nightmare

In Orson Welles's masterpiece *Citizen Kane* (Welles, 1941), Charles Foster Kane is accused both of being a communist and of being a fascist, but claims to be first and foremost an American. His life mirrors the political fortunes of America. The story of his early liberal promise lapsing into individualist megalomania might be seen as a parable of America's own missed opportunity to develop a truly social brand of capitalism. Kane's rise to fabulous wealth in the Gilded Age parallels the great era of American industrial growth. When he turns a forgotten, old-fashioned newspaper into a successful liberal journal, Kane represents the winds of social change blowing through the stultified complacency of America at the turn of the century. And, in his rise to huge wealth and power, and the consequent corruption of his ideals, he parallels the era of the 1920s. Yet the film allows no moral regeneration in the 1930s, as history would have suggested. Kane's decline and ultimate death portray not the resurgence and triumph of idealism, but its final defeat. This makes the film decisively a product of the 1940s, with its retrospective assessment of the failure of American liberalism.

When Kane, early in the film, sets out the Declaration of Principles governing his new editorship, the nation's youthful idealism in the Declaration of Independence is deliberately recalled. But within these noble sentiments are already discernible the seeds of destruction – the rampant individualism which will turn the dream from idealism into materialism. As Kane reads his Declaration to his sceptical friend Leland, the embodiment of Kane's conscience, the latter observes, 'that's the second sentence beginning with "I"'. When Kane later buys out the entire staff of the rival newspaper *The Chronicle* in order to win the circulation war, Leland questions whether these new men share the ideals on which *The Inquirer* was founded: expansion is being pursued at the cost of principles. At the turning point of the film, Kane's political career is halted when his corrupt opponent reveals the scandal of Kane's extramarital 'love nest', thereby 'setting back the cause of reform for a decade'. The subsequent estrangement of Leland and Kane – over Leland's honest critique of the new Mrs Kane's opera debut – symbolizes the passing of honesty, truth and ideals, as Kane becomes absorbed in his own private world. Leland comments retrospectively, 'he was disappointed in the world, so he built a new one', his castle of Xanadu, 'an absolute monarchy'. This is the triumph of individualism and the death of liberalism and social responsibility. From now on, Kane is presented as an ogre, malevolently towering over the proceedings, imposing his will on his environment and his wife. Youthful ideals have been overshadowed by the corrupting effects of power and money, a symbol of American revolutionary idealism perverted by American pursuit of power. Kane persistently searches for the elusive 'Rosebud', a sled from his simple, but rewarding, childhood. This may be seen as the idealism, as well as the innocence, which he once possessed, but which eludes him in later life. The film suggests that, in some indefinable fashion, America has lost its way. It was a fitting prelude to Hollywood's increasing anxiety about the direction of the United States in the 1940s.

If *Citizen Kane* marks the start of a new relationship between Hollywood and American life, then the apotheosis of this relationship in the period covered here arrived with John Huston's *Key Largo* (Huston, 1948). There are few more powerful depictions of the threat to American society posed by the return of corrupt values: the rule of immorality and repression. In this film post-war America is at a turning point. The recrudescence of selfishness and irresponsibility from the pre-New Deal era comes charged with menace in the post-New Deal world. This is not finger-wagging, but a bleak warning of the danger inherent in a return to a set of corrupt values thought to have been extinguished. Frank McCloud returns from World War II to visit a dead comrade's father and widow, Mr Temple and Nora Temple. He arrives to find that the Temples' hotel has been taken over by gangsters, led by the sinister and ruthless Rocco. McCloud has just finished fighting a war 'to cleanse the world of ancient evils, ancient ills'. This brief post-war optimism soon vanishes in the face of reality. Johnny Rocco had been expelled from America in the 1930s as an 'undesirable alien', a result of his Prohibition-era gangster exploits. Now, Rocco pronounces triumphantly, he is back. Rocco proclaims that he is no 'dirty Red', an explicit reference to the rising tide of anti-communism in the United States, which counted any liberal tendencies as subversive. This patriotic representative of Prohibition Republicanism thinks he can find a place in the new climate of post-New Deal America. Rocco, says McCloud, is someone who 'wants more'. He has plans to buy politicians, to reintroduce racketeering; he ruthlessly humiliates and routinely abuses his weak, alcoholic girlfriend, Gaye; he has already killed the local deputy sheriff, a crime for which two innocent Indians are later shot by the sheriff.

At first McCloud declines to take a stand against Rocco, preferring not to risk anything on behalf of others, but he cannot sustain such a passive and selfish role. When he does intervene, Nora congratulates him, telling him that while idealists like him still survive and fight, 'the cause is not lost'. A hurricane blows up, a natural, purifying force that unnerves Rocco. When the two wanted Indians seek shelter, Rocco locks them out. Their later murder moves McCloud to action. The individual idealist hero must take a stand to oppose the representatives of evil and protect the defenceless and the vulnerable. The film ends with McCloud overpowering Rocco and his gang on their boat to Cuba, before deciding to settle down with Nora and her father-in-law. As he radios from the boat his decision to come back, she opens the shutters, letting in a flood of light for the first time in the film. This seems an optimistic ending, but in the context of the film it feels more like a cry for help than a realistic assessment of the chances for liberalism in the late 1940s.

Not many films could match the brooding intensity of *Key Largo*, but a number of films from the mid-1940s onwards called attention to the battle to retain a moral basis to American life. The noted left-wing playwright Clifford Odets wrote two of the more memorable ones. *None But the Lonely Heart* (Odets, 1944), which he also directed, portrayed Ernie Mott's search for moral direction in a society divided between 'victims and thugs, hares and hounds'. Mott's moral equivocation seems inadequate to the demands of the time. At the end of the film, he cries out in despair for a time when 'the human soul will get off its knees', a time when Mott can 'fight with men who'd fight for a better way of life'. In this speech Odets still sees hope

for the triumph of the liberal cause at the war's end. His disappointment became evident in another of his screenplays, *Deadline at Dawn* (Cluman, 1946), which he did not direct. The unremittingly bleak and pessimistic atmosphere of this film, with its sordid apartments and vulnerable characters, well captured a mood of post-war despair.

The lonely hero

These stark dramas of the transformation of the American dream were accompanied by a series of films recording the moral emptiness at the heart of American life in the 1940s. Into this moral vacuum a lone hero would venture, whose grasp of ideals provided a tenuous link back to the certainty of the New Deal. Yet this could not constitute any permanent triumph of morality. Individual battles could be fought, but the war could hardly be won by these sole survivors of earlier moral times, cast adrift on a sea of greed and lust for power. Taking their inspiration from the 'tough guy' novels of the 1930s and early 1940s, these films abandoned belief in the achievement of a moral resolution. Instead, they nurtured the optimistic hope that liberalism could at least survive on the margins of society, awaiting its return to full participation in the life of the nation.

Philip Marlowe retained his integrity against the odds in *Farewell, my Lovely* (Dmytryk, 1944), *The Big Sleep* (Hawks, 1946), and *The Lady in the Lake* (Montgomery, 1946), all derived from Chandler's novels. Hammett's *The Glass Key* (Heisler, 1942) was remade in this decade, with appropriately bleaker settings and more violent beatings of the hero than had attended the 1930s version. Hammett's *The Maltese Falcon* (Huston, 1941) was also remade, the later version providing a key reference point for the films noirs of this decade. These were close cousins of the dramas of despair considered above. Hollywood recognized the passing of the New Deal and lamented it, but could not offer a convincing alternative. Deprived of any realistic expectation of shared values, these films vested all their hopes in the isolated individual's conscience. The films betrayed an uneasy mixture of moral uncertainty, moral anarchy and, in the central hero, grim moral determination.[5]

Hollywood liberalism and fantasy

Not all Hollywood film-makers in the 1940s expressed directly the mood of pessimism and moral uncertainty prevalent at the time. A number of films reacted to the crisis with a more oblique presentation of the hollowness of American ideals. These film-makers sought to restore the New Deal values by means of a fantasy resolution. These apparently optimistic assessments of the continuing relevance of American idealism actually found hope only in the context of fairy tales, rather than in 'real life' resolutions. This genre of pseudo-religious or fantasy films is better understood, then, as a lament for the era of idealism, even though the films might at first appear to celebrate the liberal cause. The most important example is

Frank Capra's masterpiece, *It's a Wonderful Life* (Capra, 1946). Capra uses a fantasy context to demonstrate the ideals and values which ought to underlie American society. A film that, a few years earlier, would have portrayed the triumph of liberalism, here allowed that triumph only through the intercession of God and his angels. *It's a Wonderful Life* remains the definitive expression of Capra's philosophy, but it betrays an uncertainty about the durability of his world view. Capra's works of the 1930s were far more confident about the ultimate triumph of New Deal philosophy. The critical response to this film is considered below – it is instructive that, when Capra paid tribute in *It's a Wonderful Life* to the essential good in all human beings and the triumph of friendship, critics found it ill-matched to the needs of American society.

In one sense, the film's story of George Bailey, resident of small town Bedford Falls, and his fight to build decent housing in opposition to the profit-hungry slum builder, Potter, is a classic product of New Deal Hollywood. It pits the representative of community and welfare against the agent of greed, self-interest and uncaring business. Yet it has to resolve this conflict by means of a fantasy resolution. No longer could the audience be expected to believe that the representative of New Deal culture would naturally triumph. In this way, the film marks itself out as a product of post-war anxiety. George Bailey has throughout his life sacrificed his own interests for other people. As a friend remarks of him, 'he never thinks of himself, that's why he's in trouble'. Self-sacrifice in the later 1940s was now an ethos outside social norms. When George's father dies suddenly, the avaricious Potter moves in to close down the loan company Mr Bailey has run benevolently for many years. Potter profoundly disapproves of the late Mr Bailey's business conduct, condemning him as 'a man of high ideals, so called … [a] starry-eyed dreamer' who ran a charitable company instead of encouraging a 'thrifty working class'. George is moved to defend his father's record: a man who never enriched himself, a man to whom ordinary folk were 'human beings … not rabble', a man who dedicated his life quietly to giving the poor decent housing, without making them starve all their lives to get it. At the end of his defence of New Deal liberalism against Potter's 1920s-style avarice, George decides to take over his father's business – and, we can infer, perpetuate his father's ideals.

The film continues in a similar vein. George builds a model green belt housing estate and, as he helps people to own their homes, Potter's slum-rents decline. 'Bailey Park' does not make a profit for George, but it stands as an investment in America's future and a testament to welfare capitalism. In a further confrontation with Potter, who tries unsuccessfully to buy George off, Bailey contrasts the values of unprincipled capitalism with the values of helping people. Potter may be a big wheel in financial terms but, 'in the whole vast configuration of things, I'd say you're nothing but a scurvy little spider'. The crisis for George Bailey's ideals comes when, via a plot contrivance, Bailey loses all of his company's savings. Threatened with bankruptcy, imprisonment for misappropriation of funds, the end of his welfare building scheme and the final triumph of Potter's style of capitalism, George decides to kill himself. At this point, God sends an angel to Earth to explain to George the meaning and the worth of his life. The angel's tactics are simple: he shows George what Bedford Falls would

have been like had he, George, never lived. In so doing, Capra was able to speculate on what American life owed to the values of New Deal liberalism and what, by implication, was at stake in the post-war battle for American idealism.

George is shown the town of 'Pottersville', full of strip joints, sleazy bars and self-interested people whom George remembers as ordinary, honest folk. George's residents from Bailey Park live in slums in 'Potter's Field'; his mother runs a seedy boarding house; his wife is a dowdy, spinster librarian; his uncle is confined in an asylum; his friend is an alcoholic ex-convict. George has helped these people to avoid degradation, poverty and despair. This is the value of a life lived, not to amass personal wealth, but to help fellow human beings. Its benefits are intangible, unlike material success, yet its fruits are more valuable and durable. George recognizes the value of his ideals, and he returns to reality. The townsfolk have collected enough money between them, in an affirmation of communal spirit, to make good the lost money, and the loan company is saved. The angel delivers the film's summary message to George: 'no man is a failure who has friends'. This succinct tribute to American idealism stressed the bonds of human fellowship, and the value of reputation, over the outward success of self-enrichment. Nevertheless, the salvation of American idealism had to be effected in the film by divine intervention, not social action. Capra's faith in humanity was still evident, but he introduced a new element – direct action by God. It is no coincidence that, when George returns from his fantasy nightmare of Pottersville, the film showing at the Bedford Falls cinema is *The Bells of St Mary's* (McCarey, 1945), another key fantasy/religious film.

The critical reception of this film illustrates the extent to which the place of idealism in American life had changed. Critics commented on the inadequacy of Capra's solution to America's post-war problems. His 1930s liberalism no longer carried conviction. In the past critics had praised Capra's dramatic sentimentality, finding in it essential truths about American ideals. Now they objected to this same sentiment, because it appeared to be an avoidance of reality – yet reality had not been the yardstick for many critics in the idealistic 1930s. Bosley Crowther of the *New York Times* wrote:

> [T]he weakness of this picture ... is the sentimentality of it – the illusory concept of life. Mr. Capra's nice people are charming, his small town is a quite beguiling place and his pattern for solving problems is most optimistic and facile. But somehow they all resemble theatrical attitudes rather than average realities ... [Capra's philosophy], while emotionally gratifying, doesn't fill the hungry paunch.[6]

Richard Griffith wrote that the gap between the harsh reality of American business life and the 'fantasy' of goodwill was now too wide to be bridged by Capraesque idealism. An audience in 1946, Griffith argued, could no longer accept such an interpretation of real life. The film 'alienates while it entertains'. 'Perhaps,' he speculated, Capra 'feared that American audiences couldn't take this direct dissection of their own lives without reassurance that it was all part of the divine design.'[7] While Capra was preparing *State of the Union*

(Capra, 1948), his follow-up to *It's a Wonderful Life*, Harold Salemson summed up an increasingly common attitude to Capra's once popular idealism. He criticized Capra's 'short cuts to Utopia' and his tendency to prescribe simple remedies for social ills:

> Capra offers a panacea which treats the symptom of the illness, but not the source of the infection ... [Can] Capraism ... continue to retain public attention through its diversified presentations of virtue as the ultimate answer to what ails this world of ours?[8]

Salemson's doubts about Capra would have been unthinkable a decade earlier, when the film director exemplified the dominant cultural assumptions of the New Deal. Now, that faith in idealism which had so captured the spirit of 1930s America looked dated, naive and simplistic – but above all, and most damagingly for Capra and his New Deal cohorts, that idealism was judged irrelevant and inappropriate for the times.

Another excellent example of the fantasy resolution genre comes in Joseph Mankiewicz's *The Ghost and Mrs Muir* (Mankiewicz, 1947). In this film a widow finds happiness and personal fulfilment when she has a relationship with a ghost, a spectre from the past. She thus establishes a tenuous hold on the past and its idealism through a fantasy figure. When she takes a corporeal lover, the absence of idealism from today – from reality – becomes apparent. The man who courts her is without moral values – he turns out to be married. She has based her ideals on a fantasy about the past, and their foundation is not on solid ground. Her ghost lover leaves her alone to grapple with the reality of the present. Her real lover then returns to his wife, and she is left with no one. The inspiration of the past has gone and the promise of the present turns out to be illusory. She leads a long, sad and lonely life before rejoining her ghostly lover in death. The film is a profoundly pessimistic allegory for the loss of idealism.

Another important example of this response to the bleak prospects for liberalism is *Miracle on 34th Street* (Seaton, 1947). Here the liberal film-makers pin their hopes for the triumph of idealism on Father Christmas. Kris Kringle, a man who seems genuinely to believe that he is Santa Claus, is committed to an asylum. It is almost as though his belief in spreading goodwill, rather than subscribing to the ethos of unbridled, competitive capitalism, renders him insane in society's eyes. The values of cooperative liberalism have, it seems, become a crime. Ready to give up on his mission to restore goodness to the world, Kringle is persuaded by an idealistic lawyer, Fred Gailey, to stand trial for his sanity and, by implication, the soundness of his views in American society. Gailey tells his disillusioned girlfriend that he has to defend 'people like Kris who're being pushed around'. It is a trial, he explains, for 'the intangibles' – love, kindness, Christian charity – which are far more important than 'reality'. This defence of American idealism was topical. In reality, liberals in Hollywood were indeed 'being pushed around' by those whose cause would soon be taken up by Senator McCarthy. Gailey's girlfriend is a shallow materialist, devoid of higher ideals: 'you don't get ahead by going on an idealistic binge', she asserts. The trial, however, evinces massive public belief in Santa Claus. The film thus demonstrates a continued faith

in something more than materialism in post-war America. The triumph of idealism seems, again, an optimistic conclusion. One might, however, detect a sense of desperation when that triumph is effected through the medium of Father Christmas.[9]

Denial

The fourth and final response to the moral crisis facing the country was a number of films that chose to reiterate New Deal values, as if reaffirming them would compensate for their absence. This whistling to keep up spirits gave the impression that all was well with the moral climate in America. *Magic Town* (Wellman, 1947), written by Robert Riskin, Capra's regular screenwriter, offered the triumph of community spirit over failed, materialistic politicians. This resolution, which would have been more suited to a Capra film at the height of the New Deal, has an air of desperation about it in the later 1940s. *Mr Blandings Builds his Dream House* (Potter, 1948) satirically portrayed two New Deal liberals trying to recreate the old values in the modern materialist society. It undermined its satirical thrust by allowing their values to triumph in the end. The optimism of these films was ill-suited to the times, and Hollywood did not engage too often in such anachronistic wish-fulfilment.[10]

Hollywood's other New Deal themes, 1933–1948

For completeness, I shall briefly summarize some of the other key trends of New Deal culture which were reflected in Hollywood films. The corruption of politicians and the restoration of democracy to ordinary people is a theme often seen in films about the founding of American civilization from the lawless West.[11] Undoubtedly, though, the most important film to examine American politics in this period was Capra's *Mr Smith Goes to Washington* (Capra, 1939), a classic formulation of New Deal liberalism.[12] Another important theme was law and order, typified by a conflation of liberal opposition to gangsterism and a fairly clear preference for violence against lawbreakers.[13] The idea that the law was unwieldy and that intuitive justice was superior was a common motif in American New Deal cinema and further evidence of American pragmatism and distrust of authority.[14] Another common sub-theme was anti-intellectualism, including the lampooning of psychiatry.[15] A major theme in itself was the treatment of the media, sometimes depicted as the guarantor of truth and democracy, at other times remorselessly satirized.[16] Finally, one should note Hollywood's occasional direct exploration of the labour movement as a political issue, handled with characteristic 'apolitical' liberalism. Unionization was usually shown, in the tradition of New Deal politics, as nothing more than the reasonable demands of workers to share in American society. The urge to avoid conflict was the key theme, along with the need for management to understand the wider social goals of justice, rather than simply pursue private profit. A rational consensus between modern management and temperate labour leaders was normally achieved.[17]

Notes

1. See also Capra's *Lost Horizon* for a fully developed alternative society, based on love, peace, community values and human bonds instead of capitalist, individualist success.
2. Films exhibiting a clear New Deal interpretation of success in American life are legion. Some good examples include *The Barretts of Wimpole Street, The Crowd Roars, Only Yesterday, History is Made at Night, Captains Courageous, The Big City, Hold That Co-Ed, The Duke of West Point, Vigil in the Night, One Million BC, They Drive by Night, The Great McGinty, Christmas in July, Devil Doll, Footlight Parade, Gold Diggers of 1935, National Velvet, Penny Serenade, Personal Property, The Philadelphia Story, Sadie McKee, The Strawberry Blonde, Vivacious Lady, Woman Chases Man* and *The Young in Heart*. Sturges' *Hail the Conquering Hero, Mad Wednesday* and *The Miracle of Morgan's Creek* all implicitly value human affinities over material success. His *Sullivan's Travels* gives a graphic account of the miseries of the Depression and a commensurately serious defence of Hollywood's idealism. Hollywood was not completely homogeneous in its response, of course. For rare examples of films overtly hostile to the New Deal, see *Boom Town, Without Reservations,* and *Kings Row*, as well as much of Cecil B. DeMille's work – see *Reap the Wild Wind* and *Unconquered*.
3. As well as the films considered in the text, see also *Drums along the Mohawk* for a classic Ford treatment of American democracy's roots in the rural foundation of the country. See further his two films *Young Mr Lincoln* and *The Fugitive*. For illustrative secondary literature on Ford (based on structural theories, rather than historical research), see Ralph Brauer, 'The Fractured Eye: Myth and History in the Westerns of John Ford and Sam Peckinpah', *Film & History*, 7 (December 1977), 73–84; H. Peter Stowell, *John Ford* (Boston, Mass., 1986); Michael Dempsey, 'John Ford: a Reassessment', *Film Quarterly*, 28 (Summer 1975), 2–15; and Joseph McBride (with Michael Wilmington), *John Ford* (New York, 1976). The Editors of *Cahiers du Cinéma*, 'John Ford's "Young Mr Lincoln" ' (1970), reprinted in Mast and Cohen (eds), *Film Theory and Criticism*, 778–831, is a well known piece which offers a learned, theoretical reading of the film, but arguably betrays an inadequate grasp of its historical context.
4. For other references to the rural ideal, including the rejection of modernity, see *Abe Lincoln in Illinois, Angel in Exile, Captain from Castile, China Seas, The Clock, The Keys of the Kingdom, Of Human Hearts, Stanley and Livingstone, Lost Horizon, Saratoga Trunk, Song of Bernadette, Jesse James, The Black Swan, They Died with their Boots On, The Prisoner of Zenda, The Little Minister, Marie Antoinette, The Master Race, The Moon and Sixpence, One Million BC, Peter Ibbetson, The Story of Dr Wassell, Tortilla Flat* and *The World Changes*. A connected theme is the corruption of the city (usually New York City, the most developed part of the country): see, for example, *The Big City, Boom Town, Camille, I Am the Law, Mr Smith Goes to Washington, National Velvet, Only Yesterday, Pride and Prejudice, Red Salute, Sadie McKee, Success at any Price, T-Men, This Is my Affair* and *Three Loves Has Nancy*, among a host of others. Similarly, the depiction of the small town as the heart of America is relevant in this context: see *Going my Way, Little Women, To Each his Own* and *A Woman's Face* for some representative examples. A related theme is conflict between parents and children, which is used to illustrate the gap between the past and the present. The parental generation embodies the values of capitalist greed and irresponsibility, and oppresses the young lovers. The older generation has betrayed its children, who represent hope for a new future based on different values. See, from a very large group, such examples as *The Bells of St Mary's, Captains Courageous, The Corn is Green, The Crowd Roars, The Curse of the Cat People, The Dark Angel, The Enchanted Cottage, Going my Way, Kings Row, The Lost Moment, Miracle on*

34th Street, *Only Yesterday*, *Red River* and *The Wizard of Oz*. For examples of small-town values being satirized, see *The Great Man Votes*, *Hail the Conquering Hero*, *The Miracle of Morgan's Creek* and *Nothing Sacred*.
5. For other examples of the isolated hero, see *Body and Soul*, *Treasure of the Sierra Madre*, *To Have and Have Not*, *They Won't Believe Me*, *The Lady from Shanghai* and *The Dark Corner*.
6. Bosley Crowther, *New York Times* (23 December 1946).
7. Richard Griffith, *National Board of Review* (February-March 1947), in Griffith, *Frank Capra*, 34–36. See also James Agee, *The Nation* (15 February 1947), in Glatzer and Raeburn, *Frank Capra*, 157–59; Agee writes that 'Capra's idea of a kind of Christian semi-socialism, a society founded on affection, kindliness, and trust' fails to recognize that evil is intrinsic to us all, and that everyone has responsibility for themselves and must depend upon their own 'moral intelligence and courage'. Capra's idealization of small-town life is not appropriate to modern America, Agee concludes.
8. Harold J. Salemson, 'Mr Capra's Short Cuts to Utopia', *Penguin Film Review*, 7 (September 1948), 32–34.
9. For the early stirrings of Hollywood's religiosity, a precursor of the trend towards mysticism and fantasy, see *Tortilla Flat*, *Song of Bernadette* and *The Keys of the Kingdom*. With *Going my Way* and *The Bells of St Mary's*, the trend began to develop a deeper spiritual significance than simply reverence for the church. Further unabashed fantasy is found in *The Enchanted Cottage* and *Angel in Exile*. See also *The Fugitive* for a mystical treatment of the priesthood; *The Curse of the Cat People* for use of the fantasy world of children to symbolize love and the affirmation of friendship at a time of global strife; and *Man Alive* for the use of a ghost to give a formulaic marital comedy some added interest.
10. For other determined optimists intent on wishing the New Deal back into existence but simultaneously recognizing that its values were under threat, see *Red River* and *The Lost Moment*, both of which deal with the past in an arguably over-optimistic fashion.
11. For films which do the opposite, and welcome the coming of progress to the wilderness, or the modernization of society, see *Reunion in Vienna*, *The Great Ziegfeld*, *Gone with the Wind*, *Northwest Passage*, *Bad Man of Brimstone*, *Honky Tonk*, *Gentleman Jim*, *Return of the Bad Men*, *Unconquered* and *In Old Chicago*.
12. See also Capra's other political treatise, the intensely topical *State of the Union*. Other films which deal directly with politics and democracy at some level include: *The Big City*, *The Black Swan*, *Citizen Kane*, *The Count of Monte Cristo*, *The Great McGinty*, *His Girl Friday*, *Hold That Co-Ed*, *The Senator Was Indiscreet*, *They Died with their Boots On*, *This Day and Age*, *Magic Town*, *The Great Man Votes*, *Keeper of the Flame*, *Hail the Conquering Hero*, *This is my Affair* and *Union Pacific*. For studies of great leaders, see *Young Mr Lincoln*, *Abe Lincoln in Illinois*, *Wilson* and *The Gorgeous Hussy* (about President Andrew Jackson). The model of leadership was always the reluctant man, called to office to sacrifice his private interests for the sake of the nation. It was not confined to American presidents, nor even politicians. See, for other nations' leaders exhibiting the same qualities, *Anna and the King of Siam*, *Conquest* (about Napoleon), *Marie Antoinette*, *Mary of Scotland* and *The Prisoner of Zenda*. Religious leadership took on similar qualities – see *The Fugitive*, *The Keys of the Kingdom* and *The Song of Bernadette*. Leaders of nationalist rebels could display similar virtues – see *Kidnapped* and *The Son of Monte Cristo*. For the rejection of politics, see also *Drums along the Mohawk*, *Escape*, *The Prisoner of Shark Island* (another film about Lincoln), *Sadie McKee*, *A Tale of Two Cities* and many other films.

13. See, for example, *Bullets or Ballots, I Am the Law, This Day and Age, Let 'Em Have It, T-Men* and *Raw Deal*, for a brief introduction to the evolution of this subject over the fifteen-year period. One should also note a number of films which stressed the right of citizens to speak before a court and receive natural justice there; see *The Adventures of Huckleberry Finn, The Big City, Brigham Young* (although the highly prejudiced jury is unswayed in this case), *The Count of Monte Cristo, Dance Girl Dance, Miracle on 34th Street, Penny Serenade, Reap the Wild Wind, Souls at Sea, The Unfaithful, Vigil in the Night, A Woman's Face* and *Young Mr Lincoln*. For illustrations of how a court should *not* behave see, for example, *Marie Antoinette, The Prisoner of Shark Island, The Song of Bernadette, Sullivan's Travels* and *A Tale of Two Cities*. Respect for the law as the foundation stone of democracy and freedom is well expressed in *Anna and the King of Siam*.
14. In addition to many of those just cited, see *Captain from Castile, Central Airport, The Clock, Destry Rides Again, The Doughgirls, For Whom the Bell Tolls, Hudson's Bay, Jesse James, Key Largo, Kings Row, Stanley and Livingstone, Station West, They Drive by Night, This is my Affair, Wife versus Secretary* and many others.
15. See *Ball of Fire, The Bells of St Mary's, Bringing Up Baby, Hellzapoppin', How Green Was my Valley, Invisible Woman, It's Love I'm After, Love Crazy, Mad Wednesday, Make Way for a Lady, Miracle on 34th Street, The Mighty Barnum, My Man Godfrey, Northwest Passage, Sergeant York, They Died with their Boots On, Tycoon, Union Pacific, Without Reservations, The Wizard of Oz* and *Young Mr Lincoln*. But note, too, the opposite, where a rational understanding of the world, often symbolized by the power of technology or science, is held to be superior, particularly in comparison with developing world civilizations. See, for example, *Anna and the King of Siam, Captain from Castile, The Count of Monte Cristo, The Good Earth, I Am the Law, The Keys of the Kingdom, Kings Row, Let 'Em Have It, Little Women, The Lost Moment, Man Alive, Mr Skeffington, The Moon and Sixpence, The Philadelphia Story, Too Hot to Handle, The Valley of Decision* and *Vigil in the Night*.
16. For examples of the former, see *Citizen Kane, Dancing Co-Ed, Keeper of the Flame, Stanley and Livingstone, Arise my Love, Intrigue, Mr Smith Goes to Washington* and *The Son of Monte Cristo*. For examples of satirical approaches to the media, see *The Bride Came C.O.D., It Happened One Night, Nothing Sacred, Sullivan's Travels, His Girl Friday, Too Hot to Handle, Libeled Lady* and *The Miracle of Morgan's Creek*. *Command Decision*, a film of the right, shows newspapers as corrupt because they undermine American patriotism and militarism.
17. See *The Devil and Miss Jones, An American Romance, The Valley of Decision* and *How Green Was my Valley*.

Case Study 1

'Everything That Happens Must Be Strictly American': Fritz Lang and Hollywood Idealism

Introducing Fritz Lang

Friedrich Christian Anton Lang was born on 5 December 1890, in Vienna. The son of an independently wealthy Jewish woman, Paula, and a Roman Catholic property developer named Anton, Lang was brought up a Catholic in middle-class prosperity in a house inside the Ringstrasse.[1] A poor scholar who failed to matriculate, Lang disappointed his father's hopes for a technical student who could join the property business. His mother nurtured the young Fritz's artistic leanings instead and, at the age of 21, Lang left home to travel in Europe. Wandering without too much purpose, playing the part of the dilettante painter, Lang migrated to Paris.

His youthful sojourn was rudely interrupted by the outbreak of World War I, and in January 1915 Lang volunteered for service in the German army. A patriot, and later justly proud of his war record, Lang saw activity on the Eastern and Italian fronts during the long conflict, received injuries which required hospital treatment and convalescence, and was much decorated. Surviving the war, Lang left the army and had settled in Berlin by December 1918. Here, in circumstances which remain vague, he met the prestigious German film producer, Erich Pommer, who offered him a job as a script-reader and editor. Pommer owned a film production company called Decla, which would merge with Bioscop in 1920 and then with the giant Ufa film company. The German film industry was experiencing a boom period at the time Lang joined, and he soon graduated from reading scripts to writing them. Lang had a technical bent, and it was a natural development for him to move behind the camera and start directing in 1919.

After two early films (both now lost), Lang found his stride in his two-part epic espionage thriller, *Die Spinnen/The Spiders* (Lang, 1919). In a style that was to become his hallmark during a brilliant decade at the top of the German film-making profession, Lang dazzled audiences with special effects, breathless pursuits, tortuous plot twists, double identities, secret agents and shady master criminals. In another hallmark of the Lang style, he displayed on set an autocratic, cruel and domineering command of crew and cast, forcing them to work throughout the night, controlling every aspect of the production and insisting on multiple takes in search of the perfect shot. As his career developed in Germany, he became ever more dictatorial, even instructing actors in the details of their movements. It was a style of working which was to make his transition to Hollywood very difficult.

After the success of *Die Spinnen/The Spiders*, Lang briefly worked with another producer, Joe May, and met a gifted author and screenwriter, Thea von Harbou, who was married to one of the leading German actors, Rudolf Klein-Rogge. Von Harbou and Lang hit it off and began collaborating on film projects as a writer–director team. Before long, their collaboration extended beyond the film studio, and they were to marry in 1922. Returning to

Case Study 1 – 'Everything That Happens Must Be Strictly American': Fritz Lang and Hollywood Idealism

Pommer, Lang made a series of famous silent films for Ufa in the 1920s, a number of which are still regarded as masterpieces of their time. Beginning with *Der Mude Tod/Weary Death* (Lang, 1921), Lang continued with *Dr Mabuse der Spieler/Dr Mabuse the Gambler* (Lang, 1922), another two-part epic fantasy centred on a mysterious master criminal and one in which Lang introduced further technical innovations in his special effects and camerawork. With his reputation growing, both as a major director and as a monstrous perfectionist egomaniac, Lang's position was pre-eminent by the end of the year, helped by Lubitsch's departure for the States. Lang and von Harbou were much photographed at receptions, dinners and premieres – a true celebrity couple.

With his next work, *Die Nibelungen* (Lang, 1924), Lang introduced another hallmark of his style – intense, detailed and extended pre-production, working with a hand-picked team – cameraman, set designer, costume designers and von Harbou as writer. Lang began his habit of prescribing every camera movement and angle, and every hand or foot or facial movement of the actors. In October 1924, he visited America with Pommer, saw the impressive facilities offered by Hollywood, and met Lubitsch and swam in his Beverley Hills pool, before returning to his role as the giant of the German film industry. Back home, Lang took his interest in technical innovation and epic storylines one step further with *Metropolis* (1926), another film preceded by months of preparation. The film was very expensive to make and failed to recover its costs. Ufa went into financial restructuring (not solely because of *Metropolis*) and Lang – not for the last time in his career – set up an independent production company, this one financed by Ufa. *Spione/Spies* (Lang, 1928) and *Frau im Mond/Woman in the Moon* (Lang, 1929) were produced through this means, but neither was commercially successful, and Lang's experiment with independence faltered – just as it would in America. Falling out with his backers at Ufa, as he was to fall out with a number of producers in Hollywood, Lang joined forces with a small independent company, Nero Films, to make his final two German works.

The first – his first sound picture – was perhaps his greatest ever creation, *M* (Lang, 1931), a gripping, harrowing and moving account of a serial child murderer. With this film, Lang's reputation reached its apotheosis. He was comfortable working in Germany, with the high status accorded to film directors and the way in which the director's artistic freedom was prized more than commercial imperatives. Moreover, he enjoyed the ability to tackle controversial subjects without heavy-handed moral policing. In this environment Lang produced his greatest works. It is from this era that his critical reputation as a major artist derives. He would never achieve this level of recognition in the United States. Indeed, he would never again fully demonstrate his talents, nor realize his aspirations, once the arrival of the Nazis forced him to leave Europe.

In October 1932 Lang began shooting a follow-up to his first Mabuse film, to be called *The Testament of Dr Mabuse*. Things began to unravel. At the end of the year, von Harbou left him for another man. At the start of the next year, filming was completed on *Testament*, and editing had finished by March. That month, on 28 March, Lang attended a conference on German cinema, convened by the new government and hosted by the Propaganda Minister,

Josef Goebbels. Although Goebbels admired *Die Nibelungen* (and that classic creation of the hated Soviet regime, *Battleship Potemkin* (Eisenstein, 1925)), *Testament* was banned the very next day and not shown in Germany until after the Second World War. The prospects for Lang working in the Nazi film industry were not promising.

Lang's oft-told story about how Goebbels offered him the leadership of the German film industry and how he fled the country that night with barely a penny to his name has been comprehensively discredited and debunked. Film scholars, no longer relying exclusively on celebrity anecdotes, have discovered that the evidence does not match the myth.[2] Lang did indeed leave Germany in 1933 and migrated once again to Paris, as he had done in his youth – but he did not leave overnight, and neither did he flee in fear for his immediate personal security. He went for the entirely understandable, albeit less momentous, reason that he was searching for work. In Paris he teamed up with the exiled Erich Pommer to make one film, *Liliom* (Lang, 1934), before setting sail for America on 6 June that year. Lang thus joined the stream of German film personnel, along with writers, performers, musicians, artists and many others, who were forced on the move by the rise of Nazism. Very many of these artistic refugees were Jewish men and women, fleeing for their lives. Lang did not have that status, although one cannot be certain about his safety if he had stayed, given that his mother was Jewish. In any event, by 1934 he had lost his prestigious position as the powerhouse of European cinema. He was an economic migrant.

The German community in Hollywood made great efforts to ensure that their artistic brothers and sisters in Europe were given visas and work permits in America. They would guarantee accommodation and some form of work to the émigrés, who were thus permitted to enter the United States. Although the émigré might have only a temporary visa, it appears that there was a convention for circumventing American immigration controls. This involved the refugee crossing the border into Mexico and remaining there for a matter of hours. They did not, therefore, overstay their temporary visitor permit. The refugee would then return to the American border and seek re-entry under a permanent visa. He or she would furnish a letter from a US citizen guaranteeing that the immigrant would be employed and not a burden on American welfare. For reasons which are not clear to us today, such a visa would then be granted. Both Lang and Wilder obtained their extended rights to stay in the United States through this route.[3]

Lang's invitation to America came from David Selznick, a producer at MGM who ran his own unit at the studio prior to establishing himself as an independent. On arrival, Lang cut a figure very different from the one he had adopted in Germany. He was not, as was Lubitsch, part of a much heralded 'German invasion' – someone who had been talent-scouted. His films were not popular, or often even known, in America. His status was comparatively low. Lang made matters worse by behaving as if he was, in fact, a giant of Hollywood, as well as German, cinema. Throughout his patchy career in America, which lasted over twenty years, he struggled to achieve artistic control over his pictures; he acquired a reputation as 'difficult'; he was a truculent, arrogant man, used to getting his way and not a skilful networker or negotiator. In America, he hardly ever worked with the same cameraman,

producer or writer more than once, whereas Lubitsch and Wilder formed enduring alliances with studios, with writers and with producers. Lang often had to make do with second-rank actors, while his European compatriots worked with the top talents. Lang made enemies easily. He would often take the credit for other people's work, and had an equal facility for blaming others for his own mistakes.

He struggled to get a project off the ground during his first year in America, and it was not until 1936 that he made his Hollywood debut with *Fury* for MGM. He exaggerated his political bravery in the years that followed and created myths about himself designed to plump up his reputation as a radical social commentator. Yet it would be unfair to denigrate his many achievements. Despite weaknesses in many of his films, and despite his obvious personality flaws, Lang was to make a number of works which engendered a deep analysis and critique of New Deal politics and which challenged American notions of liberalism. He would also introduce into Hollywood cinema one of the most adult discussions of foreign affairs in the 1940s, with his Brecht collaboration, *Hangmen Also Die!* (1943). His contribution to the cinema of the New Deal is a vital one.

Lang's philosophy of cinema
Lang's creative autonomy was on occasion severely restricted within the Hollywood studio system, and his career was uneven. Unlike Lubitsch and Wilder, he did not form lasting attachments to particular studios. Again, unlike his two European colleagues, he did not habitually work with the same screenwriter or producer. Between 1933 and 1948, Lang directed twelve films, working for such major studios as MGM, Twentieth Century-Fox and Paramount, as well as for independent producers. He may have hoped to gain a measure of freedom through his itinerant style, but this was not to be. It was not just that Lang discovered that independent companies could be as interventionist as any major studio. It was as much to do with his personality flaws. Both Lubitsch and Wilder achieved higher and more consistent levels of autonomy *within* the studio system. They established good working relationships with the studios and achieved reputations for excellence. Accordingly, they found that they could work with virtually no interference.

Lang was very different. He did not adjust well to the demands of Hollywood. If left to his own devices, he could on occasion be a creative film-maker. He liked to work closely on the script if his interest was engaged by a project, as well as direct the film. He usually sought to control the final assembly of the picture for release.[4] Yet the archives reveal a significant difference from film to film in terms of Lang's personal involvement and control. On occasion, Lang would have no input in the script process, simply filming a studio's final screenplay with no discernible departure from it.[5] On other occasions, he would lose control of the film during the editing stage.[6] Lang himself would deny artistic responsibility for some of 'his' films at times and reminded one interviewer that, 'when you're under contract you often have to do things you don't like … even a director has to live, he can't afford to be put on a layoff'.[7] In assessing the personal contribution to American culture of this film director, then, it is essential to know the nature of his involvement in a given

film. Documentary evidence helps in this respect. Although he was the director of twelve films in this period, unless he also wrote or supervised the script and controlled the editing it is unsafe to regard the films as necessarily reflecting Lang's personal views. There is a clear distinction between his personal works and his contract projects. In many cases, it is possible to know for certain exactly how much control Lang exercised over a given film – and this has influenced which films I have included in my assessment of his contribution to the culture of his time.

Fritz Lang believed that cinema was the most important art form of the twentieth century. It was the art of the masses and, he argued, 'this is a century during which the masses are coming into their own'.[8] The importance of cinema, therefore, lay in its ability to address the vital issues of the day. For young people in America, 'faced with the most pressing problems of life', Lang wanted to provide films that dealt with their questions.[9] If cinema was the 'means of conveying social messages', then Lang would use it to depict 'people of today and the things that interest them or imprison them'.[10] He was from Europe but, he proclaimed, his themes were resolutely American: 'about America, American people and American problems'.[11] Lang consistently argued for a more mature, and less celebratory, approach to American social issues. In 1939 he impressed on an interviewer the need for stories 'concerning the pertinent problems that trouble American people today'. He challenged the 'rigorous censorship', detecting signs of a desire on the part of audiences for 'profound and stimulating' movies.[12] This, Lang argued, was a change from what audiences had wanted in the more self-assured time of the early New Deal. Optimistic outcomes, individual dignity and personal happy endings had been real possibilities for Americans in that era.

Writing in 1948, Lang returned to the theme:

> [In] a world of greater material comforts, broadened human freedoms with greater emphasis on the worth of the individual, it is no wonder that people took delight in seeing and hearing over and over again the old fairy-tale assurance, 'and they lived happily ever after'.

Following the horrors of the war, and with the confusion of the immediate post-war upheavals in Europe, Asia and at home, American audiences now needed new solutions. The job of the film director was to discover 'the real cultural needs which lie behind the audience's demands', to be a film-maker 'responsible to our own time'.[13] This had two related consequences, in Lang's view, for American film. First, the system of censorship had to be modified so that American screens could show the reality of modern life. Lang questioned the notion that the governors – that is, the censorship authorities – were more mature than those they governed; he raised the issue of who guarded the guardians; and he placed the argument in the context of America's avowed commitment to freedom of expression. It was a direct challenge to the continuation of the Hays Code.

The second step required to respond to the changing times was, Lang argued, more searching social analysis by film-makers and a consequent reformulation of the happy

ending. He eloquently put the case for socially committed film-making in an article of 1947:

> [Crime, disease and poverty] originate in social and economic conditions; the idea that people are poor just because they are lazy or that they commit crimes simply through weakness of character is as outmoded as the doctrine of original sin from which it stems. The way to abolish crime is not to hush up its existence but to examine its sources and, having laid them bare, to eliminate them ... Let us look for motives, then, and in tracing them we shall throw light on the pressing problem of our time and society.[14]

On the happy ending, he suggested that sugar was no longer the right taste, but then neither was arsenic. Lang preferred 'affirmative resolutions', rooted in the reality of struggle, based on the 'ideals and ethical concepts' of modern, democratic audiences:

> I think we can all agree that when we deal with the largest life-and-death questions – war, fascism, depressions – as they affect millions, the audience does not want the traditional happy ending ... [They require] a happy ending achieved through thought and feeling rather than through miraculous events.[15]

The inevitable triumph of virtue had to be superseded by the triumph of virtue through struggle. Problems could still be solved, but 'the greater maturity [of today's audience is] expressed in the people's belief that the future does not come of itself – it must be achieved'.[16] Lang's response to the challenge of the 1940s was to try to develop further his early concern with social injustice and inequality of opportunity. He always preferred the context of realism to the American predisposition for idealism. For him, 'Films must draw strength from life, for only by modelling themselves on the ever-shifting patterns and conflicts of society can they continue to interest, to stimulate and, by dramatizing society's problems, to indicate solutions'.[17]

Fritz Lang's challenge to American idealism, 1936–1945
In his first three films in Hollywood in the 1930s, Lang did not participate in the construction of the new liberal consensus. Instead, he focused on the problems of the American Depression. Subsequently, in the 1940s, Lang was at the forefront of those who helped to articulate Hollywood's alienation from the decline of American liberalism. Taken together, Lang's major films from the New Deal era offer a scrutiny of America's apparent social, moral and political consensus that was scarcely attempted by his Hollywood colleagues. He tackled unconventional subjects, such as lynching, injustice, violence and sex, to expose the discord below Hollywood's celebratory idealism. He identified the underlying contradictions and social fissures in the United States. He refused to share in Hollywood's trumpeting of liberal capitalism. His roots lay in a tradition of political diversity and polemical conflict. Lang's relationship with the land which had given him refuge was complex. He expressed

his admiration for its values, but he also expressed his disappointment at the gap between American ideals and American reality.

The perils of democratic populism: *Fury*

In publicity material prepared for the release of his third film in Hollywood (in 1938), Lang professed his love for America. He claimed to see a nation of people 'who are well-fed, well-dressed; people who look forward to the future with hope … Do you see poverty, oppression, or fear? No, you see happiness, and hope'. As he continued 'waving the American flag', however, he reflected that his first two films – *Fury* (1936) and *You Only Live Once* (1937) – had dealt with the problem of crime in America.[18] This tension between the apparent blessings of American life and the reality of economic hardship and social injustice lay at the heart of Lang's reaction to living in America. His concern with social criticism began with his very first American film, *Fury*. *Fury* was an examination of mob violence and lynch law. Cinematically and thematically it stood apart from its Hollywood counterparts. It set out to portray the gulf between America's professed ideals of equality and justice, and the reality of discrimination and injustice. The story was simple. Joe Wilson, an ordinary, decent man trying to make a living, is mistakenly identified as a wanted criminal. He is arrested and thrown into a local jail in the town of Strand. A lynch mob burn down the jail, apparently murdering Joe. The mob are put on trial, and although they conspire to evade justice, filmic evidence proves their crime and they are condemned to death. But Joe has secretly survived, and in the final scene he dramatically enters the courtroom and stops the trial, saving the lives of those who would have killed him.

In the early scenes, Lang evokes the calm before the storm. Joe and his girlfriend Katherine discuss their long-term marriage plans as she leaves to earn money in distant California. Their quiet dreams are the dreams of ordinary American citizens. After she has gone, Joe argues with his two brothers about their consorting with petty criminals, telling them that the gangsters' days of triumph are over. Soon the three have bought themselves a garage and have begun to participate in a small way in the American dream. The attractions and benefits of an honest life, working to earn enough to live, marry and raise a family, are contrasted with the immoral but easy wages derived from crime. These are the stakes. In what follows, the film offers an unusual dissenting voice, a rare example of a New Deal film which questions whether American idealism was, in fact, an appropriate response to the Depression era.

Lang's exploration of this issue is conducted through two main channels: the straightforward theme of a man denied an opportunity to defend himself in law and the more complex consideration of what individual responsibility means in the world's largest democracy. The latter theme exercised Lang the most in the months when he grappled with the script. He wanted to address the conflict in American society between populist democracy and the rights of the individual. He sought to scrutinize the notion that in America the people were the repositories of freedom and equal rights. Could it not be just as true, Lang wanted to argue, that the people were the tyrants of ignorance, prejudice and oppression? Was not

Case Study 1 – 'Everything That Happens Must Be Strictly American': Fritz Lang and Hollywood Idealism

American democracy a fragile thing when it placed its trust in the people? Lang's idea was to portray the town of Strand almost as a separate character in the film. The community commits a crime and then collectively acts to hide the individual perpetrators. This theme is announced in a conversation between Joe and his brother Charlie. Criminals must fail, Joe asserts, because 'the people are against you now'. Charlie challenges Joe's naive faith in the people: 'the people ain't doin' so well', he retorts, a reference to the ravages of the Depression. Later, after his horrific experience at the hands of the Strand mob, Joe explains that he had tried to live honestly but 'they won't let you – the people'. His subscription to the ideals of American life has been destroyed by the realization that injustice and brutality are part of his country. As he says in his final speech to the court, 'a belief in justice – and an idea that men were civilized – and a feeling of pride that this country of mine was different from all others – burned to death within me that night'. Lang's first cinematic comment on American idealism was identifiably European. Beneath the rhetoric lay a society as flawed as any across the Atlantic – and Lang was prepared to say so.

To underpin his critique of populism, Lang took particular care to depict the bigotry and ignorance of the townsfolk in Strand and to chart the growth of the mob and the subsequent collective evasion of guilt. In one brilliant sequence, the gossip of Joe's arrest spreads. As the women of the town pass on the story with increasing embellishments, Lang intercuts a gaggle of geese; local dignitaries anticipating the favourable publicity if they have indeed apprehended a notorious criminal; and a local thug stirring up the ignorant people, supported by a strike-breaker passing through town. There is disdain for the legal process; a trial will not be necessary, people assert, because no one who was innocent would be arrested in their county. Finally, the frenzied mob sets forth and burns down the jail, with Joe Wilson trapped in his cell. The state governor, who fears to intervene in local affairs in an election year, blocks the desperate sheriff's appeal to the National Guard. Lang exposes populist democracy as the triumph of the basest instincts in people. Later, when the trial is being prepared of 22 townsfolk suspected of participation in the lynching, one woman reassures a frightened resident, 'it's a community, and not an individual, thing. So, everybody's gotta stick together'. At the trial the idealistic district attorney lambasts communities throughout America that refuse to identify lynchers. 'In God's eyes at least', he asserts, they are as guilty as the individual murderers. Much of the trial sequence is taken up with one Strand resident after another providing fake alibis for the accused or lying about their recollection of the night's events. The whole community engages in a conspiracy of silence. In these ways, Lang builds up the tension between every individual's responsibility for their actions within a society and the notion of democratic populism, in which freedoms and rights reside in the people.

Beyond this central moral issue is Lang's head-on confrontation with the topical problem of lynching in the United States. He gives the district attorney a speech in which he recites the figures: 6010 people lynched over the past 49 years, an average of one every three days, and only 765 ever brought to trial. Lang's victim in *Fury* is white – Hollywood would not risk the controversy of the historically accurate portrayal of a black man's murder. Nevertheless, he

alludes to the racial dimension indirectly, by showing a black woman singing in a courtyard to foreshadow the events of the lynching, and when the mob first sets out from a bar, a black man scampers out of their way in fear. Lang depicts the violence of the mob graphically. As the jail is set alight, he provides a montage of close-ups, the onlookers' faces distorted by camera angle and lighting into an ecstasy of hatred and bloodlust. A boy munches a hot dog unconcernedly; a mother holds up her baby for a better view; the mob leader slouches back with a satisfied grin. Later, in the trial itself, Lang uses newsreel footage to show the mob leaders in action, freeze-framing each of them in a posture of delirious excitement as they set the jail on fire and prevent the firemen from helping Joe Wilson.

The film's ending, although a source of controversy among critics, was typical of Lang's approach to personal morality. Joe, having in fact escaped death, is finally driven to halt the trial after he tries to celebrate the execution sentences of the 22 defendants. His evening out becomes a living nightmare in which he is haunted by responsibility for their deaths. In this section of the film, Lang prefigures his *Scarlet Street* (1945), in which Christopher Cross escapes legal punishment for murder, but has to endure a lifetime of remorse. Commentators at the time and since have denigrated the so-called 'happy ending', in which Joe frees the defendants by his appearance, confesses his hoax and embraces Katherine. Many have claimed that the ending resulted from producer interference. Although Lang later said he deplored the final kiss, he never attempted to evade responsibility for the film's denouement more generally. Indeed, Wilson's courtroom speech is uncompromising in its criticism of a society which allows mob rule to overturn the working of the law. Lang did not have to apologize for his ending: one quick kiss could not detract from the power of his sustained assault on the darker side of American democratic life.[19]

It is instructive to examine the creative process that resulted in *Fury*, because it provides a clear insight into Lang's intentions and his special concerns in making the film. It had begun life as an eight-page rough treatment by Norman Krasna called 'Mob Rule', which MGM sent to Joseph Breen of the PCA in August 1935. The censors welcomed this 'preachment against mob violence' and gave the project the green light.[20] The studio handed Krasna's story to Lang, who had been in America for a year and had yet to make a film. From late August to January 1936, Lang and his collaborators – Leonard Praskins, later replaced by Bartlett Cormack, and MGM producer Joseph Mankiewicz – worked up a screenplay from this bare outline.[21] Krasna's story provided the idea of an innocent man almost burned to death by a mob, who secretly returns and attempts to have 60 people executed who participated in the lynching. Lang departed from this story in two main respects. The first change related to Wilson's social class. Within a week of starting work on the script, Lang had an idea: 'Maybe the man should not be a lawyer. He should be very bewildered [and] puzzled while in jail … A clever attorney would never get in this kind of a situation. He would know what to do'.[22] The second change was that Lang rejected Krasna's ending. Originally, Joe, 'more insane than sane', was left alone at the end, 'old and piteous', nursing his hopes of revenge, while his wife and the district attorney rushed off together to halt the executions. Lang's film allowed Joe to recognize the self-destructive effects of his desire for revenge and to reform at the end.

Although this may appear a more optimistic and morally rigid outcome, it enabled Lang to bring Joe back into the courtroom in the final scene and make his passionate criticisms of American society. By coupling this with Joe's redemption, Lang retained Krasna's point that revenge was a flawed response to social violence, but gave far greater force to the indictment of a society that created lynch mobs.

As the screenplay evolved, Lang refined his main ideas for the film. Two aspects in particular were important to his conception of the story: the threat to American ideals posed by a society that permits lynch law and the danger of a democratic philosophy that placed its confidence in the rule of the people. To illustrate the first theme, Lang wished to portray Joe as an idealist whose faith in American values is shattered by his experience. In the film this is achieved by contrasting Joe's confidence in the American dream with his brothers' petty criminality, eventually showing that the former is unsustainable in a corrupt or unjust society. Lang's original idea had been to establish an opposition between Joe (still a lawyer at this stage) and his crooked partner, who defends gangsters like Al Capone. Joe is an idealist who believes that 'the law is to protect the innocent man – I don't feel it is to provide a loophole for the wealthy and cunning guilty'.[23] His crooked partner is a realist, practising law only for money and publicity. Lang's idea was to show the triumph of this cynic's values, so that Joe eventually comes to 'betray his ideals'.[24]

This clash of values evolved into the film's conflict between Joe's faith in American institutions and his brothers' involvement with crime. Lang had originally intended to highlight the effects of poverty and the Depression on the two brothers: 'Definitely show kids getting nasty and desperate because of circumstances not because they are naturally [sic] bad'.[25] Joe was to exercise a good influence over his younger brothers, trying to keep them on the path of honesty. He 'believes in the American ideals'.[26] Lang stressed this: 'Must build up character of man who believes in America … Man is down [i.e. poor] but he knows he will get a chance because "this is America" '.[27] The politics of the story were clear: still flirting with the idea of portraying the brothers as down-and-outs, Lang and Praskins invented a dog called 'Depression' or 'Breadline' and renamed 'Roosevelt' because 'he gave the boys an opportunity'.[28] Lang's ideas for the conflict between American ideals and American reality gradually took shape.

His other main theme was the issue of collective or individual responsibility. Initially, Lang was confused about his purpose. In the script conferences, as he groped his way towards the film's condemnation of American populist excesses, he conflated mob rule with 'collective' thought. At times, he appeared to see the conflict as one of socialism versus individualism. Lang could see that the mob was a collective unit, with no one person responsible for its actions, whereas 'each man alone is responsible for his deeds'. The mob, however, believed that, 'we are the law'. Then a thought struck Lang, indicating his continued confusion:

> This is it – [Joe] … believes that we, the people, are the law. The crowd is always right – the laws are a result of their collective thoughts. He hates criminals because they are individualists. This nation – the world, etc. – is the result of collective thought.[29]

Lang was preparing to criticize Joe's belief in 'government by the people, for the people and of the people' as collectivist dogma, seeming to misunderstand the American political system's commitment to the creed of individualism and egalitarianism.[30] It was misconceived for Lang to try to establish an opposition between the mob and individualism; the conflict he was seeking – and would find – was one between American democracy's faith in the people and the propensity of those people to act in base, violent and uncivilized ways if not properly regulated. The idea in American culture of the primacy of the individual was not at stake here. Later, with Spencer Tracy's casting now agreed, Lang was still mixing his philosophy:

> Tracy's idea – people are always right because there is more than one of them – more than one brain. The individual is wrong … Tracy does not stick to his philosophy because it is wrong. Isn't the man who says, 'the people are right', a sucker … A mob in action is never right and if Tracy believes that the mob is right this can only be when he talks theoretically. Mob force can only be toward destruction – never creation.[31]

Lang's wish to scrutinize American faith in the democratic will of the people was emerging, but he continued to conflate this with a renunciation of the individual. This betrayed his European political traditions. He saw the issue in terms of individualism versus collectivism, not populist tyranny versus liberal democracy. As Lang remained confused, Praskins developed his screenplay into a Capra-esque story of institutional goodwill and benevolence – a far cry from the searing critique that Lang would eventually produce.

Fortunately, Bartlett Cormack's arrival on the writing team in October 1935 rescued Lang from both these dilemmas. In his and Lang's first draft continuity, they introduce a scene (not in the film) in which Joe and Katherine attend a cinema and get into an argument about American values. An isolationist politician seen in a newsreel proclaims, 'our trust in the sense of fair-play and commonsense of the American People!' Joe applauds these sentiments, but a fellow member of the audience dryly objects that the people are sheep, while an elderly negro tells Joe, 'Brothah, you ought t' get around more!' Joe denounces them as 'aliens'.[32] Joe's faith in the people is now no longer contrasted with a belief in the individual; it is shown as a naive belief in slogans about the American people, expressly identified with the right-wing isolationists. He will come to learn that the American people are not the repositories of freedom, justice and equality. This proposed scene provides evidence that Lang, with assistance, had found his target at last. Joe Wilson would now pass from a simplistic faith in American democracy to a bitter understanding of the prejudice, intolerance and hatred that masqueraded as Americanism. As the *New York Times* reviewer would put it, *Fury* contained 'a searing commentary upon a national disregard for the due processes of law and order that finds flower in such organizations as Detroit's Black Legion and kindred "100 per cent American" societies'.[33] Thus Lang's strategy for his first American film evolved. It was, of course, also to be an indictment of lynching, 'to prove to [the audience] that lynching is wrong', that '[a] mob never has a responsibility and for this reason a mob can not judge, condemn and destroy the accused – can not take life'.[34] Lang knew that the story was, in

parts, implausible and that it was melodramatic – yet 'we are trying to make it credible', he explained. Was not melodrama, he asked rhetorically, simply 'drama brought to its highest point of hysteria'?[35] The script was completed by January 1936, although revisions followed over the ensuing three months.[36]

On its release in May, MGM virtually disowned the 'arty' film, but the critics hailed it as something quite novel in American cinema.[37] It was controversial but important, dealing 'with a social problem that in many sections of this country is continually recurrent and thereby is a subject of topical interest … its moral is a terrific indictment of the injustice and inhumanity of mob rule'.[38] Its attraction stemmed from its difference from standard American films: 'It should appeal mightily to those of you who look to Hollywood – forlornly most of the time – for something better than superficial, dream-world romance', wrote one; 'this is a film that will haunt your dreams for many a night and make the ordinary Hollywood thing seem tamer than a vacation postcard', wrote another.[39] 'Hollywood rarely bothers with themes bearing any relation to significant aspects of contemporary life. When it does, in most cases, its approach is timid, uncertain or misdirected. *Fury* is direct, forthright and vehement.'[40] Amidst the almost universal praise for this unique contribution to American popular culture, *Variety* observed that, 'it seems curious that an Austrian director should so faithfully capture the nuances that are so inherently American and attuned to the native mentality'.[41] During the scriptwriting, producer Mankiewicz had observed that: 'everything that happens in this picture must be strictly American'.[42] Lang had spared little in his first effort to confront American audiences with the truth behind the facade of American ideals.

The rehabilitation of offenders: *You Only Live Once*

Lang's second American film developed the themes from *Fury* further. *You Only Live Once* (1937) began as a story, 'Three Times Loser', bought in March 1936 by independent producer Walter Wanger from its authors, Gene Towne and Graham Baker.[43] They were then engaged as scriptwriters and by mid-August had worked up a rough first draft which could be shown to the PCA.[44] A generally favourable response from that office led to a full screenplay being produced in September, along with a title change to *You Only Live Once*.[45] Revisions to the script were made in early October and shooting lasted until the end of the year. Fifteen days of retakes were necessary at the start of 1937, and the film was previewed on 15 and 16 January. On its release later that month, Lang, with characteristic excess, had brought his film in over two weeks behind schedule and around $90,000 over budget.[46] Press reviews were variable, praising the film for its power but appearing confused by its unrelenting misery and downbeat resolution.[47] Once again, Lang had produced a film that criticized American society with uncompromising candour and exposed the idealism of American values as rhetoric unmatched by social conduct. If anything, *You Only Live Once* was more powerful in its critique than *Fury*. That its critical reception was not so smooth lay in its refusal to accommodate American sensibilities, even to the small but significant degree that *Fury* had.

You Only Live Once was a film without the sentiment and optimism characteristic of Hollywood productions at this time. It charted the systematic destruction of the hopes of a petty crook, Eddie Taylor, who tries to go straight and rejoin American society. Lang's emphasis was on the society that had created Eddie Taylor, not on the moral issues surrounding Eddie's own past conduct. American values stressed equality, fairness and justice, and invited all comers to participate in the opportunities of the American capitalist dream. Yet, Lang argued, when a reformed criminal tries to realize the humble aspirations of a home, a job and a marriage, the intolerance of American society thwarts him. In this discrimination, the social conditions that have led Eddie astray are reproduced, driving him back to crime; thereby, society creates and perpetuates its own enemy. If the values that America cherished were to be preserved, then justice and tolerance would have to be transformed from mere slogans into practical, everyday effect. The opposition between American ideals and the reality of American life is carried over from *Fury*. When we first see Eddie Taylor being released from prison, he tells the governor that he will go straight – 'if they let me'. The governor complacently assures Eddie, 'that's up to you', but Lang shows that the responsibility rests with the people, not with the ex-convict. As Eddie leaves, he tells Father Dolan, a liberal priest, 'they're not all like you on the outside – if they were, these [prisons] would be like haunted houses'. Succinctly, Lang states his case: crime, criminals and prisons are the result not of individual moral failings but of social conditions and attitudes. Dolan's liberalism and commitment to social welfare and reform are the keys to solving crime, but his views are not reproduced in society at large.

Father Dolan later tells the prison governor that all human beings are born kings but the world stains them and makes them what they are. After Eddie is wrongfully convicted of robbery and sentenced to death, he kills Father Dolan while escaping from prison. He tells his wife, Joan, 'they made me a murderer'. Lang carefully catalogues the forces that conspire to create Eddie's tragedy. He begins with a pair of mean-minded hoteliers – representatives of small-town American bigotry – who run a lodging where Eddie and Joan wish to stay as they start their honeymoon. The husband reads a detective magazine which labels Taylor as one of the 'Desperados soon to be pardoned', under the heading, 'Public Beware!' He demands that the honeymooners leave their hotel. Lang next introduces Eddie's boss at the truck company. When Eddie is late with a consignment, because he has been showing Joan their new house, he is unceremoniously fired. He is given no opportunity to explain himself. When he goes to see the boss to beg for a second chance, the latter is unmoved, calling Eddie 'jailbird'. He talks idly on the telephone to his wife about the arrangements for that night's supper and bridge party, stressing the ordinary domestic life from which Eddie is now to be excluded. Without a job or the prospect of getting another – the boss will not give him a reference – Taylor is unable to participate in American life. He cannot make the first payment on the house. He has been encouraged to believe in the principles of fairness underpinning American capitalist life. Denied the opportunity to participate, he is forced to seek desperate remedies. Lang argues that Eddie cannot be held responsible for his actions: society has made him what he is.

In fact, Eddie commits no crime, but his fate is nevertheless sealed within the circle of discrimination. He is arrested because he is a known criminal whose hat has been found at the scene of a bank robbery (left there deliberately by the real culprit). After the death sentence, his lawyer explains that he was convicted 'purely on his record'. The circle is closed; determined to believe in the impossibility of a criminal reforming, American society has succeeded in fulfilling its own prophecy. Lang reinforces his theme by turning the Taylors' life on the run into a parody of domestic tranquillity. Eddie and Joan live in a car, with the windows broken out and replaced by curtains; they 'shop' by raiding stores and stealing food. The Taylors' alienation is completed by a daring scene in which Joan successfully gives birth to a baby in a shack, alone with Eddie. The scene is utterly devoid of the celebrations and optimism normally attendant at such moments in Hollywood cinema. The baby has no name – a symbol of the universal child in whom, somehow, the spirit of human perseverance endures in the face of overwhelming odds. The final scene makes no concession to the audience, offers no relief from pessimistic fatalism. With Joan dying in his arms, Eddie thanks her for her love and support. He offers his regrets that they could not make it to the security of a home and a normal married life. The ghost of Father Dolan appears, calling Eddie to eternity, echoing an earlier scene at the prison gates. The priest had tried to tell Eddie that he did not need to flee, that he was a pardoned man: 'you're free – the gates are open'. Now those words are repeated, signifying that only in death can Eddie at last find freedom. The transcendental ending reinforces the sense of despair. It does not undermine the film's gloomy assessment of the prospects for social redemption.

The drive to indict American society, rather than the criminals, is reinforced by the character of Joan. She is a liberal, a supporter of the underdog, a woman whose love for convict Eddie Taylor flies in the face of her sister's advice. Her values are tested in the film, and her belief in her country is proved to be misplaced. When Eddie plans to go on the run, convinced he will not get a fair trial as an ex-convict, it is Joan who persuades him to give himself up. His conviction and death sentence prove beyond doubt that the institutions of American democracy do not match the values and ideals of American rhetoric. In the process of Joan's profound disillusionment, she herself becomes a criminal and dies. Her idealism is utterly polluted and destroyed, leaving her love for Eddie as the only enduring value of hope. Their anonymous baby has an uneasy legacy at best.

The script for *You Only Live Once* already existed when Lang was hired, and his personal contribution to the story is therefore not as well documented as it is for *Fury*. But we know that he began to influence the project as soon as he arrived.[48] As the script evolved, it was probably Lang who steered it away from conventional Hollywood moralizing. He eliminated the depiction of Joan's sister as a failed career woman and reduced the romance between Joan and Whitney, the public defender, so as not to detract from Joan's love for Eddie. Eddie's initial appearance as a surly, arrogant inmate who refuses to shake the governor's hand was also altered to make him a more sympathetic character. The most important change from the early script, however, was the ending. Originally, Eddie was to offer a negative assessment of his worth, telling Joan, 'kid – I wasn't worth it!' Later, this was changed to provide a

greater sense of affirmation between the couple, with Eddie's last line being, 'kid – we made it – together'.[49] The eventual ending, as filmed, bestowed on the pair an endorsement of their tragedy. The mystical summons to eternal life offered a jaded commentary on the hopelessness of their lives in the material world.

The unrelenting doom of the film gave it an undoubted power, but also made it too confrontational for American critics. Some might refer to it as 'drama the like of which has seldom been seen on the screen', but had to acknowledge with mixed feelings its 'grimly bitter imaginative realism stretched to the last degree'.[50] For one reviewer, a 'tragic melodrama of crime-hounded lives' could not offer entertainment to audiences.[51] One reviewer summed up the difficulty of finding an audience for it in Depression-torn America: 'To those who enjoy having their emotions wracked with the sufferings of a man in the toils of a merciless fate the picture will have deeply moving appeal'.[52] The ending was not within the accepted confines of Hollywood drama, and reviewers found it hard to cope with the film's refusal to offer hope in this world. It was 'a logical, if not conventional conclusion', wrote one.[53] For another, the film deserted that optimism which American culture almost demanded: having 'sacrificed ... a normal termination, with society rendering assistance to a man who wants help ... [the film is] too depressing, too heavy modern tragedy'.[54] Walter Wanger, the film's producer (later to form a production company in partnership with Lang) had good cause to worry. Writing in his diary after the first preview, he appeared to refer to Lang's European artistic proclivities as the cause of the problem, although the 2nd word in the entry is not easy to decipher 'Bad German [?] direction slows up picture. Very depressed about possible success'.[55]

Lang's message that society creates its own criminals was also unpalatable for many Americans. Although the Hays Office had read the script 'with considerable pleasure', a New York censor found the film

> a pretty doubtful picture ... The sympathy throughout the picture is with the criminal and against the law ... and while in the end the criminal is overtaken by the law the audience is all the while 'pulling' for the law to be defeated.[56]

A New York reviewer agreed on the power of the picture, although he was more sympathetic to the underlying political philosophy, writing that,

> It considers the manner in which society virtually refuses to permit offenders against it to become rehabilitated ... Much of it has sociological meaning [and] will shock and move you and make you aware that our handling of criminals is far from perfect'.[57]

A fellow New Yorker refused to accept the film's message, arguing that the couple were not victims but instead were culpable: 'the roots of their tragedy are within themselves ... The picture tries vagrantly to blame society for their tragedy, but its arguments are none too convincing'.[58] Another reviewer lamented the moral of the film, presenting the Taylors as

the victims of a cruel and merciless society, which, the picture implies, sees no good in a man once jailed, gives him no chance to win back his respectability. Thus, the film is a sharp indictment, which almost inevitably should lead to controversy.[59]

It did: it was banned in Quebec, Australia, Austria, Sweden, Norway, Singapore, Brazil, Czechoslovakia, Hungary, Italy (temporarily), Jamaica, Trinidad and Palestine. In the United States, its only censorship difficulties seem to have resulted in minor cuts in New York – the moral regulation of American cinema was not necessarily a politically conservative phenomenon.[60] Lang had for the second time produced a powerful critique of the forces of injustice, discrimination and inequality that lay beneath the consensus of American life. It was a consensus scarcely challenged elsewhere in Hollywood.

'No director can serve two styles at once': *You and Me*
Lang's third American film, *You and Me* (1938), seems at first sight to be a natural development from his first two Hollywood projects. It concerns two paroled criminals seeking the benevolence of American capitalism in order to reform, marry and raise a family. Their crimes are seen to be inextricably bound up with the materialist society that has formed them. There is an implicit suggestion that the American market economy is different from organized crime only in that the former is legal. Yet the film failed to realize its potential social criticism, largely because Lang buried it in a hackneyed love story. Moreover, unlike his previous two efforts, Lang allowed his two protagonists to find social welfare, justice and happiness. On one level the film succeeds quite spectacularly: Lang engaged Kurt Weill to write the music for the film and then provided stunning images to complement Weill's provocative rendition of two or three prose–poem songs. Unfortunately, this stylistic experiment sat so uneasily with the rest of the film that its impact was vitiated; indeed, the sequences baffled polite reviewers and irritated others.

The idea for *You and Me* came, as had the idea for *Fury*, from Norman Krasna, whose script was sent by Paramount to the PCA in August 1936.[61] It was primarily a romance about a girl, Helen, with a criminal record who gets pregnant and marries her boyfriend, Joe. The drama revolves around whether her boyfriend will stay with her once he discovers her record. The comedy stems from a race between Helen and Joe, and their friends Dave and Flo, to see who can get pregnant first. The story also allows an ambiguity about whether Helen was married when she became pregnant. The story and structure of Krasna's script are reasonably close to the film that Lang would make almost two years later.[62] The PCA objected to the 'comedy and suggestiveness concerning the sacred intimacies of life' and forecast 'ruinous slashing' at the hands of local censor boards should the film go ahead as scripted.[63] It did not. A revised version, prepared under the auspices of independent producer B. P. Schulberg, was submitted by Paramount in January 1937, but nothing came of that either.[64]

In May 1937 Fritz Lang and Paramount screenwriter Virginia van Upp began to collaborate on their version. Lang produced and directed *You and Me*, and the archives

reveal his close involvement in writing the screenplay.[65] Although he was later to say that he regretted making the film, he never tried to disown it.[66] He and van Upp both produced short outlines, and Lang was dictating new ideas on a daily basis. Van Upp was then charged with combining their material into a 78-page outline to show to William Le Baron, one of Paramount's senior executives.[67] His response was favourable, and the writers began the screenplay, while Lang simultaneously liaised with Weill in New York about the lyrics and music for the film.[68] The writing did not proceed without incident. Lang was under pressure from Paramount to turn out an early script and start production by July, because his female lead, Sylvia Sidney, increasingly disillusioned with Hollywood, was planning a return to the stage in September. Kurt Weill told Lang that she did not have the ability for stage acting – 'but what can you do with people who don't see their limits?'[69] Lang protested against the September deadline, particularly as van Upp was too slow for his liking, but to no avail – Sidney was released as agreed. In the event, Lang managed to persuade Paramount to delay the production to accommodate the actress's absence, rather than rush to secure a script before her departure. His attempts to engage a new screenwriter, however, failed when his erstwhile colleague Walter Wanger 'was very curt' in refusing to loan him Irving Shaw. Clifford Odets was another choice, but he was unavailable.[70]

As a compromise, Jack Moffitt was assigned to assist Lang, and for the next few days both men and van Upp worked actively on the script. Lang's controlling influence was evident: '[van Upp] wanted to do a scene a certain way – but FL saw that it was not right and told her not to do it that way – but another way'.[71]

By August the team had a finished script and began the process of adding camera directions and other details to turn it into a shooting script.[72] Le Baron approved the script with enthusiasm, although he called for a reduction in the overall length and made some helpful suggestions, with which Lang concurred. Adolph Zukor, head of Paramount, was not so impressed and registered his disapproval of the script – an early portent of the difficulties the film would encounter when the critics got to see it.[73] For the rest of the summer, Lang worked on another project – a panorama of twentieth-century American history, conceived for Katherine Cornell but never realized.[74] By late September Lang was back in harness on *You and Me*, writing to Weill that the first draft had been finished 'some weeks ago' but that, as Le Baron had judged, it was 50 pages too long and needed ten days more work on it.[75] In November, with Sylvia Sidney soon to be free of her stage commitment, a start date of January 1938 was set.[76] The following month Paramount sent the screenplay to the PCA, and it was approved with only minor amendments.[77]

The air of uncertainty which had lain over the scriptwriting process continued into the New Year, however. Lang, establishing a pattern of behaviour which would so compromise his success in Hollywood, ordered nearly 30 pages of rewrites, even while shooting was in progress.[78] Moreover, Jack Moffitt was aggrieved to learn that he was to receive no screen credit for his two months' work over the summer. Believing that, 'there is scarcely a page of [the final script] on which I did not assist and work', he sought arbitration before the Screen Playwrights' Body.[79] Lang insisted that Moffitt had provided nothing creative but

had simply written up the director's ideas, which anyway had subsequently been rewritten by Lang.[80] Apart from two scenes and some linking dialogue which Lang credited to Krasna, the script was his (although he took no screen credit) and Virginia van Upp's.[81] Moffitt must have lost his case, for he received no credit in the final print. The film was previewed in May 1938. Weill, having been sure that Lang would 'get what we were talking about when I first met you in Hollywood: a Lang picture with a light touch', had lost none of his confidence by the time of the preview. He wired Lang, 'I am grateful and proud to be connected with your beautiful work of art'. He was less complimentary behind Lang's back, writing that the director 'made you want to puke' and was 'hated everywhere'.[82]

The film opened in June to very mixed reviews. *You and Me* focused on three main themes. The first was that, to an extent, crime was endemic to capitalist society because capitalism itself was theft. The second was that the way to deal with criminals was to offer them opportunities to participate in American life, with the idea that social benevolence would lead to personal reform. The third was that the love of a woman, marriage and a child would overcome a man's problems. The last of these themes did not complement the first two. In *Fury*, Lang had subordinated the romantic element to his indictment of American bigotry. In *You Only Live Once*, the romantic story brilliantly – and unconventionally – underpinned the social criticism. In *You and Me*, however, it undermined the social critique without offering any compensating narrative or thematic purpose. To add to his difficulties, Lang had woven into the film two formal experiments with light and sound, which inexplicably departed from the otherwise 'naturalistic' style. The result was an unsatisfying mixture of social analysis, conventional romance, realistic setting and artistic experimentation. Critics could not decipher it, and the general public was unlikely to try.

You and Me is set in a department store where the employees are ex-criminals, hired by the benevolent owner, Mr Morris. The film opens with a striking montage of the lure of capitalism – cash registers, jewellery, furs, silks, silverware, cars, wines and foodstuffs, even encompassing those things normally seen as beyond the reach of money – beauty and knowledge. This is accompanied by Weill's music and a spoken song, intoning: 'You cannot get something for nothing / and only a chump would try it / whatever you see you can have / provided you buy it'.

From here, Lang tried to develop the idea that all capitalism is legalized theft. The store's population of ex-crooks alludes to this theme. Lang comically shows the salesmen employing their criminal techniques to sell the goods. One intimidates a child into buying a rocker. Another demonstrates the use of a tin-opener in safe-cracking fashion, while Joe menacingly talks of the 'rackets' he knows, the camera tracking back to reveal a tennis racket in his hand. But this theme is inadequately developed, because Lang concentrates on the hackneyed love story. Accordingly, when Helen lectures the fraternity of crooks about the economics of crime, the sequence lacks impact and even feels out of place. In fact, Helen explicitly links organized crime and capitalism, drawing parallels between the bosses, the wages and the profits in each. Crime, she demonstrates, is poor economics, quite apart from the social opprobrium, personal immorality and risk of prison. The crooks, who take

the risks, profit the least. Yet Lang's potentially radical theme was vitiated by his failure to examine the causes of crime or to consider the social circumstances giving rise to crime, as he had so impressively done in his previous two Hollywood films. As Gavin Lambert observes, the social explanation for crime apparent in the first two films was replaced by a private motivation: Joe reoffends because his wife lied to him about her past.[83] This shifts the emphasis away from any sociological purport towards a trite romantic plot.

Similarly, the inclusion of the liberal store-owner, Morris, introduces an element new to Lang's American films – a conventional American liberal hero who protects the weak and underprivileged from social injustice. He tells his illiberal wife that, contrary to her belief that some are born crooked, criminals can be helped. Furthermore, he rejects mere charity donations; he believes in practical action, offering men and women opportunities for employment and rehabilitation. When he apprehends the ungrateful robbers who try to steal from his store, he lets them off with a warning (and Helen's lecture), rather than waste taxpayers' money, and their lives, in jail sentences. This type of character belonged in a Frank Capra film and complemented the optimistic New Deal liberalism espoused by many Hollywood films. Lang had not previously chosen to follow that typically American route. The Morris character served to undermine any dissenting commentary in the film.

The one successful attempt to engage in social analysis came from the Weill collaboration. In the film's most powerful sequence, a group of ex-convicts gather together in a cellar on Christmas Eve and remember their days behind bars, when they treasured small luxuries and dreamed of freedom. The dark cellar serves as the base for an imaginative leap into a world of long prison corridors. Dark areas are scoured by shafts of strong light, as Big Shot No. 1 arrives to serve a five-year sentence, screaming hysterically, 'I gotta get out!' Lang lights the reminiscing convicts' faces with the impression of the bars of the cellar, distorting their expressions with shadows and framing them in extreme close-up to emphasize the agony of their memories. All the while they chant methodically, seeming to conjure up the evocation, as a medium might at a seance. The viewer is left with a powerful vision of the horror of the prison world and the devastating effect it has on those whose lives it touches. Yet the sequence was criticized by reviewers, precisely because it jarred with the film's inane, but dominant, love story. A number of critics drew attention to the unfortunate combination of 'a mobster yarn written along the lines of romantic interest rather than that of gangland doings', believing that the film fell between two stools, and that it emerged as a confused mishmash.[84] Lang had 'attempted to combine boy-meets-girl and the Greek chorus with rather curious results'; a good gangster film had been spoiled by pretentious artiness; the film would

> puzzle audiences and earn the distinction of being one of the screwiest productions of the year ... [I]n telling the story in a style somewhere between futuristic and cubist, Fritz Lang overreaches himself and goes over the heads of the average audience.[85]

Reviewers found other inspirations for the film's confused stylistic experimentation. Some believed it was 'a sort of cinematic Mercury Theater, by way of Marc Blitzstein-Orson Welles,

with European flavoring, also'; it had been influenced by Welles' *Julius Caesar* and the Living Newspaper stage production but, 'No director can serve two styles at once. *You and Me* is torn both ways and emerges, in consequence, as a ragged drama with comic overtones.' The 'net effect … is remarkably bad'.[86] Many criticized Lang for this lapse, ranging from the observation that it was 'rather milder than Mr Lang's first American films',[87] to a conviction, shared by a few, that it must have been the writers' fault: 'Fritz Lang … should never have wasted his directorial talents on so maladroit a script'.[88] They did not know, of course, that the maladroit script was largely Lang's own work – and he certainly did not rush to take the credit. The *Hollywood Reporter* understood the problem better: what Lang needed was 'a practical production mind to hold him in check'.[89] The reviewers' disappointment at Lang's failure is instructive, suggesting that Lang was now *expected* to provide novel insights into contemporary American life. The poor reception of *You and Me* put Lang into the wilderness for over a year. Although he was eventually rescued by a contract with Twentieth Century-Fox, the film studio would permit him no creative autonomy.[90] *Variety* captured Lang's position in its characteristically succinct manner: Lang was now noted for being 'more novel in his production treatment than in b[ox] o[ffice]'.[91]

The decline of American idealism: *Scarlet Street*

Seven years passed after the debacle of *You and Me* before Lang once again produced another major work of American social commentary. The film was *Scarlet Street* (1945), a tale of a middle-aged man, Christopher Cross, who discovers the devastating consequences of his delusory idealism. Trapped in a loveless and constraining marriage, Cross dreams of becoming a painter on retirement from his office job. Simultaneously, he falls for a prostitute, Kitty. She and her pimp, Johnny, exploit Cross by secretly selling his paintings and stealing the money. When Cross leaves his wife and discovers Kitty's betrayal, he murders her. Johnny is executed for the crime, and Cross lives on, haunted by his actions, a broken man.

For *Scarlet Street*, Lang worked for his own production company and had a high measure of autonomy. He crafted a work which remains one of the best achievements of his Hollywood period. Its bleak atmosphere, the absence of any positive characters and the downbeat ending create a powerful allegory of American social change in the 1940s. Many Hollywood films had, in the 1930s, depicted American ideals as integral to the fabric of American life. Lang had challenged this notion in his first three American films. He continued the theme in *Scarlet Street,* showing idealism as nothing more than dangerous self-deception. When the central character, Christopher Cross, paints an ordinary, drooping flower in his house, he depicts it as vibrant and bursting with colour and energy. His friend views the result with amazement, struck by the contrast between the objective reality of the flower and Cross's subjective distortion of the truth, his idealization of the mundane. Later, in discussing his painting, Cross declares, ambiguously, 'that's one thing I never could master – perspective'. The film charts the gradual disintegration of Cross, as he slowly realizes that his naive idealism has been nothing but a fantasy. Lang may have intended Cross's story to serve as a

parable for the decline of American idealism in the 1940s. Very few Hollywood films took such an uncompromising line.

Lang had quite self-consciously set out to make a new type of film. Shortly before the release of *Scarlet Street*, Lang offered his thoughts on post-war American cinema. He observed that newsreels of the war had made the American public aware of the possibilities for realism in cinema, and he complained about the difficulties of making realistic films. He could not show illegitimate births, discuss what he claimed was a 70 per cent divorce rate, examine sexual desires properly, use realistic language, and so on. Yet, he concluded, he was determined to depict real-life problems and real characters in his films.[92] *Scarlet Street* provides convincing evidence of this determination. The source of the film was a novel by Georges de la Fouchardiere, *La Chienne/The Bitch*, translated into English for the American market as *Poor Sap*.[93] Lang misleadingly claimed on the eve of the film's release that numerous previous efforts to film the work had failed to conform to the PCA's 'purity standards'.[94] The archival evidence, however, shows that previous film-makers had in fact met with support from Breen on this subject, but the difficulties surrounding such a controversial story had proved overwhelming. (One of those who had considered the story was none other than Lubitsch, in 1935, with a mouth-watering cast of Charles Laughton, Marlene Dietrich and George Raft.[95]) The heady material, involving prostitution, murder, wrongful execution and sexual exploitation, obviously posed many problems for a screen version. The 1930s was certainly not the decade for moral complexity, nor for graphic depictions of sexual sordidness. Although Lang's decision to film the story made him something of a pioneer of 1940s pessimistic realism, he was, of course, tackling the subject at a more propitious time than his predecessors.

In March 1945 Fritz Lang signed contracts with the independent producer Walter Wanger and his actress-wife Joan Bennett to form Diana Productions Incorporated, releasing films through Universal Studios. Later contracts specified that their first production was to be *Scarlet Street*, and that Lang was 'to control on matters of artistic nature; Wanger to control on financial matters, and matters involving a substantial increase in costs'.[96] Later that month Lang was writing his outline for the story, tentatively entitled 'Pomander Walk'. He had visited Sing Sing 'to see what he is required to see' in conditions of some secrecy (presumably this was preparation for the execution sequence – later cut, as with *Double Indemnity*).[97] Although his outline was never finished, because Lang turned to writing the full screenplay, its faithful adaptation of the novel's opening sequence was retained in the eventual film.[98]

Lang's ideas were remarkably well formed, even at the early stage of drawing up this outline. He was already clear that the central conflict would be between Christopher Cross's real life – as a time-serving cashier married to a harridan wife – and his fantasy life – as a professional painter in love with a much younger woman. He also already knew that Edward G. Robinson would play the part. Lang wrote in the outline: 'Robinson's pretence that he is an artist provides one of the basic elements of the whole plot'.[99] Lang intended to develop the sexual theme in the film and to emphasize Robinson's lack of masculinity. He was to be

Case Study 1 – 'Everything That Happens Must Be Strictly American': Fritz Lang and Hollywood Idealism

'tied to his wife's apron strings'; he would be shown staring in a shop window at the 'scantily clad mannequins', until the window dressers shut out his fantasies by drawing the curtain on him.[100] At home his wife would give him

> some humiliating household chore ... a list of groceries and other things that he has to order on his way to the office – and he has to repeat the order like a schoolboy – and pick up on his way home. And she expects that he will be on time!![101]

Lang was even 'fooling around' with the extra humiliation of Chris being forced to paint 'in the toilet on the johnny, having his canvass tacked to the door in front of him. But I don't know ...'[102]

By the end of March 1945, Lang and Wanger were negotiating with screenwriter Dudley Nichols to secure his services, even if it was only to brush up Lang's work.[103] Nichols read the novel, talked with Lang, and by the end of April had bought shares in Diana and signed on as screenwriter.[104] Lang later claimed that he 'purposely never looked at' Jean Renoir's film version of the novel, *La Chienne* (Renoir, 1931), in order 'to be absolutely uninfluenced by it'. The records, however, show a different story. Wanger strove hard to get a print from France, before finally obtaining a copy from the British Film Institute in London in late July.[105] But by then Nichols and Lang had finished their screenplay, and two days later shooting commenced. Lang was closely involved in writing and revising the screenplay, a process that continued right up to the start of photography. Wanger's tense relationship with the director was evident from the start of production, referring sarcastically to Lang as 'the genius' in private correspondence.[106] Neither did shooting proceed smoothly. Lang fell five days behind schedule, losing the use of a street set at Paramount as an expensive consequence. When he completed filming in October, the final cost was $82,500 over budget. Lang spent a further ten weeks cutting the film, which was finally previewed on the West Coast in late December 1945.[107]

On its release, *Scarlet Street* proved to be a controversial film. It was briefly banned in New York. The ban on the film in Atlanta sparked a major lawsuit between the State censor board and Universal Studios.[108] The picture was suitably dark and pessimistic for the post-war spirit pervading American life. It transcended Hollywood conventions through its moral complexity, distributing guilt and punishment to all three of the central characters in more or less equal measure. Gone was the Langian hero, overwhelmed by social forces beyond his control, a tragic victim of remorseless fate.[109] Yet Lang did not adopt the Hollywood model of a hero who controls events and overcomes his problems. Instead, he confronted his audience with the responsibility of individuals for their own failures. A New York reviewer asserted that: 'It is in its honesty that the film seems European. Few Hollywood productions have the courage to avoid the sentimental so completely as this grim and beautifully acted drama of sordid people'.[110]

Kitty is, at one level, a standard Hollywood femme fatale exploiting an unwary man. But Lang added subtleties to his story not found in most Hollywood products. Not only is Cross

a willing, rather than unwary, victim, but Kitty is exploited herself. Abused by Johnny, she too accepts her status as 'victim', refusing to leave him in spite of her room-mate's advice. When she remarks, 'if I had any sense, I'd walk out on you', Johnny slaps her and replies, 'but you haven't *got* any sense'. Although the driving force behind the exploitation of Chris is Johnny, never once does Kitty express remorse, suffer guilt or feel shame. She will stoop to anything to preserve her indolent lifestyle. Her pimp is more intelligent but equally amoral. Interestingly, the PCA objections to Kitty and Johnny being shown clearly as a whore and a pimp seem to have been wholly ignored by Lang.[111]

The critique of Cross centres around his weakness, presented as a lack of masculinity. In an exchange with his wife, we learn of his sexual repression and timidity: 'next thing,' his wife says, 'you'll be painting women without any clothes'. Cross indignantly replies, 'I never saw a woman without any clothes' ('I should think not!' cries Mrs Cross). Cross is not allowed to invite a friend around for Sunday afternoon – he has to pretend to his wife that it is an impromptu visit. He has to wear a frilly apron and do the dishes; he is not allowed to smoke; he is not allowed to paint in the house. His wife contrasts him with her first husband, a stereotypical man, muscular and powerful. Similarly, Kitty later compares him to Johnny, laughingly telling him that he would be no match for 'a real man' like her pimp. Harried by his wife at home, and grovelling to Kitty in the studio he has rented for her, Cross is a figure of contempt, not pity. As one reviewer commented, Cross does not inspire sympathy: 'he gets, and deserves, none'.[112]

When Chris's boss discovers he has stolen from the firm and asks him, 'you did it for a woman?', it carries a different resonance from Walter Neff's statement in *Double Indemnity* (Wilder, 1944) – 'I killed him for money – and for a woman'. In the latter, Neff inspires sympathy – a man who strayed off the path, regretted it and then destroyed the source of the evil – a woman. Cross in *Scarlet Street*, however, is the architect of his own misfortunes, a man whose pursuit of his sexual fantasies is ludicrous and contemptible. Lang was fond in his later life of telling interviewers that all of his films were about man's struggle against destiny or fate.[113] But from around 1943, as discussed above, Lang moved towards a belief that individuals determined their own fate. At first, he saw no conflict between classical tragedy and individual responsibility. In publicity notes prepared for the film in 1945, he compared *Scarlet Street* to 'the old Greek tragedy that everybody is responsible for his fate'.[114] He summarized the weaknesses of each of his central characters. The old man has not the courage to stand up to his father and become a painter (this is hardly alluded to in the film, but formed part of Lang's original conception of the characters). Neither has he the courage to stand up to his wife, nor to stand up to the girl. The boy deliberately uses the girl to exploit the man. She knows she is doing wrong, but does so for the boy; and so on. So, Lang concludes, 'all three people are guilty of something. Like a Greek tragedy'.[115] For him, this was a moral for his time: 'Everybody wants to sleep with a girl – everybody wants to eat – everybody wants to have a lot of money'. And, 'the truth probably is that in each of us there is a good deal of the way [Johnny] conducts himself and a small part of the way [Cross] conducts himself'. Finally, in this same note, Lang explained further how he

Case Study 1 – 'Everything That Happens Must Be Strictly American': Fritz Lang and Hollywood Idealism

expected audiences to identify with the human flaws in his characters: 'Every man will feel that Eddie Robinson is a sap when he puts on an apron and washes dishes because every one [*sic*] was in a situation where he had to wash dishes and he didn't like it'.[116]

By 1948 Lang's views had changed. Now he saw a distinction between classical tragedy – which depicted men as helpless, trapped by fate and at the mercy of more powerful forces – and his own films. Today, Lang argued, men held sway over nature. Pessimistic determinism would constitute 'a triumph of evil and a waste of human life **for** nothing and **because** of nothing' (original emphasis).[117] In *Scarlet Street*, he wrote, he had made the 'unstated affirmation that evil in its many forms – the evil of crime, of weakness, of deceit – must reap some sort of physical or mental punishment, and not punishment by Fate, but created by the characters themselves, each one of whom – the boy, the girl and the old man – chooses an easy road to happiness without regard for moral and ethical standards'.[118]

The most significant innovation in *Scarlet Street* was its ending. Cross escapes legal retribution for murdering his prostitute lover, Kitty, suffering instead the greater agonies of guilt and remorse. This reinforced Lang's point that people had to face up to reality, to live with the consequences of their actions rather than seek to escape them (even through death). Hence Cross fails when he attempts to hang himself in a seedy hotel room. Neither is he successful in his efforts to give himself up to the police for legal execution – they regard him simply as 'nuts'. Lang's second purpose in ending his film in this way was to demonstrate the importance of individual conscience and personal morality, rather than traditional reliance upon the sanctions of law enforcement. This was a novel strategy in Hollywood. Punishment for criminal behaviour was almost universal in American cinema at this time – punishment enforced by the institutions of law and order. Lang broadened the interpretation to argue that social regulation in a democracy ought to lie with the individual's own sense of morality. Lang was challenging American moralists to have the courage of their convictions: if God vested the ability to choose the path of right or wrong in all humans then, ultimately, punishment was a matter of conscience, not of the agencies of justice. This was Lang's 'affirmative resolution', replacing the 'happy ending' which had served Hollywood culture so well. Morals could still be upheld, argued Lang, but his emphasis was on the struggle to improve, rather than on bland assurances that all would work out for the best in the end.

Scarlet Street, particularly the ending, divided opinion. Lang later claimed that Breen objected to the lack of legal punishment, but there is no evidence that the PCA ever opposed the ending.[119] Indeed, the high moral tone of the ending satisfied the censors. Breen later explained that, although the Code normally required criminals to be apprehended, the stipulation had been waived on this occasion: 'the murderer was adequately punished by a higher power, working through his own conscience, which drove him to become a social outcast and a hopeless derelict'.[120] Lang's film had persuaded Breen to accept an element of social realism in place of moral absolutes. Breen noted that the film was close to real experience: 'as frequently happens in actual life … each and every criminal is not always and often can not be apprehended and punished by the courts of the land'.[121] An editorial in the

Atlanta Journal supported the film's moral standpoint, arguing that the fate of the characters contrasted with the usual 'gaudy, sexy comedies and melodramas, depicting crime and loose living in glamorous terms, and then seeking to atone by a trick of punishment at the end. Censors pass that kind every week, but the young people remember the lush story more than they do the phony ending.'[122] The film's writer, Dudley Nichols, believed that his screenplay had been honest about the issue of human guilt and its consequences and that, like all writers since the time of the Greeks, he had 'search[ed] for moral values through human behaviour'. 'Religion', he argued, 'is based on man's proclivity towards sin and the means of attaining grace ... To deny sin's existence is to send young people out into a wilderness of pitfalls for which they are not prepared. Only truth, only facing the world as it is, can prepare the young to lead moral lives.'[123] For one reviewer, the ending was all too familiar, 'a painfully moral picture and, in the light of modern candor, rather tame'.[124]

The controversy reflected the level of moral confusion in America at this time. Lang's film had questioned the durability of American idealism, with its parade of unsympathetic characters, its sordid setting and its bleak conclusion. *Scarlet Street* was a powerful challenge to America's long affair with idealism. It demanded that the nation face up to present realities.

Lang under contract: *The Woman in the Window*

Lang had achieved significant artistic control over all four of the films discussed above. His personal interests are evident in their content. One other film from this period might contend for a place in the category of Lang's social comment, and that is *The Woman in the Window* (1944). The film was made immediately before *Scarlet Street* for writer–producer Nunnally Johnson. It was something of a dry run for *Scarlet Street*: like that film, *The Woman in the Window* starred Edward G. Robinson as a middle-aged, respectable married man who encounters a beautiful young woman (played in both films by Joan Bennett) and who commits murder. Yet archival evidence shows that this particular film was not one in which the director was the leading contributor. Johnson was a prolific and successful writer–producer. He wooed Lang with a telegram, saying he was keen to get Lang's 'views, ideas and suggestions' on his screenplay, and that he would be 'very receptive' to them.[125] But it appears that Johnson alone wrote the first script, between September and December 1943, while Lang was in New York with pneumonia.[126] Production began on the film (called at this stage, 'Once Off Guard') in March 1944, and a full screenplay was with the PCA by the end of that month.[127] No doubt Lang had spent the first three months of 1944 collaborating with Johnson on the production, although the nature and extent of his influence is unknown. On the film's release, *Variety* credited Johnson with the main responsibility for the film, praising Lang only for the 'fine timing' of his direction.[128]

Judging by the content of the film, and comparing it to *Scarlet Street* where Lang's overall control is certain, it seems most likely that *Variety* was right. Lang would have been attracted by the story of a man caught 'once off guard', who succumbs to the impulse to commit violence. Lang believed such impulses lay beneath all supposedly civilized human beings.

He had given the barber in *Fury* a speech to exactly that effect. He would return to the theme in *Secret beyond the Door* (1948), where Mark Lamphere asserts that, 'there are dark forces within us. We're all of us children of Cain, we've all of us once thought of murder.' Yet *The Woman in the Window* is nothing more than a well directed, well written, entertaining thriller. It achieves none of the analytical and critical depths of *Scarlet Street* or of Lang's earlier personal work. Lang was content to work within the confines of someone else's overall conception, bringing to the film little in the way of personal, intellectual baggage. He simply filmed, extremely professionally, a lightweight thriller that raised certain interesting ideas.

It is a study of a man who momentarily strays outside the safety of his middle-class married life and reaps the fatal harvest of his lack of caution. It examines the subconscious impulses and urges which drive us to act in ways which contradict the veneer of civilization. These are themes that fascinated Lang throughout his career in Hollywood, and he would develop some of them further in his subsequent work. The dream ending, which was not in the original novel, annoyed a great number of reviewers, many of whom incorrectly attributed it to 'Hays Office' demands.[129] A Los Angeles journalist summarized the New York reaction by saying that the critics 'tossed hats in the air – and bricks at the Hays Office – realizing that producers had to lay off the payoff because of the Hays Office'. Dudley Nichols wrote to Lang, admiring the film but decrying the ending – 'but of course it was Hays Office', he concluded.[130] Lang, however, defended the ending as necessary, avoiding 'a futile dreariness which an audience would reject'.[131] Although the film is an interesting minor work in Lang's canon, it does not achieve the same status as his four major pieces of social criticism.

Notes

1. The account of Lang's early life and career that follows is derived from McGilligan, *Fritz Lang*.
2. McGilligan, *Fritz Lang*, 174–182, gives a detailed analysis and refutation of this famous anecdote.
3. McGilligan, *Fritz Lang*, 207 and Sikov, *On Sunset Boulevard*. The latter relies rather too heavily on Wilder's unlikely account of his immigration before concluding, 'There is clearly something missing here' (105).
4. See Lang's comments on the three stages of creativity in film-making (writing, directing and editing), in Higham and Greenberg, *The Celluloid Muse*, 114; see also his emphasis in the same interview on script participation by the director (107). Marguerite Tazelaar, 'Fritz Lang Likes Hollywood, America and Social Themes', *New York Herald Tribune* (7 February 1937), VII, 3, also reports Lang as saying, 'so much of the time [making a film] is taken up preparing a script'. As a cautionary general observation, it should be noted that Lang is one of the most interviewed directors of his era. As observed earlier, much of what he says, particularly in his later years, when his memory was faulty and the myths had supplanted the truth, must be treated sceptically. I have preferred to rely on archival sources. For a comprehensive list of Lang's interviews, with synopses, see Kaplan, *Fritz Lang*.
5. Lang's involvement in the preparation of his 'personal' films is detailed below in the text. For an account of his routine contract work at Fox, which demonstrates Lang's detachment from the

scriptwriting process, and the controlling hand of the studio executives, see Nick Smedley, 'Fritz Lang Outfoxed: the German Genius as Contract Employee', *Film History*, 4 (1990), 289–304.
6. Lang frequently complained about producers' interference in his pictures: see, for example, Higham and Greenberg, *The Celluloid Muse*, 109, 113, 117, 118; Bogdanovich, *Fritz Lang in America*, 57, 63, 65, 69–70, 72–74; and Don Ross, 'Lang, Director of "M", Seeks to Escape Net', *New York Herald Tribune* (20 May 1956), IV, 1–2. There is archival evidence to support Lang in respect of *Scarlet Street*, *Cloak and Dagger* and *Secret beyond the Door*, although even then, Lang claimed to be satisfied with the outcome of the last – see Case Study 4. He also disclaimed responsibility for *Ministry of Fear*, on the grounds that he had been unable to influence the script. There is no evidence to contradict Lang on this point and, indeed, the film is an unexceptional thriller, redeemed to an extent by a striking visual style; see Higham and Greenberg, *The Celluloid Muse*, 113 and Bogdanovich, *Fritz Lang in America*, 65.
7. Higham and Greenberg, *The Celluloid Muse*, 110.
8. W. L. Snyder, 'Cinema and Stage', *Cinema Progress* (June-July 1939), 4, 11. See also Lang's comments in Tazelaar, 'Fritz Lang Likes Hollywood, America and Social Themes'.
9. Snyder, 'Cinema and Stage', *Cinema Progress* (June-July 1939), 29.
10. Tazelaar, 'Fritz Lang Likes Hollywood, America and Social Themes'.
11. Paramount publicity sheet (27 May 1938), in the Margaret Herrick Library, Los Angeles, Fritz Lang personality file.
12. Snyder, 'Cinema and Stage', *Cinema Progress* (June-July 1939), 29. The words are Snyder's, although the sentiments emanate from his discussion with Lang.
13. Fritz Lang, 'Happily Ever After', *Penguin Film Review*, 5 (1948), 24; 26–7.
14. Lang, 'The Freedom of the Screen', *Theater Arts* (December 1947), reprinted in Koszarski, *Hollywood Directors 1941–1976*, 138–142.
15. Lang, 'Happily Ever After', *Penguin Film Review*, 5 (1948), 27.
16. Lang, 'Happily Ever After', *Penguin Film Review*, 5 (1948)28–29.
17. Lang, 'The Freedom of the Screen', reprinted in Koszarski, *Hollywood Directors 1941–1976*, 138.
18. Both quotes are from the Paramount publicity sheet – see note 11, above.
19. The *New York Sun* complained about the 'final, wishy-washy close-up', quoted in *Hollywood Reporter* (13 June 1936); in the Margaret Herrick Library, Production Code Administration Collection (hereafter, 'PCA'), Fury file (hereafter, 'Fury'). Harry Wilson, in 'The Genius of Fritz Lang', *Film Quarterly*, 18 (Summer 1947), complained about 'the absurd "happy ending" (foisted on the film against Lang's wishes)'. Lang disclaimed only the close-up of the kiss, in his interview with Peter Bogdanovich, *Fritz Lang in America*, 26, 28.
20. Krasna, 'Mob Rule', PCA, Fury; another copy of the story is in the Doheny Library, University of Southern California, MGM Collection (hereafter, 'MGM'), Fury. The plot was outlined to Shurlock of the PCA and then a copy of the story sent to Breen the next day – Shurlock, memo (21 August 1935); Maurice Revnes, letter to Breen (22 August 1935). Breen then wrote to Mayer (26 August 1935), giving a generally favourable response; all PCA, Fury.
21. The story conference notes ('Notes at Random'), dating from 30 August to November 1935, are in MGM, Fury; a first draft script (dated 20 January 1936) went to Breen on 24 January 1936; see PCA, Fury. See also McGilligan, *Fritz Lang*, 209–216, for an excellent account of Lang's first, frustrating year in America, waiting for a job.
22. Conference notes (3 September 1935), MGM, Fury. The writers also dropped Krasna's hackneyed romantic subplot, in which Joe's wife falls for the district attorney.
23. Conference notes (30 August 1935), 3–5, MGM, Fury.
24. Conference notes (31 August 1935), 1–2, MGM, Fury.

Case Study 1 – 'Everything That Happens Must Be Strictly American': Fritz Lang and Hollywood Idealism

25. Conference notes (4 September 1935), 2, MGM, Fury.
26. Conference notes (5 September 1935), 1, MGM, Fury.
27. Conference notes (9 September 1935), 2, MGM, Fury.
28. Conference notes (4 September 1935), 2, MGM, Fury.
29. Conference notes (31 August 1935), 5–6, MGM, Fury.
30. Conference notes (31 August 1935), 6, MGM, Fury.
31. Conference notes (3 September 1935), MGM, Fury.
32. Bartlett Cormack and Fritz Lang, 'Fury', first dialogue continuity, fragment (13 November 1935), 4–7, MGM, Fury. The earliest Cormack script fragment is dated 26 October 1935. He seems to have been brought in following possible dissatisfaction with Praskins' draft screenplay. This ran to seventeen pages by 19 September, but struck absolutely the wrong chord, opening with a sequence in which the destitute Joe is jailed by a benevolent judge – to provide Joe with a bed for the night – and then hired as the judge's chauffeur the next morning; see MGM, Fury.
33. F. S. Nugent, *New York Times* (6 June 1936), 21.
34. Conference (3 September 1935), 1; Conference (5 September 1935), 6; MGM, Fury. The latter comes almost verbatim from Krasna's original story, in which he describes the district attorney as setting out to prove that no man should 'judge, condemn and sentence another man', 6; see PCA, Fury.
35. Conference (7 September 1935), 3; Conference (5 September 1935), 8; MGM, Fury.
36. Revnes, letter to Breen (12 February, 3 and 4 April 1936), PCA, Fury; the film was reviewed by the PCA on 12 May 1936.
37. See D. W. C., 'Fritz Lang Bows to Mammon', *New York Times* (14 June 1936), X, 2, reporting on the conflict between the notoriously 'arty' European director and the studio over the film. See also *Hollywood Reporter* (14 May 1936); in PCA, Fury.
38. *Motion Picture Herald* (20 May 1936); in PCA, Fury.
39. Nugent, (6 June 1936); Kenneth Fearing, *New Masses* (16 June 1936), in Stanley Kauffmann (ed.), *American Film Criticism: from the Beginnings to 'Citizen Kane': Reviews of Significant Films at the Time They First Appeared* (New York, 1972), 339–340.
40. Nugent, (6 June 1936).
41. *Variety* (n.d.); in PCA, Fury. Not every reviewer was enthusiastic – *Motion Picture Daily* (19 May 1936) found it too grim to 'appeal to shoppers for a pleasant evening'; in PCA, Fury.
42. Conference (5 September 1935), 3, MGM, Fury.
43. See the contracts in the Walter Wanger Collection (hereafter, 'Wanger'), Wisconsin Center for Film and Theater Research, University of Wisconsin, Madison, Box 40, 19. The authors appear to have each received $7500, plus engagement at $3000 a week from 1 August 1936 to write the screenplay.
44. Received by Breen (17 August 1936), PCA, You Only Live Once file (hereafter, 'YOLO').
45. The final continuity, incorporating changes of 30 September, 6 October and other dates, is in Wanger, Box 96, 24 and 25. Breen had read and commented on a screenplay by late September – Breen, letter to Wanger (28 September 1936), PCA, YOLO. Wanger had secured the necessary authorization for the new title by 4 September – Rupert Hughes, memo to Wanger; Wanger, Box 96, 25.
46. See the cost sheet for the actual schedule and final cost, Wanger, Box 96, 25; and the insurance contract for the estimated schedule and costs, United Artists Collection, Wisconsin Center for Film and Theater Research, University of Wisconsin, Madison, Series 5.2, Box 4, 2. References to the retakes and the previews are in Wanger's diary for 1937, Wanger, Box 35, 6.
47. See below in the text for an analysis of the film's critical response.

48. The first script, sent to Breen in mid-August, went under cover of a letter (author indecipherable, n.d., PCA, YOLO), confirming the date of a meeting between Breen, Wanger and 'the director'. Lang was free of engagements at this time, and there is nothing to suggest that any other director was ever involved. Cast and crew were being hired in late July and early August – see contracts with cast and crew members in United Artists Collection, Wisconsin, Series 4G, Box 3. Matthew Bernstein, *Walter Wanger: Hollywood Independent* (California, 1994), 115–17, 121, documents how Lang polished an existing script.
49. Towne and Baker, 'You Only Live Once', final continuity (n.d.), Wanger, Box 96, 24 and 25, with changed pages of 30 September and 6 October 1936. See in particular 6–9 for the characterization of the sister; 44–46 for an example of Whitney's jealous love for Joan; 125 shows that the baby's name was originally to have been Stephen, after the public defender, suggesting that Joan may have regretted her decision to stay with Eddie – this would not have served Lang's purpose, fatally undermining his message that society should help ex-convicts like Eddie; 12 for Eddie's scene with the prison governor; and 137 for the ending (changed 30 September).
50. *Motion Picture Herald* (30 January 1937); in PCA, YOLO.
51. *Daily Variety* (23 January 1937); in PCA, YOLO.
52. *Hollywood Reporter* (23 January 1937); in PCA, YOLO.
53. *Variety* (3 February 1937); in PCA, YOLO.
54. *Motion Picture Daily* (22 January 1937); in PCA, YOLO. Note too Howard Barnes, *New York Herald Tribune* (1 February 1937), 10, who saw the episodes of the Taylors' life on the run and the final speech as a 'counterfeit resolution'.
55. Wanger's diary (15 January 1937), Wanger, Box 35, 6.
56. Breen, letter to Wanger (28 September 1936); James Wingate, letter to Breen (28 January 1937), reporting the reaction of Esmond, a New York censor; PCA, YOLO.
57. Barnes, *New York Herald Tribune* (1 February 1937).
58. Frank Nugent, *New York Times* (1 February 1937), 15.
59. *Motion Picture Daily* (22 January 1937); in PCA, YOLO.
60. See for details of the non-PCA censorship: PCA, YOLO.
61. Hammell, letter to Breen (26 August 1936), PCA, You and Me file (hereafter, 'YM').
62. The script (25 August 1936) is in the Margaret Herrick Library, Paramount Script Collection (hereafter, 'Paramount'); a synopsis is in PCA, YM.
63. Breen, letter to Hammell (28 August 1936); Krasna and Paramount executives discussed the problems at a conference on 2 September and accepted all of Breen's points – Breen, letter to Hammell (2 September 1936); see PCA, YM.
64. Hammell, letter to Breen (15 January 1937), PCA, YM. Lang later asserted that, 'to avoid any coincidences I haven't even read the Schulberg treatment of "You and Me" '; Lang to Jacob H. Karp (28 June 1937), in the Doheny Library, University of Southern California, Fritz Lang Collection (hereafter, 'Lang'), YM.
65. Lang's diaries of his work on *You and Me* (his 'daylies') covering the period 12 May to 23 September 1937 are in Lang, YM. They show him working for whole days at a time on the script, writing considerable quantities of original material himself, as well as providing ideas for van Upp and supervising her output.
66. Higham and Greenberg, *The Celluloid Muse*, 108.
67. Lang's diary (19, 21, 26 and 27 May 1937), Lang, YM.
68. Lang's diary (28 and 31 May, 7 June 1937), Lang, YM.
69. Weill, letter to Lang (13 November 1937); on the deadline for releasing Sidney, see memo of a conference (16 June 1937); both Lang, YM. The play (*To Quito and Back* by Ben Hecht) flopped

Case Study 1 – 'Everything That Happens Must Be Strictly American': Fritz Lang and Hollywood Idealism

in New York and closed early – see Botsford, letters to Lang (7 October and 4 November 1937), Lang, YM. Sidney's career nevertheless moved ever more towards the stage and away from film acting.

70. See Lang's diary entries (16, 19 and 22 June 1937) for complaints about van Upp's lack of speed; Lang's diary (19 June) for Paramount's decision to release Sidney; Lang, letter to Weill (20 July 1937) for his securing of a deferment of the production; Lang's diary (21 June) for a discussion of whether to hire Shaw or Clifford Odets; Lang's diary (22 June) for Wanger's refusal; all Lang, YM. McGilligan, *Fritz Lang*, describes the disastrous decline in goodwill between Lang and Wanger (see particularly 247).

71. Lang's diary (15 July 1937), Lang, YM. Lang refers to himself as 'FL' in his diary.

72. Lang's diary (9 August 1937) has Lang telling Paramount chairman Adolph Zukor that the 'You and Me script is finished'; Lang, YM.

73. Lang's diary (17 and 24 August 1937); Zukor's disapproval of the script is mentioned by Lang in his diary (24 August 1937); Lang, YM.

74. Lang's attempts to secure a script from George O'Neill for this project – Zukor's suggested title was 'Every Woman' (Lang's diary, 8 July 1937) – and to prepare the production are detailed in his diary, from 8 July to 23 September 1937. Lang also refers to the project in his correspondence with Weill (22 September 1937); Lang, YM. He talked about the project later to Higham and Greenberg, *The Celluloid Muse*, 107; Bogdanovich, in *Fritz Lang in America*, 131, refers to it as 'Americana' in his filmography.

75. Lang, letter to Weill (22 September 1937), Lang, YM.

76. Lang, letter to Weill (17 November 1937), Lang, YM.

77. Hammell sent the script to Breen in three batches (3, 6 and 8 December 1937); a minor difficulty about the intimation of the baby's illegitimacy – derived, in fact, from Krasna's original story – was cleared up – see Breen, letter to Hammell (11 December 1937); C. R. Metzger, memo (22 December 1937); and Hammell, letter to Breen (28 December 1937); all PCA, YM.

78. Revised pages were sent by Hammell to Breen on 26 January, 28 February and 7 March 1938; see PCA, YM. We know shooting had started because Weill had visited the set – Weill, letter to Lang (24 February 1938), Lang, YM.

79. The letters were as follows: Moffitt to Manny Wolfe (13 January 1938); Wolfe to Moffitt (17 January); Moffitt to Wolfe (19 January); and Wolfe to Howard Emmett Rogers (7 February); all Lang, YM.

80. Wolfe, letter to Moffitt (17 January 1938), Lang, YM.

81. Lang, letter to Wolfe (10 January 1938), attributing 170 pages to van Upp, 21 pages to Krasna (or 12.4 per cent) and less than 10 per cent to Moffitt. Krasna's contributions are highlighted in Lang's copy of the final script, showing that Krasna 'wrote' (or was the inspiration for) the dance-hall fight scene and the scene where Helen and Joe first arrive at her apartment after their marriage; see Lang, YM.

82. Weill, letter to Lang (24 February and 18 May 1938), Lang, YM; the less complimentary quote can be found in Lys Symmonette and Kim H. Lowalke (eds), *Speak Low (When You Speak of Love): the Letters of Kurt Weill and Lotte Lenya* (California, 1996).

83. Gavin Lambert, 'Fritz Lang's America', *Sight & Sound*, 25 (Summer 1955), 55. Eisner, *Fritz Lang*, 191, appears to borrow Lambert's analysis, although without acknowledgement. She concludes – without the benefit of archival research – that 'to Lang the plot seemed too superficial to warrant a deeper-reaching social treatment', 196. This fails to explain why Lang chose the project in the first place, and why he was unable to add depth to his plot during the ten months he worked on the script.

84. *Film Daily* (3 June 1938); in PCA, YM.
85. Frank Nugent, *New York Times* (2 June 1938), 19; Will Boehnel, *New York World Telegram* (2 June 1938); in Lang, YM; *Hollywood Reporter* (28 May 1938); in PCA, YM.
86. *Variety* (8 June 1938); in PCA, YM; Nugent, *New York Times* (2 June 1938).
87. Eileen Creelman, *New York Sun* (2 June 1938); in Lang, YM.
88. Howard Barnes, *New York Herald Tribune* (2 June 1938); see also Archer Winsten, *New York Post* (2 June 1938); both in Lang, YM; and the *National Board of Review's* (June 1938) lament that Lang had wasted his talents on such run-of-the-mill material, in Stanley Hochman (ed.), *A Library of Film Criticism: American Film Directors* (New York, 1974), 247.
89. *Hollywood Reporter* (28 May 1938); in PCA, YM.
90. See Smedley, 'Fritz Lang Outfoxed'.
91. *Variety* (8 June 1938); in PCA, YM.
92. See Lang's 'confession' about his films' qualities. This document was probably prepared as publicity for the forthcoming release of *Scarlet Street*, as it is filed with papers in the box dated 12 October 1945; in Wanger, Box 12, 9.
93. As reported in the *New York Times'* Hollywood column (23 September 1945); the clipping is in Lang, Scarlet Street file (hereafter, 'SS').
94. *New York Times* (18 November 1945); in Lang, SS.
95. Shurlock's memo (8 January 1935) records his and Breen's discussion with Lubitsch and includes a summary of the cast and the story. Breen felt it 'contained sufficient moral values to be told under the Code'; see PCA, SS. Although the Lubitsch version would certainly have been a different film from Lang's, the 'moral values' implicit in the story were retained by Lang, to Breen's complete satisfaction. See also the memo from Breen (4 November 1938), regarding his letter to Universal Studios (19 October 1938), in response to their screenplay for 'The Poor Sap', sent to Breen on 17 October. In that letter Breen had written that the story was familiar, 'having been submitted here, in one form or another, by many producing companies hereabouts over a period of several years'. Universal dropped their plans, even though, as Breen recorded, they accepted that his points could be taken on 'without doing much violence to the present story'; all PCA, SS.
96. See the abstract of Wanger's contract with Diana and other contracts (March to May 1945), Wanger, Box 47, 16; see also contracts for *Scarlet Street*, Wanger, Box 91, 1.
97. Lang, outline for 'Pomander Walk' (18–20 March 1945), Wanger, Box 91, 2; Bergman, wire to Wanger (26 March 1945), Wanger, Box 24, 14.
98. Lang refers to 'the second paragraph of chapter 3' in his outline (24), presumably a reference to the original novel.
99. Lang, outline, 9.
100. Lang, outline, 4–5.
101. Lang, outline, 13.
102. Lang, outline, 28.
103. Nichols was not immediately available; Nichols, letter to Lang (2 March 1945); Wanger, wire to Lang (26 March 1945); see Wanger, Box 91, 2.
104. Note for the file (n.d.) records Lang and Nichols' meeting on 16 April 1945; Wanger wired Lang (20 April), authorising him to engage Nichols for his asking price of $30,000; Diana's lawyer, Martin Gang, wired Wanger and Lang (26 April) to say that Nichols had bought the shares; all Wanger, Box 91, 2. The cost and estimate sheets for the production show Nichols' fee as $50,000; in Doheny Library, University of Southern California, Los Angeles, California, Universal

Case Study 1 – 'Everything That Happens Must Be Strictly American': Fritz Lang and Hollywood Idealism

Collection (hereafter, 'Universal'), SS. By now, the title 'Scarlet Street' had been settled; Lang explained that it came through reeling off street names in Greenwich Village, 'Carmine Street' suggesting 'Scarlet Street'; Lang, note (n.d.), Wanger, Box 91, 2.
105. Lang, talking to Bogdanovich in Bogdanovich, *Fritz Lang in America*, 66; Wanger, letter to Blumberg (15 May 1945), in which he asks him to get the film from France; Blumberg advised Wanger (23 May) that there were no prints available. Finally, a print arrived from London on 21 July – Wanger's office, memo to Blumberg (14 June, with later annotations); all Wanger, Box 91, 2. Bernstein, 'Fritz Lang, Incorporated', reports the search, but misses the successful outcome – see his note 32, 50 – an oversight not corrected in his later book, *Walter Wanger*.
106. The evidence of the script's evolution is scattered: Universal sold the rights to Diana in May 1945 for a little under $30,000; see Wanger, Box 47, 16; Wanger's office sent a first draft script to Breen (11 June); see PCA, SS; Nichols sent Wanger a final script on 10 July – Wanger, letter to his lawyers; in Wanger, Box 47, 16; Wanger sent this substantially revised script to Breen on 11 July; see PCA, SS; Wanger was discussing 'possible elimination [from the script] with the genius' on 14 July – Hank Spitz, letter to Wanger; and Nichols told Wanger in an undated letter that he had sent some script changes to Lang on 15 July, adding that, 'Fritz clearly wishes to take care of [the bulk of the cuts] himself'; both in Wanger, Box 91, 2. The shooting schedule is recorded in the cost sheets; Universal, SS.
107. Cost sheets; Morrie Weiner, memo to Wanger (28 August 1945), reporting the loss of the Paramount set; both Universal, SS. The press preview was held on 20 December 1945 – see advertising file, Lang, SS.
108. New York rapidly rescinded the ban; Atlanta lost its case after a lengthy court battle; in PCA, SS.
109. The standard interpretation of Lang's work, perpetuated by the director himself in countless interviews. Eisner, *Fritz Lang*, (147–48), agrees that Lang's films developed so that men determine their own fate, but dates the change from Lang's arrival in the United States in 1935. In fact, Lang did not formulate his views on this until the mid-1940s, as discussed earlier in this case study.
110. Eileen Creelman, *New York Sun* (15 February 1946); in PCA, SS.
111. Breen, letter to Wanger (12 June 1945), PCA, SS. Breen seems to have been satisfied with the revised script of 2 July, thanking 'Messrs. Nichols and Lang' for cooperating 'on this difficult story'; see Breen, letter to Wanger (16 July 1945), PCA, SS.
112. *Motion Picture Daily* (21 December 1945); in PCA, SS.
113. Bogdanovich, *Fritz Lang in America*, 35; Higham and Greenberg, *The Celluloid Muse*, 107 and, specifically with regard to *Scarlet Street*, 116; interview with Alexander Walker (British Film Institute transcript, 25 August 1967), Roll Two, 1, BFI archives, London; and many other interviews (see Kaplan, *Fritz Lang*, for further examples).
114. Notes (one dated 12 October 1945), Wanger, Box 12, 9.
115. Notes (one dated 12 October 1945), Wanger, Box 12, 9.
116. Notes (one dated 12 October 1945), Wanger, Box 12, 9.
117. Lang, 'Happily Ever After', *Penguin Film Review*, 5 (1948) 26.
118. Lang, 'Happily Ever After', *Penguin Film Review*, 5 (1948) 28–29.
119. Higham and Greenberg, *The Celluloid Muse*, 115–16. Lang appears to contradict his earlier account to Bogdanovich, *Fritz Lang in America*, 69, in which he said that he had had no trouble with the Hays Office over the ending. The film was, however, re-edited by Wanger without Lang's approval (he was away shooting *Cloak and Dagger*) – see Bernstein, *Walter Wanger*, 204–5.
120. Breen, letter to PCA lawyers (26 March 1946), as part of his affidavit in the Atlanta censors' lawsuit; PCA, SS.

121. Breen, letter to lawyers (26 March 1946), PCA, SS.
122. Wright Bryan, *Atlanta Journal* (March [?] 1946), sent by Wanger to Breen (5 March 1946); see PCA, SS.
123. Nichols, letter to Wanger ('Sunday' [probably January 1946]); Wanger, Box 91, 2.
124. Bosley Crowther, *New York Times* (15 February 1946), 29.
125. William Goetz, wire to Lang (2 December 1943); see Lang, Woman in the Window file (hereafter, 'WW').
126. Goetz instructed Raymond Cossett of International Pictures to send Lang the novel (Cossett, letter to Lang, 14 September 1943); Johnson wired Lang (25 September 1943) that Robinson had agreed to appear and possibly Tallulah Bankhead; Goetz's wire to Lang (2 December 1943) refers to Johnson's script being ready; Lang's reply (n.d.) explains that he had had pneumonia and would return to LA in the New Year; all Lang, WW. International Pictures informed the PCA of their intention to film the book in November 1943 – Beck, letter to Breen (15 November 1943), PCA, WW. Johnson himself later recalled that: 'The script was complete when it was offered to [Lang] and when we went over it together I can remember only one conflict of opinion [i.e. over the ending]'; in Eisner, *Fritz Lang*, 255. See also Tom Stempel, *Screenwriter: the Life and Times of Nunnally Johnson* (San Diego, 1980).
127. RKO (whose facilities International used) issued a production no. on 10 March 1944 for 'Once Off Guard'; Lang, WW. Beck registered the titles 'Woman in the Window' and 'Girl in the Window' in February 1944 and sent the screenplay to Breen in two batches the following month (Beck, letter to Breen, 17 and 30 March 1944); the title change was not effected until May, however – see 'R.D.', memo to file (16 May 1944); all PCA, WW.
128. *Variety* (11 October 1944); in PCA, WW. Thomas Pryor, *New York Times* (26 January 1945), 16, credited the ending to Nunnally Johnson's 'huge joke', rather than to Lang.
129. See Pryor, *New York Times* (26 January 1945); P. K. Scheuer, *Los Angeles Times* (10 October 1944), II, 7; Bert McCord, *New York Herald Tribune* (26 January 1945); all in PCA, WW; and *New York Daily Mirror* (27 January 1945); Irene Thirer, *New York Post* (26 January 1945); Jane Corby, *Brooklyn Daily Eagle* (26 January 1945), in which she describes the ending as 'a crime against the moviegoer'; *P.M.* (26 January 1945); Alton Cook, *New York World-Telegram* (25 January 1945); and *New York Journal-American* (26 January 1945); all in the Doheny Library, University of Southern California, Edward G. Robinson Collection.
130. *Hollywood Reporter* (31 January 1945), 10; Nichols, letter to Lang (2 March 1945); Wanger, Box 91, 2.
131. Lang, 'Happily Ever After', *Penguin Film Review*, 5 (1948) 28; he confirmed his support for the ending to Bogdanovich, *Fritz Lang in America*, 63, and to Higham and Greenberg, *The Celluloid Muse*, 113.

Case Study 2

Sex, violence and alcohol: Billy Wilder in the 1940s

Introducing Billy Wilder

Samuel 'Billie' Wilder was born in Galicia, Poland on 22 June 1906, the second son of a Jewish family of German-speaking Poles (his nick-name was later Americanized to 'Billy'). His father, Max, ran a small chain of railway cafes, before moving the family, when Samuel was five years old, to Cracow, where he ran a hotel.[1] In or around 1916, the Wilders moved to Vienna, where at first they lived in moderate prosperity, moving to less desirable accommodation around 1924. The young Wilder attended schools in the Austrian capital, but did not go on to higher education. Instead, he began submitting articles to some newly established tabloid newspapers in Vienna, gradually acquiring a reasonably steady income as a freelance journalist. In 1926 he moved to Berlin and worked as a newspaper writer until 1931, specializing in sports, music and theatre. Hanging around cafes during the day, Wilder got to meet writers and others involved in the German film industry. Sometime around late 1928, he began to try his hand at writing screenplays.

The first confirmed, autographed script from Wilder is *Der Teufelsreporter/The Daredevil Reporter* (Laemmle, 1930*)* of January 1929. From then on his output became steady, and by the end of 1931 he was making his living almost exclusively as a screenwriter, in constant employment and well paid. 1932 was a particularly productive year for him, with seven films to his credit. Work on the eighth, *Der Frack met der Chrysantheme/Frock coat with Chrysanthemum*, for Erich Pommer, was never finished. Begun in later 1932, production was still ongoing when, in January of the following year, Hitler came to power. Wilder did not have the option that Lang had of a leisurely departure from Berlin. The details of his leaving are vague, but he turned up in Paris later that year, living in reduced circumstances with a number of other refugees from the artistic community. While Lang was able to stay in style at the prestigious George V hotel, Wilder had been a very minor figure in the German film industry and would have been unlikely to prosper in France. Nevertheless, a skilful networker and a streetwise hustler from his days in journalism, Wilder was a survivor. He managed to make one, low-budget film in Paris in 1934, *Mauvaise Graine/The Bad Seed* (Esway & Wilder, 1934,) experiencing – and not enjoying – his first attempt at directing. But his sights were set on escaping Europe and trying to find film work where many Germans had gone before – Hollywood.

The details of when and how Wilder went to America are unclear. It seems that, around the start of 1934, fellow émigré Joe May gave Wilder the all-important invitation to 'work' in America, and he set sail. Once there, with the support and camaraderie of the expanding German set in Los Angeles, Wilder took the necessary brief trip to Mexico and then began his life in California. He spoke almost no English, and he had no status whatsoever in the film colony – but the German artistic community, congregating around Salka Viertel, provided

him and many others with numerous contacts and connections. Erich Pommer and Joe May were working in Hollywood, and Wilder began contributing to writing projects from the summer of 1934. Work was sporadic and low-key. His big break came in 1937. Wilder had done some work at Paramount in 1936, and the following year Lubitsch was preparing his latest project, *Bluebeard's Eighth Wife* (Lubitsch, 1938). He wanted to put together a new scriptwriting team and, with input from the Paramount executives, came up with a combination of complementary opposites. First was the experienced, 43-year-old East Coast writer, Charles Brackett. Offsetting him was the novice, the 29-year-old Jewish Pole, 'Billy' Wilder. The resulting team was a triumph, and it made Wilder's fortune. Suddenly, the unknown exile was working with two men, one of whom was the great genius Ernst Lubitsch and the other an American writer who was shortly to become the president of the Screen Writers' Guild.

Although *Bluebeard* was received poorly by the critics, the writing team had gelled, and Paramount assigned the duo to a series of films. Brackett and Wilder polished off one witty, entertaining and charming film after another – *Midnight* (Leisen, 1939) for Mitchell Leisen; *Ninotchka* (Lubitsch, 1939), once again working with Lubitsch; *Arise my Love* and *Hold Back the Dawn* (Leisen, 1940 and Leisen, 1941); and, finally, before taking the director's seat himself, *Ball of Fire* (Hawks, 1941) for Howard Hawks.

How Wilder came to direct his first film, *The Major and the Minor* (Wilder, 1942) for Paramount, is not clear. It is probable that Wilder wanted to exercise more control over his scripts and take charge of his film projects. He had had the chance to learn the craft of directing from Lubitsch; he had formed a stable association with Paramount; and he had an effective writing partnership with Brackett. Orson Welles, John Huston and Preston Sturges were leading the way as the first writer–directors to emerge from the studio system. Wilder would join them. Sturges' *The Lady Eve* (Sturges, 1941) had been the biggest grossing film for Paramount of 1941. It may well have been that the studio thought Wilder could deliver a similar success – it was certainly worth the low risk of trying.[2] When he came to his first solo directing project, Wilder adopted a play-safe strategy, choosing an innocuous and rather formulaic piece, which contained no 'European' perspective on American culture. It was a simple commercial strategy, allowing Wilder to get over the fence and prove he could handle a project at the helm. Immediately he had established himself as a director, however, he moved on to more edgy, controversial material.

Wilder's contribution to New Deal culture has to be assessed on the basis of fewer films than in the cases of Lubitsch and Lang. Nevertheless, it was significant. Over the course of a career spanning more than four decades, Wilder proved himself a master of witty, and often cruel, satire. He never sought to create a recognizable, individual style in his cinematography, preferring to concentrate on a strong story and a clever, funny script. His apprentice years, covered in this book, show that he began as he would continue. In the six years leading up to 1948, Wilder would prove a bitingly satirical commentator on the American way of life, offering powerful social insights. By the time his directing career started, the United States had already joined the Second World War, and the forces of conservative reaction were

starting to regroup in the declining years of the New Deal. Wilder was to be a key voice in the articulation of liberal anxiety in the 1940s with his two consecutive masterpieces, *Double Indemnity* (Wilder, 1944) and *The Lost Weekend* (Wilder, 1945). After the war he made a scathing critique of American foreign policy, *A Foreign Affair* (Wilder, 1948). This film stands in a class of its own, a brave and frank challenge to American platitudes relating to the post-war settlement. Wilder joins the ranks, together with Lubitsch and Lang, of European directors whose works challenged American audiences to reconsider critically their values and their complacency.

Wilder's philosophy of cinema

In the period covered by this book, Wilder directed (and co-wrote) six films. He never expressed a consistent thematic purpose, nor did he attempt to achieve a corpus of work – as Lubitsch so ably did and as Lang strove to do – that reflected a coherent world view. Wilder was, to a great extent, the supremely talented opportunist, the journalist turned film-maker who was quick to perceive openings for controversial and sensationalist material. Even so, his sharp satirical skills and liberal politics mean that his films often contain much of interest to the social historian.

Wilder has not been highly regarded by film theorists. They have been unimpressed by his lack of interest in the formal properties of film. His varied subject matter has not lent itself to the auteur theory discussed in Chapter 2, which demands from a director a single, unifying theme to help critics categorize their oeuvre.[3] Wilder himself, in interviews given some years after the 1940s, helped to furnish this image of a superficial director who offered mere entertainment, with no intention of making social commentary. In 1957 he claimed, 'I do not champion any causes in my film-making. Films are an entertainment; and I believe in keeping them that way.'[4] In 1963 he denied the existence of messages or meaning in his work, explaining that he did not want 'to ram a lecture' down an audience's throat.[5] 'I'm a director who prefers not to have a particular style, unlike Hitchcock or Ford', he told another interviewer. 'If I get a story I like or a subject that appeals to me, I make it.'[6] Time and again he expressed his distaste for the pretensions of European art movies and his preference for the mass entertainment value of Hollywood films. Denying the influence of Brecht or Berlin on his own work in America, he riposted, 'After all, was Mickey Spillane influenced by Tolstoy?'[7]

At times, however, Wilder seems to have regretted creating the myth of his own crassness and sought to repair the damage. On occasion he would waver from his firm denials of social comment, referring to hidden, 'contraband' messages.[8] Indeed, his well attested pro-Roosevelt politics might have been expected to lead him to address topical social issues. He was described as 'a left-wing Democrat' by *Liberty* and as 'a fervid New Dealer with leftish leanings' by *Life*.[9] What is more, he worked with complete creative autonomy and had the freedom to tackle whatever projects he chose. He not only directed, but also helped to write all of his films; he formed a stable working relationship with Paramount; and on four out of the six films he made in the period considered in this book, he worked with the same producer–co-writer, Charles

Brackett. Contemporary reports attest to this couple's freedom to 'put on screen what they like' and to their strategy of writing their scripts at the last minute to avoid studio oversight and, as archival sources show, PCA interference.[10] Wilder himself confidently wrote in 1946 of 'being allowed to pick and choose our screen vehicles [and] to oversee every detail of production, from first draft of the script to the final job of editing'.[11]

Wilder and the decline of American idealism: *Double Indemnity*

Wilder's self-created reputation for blandness is contradicted by some key films he made in the 1940s, which illustrate his growing maturity as he gathered confidence. In his first film, *The Major and the Minor* (1942), we see Wilder emulating the New Deal celebratory approach to the virtues of the countryside. Susan's love for her hometown in Iowa is celebrated in contrast to the decadence and corruption of New York. This is a classic American theme of the 1930s, on which Wilder was probably capitalizing. Yet, when he came to make the more personal *A Foreign Affair* (1948) six years later, Wilder satirized cruelly the small-mindedness of his congresswoman, Phoebe Frost, who was also from Iowa. In the latter film, Wilder made many jokes at Iowa's expense and included a set piece in which Frost is arrested while drunkenly singing the Iowa song. Similarly, one might contrast another of his films from this period, *The Emperor Waltz* (Wilder, 1948), with one of Wilder's more serious efforts, *Double Indemnity* (1944). The former's opportunistic celebration of American values makes it an unconvincing oddity in Wilder's early career. It includes a paean to the entrepreneurial skills of the American salesman, in stark contrast to the portrayal of Walter Neff, insurance salesman, in *Double Indemnity* – the film I shall now discuss.

Wilder's *Double Indemnity* is important for two main reasons. First, it contains an influential depiction of American idealism in retreat. Second, it offers an early – and, again, influential – portrait of the femme fatale in Hollywood (this aspect is considered further in Case Study 4). When Wilder chose to film James M. Cain's novella, he was tackling a story that had already been considered unfilmable by the Hays Office. In 1935, shortly after the book's publication, MGM had sought Joseph Breen's opinion on the prospects for a film version. Breen's reply set out the reasons why he 'would be compelled to reject' any screen version.[12] First, there was the detailed and cold-blooded murder; second, the two murderers evade legal punishment for their crime (they both commit suicide in the book, and shoot each other in the film); finally, there was the adulterous sex. Breen concluded: 'The general low tone and sordid flavor of this story makes it, in our judgement, thoroughly unacceptable for screen presentation before mixed audiences ... all consideration of it for screen purposes should be dismissed'.[13] To forestall other studios' plans, Breen copied his letter to Warner Bros. and Paramount, and read its contents over the telephone to Columbia.[14]

In March 1943 Wilder had completed shooting on *Five Graves to Cairo* (Wilder, 1943) and was looking for his next project. A Paramount official made enquiries to find out whether Breen saw any reason to change his decision of seven years earlier about *Double Indemnity*, but was rewarded only with a copy of the 1935 letter, re-dated.[15] Clearly undeterred, Wilder and his co-writer for the occasion, Raymond Chandler, began work on a script that was

submitted to Breen in September.[16] There is no evidence of what, if anything, passed between the PCA and Paramount which might have alleviated Breen's concerns of seven years' standing. Nevertheless, Wilder's script secured an easy passage through the censors, with Breen offering help on how to avoid potential local censorship problems. It was approved, after the most minor adjustments, before the end of the year.[17] Wilder may have kept within the Hays Office guidelines, but even so, he had succeeded in bringing to the screen a new type of film in Hollywood. It portrayed an alluring woman who quite ruthlessly manipulates another man to help her kill her husband. Phyllis's sexual attractiveness, which triggers off Neff's involvement in the conspiracy, is emphasized, even though this was an element of the book to which Breen had originally objected. Indeed, Cain himself protested about the way in which the censors had scotched early plans to film the novel, only to allow Wilder to proceed in breach of these very objections.[18]

On its release, reviewers noted the novelty of Wilder's depiction of lust and murder. It had a power that 'You will not find ... often in Hollywood-made films', wrote one.[19] 'All of the sexual implications are there ... [it] at no times makes compromise with an adult approach to drama', wrote another, adding that Wilder and Paramount had shown great courage in tackling the subject in this way.[20] The *New York Times* observed that the film had 'a realism reminiscent of the bite of past French films ... detailed ... with the frigid thoroughness of a coroner's report ... as hard and inflexible as steel'.[21] James Agee welcomed the film as marking a return to the harder dramas of the early 1930s, in a Hollywood that had since 'developed softening of the brain'.[22] Bosley Crowther of the *New York Times* compiled in 1946 a retrospective review of the films of the war period, identifying *Double Indemnity* as a new type of 'elegant 'shocker'", the like of which had not been seen before.[23]

On the face of it, the film is little more than an entertaining (albeit superior) thriller, exactly the sort of crowd-pleasing vehicle that Wilder claimed he liked to make. Yet the clash of values implicit in the film's three central characters introduced an important element of topical social observation. The motives of the murderous duo, Walter Neff and Phyliss Dietrichson, are pitched against the values of Keyes, the honest insurance claims investigator. This provides the film with a depth well beyond the surface appearance of a murder film. As one New York reviewer remarked, *Double Indemnity* is more than just 'a fascinating thriller ... it reaches the level of high tragedy'.[24]

The personal drama in the film comes not from the central murder story, but from the interaction between Neff and Keyes. Neff is a salesman, of the fast-talking, foot-in-the-door variety, self-interested and self-assured. Keyes is older and seeks from life something more than money. Accordingly, he is not a salesman but an investigator of frauds against the company. He is just and liberal. When we first see him, he is ruthlessly exposing a poor immigrant truck driver's insurance fraud. Yet once the hapless man has signed a waiver on his claim, Keyes declines to call in the police. He turns to Neff and sums up the irresponsibly materialist attitude of the company: 'they'll do anything just to get someone's name on the sheet', after which Keyes has to sort out the human problems that inevitably arise. Neff later looks back and reflects that, 'behind the cigar ash on your vest, you had a heart as big as a

house'. The two men have evolved a relationship of interdependence, characterized by Neff always providing Keyes with a match for his cigar. Each contributes something vital to the other, neither could be said to be whole without his counterpart. Thus Keyes has morality and integrity, but is too cautious to form relationships with others. He lacks the dynamism of Neff. Neff is a brilliant salesman, representing the energy and drive of successful capitalism, yet he lacks the maturity and humanity of Keyes, skirting dangerously close to amoral materialism. As a pair, then, they represent the two most important forces in American life: capitalist initiative, grounded in a sense of moral destiny.

The characters in the film symbolize the drift of the nation in the 1940s from a moral outlook to materialism. Neff loses his moral compass when he decides to commit himself to the pursuit of wealth, and he betrays the trust of Keyes by choosing the corrupting influence of Phyliss. An opposition is thereby established between the attraction of easy money and immorality with Phyliss, and the pursuit of integrity and moral enterprise, symbolized by Keyes. Wilder makes it clear that the former is tempting when Neff reflects, 'how could I have known that murder can sometimes smell like honeysuckle?' Yet he also stresses that Neff's shallowness is inadequate to the needs of the time. The key scene comes a little way into the film, when Keyes approaches Neff with the proposal that they join forces in the investigation division of the company. At this stage, Neff is still uncertain whether he will go through with the plan to murder Mr Dietrichson. Keyes offers him an escape route from the destructive path upon which he is about to embark. Keyes scorns the values of the salesman and makes a passionate speech about how an insurance investigator is a surgeon, a father confessor, a judge and a jury, someone who needs brains and integrity. Neff cannot see the attraction of a challenging job that pays a lower salary than he can earn as a salesman: 'nobody's too good to be a salesman', he tells Keyes. In the middle of the debate, Phyliss telephones Neff to confirm that the murder is to take place that very night. The choice, then, is plain. This is a parable for America's dilemma in 1943: should it reject the high moral tone of Roosevelt's New Deal welfare capitalism in favour of that unprincipled pursuit of profit which had brought disaster in 1929? Neff chooses to do so, and the consequences are devastating.

Wilder makes explicit the two murderers' lust for money. Phyliss tells Neff immediately that she married her husband for security, but that he is now in financial difficulties. After marrying Dietrichson, Phyliss explains, she discovered that all his life insurance was in the name of Lola, his daughter by his first wife. Phyliss wants the money. Her plans to acquire it through marriage have failed. Now she will murder for it. To emphasize the commercial nature of their partnership, Wilder has Phyliss and Neff's later encounters take place in a supermarket, surrounded by consumer goods and shoppers with trolleys. James Agee wrote that the film was 'shot through with money and the cooly intricate amorality of money', adding that 'among these somewhat representative Americans money and sex and a readiness to murder are as inseparably interdependent as the Holy Trinity'.[25] The wider significance of this ostensible thriller was certainly not lost on contemporary critics.

The effects of this heartless pursuit of money are shown to be destruction and dismemberment. The conspirators conceive their plan in a passion of lust, but cannot

thereafter risk meeting except in a supermarket. 'We did it so we'd be together,' Phyliss bemoans, 'but it's pulling us apart.' Neff recalls how, immediately after the murder, he and Phyliss had almost forgotten to kiss each other as they parted, and how he felt he had had 'the walk of a dead man'. Their dream of immediate wealth has turned into a nightmare, destroying the coherence of their relationship in the process, 'pulling apart' the forces that should bind society. The murderers are on a trolley ride together which can only end in the cemetery, says Keyes. Neither can get off without the other. Unprincipled greed is inseparable from the murder and destruction of the values enshrined in Keyes.

Neff sees himself resembling a roulette croupier, poised on the brink of dishonesty and finally plunging over the edge. In so doing, he betrays Keyes and all that he stands for. During the investigation suspicion falls on Neff, but Keyes trusts him implicitly and rules him out as a suspect. Keyes lays aside the calculating objectivity that he normally brings to an investigation, demonstrating an affection for Neff that transcends his commercial responsibilities to the company. But his trust is misplaced. At the end, Neff tells Keyes that he failed to solve the insurance fraud because the suspect was 'too close –right across the desk'. Keyes responds quietly, but with feeling, 'closer than that, Walter'. Their interdependence points to something at the very heart of American life. It is almost as if the survival of the nation's most profound values depends on an alliance between enterprise and moral rectitude. In a section of the screenplay that was not in the finished film, Keyes attends Neff's execution. He is completely shaken by his loss, as though Keyes has lost a part of himself. He fumbles for a match for his cigar and is brought up short by the absence of Neff to light it. The final shot was to have shown the following: 'Keyes slowly walks out into the sunshine, stiffly, his head bent, a forlorn and lonely man'.[26] Sensitivities about depicting an execution meant that this part of the film had to be removed from the release version.

The film's subplot of Lola's relationship with a young man, Nino Zacetti, introduced two representatives of America's future generation. They symbolize the hopes and prospects for the survival of Keyes' values. Neff forms an attachment to Lola after the murder and he finds moments of peace and contentment when he is with her. Her presence is what finally awakens his conscience and stimulates his doubt about continuing the fraud. Nino, on the other hand, is almost seduced by Phyliss after the murder, for her own ends. Neff saves him from Phyliss by killing her and sending Nino back to Lola. The film offers hope that the greed, lust and violence of their parents' generation will not taint the innocent and the young, who should inherit the idealism of the likes of Keyes. In his last few moments with Keyes, Neff tells him, 'I want you to take care of that guy Zacetti, so he doesn't get pushed around too much'. The aptly named Keyes is asked by the repentant Neff to act as custodian for the future values of the United States.

Double Indemnity was a significant early entry into the wave of Hollywood films that lamented the passing of the New Deal and alerted America to the threat of resurgent materialism and conservatism. Its mood was dark, its atmosphere bleak; Phyliss and Neff are shot almost always in subdued lighting, creating a dark inversion of a conventional romantic love affair. We cannot be sure of Wilder's commitment to the values in this

film, not least because he did not follow it up with any similar project. He may have been attracted more by the sensational aspects of the original story's explicit sex than he was by the battle for liberal values in 1940s America. Co-writer Raymond Chandler, on the other hand, had been expressing his anxiety about the direction of American social change in novels since the late 1930s. It might therefore be to him that we owe the film's central moral conflict. But Wilder was a supporter of the New Deal and he later related how he was struck on arriving in America by the overriding pursuit of money which informed the culture.[27] *Double Indemnity*, co-written and directed by Wilder, remains the best evidence that he consciously intended a defence of New Deal values. It seems likely that Wilder, a European in an alien culture, was acutely aware of the threatening social and political currents that were gathering strength at that time. He chose to make a statement about that trend, and he chose to do so under the cover of an entertaining thriller. As he wrote around this time, 'To sneak in a little mood, we have to blend it with plot'.[28] This may help to disguise the social criticism, but it does not lessen its quality. *Double Indemnity* remains one of the key films from this period which documents the decline of New Deal liberalism.

'Deeper and deeper into human problems': *The Lost Weekend*

In September 1944, immediately after completing *Double Indemnity*, Wilder began work on his most controversial – and arguably, most influential – film of this period, *The Lost Weekend* (1945). His decision to tackle the subject of alcoholism needs to be seen in the context of the search for more 'adult' subjects in mid-1940s Hollywood. As discussed in Case Study 1, Fritz Lang responded to this by formulating his ideas for 'affirmative resolutions' and writing of the need for more liberal censorship. Wilder went through a similar transition. His own ideas for the cinema matured as he too reacted to the more sombre mood in America during the closing months of the war. He complained to an interviewer in Los Angeles while shooting *The Lost Weekend* that the Hays Office was a restrictive force in Hollywood.[29] To a *New York Times* journalist, Wilder claimed after the film's release that the PCA Code prevented the growth and maturity of the cinema industry.[30] In an apparently unpublished article written shortly after the success of the film, Wilder discussed the censorship system as an 'obstacle … which discourage[s], rather than encourage[s], the manufacture of "adult" pictures'.[31] He concluded the article by expressing his confidence that the popularity of *The Lost Weekend* would encourage other film-makers to explore similarly difficult subjects, to 'dig deeper and deeper into present-day human problems'.[32] His film, he argued, had proved that modern audiences were ready and willing to support new ideas.

Once again, Wilder was consciously taking on a controversial subject. Charles Jackson's novel had, he recalled, 'created a furore in literary circles' when it was published, with its story of a long weekend spent in New York by an alcoholic on a major binge.[33] 'There was little bidding for the film rights', he explained, going on to describe the opposition he had encountered from the brewers and distillers on the one hand (who thought the film would damage their sales), and the Prohibitionists on the other (who expected the film to criticize

their unyielding moralizing over the problem of alcoholism).[34] Wilder took the opportunity to record his thanks to Paramount for their courage in supporting his unconventional screen experiment.[35] He was very conscious of the risk he had taken:

> The picture, you see, was really an experiment. It investigated a theme that was far off the beaten path. In producing it, Brackett and I went way out on a limb. [Yet] it proved not only that the public does not always have to have a moronic love story but that it will accept a serious study.[36]

The press reception of *The Lost Weekend* proved Wilder's point. Many reviewers praised the 'adult' nature of the film, which had nevertheless produced good box office returns. 'The screen acts its age', wrote one. 'The courage that is represented in this Paramount production cannot be overrated.'[37] Another welcomed its 'remarkable integrity' and wondered whether audiences, 'conditioned to the superficial, the trivial and the adolescent' might not find it 'too mature'.[38] Bosley Crowther approved the honesty with which the film had been made and its 'shatteringly realistic' content, judging it 'an overwhelming drama which every adult movie-goer should see'.[39] Wilder was paving the way towards a new cinema in America, one that rose to meet the challenge presented by the gravity and moral complexity of post-war American society. Hollywood could be, Wilder demonstrated, morally didactic and yet serious and in tune with the issues of contemporary life. He was forging a more socially critical cinema for 'adult' consumption.

Wilder's intentions with *The Lost Weekend* were radical. He wanted to show alcoholism as a serious social problem in the United States. He wanted to move the subject away from its traditional comic connotations and graphically depict the horror and degradation of the condition. His European origins stood him in good stead for the project, bringing a novel critical perspective on American attitudes towards alcohol. 'Because he was born and raised in Europe', observed a columnist for the *Los Angeles Times* during the film's production, 'Wilder is able to take a more objective view of drinking in America than most of us.'[40] Wilder told an interviewer that Europeans drank as an integral part of their culture, whereas Americans drank only to escape from the pressure of their lives. He emphasized the different cultural perspective that he was bringing to this film, drawing upon his European background to highlight the American context. He wrote that: 'Europe, I might point out here, does not have the liquor problem that exists in the United States'.[41] He elaborated on the nature of the American character that led to this difference and, at the same time, outlined the liberal view that his film would take on the issue:

> America is a very young, and therefore still inhibited, country ... We have puritanism on the one hand, gangsterism on the other, and so far no middle ground. In the picture we recognize hard drinking as a disease, which it is: but we also point out that when you run across a man so crippled, you don't suddenly snatch away his crutches.[42]

This tolerant and sympathetic attitude towards the alcoholic was a novelty in American cinema. Wilder wished to offer a completely different interpretation of the chronic drinker, which tried to capture the misery of the disease and which sought to inspire feelings of pity, not laughter or contempt. His account of this strategy is worth quoting extensively:

> In making our film on the evils of drink, Brackett and I ... decided to treat the story with the utmost sympathy, for we looked upon the hero as a sick man. But we refused to compromise with the situations or soften any of the harrowing details. It was our intent to report the facts as graphically and as intensely as we possibly could. To our mind, the story couldn't be more serious. And we were determined to keep it on this adult note at all times. Even if it flopped at the box office ... we felt that it wouldn't be the type of picture that an audience would forget ten minutes after filing out of the theater.
>
> The first thing that struck us as we went into production was a problem that is typically American: How could we break down the popular impression that this drunk was not a comedian? Drinking is considered a joke in America and drunks are usually inserted into the plot of a film for the comedial [sic] values ... In our project, however, the drunk was anything but a clown.[43]

Although written just after the film's release, this was not simply post-hoc rationalization. Wilder had made similar points to an interviewer during shooting, explaining that, although the drinker would be played 'brightly' at first, by the third or fourth day of the weekend 'it will be no laughing matter'. The journalist observed that the film portrayed

> a serious drunk. You will be asked to pity him, not split your sides laughing ... and that, my hearties, is a good deal to demand of the movie-goer brought up on rubber-legged Leon Errol, bulbous-nosed W. C. Fields, 'hic' cartoons and 'comedy relief inebriates'.

Wilder added that, 'A drunkard is a drinker who can't stop ... Every American family knows what that means, because every family has one – even if he's only a distant cousin'.[44]

The film's sympathy for the alcoholic sufferer was an important element for Wilder. A critic of his argued that he 'seems to be rather amused by the plight of the alcoholic [and that] he treats his characters with an obscene, obnoxious witticism'.[45] Brackett responded on behalf of both writers, saying that, 'The very core of *The Lost Weekend* was its insistence that a drunk is not the comedy figure he had usually been on the screen, but a tragically sick man'.[46] The film itself concluded with the alcoholic, Don Birnam, temporarily cured, musing on how many others there might be out in the city, 'comical figures' to the rest of the world but lonely, tragic figures to themselves, staggering from one binge to the next. It was a moving plea for the agony of the alcoholic. One reviewer praised the clever way in which the film brought sympathy to the weak central figure, a man with a sickness; the film, he concluded, was 'far from unimportant'.[47]

Wilder clearly anticipated problems with the censors – there were false rumours circulating that the Hays Office had banned the project[48] – and dealt with them by producing the script

in isolated segments while shooting was already in progress. Breen repeatedly expressed his annoyance at this practice, but appeared powerless to stop it.[49] Whether because of this strategy or otherwise, Breen raised no objections to the film's subject matter. Indeed, when the film ran into censorship trouble in Ohio, because of its criticism of Prohibition, Breen offered his advice and help on how to protect the picture's 'revenue possibilities'.[50] The film managed to offend both ends of the spectrum: the liquor interests and the Prohibition lobby both raised objections to the film. The former expressed their 'very serious concern about the possible adverse effect' of the film during its production, but after the preview decided to keep a low profile as the best means of defence.[51]

The Prohibitionists had more to worry about. Wilder indicted them as one of the primary causes of America's alcohol problem. He told an interviewer during production of the film that, in the alcoholic ward sequence, the intern's expression would be intended to convey the message that, 'If you think this is bad, you should have seen it during prohibition'.[52] In the event, the intern expresses this sentiment directly in the film, commenting that, 'Prohibition started a lot of them off'. Censor boards in Pennsylvania and Ohio eliminated the line and tried to cut down the alcoholic ward sequence, provoking a major row with Paramount. The studio's East Coast production contact explained to his fellow employees that, 'Ohio is a big temperance state and the requested eliminations are obviously the result of the censor's desire to eliminate any alleged attacks on the dry cause'. He added that much of the opposition was 'due to the peculiar viewpoint of our friend Miss Susannah Warfield', an official of the Ohio censor board.[53] Wilder himself remained unmoved, commenting after the film's release that, 'No one knows why America became such a heavy-drinking country. Prohibition undoubtedly was one of the causes.'[54]

The Lost Weekend certainly lived up to the expectations of controversy and challenge. It relentlessly charted the depths of degradation to which alcoholism could reduce a victim. Sheltering behind the illusion that alcohol makes him 'supremely confident', novelist Don Birnam plunges deeper into incapacity, unable to begin his new book. He steals money intended for the cleaning lady to buy himself more whisky. He steals a lady's handbag while in a bar, to pay for the drinks he has consumed there. He trudges miles up a New York avenue, desperately seeking to pawn his typewriter for money to buy alcohol, exchanging the tool of his professed trade for the very thing that is destroying his prospects of success. He holds up a shopkeeper to secure another bottle. He spends a night at the alcoholic ward of the local hospital, where he observes the horrors of patients with delirium tremens. Escaping from the ward, he returns to the apartment and himself suffers from DTs, seeing a bloody encounter between an imaginary bat and a mouse.

It was a disturbing film, which conveyed the contemptible means employed by Don to acquire his liquor and yet still evoked sympathy and pity for his desperate condition. As his girlfriend Helen says, he is 'a sick person', suffering from an illness like heart or lung disease. For their ending, Wilder and Brackett rejected the book's pessimistic conclusion, in which the hero sets out on another binge. Instead, Wilder showed a reunion between Don and Helen, and Don's decision to start his novel – about his battle with alcohol – in earnest. In terms that

remind one of Lang's ideas for the affirmative resolution (first articulated around this time), Wilder defended his ending against the criticisms made by a number of reviewers:

> The ending, of course, gave us a bit of trouble. [The book's ending] wouldn't prove anything. Besides, we gain nothing by ending the film on a question mark. So we hit upon the idea of having the barkeep deliver the typewriter, and the drunk start writing his novel. We don't say that the man is cured. We just try to suggest that if he can lick his illness long enough to put some coherent words down on paper, then there must be hope.[55]

Some reviewers saw the affirmative resolution as an evasion, ending 'rather half-heartedly, as if [the film] didn't really believe in its solution'.[56] Others, however, understood the complexity of Wilder's conclusion, writing that it 'in no way vitiates the savage insistence of the exposition', that it was 'sardonic' or, in one extreme response, that Birnam's last-minute reform was 'clearly the crowning phantasy of a doomed man. He doesn't write his novel, he verbalizes a dream of success'.[57] In any event, the overall impact of the film was beyond doubt. Wilder had produced a novel film that tackled an important social question in a mature, uncompromising way. His European perspective on drinking in America clearly brought to the film an extra dimension. *The Lost Weekend* was his contribution, first glimpsed in *Double Indemnity*, to the increasing seriousness with which Hollywood depicted American life and values.

The film was commercially and critically successful. Wilder estimated that it yielded around five times its original cost on its first release.[58] It won Oscars in 1945 for best picture, best director, best script and best actor (Ray Milland). Its effect on American attitudes to drinking can, of course, never be gauged. However, when a New York reviewer asserted that, 'Unless I am badly mistaken, *The Lost Weekend* will do far more than Alcoholics Anonymous, the W.C.T.U. [Women's Christian Temperance Union], or preachers to check uninhibited drunkenness', certain evidence appears to prove him right.[59] Corporal Don Inglis wrote to his mother in April 1946 to tell her of the effect *The Lost Weekend* had had on his fellow soldiers. Many had stopped to think seriously about their drinking, which included 'shaving lotion, hair tonic, and even lighter fluid when other drinks weren't available'. It had strengthened Inglis's own 'ideas against alcohol' and helped him 'realize that a moraless [sic] worldly life is bound to end up in unhappiness'.[60] Wilder, it appears, had assisted at least one sinner towards the light.

Notes

1. The account of Wilder's early life and career which follows is derived from Sikov, *On Sunset Boulevard*.
2. As Sikov, *On Sunset Boulevard*, reports, 172. But Sikov is less convincing when he suggests that perhaps the studio gave Wilder the chance to direct, 'so he would fail and teach other aspiring writer–directors a lesson'.

3. See, for example, Sarris, *American Cinema*, 165–67, in which he categorizes Wilder as 'Less Than Meets the Eye'. Sarris's 'theory' is somewhat undermined by his subsequent change of opinion: see Sarris, 'Billy Wilder: Closet Romanticist', *Film Comment*, 2 (July/August 1977), 7–9. See also Robert Mundy, 'Wilder Reappraised', *Cinema* (October 1969), 14–19, for a brief survey of Wilder's critical reputation and Mundy's alternative evaluation. However, Higham and Greenberg, in *The Celluloid Muse*, 12, categorize Wilder as among the creative artists 'whose films make some kind of statement about the human condition, or express some deeply-held outlook on life in a recognizably individual style'.
4. Billy Wilder, 'One Head is Better than Two', *Films and Filming* (February 1957), reprinted in Koszarski, *Hollywood Directors*, 271–72.
5. 'Billy Wilder: the Playboy Interview', *Playboy*, 10 (June 1963), 57–66.
6. John Gillett, 'Wilder in Paris', *Sight & Sound*, 6 (Winter 1956–57), 142–43.
7. 'Billy Wilder: the Playboy Interview', *Playboy*, 10 (June 1963), 57. For further instances of Wilder's interview style, see R. Gehman, 'Charming Billy', *Playboy*, 7 (December 1960), 69–70, 90, 145–48.
8. See Philip K. Scheuer, 'Wilder Seeks Films "with Bite" to Satisfy "Nation of Hecklers" ', *Los Angeles Times* (20 August 1950), IV, 1, 4; 'Billy Wilder: Broadcast to Kuala Lumpur', *Action*, 5 (November/December 1970), 18. See also Scheuer's approving remarks about Wilder keeping 'both feet on the ground' rather than being arty: 'Die Cast on Doings of a Drunk', *Los Angeles Times* (3 December 1944), III, 1–2.
9. *Liberty*, 23 (4 May 1946), 18–19, 59; Lincoln Barnett, 'The Happiest Couple in Hollywood', *Life*, 17 (11 December 1944), 103. Wilder is described as a 'Russophile' here (109).
10. *Liberty* (4 May 1946), 19; Barnett, 'The Happiest Couple in Hollywood', *Life*, 17 (11 December 1944), 103–4. The text that follows contains examples of Wilder's practice of sending Breen scripts in a piecemeal fashion.
11. Billy Wilder, 'The Case for the American Film', 4, in the Margaret Herrick Library, Los Angeles, Wilder personality file (no published source; can be dated with confidence to 1946).
12. Maurice Revnes to Breen (9 October 1935), PCA, Double Indemnity file (hereafter, 'DI').
13. Breen, letter to Louis B. Mayer (10 October 1935), PCA, DI.
14. Breen, copies and note of telephone call (14 October 1935); a 'tentative outline treatment' from Nunnally Johnson of Twentieth Century-Fox was judged by Breen as potentially acceptable, but nothing came of this – Breen, memo (19 October 1935); both PCA, DI.
15. Breen, letter to Luigi Luraschi (15 March 1943), PCA, DI.
16. Luraschi, letter to Breen (21 September 1943), PCA, DI.
17. Breen's initial reaction was almost wholly favourable, concerned largely with helping Paramount avoid local censorship of the execution scene (in the event, cut after a preview) and of the scene detailing the disposal of the corpse; Breen, letter to Luraschi (24 September 1943). Further script sequences followed between 28 September and 29 November, which met with Breen's approval subject only to minor changes; the film was viewed on 15 December and the certificate issued the next day; all PCA, DI.
18. David Hanna, 'Hays Censors Rile Jim Cain', *Los Angeles Daily News* (14 February 1944), 12–13.
19. Howard Barnes, *New York Herald Tribune* (September 1944), 18, PCA, DI.
20. Herb Sterne, *Rob Wagner's Script* (26 August 1944), in Anthony Slide (ed.), *Selected Film Criticism: 1941–1950* (Metuchen NJ, 1983), 47–48.
21. Bosley Crowther, *New York Times* (7 September 1944), 21.
22. James Agee, *The Nation* (14 October 1944), in Agee, *Agee on Film: Reviews and Comments by James Agee* (n.p., 1958), 119–120.

23. Bosley Crowther, 'The Movies', in Jack Goodman (ed.), *While You Were Gone: a Report on Wartime Life in the United States* (New York, 1946), 517.
24. Howard Barnes, *New York Herald Tribune* (September 1944), 18, PCA, DI.
25. Agee, *Agee on Film*, 119–120.
26. 'Double Indemnity', screenplay (25 September 1943), Paramount.
27. See his comments in Higham and Greenberg, *The Celluloid Muse*, 253, repeated almost verbatim in *Literature/Film Quarterly*, 4 (Winter 1976), 10.
28. Wilder, 'The Case for the American Film', 2.
29. Scheuer, 'Die Cast on Doings of a Drunk', *Los Angeles Times* (3 December 1944), III, 1–2.
30. 'End of a Journey' *New York Times* (23 September 1945), II, 3.
31. Wilder, 'The Case for the American Film', 2–3.
32. Wilder, 'The Case for the American Film', 10.
33. Wilder, 'The Case for the American Film', 4.
34. Wilder, 'The Case for the American Film', 4–5.
35. Wilder, 'The Case for the American Film', 3.
36. Wilder, 'The Case for the American Film', 10.
37. Howard Barnes, *New York Herald Tribune* (3 December 1945); in PCA, Lost Weekend file (hereafter, 'LW').
38. Sterne, *Rob Wagner's Script* (15 December 1945), in Slide (ed.), *Selected Film Criticism, 1941–1950*, 124–26.
39. Bosley Crowther, *New York Times* (3 December 1945), 17. See also *Variety* (15 August 1945) and 'Critic's Quotes', a survey of East Coast reviews, *Motion Picture Daily* (6 December 1945); both PCA, LW. *Hollywood Reporter* (14 August 1945), however, enjoyed the film for what it perceived as a critical assessment of an alcoholic, 'a menace to himself and an even worse menace to those around him'. The review went on to lament the lack of sympathy for the virtuous brother in the film; see PCA, LW.
40. Scheuer, 'Die Cast on Doings of a Drunk', *Los Angeles Times* (3 December 1944), III, 2.
41. Wilder, 'The Case for the American Film', 5–6.
42. Scheuer, 'Die Cast on Doings of a Drunk', *Los Angeles Times* (3 December 1944), III, 2.
43. Wilder, 'The Case for the American Film', 6–7.
44. Scheuer, 'Die Cast on Doings of a Drunk', *Los Angeles Times* (3 December 1944), III, 1–2.
45. Herbert G. Luft, 'A Matter of Decadence', *Quarterly of Film, Radio and Television*, 7 (Fall 1952), 62.
46. Charles A. Brackett, 'A Matter of Humor', *Quarterly of Film, Radio and Television*, 7 (Fall 1952), 68.
47. James Shelley Hamilton, 'New Movies' (October 1945), in Slide (ed.), *Selected Film Criticism, 1941–1950*, 126–27.
48. See Arch Reeve, memo to Breen (11 September 1944), reporting Jimmy Fidler's radio broadcast to that effect; the tone of the memo makes it likely that the broadcast was not factually correct; see PCA, LW.
49. Sequences A to E were sent to Breen between 12 September 1944 and 2 January 1945, with continual revisions, additions and repeated apologies for the 'piecemeal fashion' (Luraschi, letter to Breen, 24 October 1944). Luraschi wrote to Breen that shooting had started on the lot 'today' (23 October 1944); all PCA, LW. For Breen's complaints about this practice, see his letters to Luraschi (24 October, 7 and 24 November, and 7 December 1944), PCA, LW.
50. Luraschi, letter to Breen (17 September 1945), in response to Breen's offer of help – the quotation is from Luraschi; PCA, LW.

51. See the letter from Stanley Baar, executive vice-president of Allied Liquor Industries, to Y. Frank Freeman of Paramount (13 November 1944) and the briefing issued jointly by the ALI and the Conference of Alcoholic Beverage Industries to their press liaison officers (29 October 1945). This confidential briefing was possibly leaked to Luraschi, as he somehow obtained a copy and sent it to Breen (4 December 1945); all PCA, LW.
52. Scheuer, 'Die Cast on Doings of a Drunk', *Los Angeles Times* (3 December 1944), III, 2.
53. Russell Holman, letter to Luraschi (15 September 1945), PCA, LW.
54. Wilder, 'The Case for the American Film', 6.
55. Wilder, 'The Case for the American Film', 8.
56. Hamilton, 'New Movies', in Slide (ed.), *Selected Film Criticism, 1941–1950*, 126–27. See also *Daily Variety* (14 August 1945) and *Variety* (15 August 1945); both in PCA, LW. Crowther, *New York Times* (3 December 1945) felt that the 'climax of regeneration' was 'somewhat off-key … but it has the advantage of relieving an intolerable emotional strain'.
57. Barnes, *New York Herald Tribune* (3 December 1945); *Hollywood Reporter* (14 August 1945); both PCA, LW; and Sterne, *Rob Wagner's Script* (15 December 1945).
58. Wilder, 'The Case for the American Film', 4.
59. Barnes, *New York Herald Tribune* (3 December 1945).
60. Corporal Inglis, letter to his mother (5 April 1946), sent by Will Hays to Breen (25 April 1946); in PCA, LW.

Chapter 4

The Devil is a Woman: Hollywood Films and the American Woman

In Chapter 1 I described how the otherwise liberal culture of the New Deal provided no place for the liberated woman. Despite the social and economic reality that more and more women had joined the workforce, and despite women playing an increasing role in American politics and social institutions, popular culture of the 1930s did not accommodate this trend. The more women invaded the traditional space and roles of males, the more urgent it appeared that they should be reminded of their place in the domestic sphere. This hostility towards female independence became more marked after the war, when returning servicemen wanted their jobs back – jobs that had been very effectively discharged by women in the absence of the fighting men.

Hollywood's role as the self-appointed mouthpiece and cultural leader for Roosevelt's New Deal gave it a platform to expound contemporary notions of femininity. In a large body of films from 1933 to 1948, American film-makers reinforced the values which underlaid the repression of female independence. Codes of conduct for women in mainstream Hollywood cinema emphasized passivity and submission to male control. Women's desire to deploy their intelligence and resourcefulness was often acknowledged, but almost always denigrated and ridiculed. Their legitimate sphere of influence and responsibility was limited in these films to the home, to marriage, to supporting a husband and rearing children. Portrayals of the American woman in this period would, more often than not, advocate for her an essentially domestic role. Independent thinking or actions by women – most certainly career aspirations – were denigrated. Women in these films who seek independence find that it brings unhappiness. They become dysfunctional; they lose the chance of a happy marriage and children; they feel alienated from society. Very often these assertive women are shown as heartless and cruel, as unfeminine; time after time a strong man will tame them and point out the error of their ways. There was an unremitting hostility to female intelligence, enterprise and self-assertion. The broadly consensual nature of American culture, politics and society in the 1930s meant that the films were complacently confident about the subordinate position of women. It was certainly an issue to be discussed, but the outcome was pre-ordained and straightforward. Women were likely to flex their muscles, the films argued, and seek alternatives to their narrowly prescribed options in life – but they were capable of being controlled and would come to heel.

The 1940s saw a significant change. Women's place in American society was undergoing rapid transformation in the circumstances of World War II. Working-age men were away fighting; war production placed huge burdens on industry. Women squared this circle by joining the workforce in unprecedented numbers. Hollywood's depiction of the American

woman changed accordingly. The breakdown of the New Deal consensus and the resurgence of political faction contributed to an uneasiness on the part of Hollywood's liberal community. Taken together, these forces of instability led to a harsher appraisal of women's demands for independence. Here too, Hollywood was faithfully capturing the dominant American culture. In post-war America, the urge to maintain women's domesticity developed into a fear of female independence and a marked hostility towards women expanding their role outside the home. At first this took the form of aggressive depictions of female characters in films, associating women with crime and murder, as well as immorality. The complacent assertion of the previous decade, that women knew their real place and would go back to it when commanded, vanished. The resulting social anxiety led to films with a harder edge in their portrayal of the American woman. At the same time, the complexity of women's position created the phenomenon of the 'good–bad girl'. This permitted a reluctant endorsement by the film industry of the reality of female power in contemporary society, but one contained in an outer layer of old-fashioned femininity. In these different images of womanhood in 1940s films, Hollywood was again giving voice to the country's anxieties about the direction of social change in the United States.

Hollywood and the domestication of the American woman: 1933–1946

Hollywood often used the vehicle of romantic comedies to explore relations between the sexes. Babington and Evans, in their *Affairs to Remember,* argue that 1930s comedies were 'a meditation on equality between the sexes, intuitive rather than didactic, crossed at many points with the contradictions of a specific social ideology'.[1] In other words, the films were unconsciously exposing the complexity of male–female relationships, with no authorial point of view. I disagree. In my analysis, 1930s films (comedies and otherwise) were intensely didactic and generally took a clear oppositional stance to women's rights. Other modern writers have claimed that, although many films demonstrate overt hostility to women, this attitude is undermined by hidden feminist subtexts. Writers such as Annette Kuhn, E. Ann Kaplan and Molly Haskell argue that Hollywood did indeed seek to control women in its fictions but, as Kuhn puts it, 'fortunately for feminists' these narratives were 'not always completely successful'.[2] Often, she argues, the films raise questions which the narratives cannot 'contain'. This allows Kuhn to 're-appropriate for feminism' mainstream Hollywood product, based on hidden narrative codes 'not open to immediate observation'.[3]

My view is that the overt hostility to women's rights present in a great number of American films accorded well with the widespread social attitudes of that time. It is not clear why there should be hidden subversive agendas in these films, nor who might have smuggled them in. I do agree with Kuhn and her supporters, however, that the films' hostility towards female independence betrays an underlying social anxiety about the issue. The more films one watches from this period, the more consistent is this theme of female oppression. It helps, therefore, to draw upon a wide sample. As mentioned in Chapter 2, theoretical scholarship

is almost invariably based on a detailed analysis of a very small number of films, from which generalized conclusions are drawn.[4] Moreover, feminist theorists neglect the socio-historical context in which these films were made. Molly Haskell, in *From Reverence to Rape*, correctly identifies the changing nature of hostile depictions of women between the 1930s and the 1940s. But her historical analysis is, to say the least, rather anecdotal:

> The woman's film underwent a change between the thirties and forties ... The forties were more emotional and neurotic ... thirties heroines were spunkier and more stoical than their forties sisters ... The social structure wavered in the forties, with women moving up the employment ladder and down from the pedestal ... There is, as a result, a constant ambivalence in forties' films, a sensibility that is alternately hard and squishy, scathing and sentimental.[5]

The position of women in 1930s and 1940s American society might strike us today as unduly oppressive, and their choices limited, but this was not how the majority of people, men and women alike, would have viewed things at the time. Feminism as a concept had not developed very far. The suffragist movement in the early twentieth century had won women the vote, but the seismic shift in women's rights was not to occur until the women's movement of the later 1960s. Expanding economies and rising prosperity in the West since the 1950s have created a very different basis for women's participation in modern life. Today, any company that sought to exclude women from senior posts would face a serious competitive disadvantage, not to mention the fact that, in many countries in the West, they would be breaking the law. Women now go to university in numbers that would have seemed unthinkable in the 1930s. We take for granted the presence of women in the judiciary, as professors, as senior executives, lawyers, and so on. Nevertheless, even today, forty years or so after the feminist movement of the 1960s, women are still not represented proportionately in senior positions in industry and elsewhere. In the days of Roosevelt, however, expectations of women, and women's expectations of themselves, were far more restricted than today. Hollywood reflected these attitudes. And, because the position of women was changing, Hollywood articulated the cultural debate about how that change should be navigated. Hollywood responded to contemporary concerns about the position of women, not only with the sheer volume of films dealing with relations between the sexes, but also with the particular ideological response proffered. Hollywood films helped to support values of sacrifice and suffering for women, stressing the female roles of support and forgiveness. Male 'problems' were not tackled in anything like as much detail; for most of these films, the 'problem' was seen to be the woman. Support for marriage as an institution was trumpeted with a noticeable stridency and frequency, indicative, perhaps, of an underlying concern about its durability in America at that time.

The dominant motif in Hollywood's treatment of women in the 1930s was the insistence that they should not assert themselves against male authority. This overarching aim was realized through a comprehensive cultural strategy, pursued by Hollywood's film-makers across a range of genres and subject matters. Opportunities for female assertiveness were

considered and, usually, decisively rejected. Women were not to challenge male power in the marketplace by seeking employment; they were not to challenge male power in the home by seeking to choose their own spouses or by trying to exercise control over the conduct of courtship. When married, they were to remain sexually faithful but were to overlook male philandering. Finally, women were not to use their sexual power over men to advance their social status or economic position. True, traditional feminine qualities of self-sacrifice and noble suffering had also penetrated masculine cultural representations. Yet there was a hectoring insistence regarding Hollywood's portrayal of female conduct. This was a time of rising divorce rates and uncertainty about the position of women in society. Hollywood did not usually engage with these issues directly, but instead offered morality stories designed to encourage women to preserve their marriages and accept passive roles.

The Wrong Divorce

A good place to start is George Cukor's *The Women* (Cukor, 1939). This film exemplifies the theme of male infidelity and corresponding female docility. It has an all-female cast and was derived from a successful Broadway play, written by a woman. The story explores the effect on a woman of her decision to divorce her husband. Mary Haines learns that her husband is having an affair with a shop assistant. Mary's mother counsels her to exercise caution before destroying 'her home and family'. The older woman remembers how her own husband had been unfaithful, and how she had accepted his infidelity. Mary counters that her mother's values relate to the days when 'women were chattels … but now we're equal'. Such feminist views are advanced in the film only for the purpose of exposing them as ill-advised. After Mary starts divorce proceedings, her mother's advice becomes sterner. She explains how much better things were fifty years ago, when divorces were unobtainable and women were not able to destroy the lives of their children. This divorce is an avoidable tragedy, brought about, the film shows, not by the male's philandering, but by the female's wilful behaviour. In Reno a group of women on the verge of divorce are introduced, and Mary's apparently foolish behaviour unravels. One of the women tells Mary, pride is 'a chilly exchange for the guy you're stuck on'. Mary's new friend then discovers that she herself is pregnant. Demonstrating that she is a model of wifely submission, she promptly changes her mind about *her* divorce, and decides to return, to 'do everything Johnny says'. Mary meets another woman in Reno who reprimands Mary for her cowardice in divorcing her husband, for 'deserting him', for not standing by him during his crisis and winning him back through love. She reminds Mary that she cannot act as though she is a schoolgirl sweetheart – she is a wife, with responsibilities to her husband. In the end, eighteen months after the divorce, Mary returns to remarry her husband. She has learnt that pride is 'a luxury a woman in love can't afford'. The film focuses on Mary's attitude as the problem, not on her husband's conduct. Her assertiveness has destroyed her home and brought Mary only misery. Furthermore, her motives have been basely selfish and needlessly arrogant. There is little or no criticism of her husband.

A wrong-headed decision to divorce was used in other films as a device to penalize assertiveness in women. In *Wife versus Secretary* (Brown, 1936), Linda Stanhope is misled by gossip into believing that her husband is having an affair with his secretary. Ignoring her wiser mother-in-law's advice, Linda decides to leave her husband. She soon regrets her decision and returns, her unquestioning devotion regenerated and strengthened by her brief experience of independence. In *Love Crazy* (Conway, 1941), Susan Ireland misconstrues an innocent evening her husband has with an old flame and institutes divorce proceedings. Despite good advice to the contrary, the proud and stubborn woman ploughs on with her misconceived plans, until she comes to realize how much she misses her husband. Eventually, she understands her mistake, seeks her husband's forgiveness and the couple are reconciled. The misguided divorcing wife Victoria in *We Were Dancing* (Leonard, 1942) embarks on divorce proceedings when she suspects that her husband is infatuated with an old flame. Despite his struggles to prevent the divorce, a decree is granted. Instantly regretting her action, Victoria bursts into tears. When her husband pretends that he is to remarry, she becomes jealous, sees the error of her ways and quickly returns to him. The film had opened with the two of them dancing on a balcony at a society party. It closes with them, still dancing, only now in the kitchen, a tranquil domestic scene with Victoria more appositely clad in an apron rather than a ball gown.[6]

The Courtship Model

The 'wrong divorce' theme was not the only strategy for denigrating women who sought to control their lives. A commonly deployed alternative was to examine the process of courtship. The standard structure of these films sees a strong-willed woman attempting to resist male power and to control the conduct of the romance. Sometimes the woman is seeking to exercise her own judgement over whom she will wed. A strong male character then 'educates' her, explaining how empty will be her life if she does not learn to obey a man's will. He may at some point in the film use or threaten corporal punishment to bring the woman to heel. Any such spanking is presented as comic. The woman's refusal to accept male control is associated with selfishness, snobbery and stubbornness – in other words, the antithesis of New Deal values. The wooing male, on the other hand, is identified with reason and has the status of the common man. Whereas the male is passionate, the assertive woman is frigid. Frigidity is thus identified with female assertiveness – the withdrawal of sexual favours in order to control a man. It also signifies that assertive women are repressed and unable to locate their own sexuality – they remain unattractive to men until they give themselves on his terms. The man in these films teaches the woman that she will find true happiness and liberation only through marriage and control by the husband. The man's side of the bargain is to give up casual affairs and provide the security of marriage.

An early example of this courtship model is Capra's first major success, *It Happened One Night* (Capra, 1934). This tells the story of spoilt heiress Ellen Andrews, who learns what

a woman's role should be from a strong, man-of-the-people journalist. She embodies the 'anti-New Deal' values of snobbism, selfishness and irresponsibility. She seeks to control her married life by choosing a playboy aviator, another symbol of social recklessness. After a series of adventures shared with the journalist, in which Ellen experiences 'real life' – bus journeys, hitchhiking, shared cheap motel rooms – she embraces New Deal values of social responsibility and gives up the wastrel aviator. *The Bride Came C.O.D.* (Keighley, 1941) takes up a similar theme. June Winfield is a Texan oil heiress whose casual attitude to marriage stems from her wealth and her spoilt, selfish nature. As in many other films, the woman's assertiveness is paralleled with an equally undesirable trait: the selfishness of the rich. Her snobbish arrogance marks her out as someone who does not share the New Deal values of anti-materialism and social egalitarianism. Having 'spent the last two years in nightclubs', she is completely out of touch with the lives of ordinary Americans. She is proposing to marry a most unsuitable man of her own choice. When a pilot, Steve Collins, kidnaps her, an enforced sojourn together follows. Initially hostile to each other, the couple gradually fall in love. Whereas June is rich and undemocratic, Collins is brash, has native wit and is in touch with the real world of ordinary people. Trapped in a mine with Steve towards the end of the film, June reflects on the emptiness of her life – 'silly, useless, impulsive'. She has learnt from Collins to be less selfish, more democratic and, above all, to submit to the male hero's decisions over her marital future. Thus tamed, her marriage to Collins – not her original choice – can proceed.

Red Salute (Lanfield, 1935) concerns the turbulent courtship between a college student and 'feminist', Drue van Allen, who has new ideas about the role of women, and a patriotic young soldier, Jeff. The deviance of Drue's feminism is reinforced by allying her independent stance with communism – she intends to marry Leonard, a campus agitator. The film throws her together with Jeff for a period, from whom she learns the error of her feminist ways. Jeff tells her that divorce is too easy to obtain these days: if that is freedom for women, he says, then he would rather have slavery. We learn that Drue does in fact yearn for romance, but has repressed her 'natural' feelings under intellectual pretensions about modern women. Her feminism is an affectation. Jeff tells Drue, 'you don't want experience, you just want to read about it'. Thus her intelligence and rationality (reading) are compared unfavourably with impulsive living (experience). There is a sense here of a woman's 'natural' character and her 'affected' character, a difference between intuition or impulse, and rational thought. The latter is criticized, because it might provide the tools for female self-control and power. The former is applauded, because it suggests a loss of control and an acceptance of male power. Jeff goes to see Drue's father and tells him that he has neglected his daughter, that she should have had all these new ideas 'spanked out of her'. In the final scenes, Jeff incites a riot against Leonard and his followers, whereupon Leonard is arrested as a troublemaker and deported (it turns out that he wasn't really American after all). Drue van Allen marries Jeff, and America is saved from both communism and feminism.

The exposure of alleged feminist pretensions – usually meaning a desire to work – appears in other films of this period. In *The Strawberry Blonde* (Walsh, 1941), a period piece, 'Biff'

Grimes reluctantly dates Amy, a suffragette and a career woman. She openly flirts with men, smokes and does not believe in marriage ('started by the cavemen and developed by florists and jewellers'). She favours sex outside marriage. When Biff takes Amy at her word and tries to kiss her, she screams in outrage. The would-be feminist is horrified when her 'modern' values are taken seriously. Her claim to be independent and assertive is a frivolous delusion. Amy wakes up to her 'femininity' (rather than feminism) and finds contentment in marriage to Biff. Similarly, in *Without Reservations* (LeRoy, 1946), Kit Madden, the female author of a best-selling political work, encounters the macho Rusty. He challenges her self-image of a freethinking woman who writes meaningful works. Rusty tells her that he wants a woman, 'who's helpless, who's cute … [not one] trying to tell the world what to do. I don't even want a woman to tell *me* what to do.' Kit promptly drops all interest in her writing – she now sees it was merely 'the cream puff school of fiction' – and so becomes a woman suitable for marriage and domestication.

There are many other films that use the courtship model to examine female roles. I will briefly mention three (there is a long list of other films to explore in the note).[7] *Piccadilly Jim* (Leonard, 1936) has one scene in which the title character tells his chosen girl that she should not attempt to choose her own husband on the basis of logic. Marriage cannot be engineered, he explains; a woman must be guided by instinct alone. Rationality and intelligence in a woman are thus derided. She accedes to his control and drops her own choice of husband. Again, her choice is associated with unacceptable, snobbish values – she was planning to marry an English lord. *Gone with the Wind* (Fleming, 1939) has, as a central part of its plot, Scarlett O'Hara's refusal to acknowledge the great love of her life, Rhett Butler, through her insistent pursuit of a fantasy match with Ashley Wilkes. *The Philadelphia Story* (Cukor, 1940) exposes the selfish and wilful nature of Tracy Lord in not forgiving her husband's drunkenness and continuing with her plans to marry another man. In all of these films, the lesson for the male is a simple rejection of cynicism at an early stage of the story, a rejection made voluntarily and assertively. In contrast, the female stubbornly refuses to accept her station until the male has reduced her to helplessness.

The curse of the career woman

A variant of the courtship model is found in films that examine what happens to women who *do* stick to their guns and pursue a career. Two good examples of this both star Katharine Hepburn. In *Break of Hearts* (Moeller, 1935) Hepburn plays Constance, a budding pianist who marries a famous, womanizing conductor, Franz Roberti. She marries him not because of love, but because he can help advance her career. The viewer thus learns early on in the film that Constance intends to neglect her 'true' vocation as a housewife to pursue ambitions outside the home. The marriage is not strong enough, therefore, for her to tolerate one of Franz's sexual indiscretions. Although he apologizes to her, she retorts that it is not enough 'just to be your wife' and leaves him. The rest of the film demonstrates the folly of her conduct.

Constance becomes lonely. Her artistic ambitions are shown to be mere pretension, and she is reduced to working in a music store. A chance meeting in New York with Franz shows that she is secretly miserable in her new, independent life. Although he is too foolishly proud to ask her back, we understand that it is Constance's duty to forgive him. Franz declines into alcoholism as a result of her refusal to ask him to have her back. Eventually, after a 'quickie' divorce in Reno, Constance has a revelation: 'maybe I wasn't born to *be* a musician, but to love one'. She rushes to Franz's bedside, rouses him from his coma (with the song that first brought them together) and begins to tend him at his home. She tells her old friend Johnny, 'it's where I belong'. The final shots show Franz, recovered from his alcoholism, conducting again to great applause. No one is more enraptured than Constance, standing dutifully in the wings. No longer has she aspirations to be an artist in her own right; she is content now to be a spectator at her husband's career.

Katharine Hepburn also starred in *Woman of the Year* (Stevens, 1942). This film provided another opportunity for Hollywood to scoff at independent women. It is a study of a dynamic foreign affairs correspondent, Tess Harding, who we rapidly learn is a failure both as a wife and as a mother. A similarly career-oriented female friend has decided to marry. She tells Tess that she has realized it is not enough in life to win career prizes: 'this time I want to *be* the prize'. Female success is empty compared to the privilege of being a housewife. Tess fails to take this message on board. She is too busy being important to be a decent wife or mother. She neglects her husband, preoccupied with her business affairs. She adopts a baby instead of having one of her own. Even then, she is so neglectful of her maternal duties that the child returns to the orphanage of his own volition. Shortly after this, Tess's husband leaves her. When she tries to make amends by cooking him breakfast, she proves incapable of making waffles. Her final plea, to a sternly unrelenting husband, is that she be allowed to become an average housewife for him. Thus, at the film's end, the domestication of a woman who had got beyond her female station is complete.

While these two films are exemplary illustrations of Hollywood's depiction of career women, there are many others. A brief review of six representative films follows, with numerous others mentioned in the notes.[8] In *A Woman Rebels* (Sandrich, 1936), an independent-minded woman in Victorian England (played yet again by Katharine Hepburn) sets up her own feminist newspaper. In this example, the woman's unconventional feminist views and her pursuit of a career in journalism lead to the loss of her daughter's love. Her problems are solved only when she gives up her crusading newspaper.[9] *Stella Dallas* (Vidor, 1937) illustrates the incompatibility of ambition and motherhood. A socially aspiring mother has no time to look after her daughter and is forced to give her up to the care of a conventional family. At the end of the film, we see Stella lingering outside the window of the house where her daughter now resides. Stella is a lonely, tragic figure, on the outside of society, looking in on a scene of domestic bliss from which she has excluded herself. *Lillian Russell* (Cummings, 1940) addresses the issue of women's rights by depicting the life of a suffragette. The eponymous heroine learns how the apparent benefits of feminism actually result in unhappiness – but she rediscovers her joy in marriage and motherhood.

In *Gone with the Wind*, Scarlett loses her child and miscarries a second as a consequence of her ruthless ambition. Her personal assertion invalidates her right to motherhood. *The Hard Way* (Sherman, 1942) studies another ambitious woman. In a twist on the usual theme, the central character drives her sister to a successful career on the stage. The young sister's success causes her husband to kill himself – he is unable to suffer the indignity of being known solely as a successful woman's husband. *To Each his Own* (Leisen, 1946) uses melodrama to show how a career woman cannot justifiably expect to bring up her own child. Reprising the theme explored in *Stella Dallas*, a woman comes to accept that her aspirations have disqualified her from the right to motherhood. She leaves her child to the care of a conventional family.

The call to sacrifice

Finally, a different way of discussing the necessary submission of women was to glorify a woman's call to noble suffering and to place it in the context of some higher pursuit. This allowed an exploration of female sacrifice and passivity, but provided a more uplifting ideal than merely being a wife or mother. Meaningful sacrifices were a common strategy in Hollywood films. The portrayal of sacrificial feminine virtue has, of course, been a commonplace of literature, theatre and opera for centuries. Nineteenth-century literature provided fertile ground for Hollywood's version of Victorian morality and appropriate feminine conduct. Taking their inspiration from the classics, many American films of the 1930s adapted the morals of an earlier period to fit the climate of contemporary America. The punishment meted out to women who transgressed accepted boundaries was generally intensified in the films when compared with the novels. The sympathy engendered in the books for the oppressed women would usually be correspondingly downplayed in the film versions.[10] Hollywood continued the tradition in which a woman's contribution to society was based not on individual achievement, but rather on giving up personal fulfilment for a noble purpose. This strategy took on an added dimension during the war. The industry was able to introduce some flexibility in the choice of roles for women (employment was now permissible), yet continued to associate women's work with conventional images of self-sacrifice. *Vigil in the Night* (Stevens, 1940), although made before American involvement in the war, used the metaphor of nursing to explore how women could work and suffer and make sacrifices at the same time.[11] *Since You Went Away* (Cromwell, 1944) was producer David Selznick's monumental tribute to the women of the home front ('the unconquerable fortress' of the American home). Here the traditional qualities of sacrifice and suffering on the part of women were supplemented, rather than undermined, by the women working for the war effort: Mrs Hilton takes a job as 'a lady welder' and her daughter also works as a volunteer nurse. *Cry Havoc* (Thorpe, 1943) focused on the courage of nurses working in a military hospital in Bataan in 1942. Their ultimate capture by the Japanese offered a topical and dramatic interpretation of women's traditional sacrificial role.[12]

Some dissenters

Very occasionally, a Hollywood film might depart from the models illustrated above and enter a mild protest about the constant belittling of women. In Case Study 3 at the end of this chapter, I will show how Lubitsch radically departed from the prevailing culture – but he was not entirely alone in doing so. For completeness, I will close this section with an indication of some films that did not subscribe to the dominant cultural representations of women. *Little Women* (Cukor, 1933), for example, showed an independent-minded woman who accepts marriage, but does not have to sacrifice her artistic ambitions. The satires and role inversions found in much of the work of Howard Hawks and, more effectively, Preston Sturges (whose education was half spent in France), also challenged the conventional ideology. Hawks's *Bringing Up Baby* (Hawks, 1938) and *His Girl Friday* (Hawks, 1940) deliberately inverted Hollywood's codes for men and women, sympathetically depicting a powerful woman who controls the direction of courtship and who fights for independence. Sturges' *The Miracle of Morgan's Creek* (Sturges, 1943) satirized the convention whereby a woman passively waits for a man to choose her. The heroine has become pregnant after a one-night stand with a GI departing for the war. In a hilarious scene, she persuades a hapless local man, who is besotted with her, to propose to her. She has to try to control the process of courtship in the scene, while respecting the conventions of female passivity. Her resulting tortuous manipulations of the male provide Sturges with the opportunity to parody this particular Hollywood convention. Additionally, Leo McCarey's comedy, *The Awful Truth* (McCarey, 1937), is of particular interest. It begins in classic style. A woman refuses to forgive her husband's philandering, divorces him, but then regrets her assertiveness and begins to suffer. Yet by the film's end, she is dictating events to her ex-husband. He is shown to be at fault and is forced to seek the woman's forgiveness. On occasion – as in *Too Hot to Handle* (Conway, 1938) and *Arise my Love* (Leisen, 1940), the latter co-written by Billy Wilder – a woman could be allowed the upper hand without the employment of satire.

Hollywood and the dangerous American woman: 1941–48

In the 1940s Hollywood began to produce more aggressive portraits of assertive women. By the mid-1940s the complacent expectation that women would return to the home had proved ill-founded, and there ensued more graphic depictions of women as attractive and seductive, yet ultimately dangerous. These images were a logical, if extreme, development of the cultural hostility towards women that had characterized the 1930s. This undoubtedly reflected the increased tension over the role of women in post-war American society, as GIs returned from the conflict and began to re-enter the workforce. The portrayal of women became, as a result, more complex and more unpleasant. Women began to be depicted as a serious threat to men and to society at large. This threat was no longer capable of domestication, but had to be destroyed. If one were seeking the harbinger of the 1940s'

overt hostility to women, it might be found in Josef von Sternberg's *The Devil Is a Woman* (von Sternberg, 1935). Here the central female character, Concha Perez, is unremittingly destructive and is not offset by a 'pure' woman. Concha is an ambitious woman who lures a succession of men to their doom. She anticipates, in this sophisticated study of the power of women's sexuality over men, the female characters of the next decade.

Abandoning the neo-Victorian morality that had proved so valuable in the 1930s, Hollywood turned to recent popular American literature for its inspiration in the 1940s. The novels of Dashiel Hammett, Raymond Chandler and James M. Cain provided the inspiration for a number of significant Hollywood films in the 1940s, much as the nineteenth-century classics had in the previous decade. Although writing in the 1930s, these novelists had anticipated the collapse of moral idealism. Hollywood's search for a more topical interpretation of relations between men and women (and of post-New Deal morality more generally) found a useful source in these bleaker literary antecedents. Yet it must be stressed that, as with Hollywood's use of the Victorian novels, the film industry manipulated the texts where necessary to accord with its own sexual morality. The depiction of the women in the films was often far more aggressive than in the novels. Ambiguities were removed, and the fate of the women was frequently exaggerated or distorted to reflect the film industry's preferences.

The femme fatale

The tone of the 1940s was set by John Huston's directorial debut, *The Maltese Falcon* (Huston, 1941), adapted from Hammett's popular novel. Private eye Sam Spade's search for the precious statuette presents a challenge to his personal integrity, centred on his increasing interest in his client, Miss O'Shaughnessy. She appears to be defenceless, yet is in fact manipulative. She schemes to get the falcon, insinuating her way into Spade's life and finally staying at his secretary's apartment. She distracts him from his search for the truth and his quest to avenge the murder of his partner (which, it turns out, she committed). Her sexual attraction is, for Spade, almost overwhelming. It requires an enormous effort of will for him to hand her over to the police at the end of the film. This image, of a man striving to do the right thing against his baser urges, signifies the struggle to resist the lure of evil in pursuit of higher ideals. In this instance, a sexually attractive, greedy and murderous woman personifies that evil.

After this adaptation of Hammett, films based on the works of Chandler and Cain developed further the idea of the dangerous woman. *Farewell, my Lovely* (Dmytryk, 1945) focused on the corrupting power of the sexually alluring 'Mrs Grayle', a seductress and socially aspiring woman who has changed her identity to marry a rich man and then committed murder to prevent detection of her deceit. In the end she is shot. The following year *The Postman Always Rings Twice* (Garnett, 1946) showed Cora's sexual power over her seduced 'victim', Frank Chambers. The film studies the reckless ambition and greed of Cora, who marries for financial security, not love, and then persuades Frank to murder her husband, Nick.

She uses her sexuality to gain power over Frank and then exploits him. Once Nick is out of the way, she reveals that her motive was a $10,000 insurance policy. After the successful murder, she concentrates on building up the roadside diner which had been her husband's business. The marriage into which she and Frank are forced to enter to preserve appearances is a travesty, built on mutual loathing. The marriage licence is symbolically placed in the cash register next to the licence to sell alcohol. Cora's clothes evolve, from the white of the pre-murder sequences, to black. Ultimately, her reign must come to an end, and she dies in a car accident. Once again, evil takes the form of a greedy, manipulative, woman. These, and many other such films, represent the nadir of Hollywood's assessment of the qualities of women. Women were seeking to consolidate their wartime gains and liberate themselves from domesticity and male control. Hollywood sought to deny them that chance.

The good–bad girl

There was, however, an alternative means employed by Hollywood film-makers who wanted to examine the changing role of women in 1940s America. This approach acknowledged the dark side of women, in the same way as the films just discussed, but allowed it to coexist with a more conventional heroine. This led to the emergence of a phenomenon known at the time as the 'good–bad girl'.[13] This fictional creation helped the confused film-makers to bridge the gap between the reality of women's changing status and the cultural requirements for women to be controlled and powerless. Using this hybrid of good and bad in one person, the films showed for most of their length a powerful, resourceful and sexually forward girl, often (apparently) involved in criminality and immorality – the 'bad' girl. This image accorded the woman some power, resembling to that extent the real world. But the film-makers were not content to leave the viewer with the notion that such a girl was a possibility in real life. Accordingly, in the film's closing reel it would be revealed that she was not responsible for the criminal machinations. There had been a case of mistaken identity throughout. At the end of the film the viewer is reassured that the girl is 'good' after all. Through this device, audiences could relate to the reality of a strong woman, but go home safe in the knowledge that she was, at heart, a tamed, domesticated, 'good' girl. Such a complex character type reflects the difficulty Hollywood had in finding roles for women in the changing times of the post-war years.

Perhaps the earliest manifestation of this compound character came with *The Glass Key* (Heisler, 1942), made only shortly after *The Maltese Falcon*. The character of Janet Henry might be the prototype of the good–bad girl. Throughout the film, it appears that Janet is a murderer, cynically prepared to let an innocent man who loves her take the blame for her crime. She is finally revealed to have been innocent, and her true virtue allows her to marry the hero. We are thereby enabled to savour the excitement of an amoral and sexual woman without having either to reform her or to accept her on those terms. Her vices simply disappear because they were never there in the first place. Such a woman can

become, therefore, compatible with notions of domestication and marriage. The ambiguity in this simultaneous savouring and rejection of vice places the film squarely in the era of the New Deal's decline. It stands in marked contrast to the oppositional model of the 1930s, where good and bad were clearly distinguished and where sexual women were obviously impure.

Howard Hawks' *The Big Sleep* (Hawks, 1946) pursued the same strategy with regard to its heroine, Vivian Sternwood. Implicated throughout the film's increasingly confused narrative in a catalogue of murder, blackmail and narcotics, her seductive powers constantly threaten Marlowe's search for the truth. The viewer is led to believe that Vivian is at the centre of the criminal activities whirling around Marlowe, who struggles more and more to make sense of events. She is a powerful and beautiful lady, both attractive and menacing. Yet, in the final stages of the film, she is suddenly revealed as entirely innocent. She comes to Marlowe's aid when he is at his lowest point, tied up and beaten by the mobsters. She sets about helping Marlowe, until the two become lovers. The audience is thus able to savour the attractions of her nefarious side and then leave the cinema reassured that she was, after all, a 'good' girl.

In *The Lady in the Lake* (Montgomery, 1947), the exploration of the female character, Adrienne Fromsett, is more complete. Time is taken not only to demonstrate her initial sexuality and possible corruption, but also later to show her true nature as a suitably domesticated young lady. In the first half of the film she is depicted as a powerful publisher, whose marital sights are set on her millionaire employer. For a while, she appears likely to be the criminal centre of the film, as well as an alluring woman to whom Marlowe is both attracted and hostile. In early conversations, she professes interest in marriage for money. Marlowe accordingly offers her a moral lesson, telling her that he is looking for 'someone who'll take care of me – unglamorous isn't it?' However, when Marlowe's fortunes reach their lowest ebb, he calls on her for help and brings out the maternal, caring side of Adrienne. Now we learn of her loneliness and her desire 'to be your girl'. Renouncing her pursuit of money and a successful publishing career, she recognizes the inevitability of domesticity for a woman: 'this is what the world is like, isn't it?' Once again, the vice-ridden girl can also be the embodiment of domestic purity. Yet there is no conversion or transition – simply a revelation.[14]

Hollywood's men, 1933–1948

The reverse side of Hollywood's treatment of women was its depiction of masculinity. To an extent, we learn something about the attitudes of the time towards women by contrasting them with attitudes towards men. Hollywood's depiction of male attributes was not as complex or as intensive as was its preoccupation with women and femininity. The incessant didacticism which Hollywood brought to its portrayal of women was absent from its comparatively relaxed exploration of male values. The multilayered construction of the female ideal surpassed in its depth and complexity the superficial models available for

constructing the male image. Broadly speaking, Hollywood's embracing of the New Deal values of self-denial, and of achievement measured in human terms rather than in terms of material success, was mirrored in its images of masculinity. Personal enrichment was shown to be no more than shallow, irresponsible greed. The exercise of power and self-advancement gave way to the virtues of sacrifice in a noble cause. Reputation was valued above wealth and outward success. Images abounded of Christlike men suffering stoically and altruistically for a higher purpose than personal ambition. Once the height of the New Deal had passed, there was a transition from a socially contextualized altruism to an individual, and alienated, idealism. The overall emphasis upon male sacrifice found obvious parallels in the ethos of communality propounded by the New Deal's social and cultural impetus. It also reflected the increasing occupation by men of what had traditionally been an exclusively female domain. The high status accorded by Hollywood films to men who gave up personal gain is difficult to separate from New Deal values more generally. Much of the films' discussion about how men should behave is virtually indistinguishable from Hollywood's ideas about how the system of capitalism should function in post-Crash America. This is largely because the American male was, for contemporary Americans, inseparable from the forging of American economic power. The values of masculinity were the dominant social values. Indeed, the overpowering virility of American culture accounts to no small degree for the historical oppression of women in that country.[15]

In the 1940s the virtues of sacrifice and male participation in the higher ideals of American life began to seem inappropriate. Hollywood could no longer confidently invest its male heroes with triumphant New Deal values of self-denial and social responsibility. These could no longer be assumed to be pre-eminent. Instead, male heroes acted as solitary repositories of ideals that appeared to have been lost in society at large. This called forth a new type of male image, that of the stoic, isolated, often misunderstood male, whose personal code of ethics existed precariously in a corrupt, greedy and violent world. The private eye was an ideal purveyor of such an image for this decade, but he was not alone. Again, the male hero of these films embodied not only attitudes towards masculinity, but also more widely a view of the changing nature of American culture.[16]

Notes

1. Bruce Babington and Peter William Evans, *Affairs to Remember: the Hollywood Comedy of the Sexes* (Manchester, 1989), 27.
2. Kuhn, *Women's Pictures*, 34–35. See Also E. Ann Kaplan (ed.), *Women in Film Noir* (London, 1980) for a representative collection of feminist theoretical essays on Hollywood and women.
3. Kuhn, *Women's Pictures*, 32, 87–88.
4. The majority of essays in Kaplan, *Women in Film Noir*, for example, are devoted to a discussion of just one film: see Pam Cook, 'Duplicity in "Mildred Pierce"', 68–82; Claire Johnston, '"Double Indemnity"', 100–111; Richard Dyer, 'Resistance through Charisma: Rita Hayworth and "Gilda"', 91–99. Also studied, from later periods, are *The Blue Gardenia* and *Klute*.

5. Molly Haskell, *From Reverence to Rape: the Treatment of Women in the Movies* (2nd edn, Chicago, 1987), 172.
6. Examples of general wifely duties, feminine submissiveness and domestication of women are very common: some of the best illustrations include *Boom Town*, *Make Way for a Lady*, *Three Loves Has Nancy*, *Return of the Bad Men*, *Till the End of Time* and, most graphically, *Star Spangled Rhythm*. Isolated examples of male domination and female passivity occur so often as to defy reference, but see for instance *Only Angels Have Wings*, *The Big City*, *Tortilla Flat*, *Kings Row*, *Union Pacific*, *Saratoga Trunk* and *The Unfaithful*. On the specific point of women tolerating their husbands' infidelities, see *Ah! Wilderness*, *The Great Ziegfeld*, *Man Alive*, *The Sailor Takes a Wife* and *Vivacious Lady*.
7. For further good examples of how the pursuit of love is used to subdue assertive women, see (from a very long list) *The Black Swan*, *History is Made at Night*, *Mr Smith Goes to Washington*, *It's a Wonderful World*, *The Prisoner of Zenda*, *Souls at Sea*, *Thirteen Hours by Air*, *Three Loves Has Nancy* and *We Were Dancing*. *Libeled Lady* also charts a woman's transition from selfish millionairess to responsible, New Deal married lady. A related theme is the treatment of marriage. Hollywood's concern for this institution usually took the form of shoring up marriage, either directly or by showing the unfortunate effects of the wrong marriage. This sometimes overlapped with the idea that women should not be in a position to determine the course of romance and marriage. See *Anna Karenina*, *Mr Skeffington*, *The White Sister*, *Personal Property*, *Tom, Dick and Harry*, *Peter Ibbetson*, *How Green Was my Valley*, *Sadie McKee*, *A Woman's Face*, *David Copperfield* (three wrong marriages in one short film) and *Now, Voyager*. See *Vivacious Lady* for the issue of marriage and social class and *Penny Serenade* for the pressures child-rearing imposes on a marriage. Strong endorsements of marriage are common too; see *The Clock* and *The Doughgirls*, for example. *Footlight Parade* refers comically in one of its musical interludes to the fact that marriage is a convenient way for men to realize their sexual desires.
8. Other examples of this conflict between work and femininity include *Morning Glory*, *Mr Skeffington*, *Anne of Green Gables*, *Dance Girl Dance* (this film's supposedly feminist credentials derive merely from the fact that it was directed by a woman; thematically, it is no different from the general anti-feminist thrust of Hollywood's output at this time; see also the same director's *Craig's Wife* for a classic example of punitive treatment of an assertive woman), *Dancing Co-Ed* and *National Velvet*.
9. Haskell, in *From Reverence to Rape*, takes the character's feminism as evidence that it was a feminist film. She then argues that it 'was too threatening. The film flopped' (179). The film may, of course, have flopped for many other reasons. Certainly, the feminist elements are not in any way threatening by the time the film concludes.
10. The protagonists of *Anna Karenina* (1935) and *Camille* (1936) are two such examples of women who transgress moral and sexual boundaries and reap the requisite punishment.
11. Nursing was a well established anti-feminist metaphor, common in literature, painting and drama, as well as cinema; for an extraordinary analysis of male sexuality and female icons (specifically in relation to the appeal of Nazism), see Klaus Thewelweit, *Male Fantasies II: Male bodies: Psychoanalysing the White Terror* (Oxford, 1989).
12. For a few examples, from a very long list of possibilities, of both war-related and other female sacrifice, see *The Little Minister*, *Mary of Scotland*, *The Gorgeous Hussy*, *The Son of Monte Cristo*, *The Prisoner of Zenda*, *Marie Antoinette*, *Anna and the King of Siam*, *Conquest*, *Only Yesterday*, *Escape*, *Song of Bernadette* and *Three Comrades*.
13. The term is from Martha Wolfenstein and Nathan Leites, 'An Analysis of Themes and Plots', *Annals of the American Academy of Political and Social Science*, 254 (November 1947), 41–48.

14. For the association of sexually forward women with immorality, see further *Now, Voyager; The Good Earth; Destry Rides Again;* and *Honky Tonk*. For 1940s portrayals of sexual women with murderous tendencies, see further *The Lady from Shanghai, They Drive by Night* and *Ivy*. See *The Unfaithful* for another equation of adultery and murder.
15. There are many examples of male sacrifice: see, for a selection of the better illustrations, *Only Yesterday, This Is my Affair, The Strawberry Blonde, Devil Doll, Bad Man of Brimstone* and *Jesse James*. For Christlike portrayals of male suffering, see *Abe Lincoln in Illinois, Young Mr Lincoln, A Tale of Two Cities* and *The Prisoner of Shark Island*. For the loss of male reputation, rather than the loss of life or liberty, see *Souls at Sea, King of the Turf, The Count of Monte Cristo, The Son of Monte Cristo, The Bells of St Mary's, Reap the Wild Wind, The Story of Dr Wassell* and *Unconquered*.
16. For examples of the isolated or alienated male hero, see *The Maltese Falcon, The Big Sleep, The Glass Key, Farewell my Lovely, The Lady in the Lake, The Dark Corner, The Long Voyage Home, Confidential Agent, Deadline at Dawn* and *The Lady from Shanghai*. For other aspects of masculinity regularly treated in Hollywood, see: on the importance of male groups, *Beau Geste, They Were Expendable* and *Treasure of the Sierra Madre*; for the threat to male friendships posed by a woman, *Boom Town, Central Airport, The Devil Is a Woman, Libeled Lady, The Maltese Falcon, The Mighty Barnum, Three Loves Has Nancy, Only Angels Have Wings, The Road to Glory, Gunga Din, Tortilla Flat* and *Union Pacific*; on the conflict between career and marriage for men, see *Deception, Libeled Lady, Penny Serenade, They Drive by Night, Tycoon, Wife versus Secretary* and *Tom, Dick and Harry*. *His Girl Friday* wittily inverts the conflict by giving the woman the choice of a career or marriage, with no attempt at the conventional punitive morality. One should also note here the satirical thrust of much of Preston Sturges's work in relation to masculinity: see *The Lady Eve, The Palm Beach Story* and *Unfaithfully Yours*.

Case Study 3

'Definitely Bawdy and Offensively Suggestive': Lubitsch and the American Woman

Introducing Ernst Lubitsch

Ernst Lubitsch was born on 29 January 1892 in Berlin, the youngest son of a prosperous Jewish tailor. He was short, reaching only 5' 6" at maturity and, like Lang and Wilder, a poor scholar. He failed to matriculate on leaving school when he turned 16 years old. For him, the future was performance – acting in the German capital's theatres and music halls. For his respectable father, however, Ernst's future lay in the family business. But this was not to be. After some desultory attempts by the young man to learn the science of tailoring, Ernst found in 1911, at the age of 19, a more congenial apprenticeship – with the legendary theatre director, Max Reinhardt.[1] The young Lubitsch would act in Reinhardt's prestigious troupe for six years, but he would never rise above minor roles. From around 1914, he began acting in films, which proved to be a much more fruitful medium. Within a couple of years, Lubitsch had become a popular comic star in a series of short movies. The comparative informality and fluidity of early silent comedy also meant that the novice soon found an opportunity to try his hand at directing.

In 1917 the great German film production company, Ufa, was formed – a partnership between private finance and government money. It offered directors and producers vast resources and production facilities, second only in the world to Hollywood. And, crucially, the European artistic culture, differing from the more commercial imperatives of America, meant that German film directors exercised complete autonomy, on and off the set. These early directors were truly in command of their productions. They determined what went up on screen. Unlike in Hollywood, the major film directors did not have to fight with powerful, interventionist producers, nor work with armies of screenwriters imposed on them by the studio heads. There was not that desire, as was commonplace in America, to make films which would appeal to a lowbrow mass market. The great early European directors were the single most important voice in creating a film, if not the only voice: in this sense, they were the auteur film directors – the sole authorial creators – so beloved by film theorists.[2]

Joining the Ufa ranks, Lubitsch's reputation grew as he directed a series of prestige pictures, often starring Pola Negri. Varying his output during the early 1920s, Lubitsch offered not just comedies, but also epic historical costume dramas. Two of these – *Madame DuBarry* (Lubitsch, 1919) and *Anne Boleyn* (Lubitsch, 1920) – achieved considerable artistic and commercial success in the United States, released under the more sensationalist titles of *Passion* and *Deception*. Their success led to a brief, but significant, American interest (primarily in New York) in German cinema and German film directors. Hollywood executives began to contemplate buying in some European talent – and, incidentally, buying off some European competition.

During the Christmas and New Year holidays at the end of 1921, Lubitsch paid his first visit to America. The following December, just under a year later, he was enticed to emigrate to America by the chance of a contract to work in Hollywood. In taking that journey, Lubitsch inaugurated the short wave of émigré German film directors bound for Hollywood. Although he would return for brief visits to his homeland on two occasions thereafter, by 1922 Lubitsch had effectively emigrated and become a permanent feature of the Hollywood scene. His considerable charm, wit and skill with people meant that he would prove well able to navigate the politics and egos of the American film industry.

Lubitsch came to America to make a film with the megastar Mary Pickford, at United Artists. Originally planning to film 'Faust', the two clashed at once over stories and ended up making *Rosita* (Lubitsch, 1923). As soon as he had fulfiled his commitment to Miss Pickford, Lubitsch signed a contract with Warner Bros. giving him explicit artistic control – as his biographer Scott Eyman puts it, 'in essence, he was given his own production unit … [and] had final cut'.[3] Warner Bros. were expanding and wanted to go upmarket, to cultivate a more sophisticated reputation. Their new signing, with his German worldliness and continental manner, was a clear demonstration of this change of direction.

By 1926 the so-called 'German invasion' was over; the fashion for things continental had waned. Lubitsch had turned out a series of pictures since his arrival in 1922, all modestly commercially successful, but far from showing mass-market appeal. His box office returns gradually declined as the decade wore on – but his artistic reputation went from strength to strength. *The Marriage Circle*, *Three Women* and *Forbidden Paradise* (Lubitsch, all 1924), *Kiss Me Again* and *Lady Windermere's Fan* (Lubitsch, both 1925), *So This Is Paris* (Lubitsch, 1926) – these formed a string of sophisticated comedies of manners, but with revenues declining from around $200,000 to $60,000 per picture.[4]

The Warners were less than ecstatic about the performance of their European discovery. The brothers' quest for artistic respectability soon gave way to the more usual Hollywood quest for profits, and Lubitsch moved on in July 1926 to Paramount. Although he was not – and never would be – a revenue-generating colossus, he was revered by critics and the establishment, and regularly cited as a 'genius'. His ability to comment with wry and humorous insight on buttoned-up American morality introduced a new level of sophistication into Hollywood cinema, immortalized by the epithet, 'The Lubitsch Touch'. Moreover, Lubitsch was a gentleman on set, who managed to control the production and achieve exactly what he wanted without ever raising his voice. As the decade ended, and the 'talkies' arrived, Lubitsch made the transition to sound skilfully, 'inventing' the musical in response.[5] His output remained regular, albeit with varying degrees of artistic and commercial success. After the flop *Eternal Love* (Lubitsch, 1929), he made *The Love Parade* (Lubitsch, 1929) later that year, *Monte Carlo* (Lubitsch, 1930) the following year, and *The Smiling Lieutenant* (Lubitsch, 1931) in 1931. In 1932 he met Samson Raphaelson, a Paramount screenwriter with whom Lubitsch would craft some of his greatest works in the remaining fifteen years of his life. Their first collaboration, however, was a failure at the box office: *The Man I Killed* (Lubitsch, 1932). Lubitsch bounced back with *One Hour with You* (Lubitsch, 1932) and

completed his pre-New Deal work with *Trouble in Paradise* (Lubitsch, 1932). All three of his feature films released in 1932 lost money.[6] But Lubitsch himself was certainly not losing money. When he signed a second contract with Paramount in March of that year, his salary was $225,000.[7]

Thus, as the New Deal approached, Lubitsch had established himself as one of the most influential stylists of American cinema. He had raised the discussion of sexual manners to new heights in Hollywood's output and had shown how a more sophisticated examination of adult themes could nevertheless be charming and in exemplary taste. He entertained his grown-up audiences, yet dissected marital tensions and extramarital affairs with precision and insight. His was truly a cinema which grafted continental knowingness on to American mores, and he found a highbrow audience with an appetite for his European recipes. His challenge to the moral regulation, prudishness and hostility towards women of the New Deal era would be Lubitsch's radical, and enduring, contribution to the cinema of this period. In addition, he would play a crucial part in the dialogue within America about isolationism versus international engagement.

In December 1932 Ernst Lubitsch returned to Germany for the last time. He went to Berlin for the premiere of his new film, *Trouble in Paradise*. His home country was a month away from the appointment of a new Chancellor, Adolf Hitler. Back in America, a new president had been elected and was waiting to be sworn in at the start of 1933 – Franklin Delano Roosevelt. With the inauguration of FDR would come the commencement of the New Deal and a new era in Hollywood film-making.

Lubitsch's philosophy of cinema

Ernst Lubitsch made an exceptional contribution to American culture in the 1930s and 1940s in his exploration of the role of women in American society. As we have seen, the prevailing orthodoxy stressed the need to control female independence, and Hollywood films routinely denigrated women's ambitions. As the New Deal era progressed, the assault on female emancipation became more aggressive. Lubitsch dissented from these dominant representations. As a rule he preferred to portray women's desires as legitimate, and criticized their subjection to unnecessary and unacceptable male oppression. His sympathetic portraits of women, and the care he took to empower his female characters, marks him out from virtually all of his contemporaries. He consistently formulated images of women who are free to express their sexual desires, and who free themselves from overweening men. It was a sustained and vital contribution to the popular culture of this period, and one for which Lubitsch deserves belated recognition.

Lubitsch is important for another reason. Just like his two compatriots Lang and Wilder, Lubitsch made films that challenged the Production Code and its rigid morality. Lubitsch could not express his dissent from American culture under a code that prohibited the depiction of female sexual needs, so he skilfully manoeuvred to circumvent it. Although Lang and Wilder were conformist in their cultural hostility towards women, they nevertheless sought (in *Scarlet Street* and *Double Indemnity*, respectively) to depict sexual relations

more graphically. In their concerted efforts to undermine censorship and to expand the boundaries of what was permitted on screen, all three émigré directors participated in a programme of dissent from American cultural norms.

Lubitsch worked with considerable autonomy within the American studio system, acting as producer as well as director on all of his films. He did not undertake contract jobs, making only those films he wished to make. His desire to wrest control from the 'czaristic dictatorship' of studio heads was articulated in 1933[8]; by 1935 he was head of production at Paramount Studios, somewhat in the position of czar himself.[9] In his brief, one-year tenure as production head, he was able to implement his long-standing proposal for a unit production system. This system established individual film units, each under the control of a producer with delegated artistic and commercial powers. The reform survived Lubitsch's dismissal from the post.[10] The director's contemporaries attested to the autonomy with which certain producers – Lubitsch among them – worked at Paramount.[11]

Moreover, accounts of his working methods given at the time agree on his close involvement with the scriptwriting process and the importance he placed on dialogue.[12] One writer who collaborated with Lubitsch went so far as to declare that Lubitsch

> is the one director in Hollywood who writes his own pictures. True, he has writers working with him, but he is always the guiding genius – the leader of the band. He is the best script writer in the business, barring none.[13]

Lubitsch disowned the customary Hollywood practice of using up to ten writers on a script, declaring that it meant, 'no concentration of thought, no definite evolution of situation, no logical development of character'.[14] His working method was to iron out all of the film's problems in the writing. For him, films were 'finished' before shooting even started:

> You give extraordinarily careful attention to the script. As you write the script, you cut the film ... you set the tempo, you delineate the characters ... In writing a script, you are creating, inventing. I like to do it so thoroughly that when I finish the script, I breathe a sigh of relief. Creation is the most intense sort of work, the most satisfying. And for me it is virtually all done in the script. What remains is just the execution of an idea.[15]

His autonomy, as supervising writer and as producer–director, is beyond dispute. One may therefore consider his films as embodying the ideas, thoughts and themes of one particularly creative artist. It is scarcely surprising that the work of a film director with such close creative control should reveal a clear sense of thematic purpose. Yet Lubitsch was not concerned with addressing the major social problems of his time. His interest was in human relations: 'I believe in taking a lesser theme and then treating it without compromise'.[16] This refusal to compromise meant not only a rejection of box office considerations in favour of 'artistic pictures', but also a constant battle with the Hollywood censors.[17]

Case Study 3 – 'Definitely Bawdy and Offensively Suggestive': Lubitsch and the American Woman

Contemporary observers noted the way in which Lubitsch's 'international rather than national' perspective shed new light on America's parochial understanding of its own culture: 'an authority on manners and matters Continental … he [has] made a distinct contribution to the American screen – and also in depicting the American scene'.[18] For Lubitsch, the one thing that mattered was the relationship between men and women, and it was to this subject that he devoted almost his entire cinema career: 'The most dramatic conflicts in life are the conflicts of sex … The conflict of man against woman against man has provided high drama down through the ages'.[19] Lubitsch was to articulate an extraordinarily coherent cultural challenge to the consensus of American sexual values in the New Deal and post-war eras.[20]

I have divided his challenge into three categories. First, his most radical dissent from American morality came in three particular films – *Design for Living* (1933), *Angel* (1937) and *That Lady in Ermine* (1948), his last film. Second, the ideas about women expressed in these films were also expounded, but to lesser effect, in other works: *Bluebeard's Eighth Wife* (1938), *Ninotchka* (1939), *Cluny Brown* (1946) and, indirectly, *Heaven Can Wait* (1943). *The Merry Widow* (1934) is considered in a third category, on its own. Although there are significant elements of subversion in this film, they are contained within an ostensibly conservative narrative. This particular film's importance lies in its overt challenge to sexual morals, and its consequent censorship difficulties. Finally, I consider his more conservative films, for completeness, at the end of this case study. Lubitsch was not absolutely consistent in his radical re-appraisal of women's rights.

Lubitsch and the liberated woman: *Design for Living*

The first film Lubitsch produced and directed after Roosevelt's election was *Design for Living* (1933). On the evidence of the film alone, one can appreciate the extent to which it departed from contemporary American morality. Fortunately, we do not have to rely solely on the film to construct this interpretation. The records of the censors and the surviving statements by Lubitsch about his intentions in making the film provide clear evidence of the challenging originality of *Design for Living*. The film was derived from Noel Coward's play, which had opened in America at the Ethel Barrymore Theater on 24 January 1933. A watchful representative from the Hays Office had attended the premiere and concluded that any film adaptation would face the 'basic difficulty' that a motion picture audience would be unlikely to accept the characters' 'unconventionality'.[21] For Lubitsch, however, the opportunity to fashion a story from the play proved irresistible. He and his scriptwriter Ben Hecht proceeded to use the play as the basis for an exploration of the hypocrisy of male attitudes towards women's sexuality. It would also offer a frank avowal of the attractions of sexual licence over the conventions of marriage and respectability. It became a deliberate critique of American conventions governing female conduct.

Aware that he was embarking on an uncharted course, Lubitsch issued press statements through the Paramount publicity office. In them, he explained the novel ideas in his new film and attempted to align his intentions with his own expectations of an increasing maturity on the part of cinema audiences. He may have been consciously trying to forestall public

criticism by moral pressure groups. In the event, the film proved very controversial. In his press statements, Lubitsch focused on the sequence in the film in which Gilda confesses that she wants to have a relationship with two men under one roof, rather than settle for conventional marriage. Her speech, as reported by Lubitsch in the press release, reads like a feminist manifesto:

> Here's how she explains it: 'A thing happened to me which usually happens to men. You see, a man can meet two, three or even four women and fall in love with all of them. And then, by a process of interesting elimination, is able sometimes to decide which he prefers. But a woman must decide only on instinct – guess work – if she wants to be considered nice. It's quite all right for her to try on a hundred hats before she selects one, but in the important matter of a mate, she must take pot-luck'.[22]

The intimations of sexual experimentation are clear.

Lubitsch admitted that this 'frank philosophy [will] violate all the traditions of the past' but he hoped that audiences would be provoked and yet satisfied. 'After all', he went on, 'boil her confession down and it is merely the story of a woman with no inhibitions; a woman who does on the screen what all male Don Juans have been doing for ages.' He clarified the radical break with conventional morality that he was inaugurating.

> Heretofore, the picture industry has complacently sat back and allowed the screen to maintain that romance for screen women meant a love which led to a singleness of coupling – heroines had to be in love to enjoy bedtime stories. Now we have a picture which upsets that. The woman in our triangle contends that her sex is entitled to a liberty that only men have enjoyed in the past.

Lubitsch hoped that his daring rejection of American conventions would find a receptive public, ready for a cinema that addressed adult issues with a new frankness. With perhaps more wishful thinking than accuracy, he identified a 'sudden metamorphosis of public taste ... due to the younger generation's tolerance of the essential weakness of human nature ... [and] the older generation's sincere wish that their offspring grow up as liberal-minded men and women'. He hailed 'the public's new acceptance of freedom in love', which gave 'broader scope and freer reign to the motion picture director who strives to achieve something different in lines of truth'.[23] Lubitsch correctly assessed the novelty of his film – but his expectation of a change in public morality was to be seriously disappointed, as the film's passage through the Hays Office and its subsequent reception were to demonstrate.

Design for Living differed in a number of significant respects from the conventions being established by Hollywood at this time. Gilda's characterization as an assertive, independent-minded woman who rejects the usual options available to women is highly unusual for the period. In the film she abandons her unsatisfactory marriage, yet remains not only unpunished, but dominant in the triangular relationship she establishes with George

and Tom. It is Gilda who drives the men on to success, through what one reviewer called her 'high-powered salesmanship methods'.[24] Again, it is Gilda who subsequently calls off the triangle and leaves the men to themselves; who later tires of her marital status; and who, finally, presides again over the triangular relationship. Moreover, she – and the two men – find happiness in a relationship of quite patent 'immorality'. The film decisively rejects marriage as an uninspiring commercial transaction.

The contrast between Gilda's search for a meaningful relationship and the distasteful convention of marriage is best encapsulated in her husband Plunkett's defence of moral order: 'immorality may be fun but it isn't fun enough to take the place of 100 per cent virtue and three square meals a day'. The association of marriage with commerce (and the counterpoint of independence with art) recurs throughout the film. Plunkett files the marriage certificate under 'M', along with 'Manhattan Plumbing'; Gilda declares when leaving Plunkett, 'I'm sick of being a trademark married to a slogan'. The point is reinforced by having the amoral relationship become essential to the artistic success of the two men: each becomes renowned in his field during the tripartite relationship, while neither is able to achieve success when ordinary life is embraced. A worried Hays Office employee noted how the script indicated 'that by her association with these two men she makes both successful', thereby providing an unwanted endorsement of the bohemian lifestyle.[25] In Lubitsch's film, he characteristically takes the Hollywood convention of a woman pursuing the 'wrong' marriage and upends it to markedly subversive effect. Here Gilda successfully achieves the marriage of her choice and is then given the further luxury of a change of heart. She rejects the wrong marriage, not in favour of a different, conventional marriage to a dominant American male, but instead for an extraordinary, immoral liaison with two young, virile men. She does this of her own volition and is punished neither for her original choice of marriage, nor for her subsequent assertive rejection of her husband. Gilda, a sexually and socially assertive woman, is rewarded in the end with everything she desires and on her *own* terms. Her character remains one of the strongest women ever produced by Hollywood's fictions.

Lubitsch's *Design for Living* appeared at a turning point in the development of American morality. Partly as a result of this film, the scope for moral licence in Hollywood was severely curtailed in 1934. While Lubitsch was claiming to detect a trend towards liberalization of moral codes, in tandem with increasing political liberalism, in fact the opposite was occurring. The arrival of the New Deal in 1930s America did not bring with it any expansion of acceptable roles for women in American life; neither did Roosevelt's liberal agenda embrace a more licentious morality. Indeed, as the moral regulators in American society became more aware of cinema's reach and power, the pressure for a firmer and more stringent moral policing grew. Hence, in this period the fairly informal regulation of the original Hays Office was replaced by the far more interventionist and structured regime of Joseph Breen and the PCA. This change can in fact be tracked from a study of the censorship history of *Design for Living*.

Although the Hays Office had, in January 1933, thought it problematic for any film to be made from the Coward play, within six months Paramount Studios had submitted a first

draft script to Dr James Wingate at the Hays Office. In the customary practice of that office, Wingate identified points of potential difficulty with the local censor boards and suggested ways of retaining the ideas in the script without violating state or city censorship sensibilities. Later, Wingate filed a report to Will Hays on a group of films. One was *Design for Living*. Wingate alluded to Lubitsch's talent for transforming seemingly harmless written material into morally subversive films – through gestures, delivery of a line or clever juxtaposition of dialogue and images: '[*Design for Living*] again is a picture which will have to be judged pretty much by the way it appears on the screen, as is usually the case with a Lubitsch production'.[26] This was tantamount to an admission of defeat by the Hays Office. There was an understandable reluctance on the studios' part to alter films after production was finished, with the attendant expense and inconvenience of recalling employees and reusing sets which might have been dismantled. Changes to a film were, except in extreme cases, made at the scriptwriting stage. Even re-editing to alter material was a last resort.

In the case of *Design for Living*, such drastic steps were not thought to be necessary – at least, not at this stage. With a broad-mindedness soon to disappear from the Hays Office, Wingate expressed his delight at the script, 'treated on the whole in excellent taste, as is the case generally with Lubitsch'. As he somewhat naively saw it, the moral of the tale was that 'three people ... find there is something more important in life than sex' and that 'whatever loose living is indicated, is not justified [i.e. by the film], but is shown as inimical to their happy relationship'. Under this complacent style of supervision, the film proceeded to secure Hays Office approval, after some re-editing to remove 'one major Code violation' in November. But unusually, the story did not end there. By the following May, the Legion of Decency had been formed to counter Hollywood's perceived drift into immorality and had banned 63 pictures to its membership – including *Design for Living*.[27]

The subsequent history of the picture illustrates just how far ahead of his time Lubitsch was. When, in August 1935, Paramount sought Joseph Breen's permission to reissue a number of old films, it was refused for *Design for Living* (and also for Lubitsch's previous work, *Trouble in Paradise* (1932)), providing clear evidence of the extent to which the moral order had been reformulated within the short time span of two years.[28] Two further years later, Martin Quigley, moral ideologue and an author of the Production Code, usefully summarized Lubitsch's intentions in the film. The problem with this 'evil influence', Quigley explained, was that 'it presents conduct on the part of attractive and likeable people which indicates denial and contempt of traditional moral standards, presenting, charmingly, wrong conduct as if it were right conduct'.[29] Lubitsch was very conscious of his ability to present outrageous ideas in a charming light. He explained that the values propounded in *Design for Living* would, if put baldly, 'sound like something that is usually left unsaid. But to have a pretty woman speak such lines with sincerity and charm gives the picture an entirely different complexion.'[30]

The durability of the new moral consensus meant that plans by RKO Studios to remake *Design for Living* in 1940 were scotched by Breen, 'because it is a story of gross sexual irregularity ... [with] no "compensating moral values" of any kind'. Even as late as 1944, Breen

was still refusing permission to Paramount to reissue Lubitsch's film, reminding the studio acidly that the film was one of those 'which contributed much to the nation-wide public protest against motion pictures, which flaired [sic] up early in 1934, and which resulted in the formation of the Legion of Decency'.[31] We do not know whether this attribution of responsibility for the moral clampdown in the 1930s would have pleased or offended Lubitsch. It does, however, serve as a useful reminder of his influence in Hollywood at this time. He was at the forefront of those seeking new and more progressive treatments of the drama and comedy of American sexual life in the New Deal era.

Angel: freedom through adultery

Lubitsch developed his ideas about women in a later project, *Angel*, again registering his dissatisfaction with the limited roles permitted to women in American society. In late 1936 Lubitsch began to draw up the script for *Angel*, a film eventually to be released the following autumn. He had planned to make a film with Marlene Dietrich since early 1935, but it was only now that he achieved his goal.[32] Melchior Lengyel's play, *Angyal*, was once again a controversial subject for Lubitsch to have chosen. Under his creative control the film provided scope for Lubitsch to consider the dual nature of women, frankly acknowledging their sexual drives and accepting these as legitimate. At the same time he criticized men for their sexual exploitation of women. Adultery and sex formed a major part of the story. The play's treatment of adultery, by a woman who believes in free sex outside her marriage, had led the Hays Office to scotch earlier plans to film it in 1934. Responding then to plans by Universal to mount a John Stahl production, Breen and his team had found themselves unable to approve the project, even though Stahl had undertaken 'to eliminate most, if not all, of the subject of adultery'. Breen and his officials had found the play's criticisms of the institution of marriage and the main character's 'belief of the double standard for women' problematic. Additional objections had been made to a play which 'seems to justify the adulterous activities of a happily married woman' and to offer 'a patent condonation [sic – meaning 'condoning'] of adultery … played against the background of a Parisian brothel'.[33]

This, however, was familiar territory for Lubitsch. In December 1936, either unaware of, or unconcerned by, Universal's failure to secure permission for a film, he submitted a script to Breen.[34] Lubitsch's conflict with the censors on *Design for Living* and then *The Merry Widow* (the latter is considered below) had not deterred him from tackling difficult subjects. He negotiated the obstacles placed before him by the Breen Office and produced a film that was widely recognized on its release to have bent, if not broken, most of the rules of censorship. The *Motion Picture Daily* captured the general feeling well: 'Sophisticated is the nice word for *Angel* … a play in the so-called continental, and latterly frowned upon, manner … Dietrich gives her usual interpretation of the extremely sensitive if not downright sexual, woman'.[35]

Breen, sympathetic as he often was to Lubitsch's desires to explore sensitive issues, felt sure at the outset that, with careful handling, objectionable material could be avoided. He nevertheless went on to review a series of worries. The use of a house of assignation was

unwelcome. Any suggestion of an illicit relationship between the main characters, Maria and Tony, should be avoided, or at least not condoned. The suggestion that Tony and Frederick (Maria's husband) had at one point shared a mistress was not acceptable. And Frederick's reaction at the end to his wife's sexual licentiousness seemed to condone her past behaviour.[36] But anyone viewing the film today will note that every one of the issues to which these objections were raised remains intact: they are indeed central to the film.

Following Breen's initially cautious reactions, Lubitsch refined and developed his ideas, not paying much heed to the censor's concerns. By February 1937, possibly as a result of negotiations and lobbying behind the scenes, Breen was content, although he was not confident that the Legion of Decency would share his view. By June the film had been viewed and approved.[37] The 'pressbook' (that is, the publicity brochure) for the film identified the two main themes Lubitsch was keen to explore: the husband's egoism and whether the wife 'should take a fling at life or stand secure behind the unexciting bulwarks of convention'.[38] The second theme in particular encapsulated Lubitsch's ideas about the duality of femininity. Here the context was a bored, neglected wife of an English diplomat, who satisfies her sexual desires with a man she meets in a Paris 'salon'. Her husband's discovery of this alerts him to the failure of his marriage, and he has to fight to retain his wife's affections. What might have been a conventional treatment of a woman's vain efforts to realize self-expression outside marriage was here transformed into a powerful challenge to American belief in male power. Maria's sexuality was endorsed in the film, while her adulterous affair and frequent visits to a brothel went unpunished. Indeed, Lubitsch argued that adultery was the essential catalyst in Maria's efforts to rescue her marriage.

In one key scene, Tony and Frederick, not suspecting that they both love the same woman, discuss their different attitudes to women. Frederick disdains grand love affairs and impetuous romance, preferring the safety of tradition. Tony, on the other hand, proclaims the power of love and rejects the suffocating influence of convention ('What's 200 years? Twenty-five pages in history'). Frederick ironically remarks that they would each seek very different things from a woman. At that moment Maria, the embodiment of both men's desires, enters the room. Tony, suddenly realizing that he is in love with Frederick's wife, contradicts him: a woman can be two things at once, he asserts, depending on one's attitude. A blue lamp, he observes, can be green when lit. A respectable, married woman can at the same time be a vital human being, argues Lubitsch, with passions and desires. Frederick can see only the surface of the lamp, just as he cannot understand Maria's deeper emotions. Tony, by 'lighting the lamp' in his affair with Maria, reveals her hidden depths and liberates her emotional centre. Maria's inner desires are legitimized and realized in the film, not punitively repressed.

Lubitsch reinforced his point by criticizing the male hypocrisy that idolizes the frigid wife and castigates her loose-living opposite. Tony and Frederick, we learn, know each other because they shared a mistress in France during World War I. Frederick sees no contradiction in a society that provides amusement for sex-hungry men, yet forbids respectable women similar freedoms. He is complacent about his entitlement to sexual experimentation, while condemning Tony's mysterious lover (in fact, his own wife) as a person of ill repute. The final

scene underscores the film's critical focus on Frederick. He confronts his wife in her Paris 'salon', determined to know whether she is in fact the 'Angel' whom Tony has talked about. Maria scorns her diplomat husband's sudden interest in her: 'you left all Europe waiting, just to find out if a woman is a brunette? Does it really worry you – as much as Yugoslavia?' She wants him to be 'uncertain – of yourself, of me', and her challenge to Frederick is successful. In the end, it is he who must change and accept his wife's critique. The marriage is finally endorsed, but not by the conventional means of punishing the assertive woman. On occasion, Lubitsch's dissent from accepted values was hard for contemporaries to swallow. Reviewers noted the unconventional strength of the female character and balked at it: 'Miss Dietrich's Angel makes fools of [both men], and we resent it, for the character is too shallow to hold the destinies of two intelligent men'.[39]

Lubitsch's swan song

That Lady in Ermine (1948), Lubitsch's last film, was his third major challenge to American views on sex and marriage.[40] It, too, incorporated a critique of masculinity and a striking – and controversial – portrayal of an assertive woman who liberates a protégée from sexual, social and marital constraints. For this film Lubitsch selected an operetta by Rudolf Schanzer and Ernst Welisch, *The Lady in Ermine*.[41] Set in Verona in 1810, the story told of an invading Austrian colonel who conceives a passion for an Italian countess dissatisfied with her marriage. The key moment revolves around whether she will sacrifice her virtue by sleeping with the colonel in order to save her captive husband's life. This test of feminine virtue is a theme familiar from countless works of art, including Shakespeare's *Measure for Measure*, numerous operas and many Victorian novels. (Billy Wilder even has Field Marshall Rommel satirize the triteness of the idea in *Five Graves to Cairo*.) The conceit of the operetta is to resolve the virtuous heroine's dilemma by allowing her ancestor's ghost – the lady in ermine – to satisfy the colonel's desires, while the wife remains faithful to her husband. In this way the marriage is preserved. Lubitsch, however, was to alter this conclusion and thereby effect a fundamental change in the moral of the piece.

The first extant screenplay is by Ladislas Fodor, but his flat, stage-like script, awash with unsubtle sexual innuendo, remained uncompleted and was virtually ignored by Lubitsch.[42] Lubitsch himself, in February 1947, drafted a 54-page treatment that formed the basis of the eventual film. Samson Raphaelson's subsequent screenplay stuck closely to Lubitsch's original framework.[43] The most significant change that Lubitsch made to the operetta was in the resolution of the Countess Angelina's moral dilemma. Lubitsch's idea was to use the colonel as a catalyst, liberating the countess's sexual desires. He brought forward the colonel's occupation of the castle to the night of Angelina's wedding to Mario, thereby ensuring that the marriage was not at this stage consummated. The colonel's sexual challenge is no longer a threat but an opportunity, one which Lubitsch has Angelina realize: she leaves Mario and her unconsummated marriage to pursue and marry the colonel.

In his treatment, as in the eventual film, Lubitsch concentrated on the inadequacy of Angelina's marriage. He uses the ghost of the lady in ermine to effect Angelina's liberation

from sexual and social captivity. When Mario claims that Angelina will soon be married and 'belong' to him, Lubitsch explains in his treatment that she worries about whether it is 'a promise or a warning'.[44] The invading Austrian colonel forces the countess to think about her imminent marriage. It is a question of whether Angelina should follow her passions or willingly enter her marital prison. Thus, when the lady in ermine, Francesca, visits the colonel's bedchamber, her role is not to preserve Angelina's virginity for her marriage to Mario. Instead, Lubitsch alters the original story so that Angelina's sexual desires are liberated by the intercession of the ghostly lady. As in *Angel*, Lubitsch's heroine is permitted to achieve sexual liberation without being deprived of happiness – Angelina rejects Mario and marries the colonel.

This already complex plot was rendered even more elliptical by Lubitsch's ideas for motivating the lady in ermine to liberate Angelina. He decided to counterpoint Angelina's moral choice with a similar episode from the lady in ermine's past. Lubitsch showed in flashback a scene two hundred years earlier where Francesca, in a similar moral dilemma, had killed an invading Austrian colonel (played by the same actor who plays the 'modern' colonel), rather than lose her virtue. But, in ghostly form, the Lady's husband and relatives torment her and themselves with speculation about whether Francesca had in fact slept with the colonel before killing him. Lubitsch introduces this doubt to show that Francesca's passion had been for the man she murdered, not for her husband. Yet she had sacrificed her great love for her husband, who did not appreciate her efforts. His suspicions about her behaviour on that night have haunted him – and plagued her – ever since. Accordingly, she is now prepared to help her latter-day counterpart, Angelina, achieve the sexual fulfilment which Francesca denied herself, rather than see another woman driven by convention into denying her self-expression. We learn that Francesca had *not* in fact slept with the colonel in 1661; but, in 1861 she takes her opportunity and, vicariously via Angelina, realizes her ambition of running away with the colonel. This is a complex plot strategy – Darryl Zanuck had to ask to have it explained to him[45] – which contains an explicit critique of marriage, smuggles in extramarital sex via Francesca's ghostly union with the colonel and has much mirth with the notion that Francesca may have committed adultery in 1661.

The script displeased the censors on all counts. Raphaelson's screenplay went to the PCA in June 1947. Breen replied a few days later and then called Lubitsch to a conference. The story was unacceptable, he wrote, because of the way in which 'adultery and suspicion of adultery are treated for comedy without any compensating moral values'.[46] More serious was Lubitsch's readiness to allow a woman to throw over her marriage in pursuit of sexual fulfilment. The annulment of the marriage had to be shown, demanded Breen, to be Mario's decision, made 'over the protests of Angelina, who wants to preserve the marriage, as is her duty'.[47] The point was reiterated following another conference held three months later. ('It is the husband who secures the annulment.')[48] This is forceful evidence of the novelty and daring of Lubitsch's decision to give the woman the initiative in this matter. Despite subsequent script revisions during October 1947, *That Lady in Ermine* retained Lubitsch's crucial depiction of Angelina's sexual liberation and the rejection of female passivity in

marriage that had so alarmed the Breen Office.[49] Once again, Lubitsch had triumphed over the censors and maintained the integrity of his views and values in the depiction of women.

While these three films were the most radical entries in Lubitsch's oeuvre, they were complemented by a number of his other films. These too challenged the moral consensus and the prevailing views about the position of American women in contemporary society, but, arguably, to a less radical extent.

Experimenting with screwball: *Bluebeard's Eighth Wife*

In *Bluebeard's Eighth Wife* (1938), Lubitsch allowed a strong woman to confront a man with the shallowness of his sexual exploitation. An incomplete script for Lubitsch's adaptation of the Alfred Savoir play *Bluebeard's Eighth Wife* was first sent to the PCA in March 1937. But, with filming ready to start on *Angel*, the project was held in abeyance until the late summer.[50] Breen's early reaction was cautiously approving, alert as ever to the likelihood that a Lubitsch production might contain 'material, or a general flavor, which reflects unfavorably upon the institution of marriage'.[51] Once *Angel* had been completed, Lubitsch returned to work on the Bluebeard script with a new scriptwriting team: Charles Brackett and the future director Billy Wilder. They submitted a draft in late August that was close to the final film and which Breen read 'with considerable pleasure'.[52] Providing helpful advice on how to avoid local censorship within the United States, Breen gave the film a smooth passage. The following February, in 1938, the film was approved and, after some last-minute script changes necessitating some reshooting, *Bluebeard's Eighth Wife* was released in March 1938.[53] It was a reasonably faithful adaptation of the play, adjusted to the then fashionable trend for screwball comedy.[54] Although it had elements that were bound to appeal to Lubitsch, he expanded on certain aspects considerably in his film. First, he added a satire of marriage. Then, daringly for the American screen (as distinct from the French stage), he emphasized the sexual conflict between the married couple. The result was another Lubitsch film which called into question masculine attitudes towards sex and expanded the permitted behaviour of Hollywood's female characters.

Mike Brandon, the 'Bluebeard' of the title, marries and divorces women repeatedly, offering his wives a prearranged financial settlement, payable as soon as he has lost interest in the marriage. He thus buys sex within the supposedly respectable social institution of marriage. Lubitsch makes clear the relationship between sex and commerce in this man's mind. 'Love and business, it's the same thing: you have to gamble.' His eighth wife, Nicole, resists his strategy, however, by refusing to give Brandon his conjugal rights (dextrously depicted by having Brandon suffer from 'insomnia', with resulting irritability and tension). Her determination to challenge Brandon's approach to women is successful: ultimately, she wins the battle to gain a divorce on her terms. Her motive is to expose the crude shallowness of his life, not simply to humiliate him. When he refuses to remarry her on the basis of equality (she is now, through the divorce settlement, no longer financially dependent on him), she incarcerates him in a lunatic asylum until he accepts her terms.

Reviewers generally rejected the film, criticizing Lubitsch for lack of subtlety, for an unlikely and thin story and for a miscast Gary Cooper. Part of the problem seems to have been the absence of morality in the Brandon character, which prevented reviewers from sympathizing with him, as well as the frank portrayal of a sexually frustrated husband that may have upset some sensibilities.[55] One can only guess at the extent to which the taming of a man by a dominant woman lay behind the uneasiness with which these reviewers greeted the film.

Heaven Can Wait and the exploration of male sexuality

In 1942 Lubitsch signed a long-term contract with Twentieth Century-Fox, the first fruit of which was *Heaven Can Wait* (1943). In this film Lubitsch focused on male sexuality. The overall aim of the film seems to have been a plea for sexual tolerance in a notoriously prudish culture. Although its treatment of the main female character was conventional, the film's refusal to endorse any specific sexual morality was very rare in Hollywood at this time. Its avoidance of a moral line perhaps constitutes the film's most radical statement. The source on this occasion was a play, *Birthday*, by Ladislaus Bush-Fekete, set in Vienna between 1884 and 1934.[56] Its story takes place in six scenes, each of which occurs (at ten-year intervals) on the birthday of one man, Jack, as he evolves from his first youthful sexual encounter to old age. During his life he elopes with a woman, Vera, but leaves her after twenty years of marriage for a much younger woman. This second wife in her turn is unfaithful to Jack, and he bitterly divorces her. In the final scene, he reflects with some remorse on the foolish betrayal of his first wife, but concludes, nonetheless, that the pursuit of sex and love is in a man's nature. The rather sanctimonious moral of the play – that a man who indulges in youthful irresponsibility in his middle life will later rue his impetuous behaviour – is rendered ambiguous by the final acceptance of the perennial male sex drive.

The first extant draft of the screenplay, dated August 1942 and entitled 'Birthday', demonstrates how Lubitsch and his screenwriter, Samson Raphaelson, evolved away from the overt moralizing of the play towards the film's deliberate moral ambiguity.[57] The story of Jack – now called Henry – is very similar to the play, including a protracted sequence detailing his second marriage. Henry's pursuit of a second youth in his later middle age causes him to marry Pearl Higgins, a gold-digger with an unpleasant family in train. Although, as in the play, this second marriage brings him misery, the critical focus has shifted. By exaggerating the defects of Pearl Higgins, Lubitsch evokes sympathy, rather than condemnation, for Henry in his second marriage. More importantly, the marriage does not take place until Henry is a widower, whereas in the play Jack has a long affair while still married to Vera. The play dwells on Jack's cruel treatment of his first wife; thus the moral critique of Jack and the failure of his second marriage seem entirely just. The Lubitsch version, by inflicting an unhappy second marriage on a widowed man who has committed no serious moral wrong, loses any sense of ethical didacticism. Accordingly, as Lubitsch's script was revised, the episode of the second marriage was excised.[58] Thus, Henry pays no price for the numerous sexual adventures of his widowerhood. This removes from the

film perhaps the most important element of the play, namely the painful lesson that sexual satisfaction is had only at the cost of unhappiness. Indeed, the film's framing story allows the Devil, having heard Henry's life story, to judge him fit for Heaven. No moral opprobrium attaches to Henry's sexual dalliances; the viewer is simply invited to accept the place of sex in a man's life. In the divine balance, the film suggests, men's failings will be tolerated; as the title proclaims, God does not expect perfection from men on earth – He can wait.

Lubitsch was aware of this moral avoidance, regarding it as an achievement: 'I made this picture because it had no message and made no point whatsoever. The hero was a man only interested in good living with no aim of accomplishing anything, or of doing anything noble.'[59] The *New York Times* reviewer noted approvingly that the 'picture has utterly no significance. Indeed, it has very little point, except to afford entertainment.'[60] This was not simply testament to an escapist urge on Lubitsch's part. His refusal to offer a moral in *Heaven Can Wait* was a conscious and novel approach towards the depiction of sexuality in 1940s Hollywood. Overall, his strategy of eschewing moral judgement subtly made a strong case for liberalism in matters of sex and public morality.

Transforming the conventional: *Ninotchka*

Between *Bluebeard's Eighth Wife* and *Heaven Can Wait*, Lubitsch made what is arguably his masterpiece of sound cinema. *Ninotchka* (1939) had been purchased by MGM in 1937, and for almost two years a number of writers and producers had been trying to shape a suitable screenplay. In transforming the scripts he inherited into the completed film, Lubitsch reworked a conventional Hollywood romance into a challenging film that transcended its generic limitations. (The film's commentary on communism and international relations is considered in Case Study 5.) He did not discard all the previous work on the story. He willingly accepted a conventional narrative structure but, working within it, once again subverted the innate conservatism of his material. To appreciate this achievement, one must go back to the original story that Lubitsch took over.

Ninotchka began life in 1937 as an original screen story by Melchior Lengyel, the same man whose play *Angel* Lubitsch had filmed that year.[61] Subtitled 'Love Is Not So Simple', it had a familiar formula: a cynical man, Leon, woos a Soviet woman, Ninotchka, for commercial reasons, but falls in love with her in the process. A power struggle between the man and the woman ensues until Ninotchka recognizes her destructively assertive behaviour, gives in, and the couple marry. It is a typical Hollywood romance, and Lengyel undoubtedly meant it to be so. He attached a foreword that emphasized that 'the international background has no political implication'; it was simply a plot device. He recommended a light comedy treatment.[62]

Lengyel soon dropped out of the project and a protracted script development began.[63] The playwrights and screenwriting duo, Ben Hecht (who had written *Design for Living*) and Charles MacArthur, produced a fourteen-page outline, 'Garbo – Russian Story', which emphasized the twin themes of the taming of an emancipated woman and the parallel repudiation of Soviet politics.[64] 'Garbo's' (that is, Greta Garbo, who was to play Ninotchka)

transition from a symbol of 'feminine emancipation' to an irrational, jealous woman, hopelessly in love, allowed the writers to conclude, with evident relief, that there is no 'new race of women'.[65] Ninotchka repudiates her early belief that marriage is 'too much a surrender of her modern ideals' and her feminist pretensions are revealed to be misguided.[66] Neither MGM nor Breen liked their treatment: a studio executive told Breen that he was disposed 'to disgard [sic] entirely' their work.[67] Over the next twelve months a succession of writers tried to develop an acceptable screenplay – Jacques Deval, the noted writer S. N. Behrman and Lubitsch's later collaborator Samuel Hoffenstein (who would work on *Cluny Brown*). They were closely supervised by MGM producer Sidney Franklin.[68] The resulting conglomeration of script material hardly departed from Lengyel's original scheme. Clichés abounded; in a Behrman scene, Ninotchka refuses to believe in Leon's reform and behaves with all the 'resentment of the woman spurned'.[69] As late as February 1939, Franklin was suggesting further ways of setting up Ninotchka's feminist ideas for a fall, proposing that she deny the existence of jealousy, the very emotion that will cause her later pain.[70] Her rationalist notions would be made to appear foolish, while the male hero was to be treated with great sympathy.

Although Lubitsch retained much of the story's structure, the final film is fundamentally different from the Lengyel–Deval–Behrman–Hoffenstein scripts. Lubitsch converted this tired material into an altogether more complex political satire. Instead of Ninotchka evolving from assertive woman to controlled wife, Lubitsch used her transition from frigidity to love to parallel the breaking of barriers raised by political systems. Nintotchka's discovery of love came to represent the growth of human affinities in a world divided between democracies and dictatorships. Ninotchka's strength and power were accordingly retained and treated with dignity. The earlier scripts' anti-feminism became Lubitsch's manifesto for reconciliation between nations.[71]

Lubitsch's writing team of Brackett and Wilder (fresh from *Bluebeard's Eighth Wife*) was supplemented by Walter Reisch, an Austrian refugee from the Nazis (who would later adapt *Divorcons* for Lubitsch's *That Uncertain Feeling*).[72] They dropped all aspects of the film that turned the Leon–Ninotchka romance into a battle of wills in which the woman is inevitably worsted. The complications regarding Leon's motives for wooing Ninotchka were not carried forward from the early scripts. Instead, Lubitsch made it clear that their love for each other was genuine, allowing the director to concentrate on the triumph of that love over their political differences. The customary elements of Hollywood's romances that degraded women were purposely subverted. Lubitsch did not subjugate his heroine to the man's power; she – and her political beliefs – were treated with respect. She is assertive, competent and clever without, in the end, losing any of her femininity. Her sexual and romantic awakening do not rob her of her strength, but complete her as a woman. Lubitsch achieved something almost unparalleled in Hollywood films of this era: he combined in one figure a strong, assertive woman and an attractive, feminine heroine. Instead of the controversial political theme being tacked on to an anti-feminist romance, the romance is subordinated to the wider theme of human affirmation at a time of global stress. Contemporary reviewers focused almost exclusively on the film's

political dimension.[73] For Lubitsch himself, he believed he had 'succeeded in the very difficult task of blending a political satire with a romantic story'.[74] On both counts, he had produced another challenge to the conventions of his adopted country's culture.

Emancipation in England: *Cluny Brown*
The remaining Lubitsch film in this category – of challenging films that exhibit a strong, but perhaps not fully realized dissent – is *Cluny Brown* (1946). (This film's commentary on social class in Europe is considered in Case Study 5.) Twentieth Century-Fox had purchased Margery Sharp's popular novel around April 1944 and had engaged English expatriate James Hilton to write a screenplay.[75] He wrote three treatments and a screenplay for *Cluny Brown* before the end of 1944, remaining faithful to the novel in most respects, even in points of detail and specific dialogue.[76] Hilton's treatments remained firmly at the level of conventional Hollywood romance. The studio secured from him a rather flat and humourless script that had no ending. It told the familiar story of a cynical philanderer finding love, while an initially hostile and wilful young woman finally succumbs to his overtures. The arrival of Lubitsch and the evolution of the script under his team of Samuel Hoffenstein and Elizabeth Reinhardt are not documented. All we know for certain is that they had produced a script by May 1945 and that it, rather than Hilton's, was with Breen by July. Polishing continued at Fox during August and Lubitsch was back at the directorial helm in December, after a long bout of illness. He collapsed during shooting in February 1946 but recovered, and the film was seen on the West Coast before the end of April 1946.[77]

Lubitsch had, as might be expected, dispensed with Hilton's screenplay entirely. The finished film tells the story of a young woman, Cluny, who has aspirations to break free from the restrictions of her class and her gender. She declines to marry a chemist, Wilson, the boring, controlling man chosen for her by her family. Although she initially goes into domestic service, she nurtures and finally achieves her desire to become a plumber. She is helped in this transition by meeting an upper-class European, Adam Belinski, who is sympathetic to her desires, and who conspires with her to achieve her freedom. They fall in love, and by the film's end Cluny has chosen to marry a more appropriately liberal man, taken a 'male' job and escaped her allotted station in life. She is fully empowered, in the mode of a classic Lubitsch female character. Lubitsch achieved so much more than would have been possible by following the original novel exactly, or by using Hilton's script. He achieved this through a number of devices. He redrew the character of Adam Belinski, the philanderer, to minimize the motif of 'cynical man who reforms'. Similarly, he dispensed with any criticism of Cluny's attempt to marry Wilson. Indeed, her drifting towards an unsuitable marriage is shown as the product of oppression, both sexual and social. She is not a woman who requires taming but a sorry figure, an exploited innocent. This is poetically conveyed in the scene where Wilson plays her cheap music on his organ at home, and Cluny achieves an almost transcendent look in listening to it. In this image, Lubitsch captures the poverty and the simple innocence of Cluny's dreams and the concomitant shallowness of Wilson's ambitions for her.

Lubitsch's decision to film this particular story gave him a further opportunity to portray a strong and unconventional woman. Cluny's desire to be a plumber enables her to intrude on the male world of manual labour and assert her equality. The premise is taken from the novel, but Lubitsch attaches considerably more weight to it in his film. Crucially, he invented a sequence in which Cluny offends Wilson by mending the plumbing at his mother's staid birthday party. Even as Wilson is trying to tell the horrified guests of his forthcoming engagement to Cluny, she is rolling up her sleeves and marching, wrench in hand, into the lavatory. Her non-conformity and rejection of feminine stereotypes is set against the prospect of a debasing marriage to Wilson. The chemist cuts short his announcement and the tea party is brought to a premature close. Although Wilson later relents and agrees to re-instate his offer of marriage the incident has won Cluny her freedom from his world. Her search for a more liberal feminine role is not punished by Lubitsch but rewarded. When she and Belinski finally flee together to New York, he proposes marriage to her specifically on the assumption that she will be proudly 'putting the pipes in their place'. Her image of dominance in a masculine context is endorsed.[78]

'We made a mistake in approving this picture': *The Merry Widow*

The final film I want to consider in the canon of Lubitsch's challenge to American morality is *The Merry Widow* (1934). This film, however, does not present such an overt challenge to conventional notions of femininity and masculinity. Although there are subversive elements, the film's main significance for the purposes of this book lies in its controversial censorship history. Lubitsch sought to dissent from American moral codes and expand the scope of the screen's discussion of sex. Franz Lehár's operetta had already been filmed in 1925 and was now revived, five years after the coming of sound. Lubitsch's two script collaborators were Samson Raphaelson and Ernest Vajda, both of whom had worked with Lubitsch since the late 1920s. Vajda had in fact written an adaptation of the Lehár operetta in July 1930, although it is not known whether this was intended for Lubitsch.[79] Nothing came of this initiative, but the idea was reconsidered at MGM three years later when Hans Kraly (another of Lubitsch's long-standing colleagues) wrote a treatment in broken English.[80]

The evidence suggests that Lubitsch was not yet the studio's choice of director, and two further treatments were to appear before his name was associated with the project. All three of the early treatments differ markedly from the final Lubitsch film. Kraly was superseded by Rowland Leigh.[81] When he departed, the task of preparing a treatment fell to Viki Baum, working under the close supervision of MGM's famous production head, Irving Thalberg, during November and December 1933.[82] These first three treatments concentrated on the themes of class differences conquered by love and European despotism giving way to democratic monarchy. Lubitsch, however, was not interested in the hackneyed story of a poor peasant girl's love for a dashing Prince – he had worked on this years earlier in *The Student Prince* (Lubitsch, 1927). Neither was it his style to celebrate a fake conversion to democratic monarchism, as suggested by the early treatments. Accordingly, he jettisoned

the episodes in which the widow, disappointed in an affair with Prince Danilo, foolishly decides to marry a much older man. This punitive treatment was not Lubitsch's way. The romance between Danilo (now a mere captain in the king's army) and Sonia, the widow, was to be rendered more complex than the conventional morals inherent in the previous treatments would allow.

Fragments of a script by Anita Loos, dated late December 1933, were copied to Lubitsch and Ernest Vajda.[83] By March the following year, Lubitsch had been appointed director, and script sequences were being written by 'Lubitsch-Vajda-Raphaelson'.[84] Rehearsals and shooting followed during April and May, and again from late June to mid-July 1934.[85] From the film that resulted, we can see how Lubitsch discarded virtually all of the material prepared before his arrival. In the process, he departed significantly from the original operetta, as noted by reviewers.[86] In making his changes, Lubitsch consciously continued from his immediately prior film, *Design for Living*, the exploration of sexually assertive women. Once more, his insistence on sexual frankness led to censorship problems and collided with the growing pressure for a moral clampdown.

Lubitsch's *The Merry Widow* is, on the face of it, a conventional Hollywood romantic parable, in which a cynical man reforms and a wilful woman, initially resistant to his wooing, finally sees her mistake and accepts his dominance. Yet Lubitsch transformed this rather unpromising material in two main ways. First, he endowed Sonia with sexual desires as well as feminine virtue. Second, he took pains to scrutinize Danilo's sexually exploitative attitude towards women, rather than passing blithely over male shortcomings in the way favoured by the dominant culture. Moreover, in portraying Sonia's rejection of Danilo's cynicism, Lubitsch showed the widow's plight with such sympathy that her sense of pain and rejection at Danilo's apparent manipulation is genuinely moving. She is not, as conventional Hollywood would dictate, a woman who is trying to choose her own partner and thus wilful and unduly assertive. Rather, Lubitsch shows her as a victim of male arrogance. In these two ways, Lubitsch, working within a very conventional story structure, managed to lift *The Merry Widow* above the run-of-the-mill romance it might otherwise have been.

He added to Hollywood's repertoire a new model for American women. For Hollywood at this time, the two sides of a woman – sexuality and virtue – were irreconcilable opposites, values embodied in two different women. One was to be condemned for immorality, the other idolized and subjected to rigid standards of behaviour – and thereby both were to be controlled. Lubitsch, in *The Merry Widow* (as he would go on to do in *Angel* and *That Lady in Ermine*), suggested that *both* aspects of femininity were essential to womanhood. The key scene sees Sonia, disguised as 'Fifi', courted by Danilo in Maxim's, a high-class Parisian restaurant. Not suspecting her identity, he tells her how tiresome respectable women are, always seeking commitment from men. Heartbroken, Sonia leaves him. When Danilo next meets Sonia, in her real identity, he greets her as 'Fifi', the sexual woman he now realizes he loves. She replies that Fifi is no more. Danilo has destroyed her alter ego, the sexually uninhibited, yet respectable, woman. Danilo has insisted on the inability to reconcile in one person both aspects of a woman, preferring to draw a distinction between sex and marriage.

Lubitsch, in criticizing Danilo's attitude, demonstrated the complementarity of sex and respectability in women. Unlike *Design for Living*, *The Merry Widow* accepted the convention of marriage, but only after greatly expanding the acceptable definition of femininity. It was not Lubitsch's greatest achievement in his study of sexual roles, but his handling of the genre showed his continuing wish to experiment with the permissible images of women and men in Hollywood in the 1930s.[87]

It was necessary, if Lubitsch were to succeed in his reinterpretation of male and female sexual roles, to assault the moral consensus that reinforced female passivity. This strategy again proved highly controversial, as it had done in *Design for Living*. The arrival of a new moral order in 1934 caused difficulties of adjustment for all Hollywood film-makers. Lubitsch's interest in exploring sexual relations between modern men and women inevitably placed him at the forefront of the moral debate in America. He quite deliberately challenged the accepted moral consensus, even as it was being reformulated. Taken in the context of 1930s America, *The Merry Widow* was positively risqué. The frankly avowed adulterous relationship between Danilo and Dolores, the Queen of Marshovia, is handled with customary Lubitschian innuendo, but can nevertheless scarcely be mistaken. Nor can the purpose of Maxim's be construed as anything other than a high-class brothel, in which the 'dining rooms' upstairs are not used primarily for eating. And Danilo's entrance into Maxim's is an unmistakable tribute to his sexual prowess: he is carried across the dance floor by a bevy of adoring women, one of whom takes off her garter with 'Many Happy Returns' inscribed on it by Danilo. For these reasons, the Hays Office took the highly unusual step of demanding the reshooting of some sequences. Notwithstanding, they came to believe that they had still not been strict enough.

Lubitsch's scripts seldom gave sufficient clues to the suggestive nature of certain sequences when filmed. Accordingly, when the script was submitted in March 1934, the Hays Office found it generally acceptable. Breen wrote to MGM's head, Louis B. Mayer, objecting to the use of the upstairs rooms in Maxim's for immoral purposes and to numerous provocative lines (most of which, nevertheless, were successfully retained by Lubitsch in the released film). But, in Breen's end-of-month report to Will Hays, *The Merry Widow* was classed among a number of films, 'None of [which] presented any particular Code difficulties'.[88] Breen saw a preview of the film in August at MGM, after which he organized a meeting with Lubitsch and Irving Thalberg to iron out the remaining problems.[89] Here Breen secured agreement to removing certain lines; to toning down the Can-Can number (to the amusement of journalists who got wind of this); and to a reshooting of the scene where Danilo and Sonia lie down together on a couch, 'getting away from the "horizontal" ' as he memorably recorded.[90] He expressed his satisfaction with the results of this conference to Louis B. Mayer shortly afterwards.[91] While taking account of Breen's points, Thalberg strove to protect the film from too much disruptive re-editing.[92] It was previewed on the West Coast at the end of August 1934.

Variety described it as 'a more earthy, knowing and sophisticate [sic] version' of the earlier silent film, with the romance 'refreshe[d] for mature audiences of today. It is strictly adult

Case Study 3 – 'Definitely Bawdy and Offensively Suggestive': Lubitsch and the American Woman

entertainment.' The reviewer welcomed the return of 'the old Lubitsch of sly innuendo and finessed sex implications', while recognizing that 'in less deft hands [parts might] verge on the questionable bawdy note'.[93] Breen saw the film at a preview later in September, and although he sought a few further minor changes, Thalberg telephoned and persuaded him to waive his objections in order to avoid expensive re-scoring.[94] Satisfied, Breen awaited the film's official opening in New York the following month. He did not seem aware of how significantly the moral atmosphere in the country was shifting. He appeared completely unprepared for the outcry which greeted the film's release on the East Coast, from the self-appointed custodians of American morality.

When the storm broke, Breen did not attempt to avoid responsibility. He admitted in a letter to his boss, Will Hays, written on 25 October 1934, that on watching the film again he understood 'that public reaction which criticizes it in a definite, unfavorable way'.[95] The letter reads somewhat like a retraction of past unorthodoxies by an Old Bolshevik at a Stalinist show trial. Breen now saw that it was not 'the light, gay, frivolous operetta' it should have been, 'but rather the typical French farce that is definitely bawdy and offensively – in spots – suggestive'. He had come to believe that, 'we made a mistake in approving this picture as it now is'. Breen regretted that 'I had ever passed this picture', understanding belatedly 'the present serious criticism levelled against the picture'. Ominously, he foresaw 'serious strictures to follow'. He continued his confession by blaming himself for not having pressed Thalberg harder, and blaming Thalberg for not having carried out orally agreed revisions to the picture. In conclusion, he recommended thirteen cuts to Hays, explaining that his aim was to render the film more acceptable to the mass audience, rather than leaving it to the tastes of the 'sophisticated [audiences] now viewing the picture on Broadway'. The saga closed when Thalberg wired Hays four days later, politely but firmly resisting further indiscriminate cuts. Instead, he offered to view Hays' preferred version to see whether agreement could be reached. Finally, MGM circulated a list of agreed cuts across their distribution network and Breen recorded his gratitude for their cooperation.[96] In truth, Breen had been a little hard on himself. He could not have predicted the force with which the Legion of Decency and like-minded moral groups would assail the film industry. The evidence suggests that Breen was caught by surprise, able to anticipate neither the wishes nor the power of the new pressure groups.

Lubitsch defended his film in a public debate which ensued with the moral custodians. He argued that the Legion of Decency's campaign was inhibiting producers from expressing views that conflicted with those of the reformers. This was preventing him and others 'from dealing with vital problems', and hampering the maturation of motion pictures.[97] Martin Quigley replied intemperately, denouncing Lubitsch as a foreigner with an 'extremely limited knowledge of the tastes, thoughts and habits of the American people', and issuing veiled threats about the prospects of Lubitsch continuing to work in America. He denied that the Code inhibited discussion of marriage and divorce, arguing disingenuously that the new Production Code was intended only to prevent 'pornographic' treatments of such subjects.[98] Lubitsch replied a few days later, noting that Quigley had retracted some of the

more offensive comments, agreeing that vulgarity and bad taste were to be avoided, but emphatically defending the right to discuss contemporary American society: 'No industry that lives from drama ... can exist if not permitted to deal with the urgent problems of the times, and it should not be forced to treat such problems in an unbelievable, fairy-tale manner'.[99] The debate about the new morality exposed Lubitsch's deliberate intentions behind his apparently jaunty romantic comedies – to explore the issues of male and female relations. His determination to do so, and the seriousness with which he tackled his ostensibly light, diverting films, meant that he would inevitably reject the new moral conservatism in the United States. The censorship battles he fought – most notably over *Design for Living* and *The Merry Widow* – along with his sustained challenge to American attitudes towards women, provided a major contribution to New Deal cultural and moral debates.

Lubitsch conforms: taming the assertive woman

Lubitsch was not entirely consistent in his radical treatment of women, sex and society. For completeness, I briefly consider the remaining two films he made in this period (*To Be or Not to Be*, his other work, is considered below in Case Study 5). In both of these films, his customary sympathy for women seems to have faltered. In 1939 Lubitsch signed an agreement with independent producer Sol Lesser, to produce and direct two films a year for the following five years.[100] In fact, the deal yielded only one film: *That Uncertain Feeling* (Lubitsch, 1941). It was derived from a nineteenth-century French play, *Divorçons*, by Victorien Sadou, which Lubitsch had already filmed (as *Kiss Me Again*) in 1925. There had been numerous recent failed attempts to bring the story back to the screen, including one intended for Gary Cooper and Carole Lombard, and one by the noted satirist and Marx Brothers' collaborator S. J. Perelman.[101] The film which Lubitsch made significantly changed the source material to moderate its determined hostility to women. Nevertheless, Lubitsch and his writer, Donald Ogden Stewart, left intact the play's criticism of a wife who tries to divorce her husband and restated the idea that extramarital adventure is ill-conceived. They also retained the anti-intellectualism introduced by the earlier American scripts, portraying the artist lover as a self-indulgent, hypocritical fraud. On balance, Lubitsch's final film did not rise far above its pedestrian source material. Whether the material itself was too conventional for Lubitsch to exercise his customary powers of transformation is, in a sense, beside the point. Lubitsch chose the material and presented it as he saw fit.

Although he took as his starting point a potentially subversive idea – a conventional marriage exposed as a failure; an assertive woman pursuing her desires through adultery; a husband waking up to his responsibilities to treat a woman with respect, not oppression – he chose to give the film a conservative treatment. The difference between the wife's fortunes here and those of Maria Barker in his earlier film *Angel* are revealing. Whereas Maria finds a charming and sensitive lover as an alternative to her husband, Jill Baker in *That Uncertain Feeling* finds that the alternative to marriage is an unattractive boor. Maria, in *Angel*, challenges her husband and finally exacts from him a promise to reform; Jill is too weak to sustain her challenge and eventually has to sue for terms from an unrelenting

husband. For Jill, there is no alternative but to accept her husband as he is; marriage is better than independence, even if the marriage has shortcomings. Her husband Larry's reform is not demanded by the film and must be assumed by the viewer instead. At the moment of reconciliation, Larry crows over his humbled wife, lecturing her on female irresponsibility, which wrecks a marriage and then tries to repair it one Sunday afternoon. She is spoiled and self-indulgent, he asserts. Jill, with head bowed and eyes tearful, admits: 'I'm defeated'.

This line of argument is not unqualified, however. In one important scene, Larry confides to his divorce lawyer that he will soon have Jill tamed and 'eating out of my hand'. This frank statement of male motive is important, for such motives almost always remain unacknowledged in Hollywood cinema of this period. By showing Larry in such a naked light, Lubitsch helped to illuminate abusive male power. A more significant element of dissent from the dominant culture was the film's sexual frankness. When the script was first submitted to the PCA in September 1940, Breen replied direct to Lubitsch in a letter five days later. He raised two main objections. First, 'the quite inescapable suggestion that the entire story is based upon the suggestion [sic] that the wife's general upset condition … is due to the fact that her husband is so pre-occupied with his business that he does not co-habit with her'; and second, the fact that Jill commits adultery with her lover, Alexander Sebastian. Breen went on to identify the early scene where Jill visits a psychiatrist as the key to the problem, with its clear references to the sexual nature of Jill's discontent. Breen called for new lines to be inserted, lines 'which will be believed by audiences', he stressed.[102]

Although script revisions did follow, the final film gave the critics no difficulty in getting to the heart of Jill's problem. Certain lines were removed that cast doubt on Larry's sexual prowess and even penis dimension. One such casualty, specifically challenged by Breen, was Jill's report to the doctor about looking at her husband as he came naked out of the shower: 'well, if a wife looks at her husband through a magnifying glass she's bound to see something'.[103] But still remaining in the released film was the doctor's summary remark, in answer to Jill's question, 'are you trying to break up my marriage?': 'no, just wake up your husband'. This was evidence for one reviewer that Lubitsch's famed light touch was turning into 'a sock in the jaw'; for another, it had become 'too evident and unsubtle'.[104] With the guarded approach the censors knew was needed for a Lubitsch film, they approved the script, but reserved judgement until they had seen the final film.[105] Yet Lubitsch refused to be hamstrung by American prudishness. He smuggled in the sexual element of Jill's frustration, as well as clear intimations of adultery with her lover. Reviewers reacted to Lubitsch telling a more conventional moral tale in various ways. Some were relieved and expected that male audiences would be too: 'And the majority of husbands are going to find Mr Lubitsch's theme particularly gratifying'.[106] The *New York Times* critic took a different view, however, criticizing Lubitsch for having allowed screenwriter Stewart to push the film into a typical Hollywood mould: 'his script [is not] greatly different from all the husband against wife melees of which, heaven knows, we have had plenty of late … the film becomes just another history of marital fisticuffs with the husband, of course, the winner'.[107] It was a justified critique of a disappointingly conventional entry in the Lubitsch canon.

The Shop around the Corner (Lubitsch, 1940) was another uncharacteristically conservative Lubitsch film. MGM had acquired the rights to *Illatszerter* (translated as 'Drug Store'), a three-act play by Hungarian author Miklós László, in October 1936.[108] Lubitsch did not turn his attention to it until the summer of 1939.[109] The script process was then apparently uncomplicated and speedy. By late October Samson Raphaelson had drafted the screenplay, the project had been retitled *The Shop around the Corner* and shooting was shortly under way. The film was released in early 1940 to good reviews. Whereas the source was not particularly conservative in its depiction of women, the film chose to concentrate on the denigration of the female clerk, Klara, and her intellectual pretensions. She seeks to determine the course of her life by choosing a husband whom she feels will best meet her demands. Klara's advertisement for a male penfriend informs us that she is a contemporary feminist, not a conventional girl: 'Modern girl wishes to correspond on cultural subjects ... with intelligent, sympathetic young man'. When a colleague asks her eventual penfriend, Kralik, whether his correspondent is pretty, Kralik replies, 'she has such ideals, such a viewpoint on things'. His colleague understands Kralik's meaning and replies: 'so, she's not so pretty'. This exchange captures the dichotomy that has been established between an intellectual woman and one suitable for romance and marriage. Kralik warns the independent-minded Klara at one point that she'll be 'an old maid [who'll] have a tough time getting a man to marry you'. In the final scene, Klara rejects her 'lofty ideals', accepts Kralik and explains, 'psychologically, I'm very confused, but personally – I don't feel bad at all'. In other words, her attempt to plan her life rationally has failed. She now accepts her irrational feelings and cedes control of her life to the man.[110] It was symbolic of this Lubitsch excursion into routine Americana that one reviewer could praise *Shop Around the Corner* as 'happily free of the risqué connotations commonly associated with Continental comedies'.[111]

Notes

1. The account of Lubitsch's early life and career which follows is derived from Eyman, *Ernst Lubitsch*.
2. The 'auteur' debate and literature is discussed fully in Chapter 2.
3. Eyman, *Lubitsch*, 98, where he quotes extensively from the contracts.
4. Eyman, *Lubitsch*, 114.
5. If one accepts Eyman, *Lubitsch*, 149, referring to *The Love Parade* (1928).
6. Eyman, *Lubitsch*, 212. Lubitsch's short episode in *If I Had a Million* (1932) meant he had contributed to one profit-making film.
7. Eyman, *Lubitsch*, 188.
8. Sonia Lee, 'What's Wrong with the Movies', *Motion Picture Magazine* (September 1933), 90.
9. For the details of Lubitsch's ascendancy to head of production at Paramount, highlights of his brief career there, and his subsequent downfall and enforced vacation, see *Variety* (5 February 1935), 1; (12 February), 5; (12 June), 29; (31 July), 4; (7 August), 3; (9 October), 5; (13 November), 4; (20 November), 2; (5 February 1936), 5; (12 February), 5; (26 February), 5; and (18 March), 6; and *Hollywood Reporter* (8 March 1935), 1; (19 March), 3; (26 March), 1, 3; (3 June), 1, 8;

Case Study 3 – 'Definitely Bawdy and Offensively Suggestive': Lubitsch and the American Woman

(5 June), 1; (7 June), 1; (14 June), 3; (17 June), 1–2; (18 June), 1; (26 June), 1; (2 August), 6; (24 October), 4; (31 January 1936), 1, 6; (3 February), 1; (4 February), 1–2; and (8 February), 1–2. Lubitsch's main problems appear to have been an unwillingness to control Paramount's serious cost difficulties and a preference for artistic exactitude over commercial commonsense. His practice of sending pictures back for reshooting did not help. His departure from the post in February 1936, almost exactly a year after his appointment, seems to have come as something of a relief to him – see *Hollywood Reporter* (3 February 1936), 1 and *New York Times* (1 March 1936), IX, 5.

10. Lubitsch's preference for the unit system was expressed, for example, to Lee, 'What's Wrong with the Movies', *Motion Picture Magazine* (September 1933), 90 and noted in *Variety* (12 June 1935), 29. It was introduced to Paramount in January 1936, primarily, it seems, as a means of controlling costs – see *Hollywood Reporter* (31 January 1936), 1, 6. Lubitsch was put in charge of his own unit as producer–director on his dismissal as head of production – *Variety* (12 February 1936), 5.
11. 'Paramount', *Fortune*, 40 (March 1937), 86–96, 194–98, 202–212; see in particular, 202–3.
12. See *Variety* (1 March 1932), 2, 17; *American Cinematographer*, 28 (July 1947), 238–39, 258; Lee, 'What's Wrong with the Movies', *Motion Picture Magazine* (September 1933), 42, 90–92; Charles Brackett and Billy Wilder, in 'A Symposium on Ernst Lubitsch', *The Screen Writer*, 3 (January 1948), 14–20. See also Jeanette MacDonald's comment in the same symposium, 16, that, 'His scripts were almost invariably his pictures'.
13. Grover Jones, 'Movie Magician', *Collier's* (21 September 1935), 33.
14. Lee, 'What's Wrong with the Movies', *Motion Picture Magazine* (September 1933), 90.
15. Ernst Lubitsch, Paramount press release (24 November 1937), in the Margaret Herrick Library, Los Angeles, Lubitsch personality file. This working practice of Lubitsch's dates from his earliest career – see his explanation of his working methods in *Wid's Daily*, 43 (28 December 1921), 4.
16. Scheuer, 'Lubitsch Looks at his Oscar', *Los Angeles Times* (6 April 1947), III, 3. See Lubitsch's similar tone in Lubitsch, 'What Do Film Audiences Want?', *New York Herald Tribune* (16 September 1940), 25.
17. Lee, 'What's Wrong with the Movies', *Motion Picture Magazine* (September 1933), 90–91. For Lubitsch's relations with the censors, see below in the text.
18. *American Cinematographer*, 19 (February 1938), 56.
19. Unattributed, undated news clipping, in Margaret Herrick Library, Lubitsch personality file.
20. Weinberg, in *The Lubitsch Touch*, 58, agrees that this was Lubitsch's major achievement in his later career. See also Haskell, *From Reverence to Rape*, 96–102, for an assessment of the positive attitude towards women in Lubitsch films.
21. 'E. E. B.', note for the file (26 January 1933), PCA, Design for Living file (hereafter, 'DL').
22. This, and the extensive quotes which follow in the text, all come from an undated Paramount press release in the Margaret Herrick Library, Lubitsch personality file.
23. Another Paramount press release (n.d.), in the Margaret Herrick Library, Lubitsch personality file.
24. Mordaunt Hall, *New York Times* (23 November 1933), 24.
25. Anonymous note (29 July 1933), PCA, DL.
26. W. H. Wright, letter to Wingate (14 June 1933); Wingate memo (19 June 1933) – here he makes a suggestion to enable some dialogue to appear to refer to Tom and Gilda loving each other rather than, as the script intended, to them having 'slept together'; Wingate, letter to Hays (26 June 1933); all PCA, DL.

27. The letters are as follows: Wingate to Hays (26 June 1933); Wingate to Hays (25 October 1933), writing after a preview; Wingate to A. M. Botsford (13 November 1933); E. E. B. to Joseph Breen (16 May 1934) – it is not clear what was the nature of this violation; all PCA, DL.
28. Breen, letter to Hammell (30 August 1935), PCA, DL.
29. Martin Quigley, 'Decency in Motion Pictures' (1937), in Mast (ed.), *The Movies in our Midst*, 340–44 – see 343.
30. Paramount press release (n.d.), in the Margaret Herrick Library, Lubitsch personality file.
31. Breen, letter to Joseph Nolan (29 August 1940); Breen, letter to Luigi Luraschi (2 August 1944); both PCA, DL.
32. See the report that he would direct Dietrich in 'Josephine, Wife of Napoleon'; Louella O. Parsons, *Los Angeles Examiner* (6 February 1935), in the Doheny Library, University of Southern California, Lubitsch personality file. For subsequent plans to make 'The Pearl Necklace', see *Variety* (12 June 1935), 29 and *Hollywood Reporter* (2 August 1935), 6; this became *Desire* (1935), supervised by Lubitsch but directed by Frank Borzage – see *New York Times* (1 March 1936), IX, 5, where Lubitsch takes some credit for the film. *Desire* is often discussed as a Lubitsch film, and his interest in it is evident; yet, its conventionally moral ending and its punitive treatment of the central female character mark it out as a non-Lubitsch project; see the script changes, agreed with the Hays Office, to provide a less controversial treatment of the female thief, between the versions of 4 November and 20 November 1935; in Paramount. Lubitsch might not have accepted such conventional moralizing if he had been more closely and personally concerned with the film. Finally, see the report in Parsons, *Los Angeles Examiner* (11 February 1936), that Lubitsch would direct Dietrich in 'I Loved a Soldier', plans for which were scotched when Lubitsch was dismissed as head of production at Paramount; in the Doheny Library, University of Southern California, Lubitsch personality file; and *Variety* (18 March 1936), 6.
33. I. Auster, note for the files (9 March 1934); Breen, résumé (10 March 1934); Breen, note for the files (5 October 1934); all PCA, Angel file (hereafter, 'Angel').
34. The script (dated 22 December 1936) is substantially the same as that filmed, although the character of Tony Halton (Hastings, in this version) is not, as he is in the film, left to an unspecified fate at the end; in Paramount. John Hammell of Paramount sent the script to Breen on 23 December 1936; PCA, Angel.
35. *Motion Picture Daily* (15 September 1937). See also the comments in *Variety* (15 September 1937) and *Motion Picture Herald* (25 September 1937); all in PCA, Angel.
36. Breen, letter to Hammell (28 December 1936), PCA, Angel.
37. New script submitted to Breen on 13 February 1937; approved with qualifications by Breen on 15 February 1937; the film was approved on 22 June 1937; Shurlock, memo to Breen (5 October 1937), mentions that the approval of the Legion of Decency cannot be guaranteed; all PCA, Angel.
38. Angel pressbook, PCA, Angel.
39. Frank Nugent, *New York Times* (4 November 1937), 29. See also *Variety* (15 September 1937), *Motion Picture Daily* (15 September 1937) and the sarcastic comments in *Motion Picture Herald* (25 September 1937). *Daily Variety* (14 September 1937), however, felt that Dietrich had kept 'sympathetic a role which might have become boorish'; all PCA, Angel.
40. Completed after his death by Otto Preminger, in accordance with Lubitsch's own plans for the film.
41. Schanzer and Welisch, *The Lady in Ermine*, operetta in three acts; a literal translation from the German (by Steven Vas) is in University Research Library, UCLA, Twentieth Century-Fox Collection (hereafter, 'UCLA'), FX-PRS-1095.

42. Ladislas Fodor, 'The Lady in Ermine', first draft continuity (n.d.), UCLA, FX-PRS-1095; its 69 pages take the story up to the meeting of the soldier and the wife. Lubitsch in his later treatment may have found here the idea of the husband rushing into marriage before he sets off to fight the invaders – see Lubitsch, 'The Lady in Ermine', treatment (18 February 1947), 7, UCLA, FX-PRS-1095. Another copy, with Darryl Zanuck's manuscript comments, is in the Doheny Library, University of Southern California, Twentieth Century-Fox Collection (hereafter, 'Fox'), That Lady in Ermine file (hereafter, 'TLE'). The scene is played differently in the eventual film. Lubitsch also accepted Fodor's bringing the action forward from 1810 to the middle of the century.
43. Lubitsch, 'The Lady in Ermine', treatment (18 February 1947); Raphaelson, first draft continuity (3 June 1947); both UCLA, FX-PRS-1095. Another copy, with Zanuck's casting notes, is in Fox, TLE, as well as an earlier version (22 May 1947).
44. Lubitsch, 'The Lady in Ermine', treatment, 9.
45. See Zanuck's comments on the Lubitsch treatment, 'explain retrospects to me …' and 'explain opening …'; Fox, TLE. See also the reviewer's comments in *Motion Picture Daily* (14 July 1948) that the film is rather confused; PCA, That Lady in Ermine file (hereafter, 'TLE').
46. Breen, letter to Joy (16 June 1947), PCA, TLE.
47. Breen, letter to Joy (25 June 1947), recording the results of the previous day's conference with Lubitsch, PCA, TLE.
48. Breen, letter to Joy (24 September 1947), recording the previous day's conference, PCA, TLE.
49. Final script sent by Joy to Breen on 4 October 1947; revised pages sent on 15 and 23 October 1947. The film passed through a title change at this point: on 23 October, Breen referred to 'This Is the Moment', but by 27 December, Joy was calling it 'That Lady in Ermine'; all PCA, TLE. As Lubitsch died in November 1947, the final title may not have been his choice.
50. Hammell, letter to Breen (15 March 1937), PCA, Bluebeard's Eighth Wife file (hereafter, 'BEW').
51. Breen, letter to Hammell (22 March 1937), PCA, BEW.
52. 'Bluebeard's Eighth Wife', draft screenplay (25 August 1937), Paramount; sent to Breen on 26 August 1937; Breen responded on 28 August 1937; see PCA, BEW.
53. PCA certificate issued on 5 February 1938; Hammell submitted script changes on 23 and 24 February 1938; see PCA, BEW.
54. A translation of the play is in Paramount. See the comments in *Hollywood Reporter* (17 March 1938) and the review in *Motion Picture Daily* (14 March 1938), associating the film with 'the current rage for the smart and riotous comedy'; both PCA, BEW.
55. See, for example, *Variety* (23 March 1938); *New York Herald Tribune* (24 March 1938); both in PCA, BEW; *New York Times* (24 March 1938), 21; Otis Ferguson, *New Republic* (6 April 1938), in Wilson (ed.), *The Film Criticism of Otis Ferguson*, 218. See also *Hollywood Reporter*'s summary (1 April 1938) of East Coast reviews. Favourable reviews can, however, be found in *Daily Variety* (17 March 1938), *Hollywood Reporter* (17 March 1938) and *Film Daily* (18 March 1938); see PCA, BEW.
56. An English language version of the original is in UCLA, FX-PRS-186.
57. 'Birthday', first draft continuity, UCLA, FX-PRS-186; another copy is in Fox, Heaven Can Wait file (hereafter, 'HCW'). The film changed its title to 'Heaven Can Wait' around the New Year of 1943; compare Jason Joy's letter to Breen (15 December 1942) regarding 'Birthday' and Joy's letter to Breen (20 January 1943) regarding 'Heaven Can Wait'; see PCA, HCW. The likely inspiration, not only for Lubitsch's title but also for his framing story set in Hell, was the following line from the original play, as Jack tells his grandson about his long affair with Vera: 'On her account they

will probably put me out of heaven and send me to hell ...'; UCLA, FX-PRS-186: Ladislaus Bush-Fekete, *Birthday*, 107.
58. 'Birthday' (14 December 1942), final script, Fox, HCW – see 143, and compare with the earlier version, 134–158.
59. Lubitsch, letter to Herman Weinberg (10 July 1947), in Weinberg, *The Lubitsch Touch*, 264–67; see 267.
60. Bosley Crowther, *New York Times* (12 August 1943), 15.
61. Melchior Lengyel, 'Ninotchka', story (plus synopsis) (25 August 1937), MGM, Nintochka file (hereafter, 'Ninotchka').
62. See Charlie Greene's memo (31 August 1937), in which he quotes from Lengyel's foreword (now lost). Greene was a script-reader for MGM studios; in MGM, Nintochka.
63. Lengyel, 'Ninotchka', temporary incomplete screenplay (7 and 14 January 1938), MGM, Ninotchka. This seems never to have been completed, and Lengyel's contribution appears to have come to an end after this.
64. Hecht and MacArthur, 'Garbo – Russian Story', story outline (May 1938), PCA, Ninotchka.
65. Hecht and MacArthur, 3–11.
66. Hecht and MacArthur, 11–14.
67. Breen, memo for files (13 May 1938), recording his discussion with Hyman of MGM and Hecht, and a subsequent three-hour phone call with Hyman. The latter reported that the script was now to be given to a newly arrived British novelist, probably James Hilton; nothing seems to have come of this either; see PCA, Ninotchka.
68. See the synopsis (2 September 1938) of Deval's script of 6 July 1938, as amended up to 5 August; and summary and extracts of Deval script (27 September 1938); all MGM, Ninotchka. Behrman's contribution is well documented, but it must be understood that he was working from Deval's drafts and there is difficulty in attributing credit precisely. See conference notes (28 October 1938), where Franklin, Behrman, Gottfried Reinhardt and Claudine West, a secretary, discuss the Deval script; 'Russian Sequence' (15 November 1938), incomplete story outline; temporary incomplete script (15 November 1938); verbatim note of telephone conversation between Reinhardt and Franklin (16 November 1938), in which a new page of Behrman dialogue (used in the final film) is quoted; temporary incomplete dialogue continuity (15 December 1938); notes (10, 11, 23, 24, 26, 27 January 1939); all MGM, Ninotchka. This material is supplemented by Behrman's own working notes, script fragments, longhand drafts and diary entries (November 1938 to February 1939), in which one can observe him developing the scripts later sent to Franklin; in Wisconsin Center for Film and Theater Research, University of Wisconsin, Madison, S. N. Behrman Papers, Box 26, 1. Hoffenstein was appointed by Franklin, after dissatisfaction with the speed and quality of Behrman's work; see verbatim note of Franklin's conversation with Reinhardt (16 November 1938); and conference notes (21 November 1938), recording discussions between Franklin, West and Hoffenstein; Hoffenstein, incomplete screenplay (30 November 1938); all MGM, Ninotchka.
69. Behrman, 'Russian Sequence' (15 November 1938), MGM, Ninotchka.
70. Franklin, letter to Behrman (10 February 1939), MGM, Ninotchka.
71. See Case Study 5 for a fuller analysis of the political aspect of the film.
72. The first script we have is a temporary incomplete script, dated 8 April 1939 and sent by Lubitsch et al. to MGM on 16 May. It is very close to the final film and goes up to the reunion dinner in Ninotchka's Moscow apartment; see MGM, Ninotchka. An incomplete script went to Breen on 23 May 1939, and the script was finished and then revised (and approved by Breen) between

Case Study 3 – 'Definitely Bawdy and Offensively Suggestive': Lubitsch and the American Woman

May and August; the foreword was settled in September after some minor problems with it, and the film was released in October 1939; see PCA, Ninotchka.
73. See James Shelley Hamilton, *National Board of Review* (November 1939), in Slide (ed.), *Selected Film Criticism: 1931–1940*, 174–76, for a sympathetic appreciation of Ninotchka as a strong, wise and competent woman who yet still can love in a feminine way. For a more conventional interpretation of a similar story, see MGM's *Comrade X* (1940), from a Walter Reisch story, a feeble attempt to cash in on the success of *Ninotchk*a. The 1940 film is discussed briefly in Chapter 5.
74. Lubitsch to Weinberg, in Weinberg, *The Lubitsch Touch*, 266.
75. A photostat of the novel was made for Fox on 21 April 1944; Hilton's first treatment is dated 17 July 1944; UCLA, FX-PRS-831. Hilton had had his novels *Goodbye Mr Chips* and *Lost Horizon* filmed, and he had written the screenplay for the Oscar-winning *Mrs Miniver* (1942) for MGM.
76. 'Cluny Brown', 2nd treatment (18 September 1944); treatment (with a different opening) (18 September 1944); screenplay (1 December 1944); UCLA, FX-PRS-831.
77. 'Cluny Brown', first draft continuity (10 May 1945), discussed at a story conference with Zanuck (6 August 1945), UCLA, FX-PRS-831; sent by Joy to Breen on 26 July 1945, PCA, Cluny Brown file. For the report of Lubitsch directing, see *New York Times* (16 December 1945), II, 3; for his collapse, see Parsons, *Los Angeles Examiner* (12 February 1946), in the Doheny Library, University of Southern California, Lubitsch personality file. The earliest West Coast review is *Daily Variety* (30 April 1946), PCA, Cluny Brown file.
78. Paul, *Ernst Lubitsch's American Comedy*, supports this interpretation (323): 'In *Cluny Brown* the marriage to Belinski works contrarily [to mainstream Hollywood films] to provide professional fulfillment: Belinski proposes by promising to give Cluny the opportunity to plumb as much as she likes … [T]he film never subscribes to the dominant attitude of the time that would see an opposition between this profession and the character's femininity.'
79. Ernest Vajda, 'Merry Widow', script (July 1930), MGM, Merry Widow file (hereafter, 'MW').
80. Hans Kraly, 'Merry Widow', treatment (9 October 1933), MGM, MW.
81. Rowland Leigh, 'Merry Widow', treatment and suggested storyline (16 October 1933), MGM, MW.
82. Viki Baum, 'Merry Widow', outline as suggested by Mr Thalberg (3 November 1933); outline (9 November 1933); outline (15 November 1933); outline (22 and 23 November 1933); treatment (7 December 1933); all MGM, MW.
83. Anita Loos, 'Merry Widow', script fragments (28 December 1933), MGM, MW. The scene where the widow first meets Danilo is here, and it is very similar to the scene in the Lubitsch film.
84. 'Merry Widow', sequence (22 March 1934), MGM, MW.
85. Lubitsch liked to rehearse his cast extensively before shooting started: see Paramount press release (24 November 1937), in the Margaret Herrick Library, Lubitsch personality file. His request to rehearse various actors is mentioned in Eric Locke's memos to the Casting Office (3 March and 5 April 1934); the shooting schedule was from 9 April to 12 May and again from 29 June to 13 July; see MGM, MW.
86. See Don Herold's comment that Lubitsch had ignored the stage version and 'had the boys cook up a new one more to his own notion' – *Life* (December 1934), in Slide (ed.), *Selected Film Criticism: 1931–1940*, 151–52. See also the review in *Hollywood Reporter* (1 September 1934); in PCA, MW.
87. Compare my analysis with that of Paul, *Ernst Lubitsch's American Comedy*, 89; Paul sees the film as a 'startling reversal from the more challenging attitudes' of Lubitsch's previous two films. This

183

may, in part, be due to Paul's unawareness of the film's important censorship history (see below in the text).
88. Letters, Breen to Louis B. Mayer (29 March 1934), and Breen to Hays (2 April 1934); both PCA, MW.
89. Breen, memo (10 August 1934), mentions the preview at MGM; Breen, memo (13 August 1934), records the results of the subsequent conference; see PCA, MW.
90. Breen (13 August 1934), PCA, MW. *Hollywood Reporter* (15 August 1934), 2, picked up some of this, commenting that, 'The Sinsors have decided that the historic 'Can-Can' must come out of the 'Merry Widow'. Things have come to a pretty pass, when, in 1934, you can't show such a number …' See also *Variety* (18 August 1934), (2 and 4 September 1934).
91. Breen, letter to Mayer (17 August 1934), PCA, MW.
92. Thalberg, letter to Breen (23 August 1934), PCA, MW.
93. *Variety* (1 September 1934); in PCA, MW.
94. Letters, Breen to Mayer (25 September 1934), and Breen to Mayer (26 September 1934); Breen, memo for the files (27 September 1934); all PCA, MW.
95. Breen, letter to Hays (22 October 1934), PCA, MW.
96. Thalberg, letter to Hays (26 October 1934); Kelly, (who worked in MGM distribution), letter to all branches (29 October 1934); Breen, letter to Kelly (6 November 1934); all PCA, MW.
97. Lubitsch, *Film Daily*, 66 (10 October 1934), 1, 8.
98. Martin Quigley, *Motion Picture Daily*, 36 (19 October 1934), 1, 5.
99. Lubitsch, *Hollywood Reporter* (22 October 1934), 1, 4. See also a similar debate which Lubitsch conducted in the pages of the *New York Times* (14 October 1934), X, 5 and (28 October 1934), IX, 4; and Jeanette MacDonald's observations in the same newspaper (25 November), IX, 4.
100. *New York Times* (29 March 1939), 21. The deal was effective from 1 January 1940. By the time of *That Uncertain Feeling*'s release, it was down to just two films – *Variety* (19 March 1941); PCA, That Uncertain Feeling file (hereafter, 'TUF').
101. A translation of the play, and of all subsequent script material cited here, can be found in Paramount, 'Let's Get a Divorce' file (hereafter, 'Divorce'). Various papers relating to two earlier productions, including Lubitsch's 1925 version and a 1931 synopsis, are in Paramount, Divorce. A useful summary of the film's history is also there, by Ben Winters, dated 23 December 1941. A number of attempts had been made to prepare a suitable script for this project. The surviving scripts are as follows: outline treatment (no author) (1–8 April 1935); synopsis by Herbert Fields, conceived for Gary Cooper and Carole Lombard; Norman Krasna and Jacques Thery, script (18 December 1935); Laura and S. J. Perelman, script (13 April 1936); and Benn Levy, script (2 July 1936); all Paramount, Divorce. See Winters' history for the sale of the rights to the film to Lubitsch in June 1940; there is a synopsis of the Levy script, then four years old, prepared by Jerry Greskin (21 June, 1940), doubtless commissioned by Lubitsch; see Paramount, Divorce.
102. Script submitted 19 September 1940; Breen's comments, letter to Lubitsch (24 September 1940); see PCA, TUF.
103. Referred to as unacceptable by Breen (24 September 1940); see PCA, TUF.
104. *Motion Picture Daily* (14 March 1941); *Motion Picture Herald* (22 March 1941); in PCA, TUF.
105. Breen, letter to Lubitsch (30 October 1940); the final certificate was issued on 23 January 1941; see PCA, TUF. The evidence here and elsewhere in the PCA archives contradicts interpretations of Lubitsch's career which assume that the tightening of censorship in 1934 effectively prevented him from expressing his sexual views frankly: see, for example, Paul, *Ernst Lubitsch's American Comedy* and Carringer and Sabath, *Ernst Lubitsch*, in their 'Critical Survey' chapter (19–33).

106. *Daily Variety* (27 March 1941); see also *Motion Picture Daily* (14 March 1941), pleased to see Melvyn Douglas 'master the picture and the role' by the film's end; in PCA, TUF.
107. Theodore Strauss, *New York Times* (2 May 1941), 25.
108. Synopsis (26 October 1936) by Alexander G. Kenedi (an MGM reader) for Edwin Knopf; Kenedi recommends purchasing the play for its 'motion picture qualities'; see MGM, The Shop around the Corner file (hereafter, 'SAC'). A German language version of the play, entitled *Parfumerie,* is also here, along with the Hungarian original, in copies made on 9 January 1940.
109. It was not translated into English until 8 March 1938 (by Emery Kanarik); Samuel [sic] Raphaelson's synopsis for 'The Shop around the Corner' is dated 20 October 1939; see MGM, SAC.
110. Lubitsch also altered the play's subplot (about the store-owner's wife's adultery) to introduce a more conventionally punitive treatment of the woman – see Kanarik's translation, Act III, 36, and compare it to the film; in MGM, SAC.
111. *Motion Picture Herald* (6 January 1940); PCA, SAC.

Case study 4

'Love Cures the Wounds it Makes': Lang and Wilder: Conventional Portraits of the American Woman

The radical nature of Lubitsch's output becomes even more apparent when judged alongside the more conventional depictions of women in the films made by Fritz Lang (and, considered at the end of this case study, those of Billy Wilder) during this period. In Lang's *Fury*, for example, Katherine serves as a conventional example of a 1930s woman of virtue and high principles. She is a moral force, who persuades the embittered Joe to abandon his scheme of revenge at the end of the film. She represents the love and care of humanity, appealing to Joe to relent. Similarly, in *You and Me*, Helen is the embodiment of social justice and honesty, of woman as virtue. In *Hangmen Also Die!*, Lang's heroine, Masha, is portrayed in starkly conventional terms, first striving for a 'wrong marriage' and then forced to sacrifice her virtuous reputation for a noble cause. But Lang's *Secret beyond the Door* forms the bulk of this case study.

'Stupefying silliness projected with a monumental solemnity': *Secret beyond the Door*
As a rule, Lang did not tackle romance or sexual mores, and one must judge his attitudes towards women largely on the evidence of the incidental portrayals of female characters in his films. A notable exception, however, is *Secret beyond the Door*, a psychological marital melodrama. The story, 'The Secret beyond the Door', by Rufus King, was published in *Redbook* magazine in December 1945. Walter Wanger, Lang's partner in their recently formed company, Diana Productions, made an offer for it almost immediately. By the following February, he had purchased the rights for $10,000, informing Universal, Diana's distributor, that this property was to be produced and directed by Lang.[1] In April 1946 Lang introduced a 'discovery' of his, a new young screenwriter, Silvia Richards. Lang wrote to English actor Michael Redgrave (about to star in *Secret beyond the Door*), describing her as particularly appealing to 'the intelligent younger generation in Hollywood'.[2] He told Wanger that he wished her appointed story editor, adviser and reader at Diana, as well as writer on *Secret beyond the Door* and subsequent projects. The deadline for a first draft screenplay was agreed as 31 December 1946.[3] Lang and Richards set to work over the summer and enough was ready by September to send to the film's stars, Redgrave and Joan Bennett. In October Lang reported 'exciting' progress and 'excellent dialogue' to Wanger.[4] By November the screenplay was complete. Wanger read it and pronounced it 'a great script [which] will make a successful picture for the corporation'.[5] The script went to Breen in December and, after some revisions and editing by Lang, it was returned to Breen (and sent to Universal) in January 1947.[6]

The abundance of archival records allows us to gain a clear understanding, not only of the troubled production history of *Secret beyond the Door*, but also of Lang's intentions in making the picture. There were early signs of confusion and disparate aims among the four principals.

Case Study 4 – 'Love Cures the Wounds it Makes': Conventional Portraits of the American Woman

Finding a title was their first problem. Wanger, Richards, Lang and Bennett had considered over 50 alternative titles, ranging from 'Whence Cometh my Help' and 'Break my Heart in Two' (Bennett); through Shakespearean quotes (Richards); various plays on the words 'fear', 'night', 'hell' and 'nightmare' (Lang); to 'Faithful unto Death' (Wanger). In the event, the four agreed to adopt the original book's title, with the deletion of the definite article.[7] The story by King provided only the building blocks with its saga of Lily, a rich woman who marries a wealthy widower and newspaper publisher, Earl. He has a macabre hobby of 'collecting' rooms in which murders have occurred. Lily begins to suspect that her husband murdered his first wife and now intends to murder her. Earl admits that he married his first wife for her money and that he has never loved Lily, but in the end he is killed by his own brother. Lily marries again and finds happiness.[8] What were Lang and his chosen writer to make of this slightly absurd, pseudo-Freudian melodrama? Despite his later claims that he 'never really wanted to do it anyway' or that it was one of Wanger's 'old scripts', Lang had definite expectations of this film.[9] Thinking about the publicity strategy for the film, he stressed his commitment to making films for serious, intelligent audiences, who, he argued, were not 'composed of 14–year old mentalities'.[10] He, Lang, would combine European culture with Hollywood technical and commercial expertise. Diana Pictures should reflect 'the artistic merit of European films, as well as the lively and challenging quality characteristic of the best American product'.[11] Mentioning his 'respect for women – their intuitive understanding, their efficiency and intelligence', Lang started to write *Secret beyond the Door* with Silvia Richards.[12]

His ideas seemed confused as he grappled with his material. The writers apparently had no difficulty in forging the basic narrative. They focused on the woman (now called Celia) and her emotional conflict with her possibly insane husband (now called Mark). He became an architect, in order to rationalize his interest in rooms. A disturbed figure, he was yet capable of salvation. Unlike his literary model, Mark does not deliberately use Celia for her money. He genuinely loves her, although his emotions are distorted on occasion into hate. This much was clear. Yet neither Lang nor Richards could make up their mind as to whether the film was Celia's drama or Mark's neurosis. It was to be a film with at least three stated intentions: a study of the psychology of the subconscious; a drama about marriage at a time of a rising divorce rate in America; and a study of the compulsion to kill, which, Lang was sure, was in every human being. In the midst of this mélange of ideas, however, the film would sink under its own weight. The reviewers were to lampoon it mercilessly.

When James Mason had expressed interest in playing the male lead a few months before Redgrave came on board, Silvia Richards had written him a brief explaining her (and Lang's) ideas for the character. She pointed out that the original source was inadequate, emphasizing that it was

> merely our point for departure. The screenplay will be in every respect ... more meaningful and profound, not simply a melodramatic whodunnit but a searching, sensitive, potently dramatic study of the relationship between two people who ... will prove to be most universal.[13]

These grandiose aspirations were to be focused on the personality of Mark and his subconscious hatred of women. If this suggests a feminist design, then it was to be lost in the psychological ramblings of the film's confused narrative. Nevertheless, at this early stage Richards could talk about 'a man who wants to kill women ... who in an extreme form embodies that brutality which many men feel in some degree toward women'.[14] The film would explore the complex psychological drives that pervert Mark's need for love into hatred and violence towards women, 'and we will see its resolution in his marriage'.[15] This last reference prefigures the film's startlingly conventional moral, that a woman's struggle and sacrifice to save her marriage – even at the risk of her life – is the highest form of social duty she can perform. Exercising shrewd judgement, Mason turned down the role, giving Michael Redgrave, eager to make his mark in Hollywood, the dubious privilege of starring.

After filming had started, Lang held another meeting to discuss how to publicize the film. He recognized that murder films and thrillers were 'no longer box office'.[16] Lang accordingly stressed how *Secret beyond the Door* would resolve its problems through the use of psychology, rather than violence. This idea, however, fails to come across in the final film. As Lang observed, Mark's last-minute, instant 'cure' when confronted with the roots of his disturbed behaviour was 'oversimplified, for dramatic reasons'.[17] The second angle Lang wanted to be brought out in the publicity was a faith in marriage, an illustration of how Celia's 'determination to make her marriage a success might be tied in with the overall problem of easy divorces in Hollywood and in the United States'.[18] This tribute to wifely duty – hardly a radical idea in 1940s Hollywood – is in fact the most successfully conveyed element in the film. Finally, Lang hoped to communicate his perennial interest in the idea that 'every human being is a potential murderer' – the film would mark a further progression in his aptitude for 'dealing with human relations', purportedly examining how childhood events influence adult behaviour.[19] Again, any intention on Lang's part to explore psychiatry and the subconscious was defeated by the film's laughably simplistic Freudian posturing. Richards expanded on these themes. She wrote:

> This business of unconscious motivation is, let us say, Theme No. 1. Theme No. 2 is the story from the girl's point of view. We have a story of a girl who believes what she says – 'for better, for worse, till death do us part', etc. Yet she discovers 'for better, for worse' may mean her death. Her problem is how much sacrifice, how much struggle her love is worth.

Richards went on:

> [O]ur story takes a positive attitude toward marriage, [and] it says marriage cannot be taken lightly ... cannot be tossed out the window simply because there are problems ... that in the last analysis a marriage gives what you bring to it, and a good marriage is worth a struggle, is worth great pain, because 'love cures the wounds it makes'. (A quote from the pay-off scene in our picture).[20]

There were thus three or more attempted themes in *Secret beyond the Door*, none of which properly complemented any other. Lang, as producer–director and co-writer, failed to come to grips with his material. Joan Bennett later recalled that Lang was rebellious at script conferences and 'outrageous' on the set, his ego out of control following the critical acclaim for *Scarlet Street*: 'When he was in a successful period, he was impossible'.[21] The exploration of the psychological forces impelling men towards murder – although classic Lang territory – was so poorly achieved in the film that it failed to interest audiences. The second theme, an exploration of marital difficulties, might have become quite subversive in the hands of Lubitsch, but Lang's film exhibited an unquestioning faith in marriage.

The husband's problems are explained away by his years of mistreatment and domination at the hands of various women: his mother and sister, his first wife, even his present secretary. Lang's claim to have made 'the first picture of Hollywood … to point out so powerfully the obligation of adults to maintain marriage as an institution', was mere bombast.[22] Hollywood had preached this for years. Lang's film added nothing new, neither did it provide any important critical perspectives on marriage; it was a conventional endorsement of a woman's marital duty. As he more accurately went on to say, his film demonstrated how 'the steadfast devotion of a wife who takes literally her marriage vow of "for better or worse"' can overcome even her husband's wish to murder her.'[23] It was no wonder that the Breen Office gave the script an easy passage, and that the wife of one Breen employee expressed her 'outspoken admiration' for it.[24]

The release and reception of *Secret beyond the Door* showed how badly Lang had miscalculated and how inadequately realized were his intentions to comment on the institution of marriage. Shooting had taken place from February to May 1947, bringing with it acrimonious exchanges between Wanger and Lang. The director, under pressure, reverted to type and began deploying multiple takes, insisting on 'excessive' rehearsals and long delays to secure the exact lighting he required. He eventually went eighteen days over schedule and at least $90,000 over budget.[25] After scoring the film, Lang tried to convince pioneering German animator and avant-garde artist Oskar Fischinger to devise the special effects for the film's dream-pool sequence. (The pair had collaborated in Germany on the effects for Lang's silent film, *Frau im Mond*/Woman in the Moon (1929).) Fischinger declined to work with Lang again, and the sequence was finally provided by the Disney studio.[26] The film was scored and delivered to Universal in September 1947.[27] Two disastrous previews followed later that month. The audience's comments make interesting and entertaining reading. Four people offered the identical succinct response, 'it stinks', while others expressed disbelief that Wanger and Lang could have produced such a poor film. There was criticism of Bennett's performance, the interior monologues, the pacing and the drawn-out climax. One person, noting the film's reworking of Hitchcock's 1941 classic, waggishly asked, 'Interesting technique, but where was Rebecca?'[28]

William Goetz, the new cost-cutting head of Universal, hastily began re-editing the film with Wanger's concurrence. A major battle ensued which would destroy Diana Productions, as Lang agitated unsuccessfully to retain his version.[29] The film was past saving: the new

Goetz version was previewed to equally poor responses in November.[30] Lang threatened to withdraw his name from the credits and sue unless a further agreed cut was made.[31] After a series of bad-tempered meetings within the Diana company, Universal agreed that Lang could re-cut the picture and have issued 'what amounts to a compromise cut'.[32] Amidst accusations by Lang that Wanger had conspired with Universal to destroy his reputation (strenuously denied by Wanger), Lang delivered his new version in early December 1947.[33] He wrote to a friend that after 'a very hard ninety days … the fight turned out for the best'.[34]

Wanger had indeed had reservations about the film. He had sought advice from a friend, screenwriter Leonardo Bercovici, back in October about *Secret beyond the Door*. The cogent and perceptive reply he received anticipated much of the ridicule and criticism to which the release version would be subjected. Bercovici told Wanger that, 'the story has been enveloped with a lot of foolish semi-Freudian, unrevealing nonsense – as though author and director were trying to make some profound observations when their materials were quite shallow and at best simply melodramatic'.[35] The reviewers were even less kind: 'A stupefying silliness projected with a monumental solemnity'; 'a dog wagon *Rebecca* with a seasoning of psychiatrics'; 'Psychoanalysis is a long, slow process and the picture has patterned itself in keeping'; 'a hopeless job and a worthless movie'.[36] The amateurish attempt to portray the psychoanalytic cause of Mark's behaviour and the last-minute 'cure' gave specific grounds for comment: 'The house burns and his complexes go up in smoke with it', mocked one reviewer.[37] The *New York Times* reviewer ridiculed the plot:

> Periled by death and numbed by terror, she endeavours to help her old man, and be dogged if her amateur psycho-therapy doesn't do the job. What the lady discovers is that her husband just doesn't like dames, mainly because his mother didn't come upstairs and read to him one night when he was 10 years old.[38]

Lang had strayed into territory which did not provide scope for his particular talents, as he had earlier with *You and Me*. His experiment with psychiatry and the subconscious had failed. His claim to unravel the compulsion within us to kill had been sabotaged by the triteness of his script. And his sudden interest in the problems of marriage and divorce had singularly failed to convince. Lang, for all his talent, was certainly no Lubitsch.

Wilder and the femme fatale: *Double Indemnity*

Wilder was equally uninterested in challenging the prevailing culture of hostility towards women. His first film as director, *The Major and the Minor (1942)*, had an interesting role inversion in its opening half, reminiscent of the films of Howard Hawks and Preston Sturges. It is the man, Major Kirby, who is pursuing the wrong marriage, saved only by the intercession of the heroine, Susan Applegate. Nevertheless, the film loses any sense of radical characterization at its midpoint, when Wilder allows Susan to sacrifice her love for the Major in a noble gesture. Wilder stressed in later interviews that he had self-consciously made 'a film for the box office'.[39] In any case, there is nothing in his early works to suggest

Case Study 4 – 'Love Cures the Wounds it Makes': Conventional Portraits of the American Woman

that he had privately entertained more radical views. In *The Emperor Waltz*, (1948) Wilder bordered on cliché, depicting an aristocratic and wilful young woman's snobbishness, which is challenged and overcome by that archetype of democratic capitalism, an American salesman. Her own marriage plans are disrupted by his insistent and moralizing courtship, before *he* sacrifices his love for her out of a misguided sense of duty.

Wilder went further, and embraced the hostility of his adopted country towards female independence. In fact, in *Double Indemnity* he made a significant and early contribution to the 1940s catalogue of irredeemably evil temptresses who lure men to their fate. The film's portrayal of the sexually manipulative femme fatale inspired a string of imitations in 1940s Hollywood. Walter Neff is instantly attracted to the sexually forward Phyllis Dietrichson, and he is unable to free himself from her murderous influence until it is too late. The characterization of the two, as they plan and execute the murder of Phyllis's husband, is instructive. Phyllis initiates the murder plan, using her sexual power to encourage Neff's complicity. Yet, once involved, Neff develops into an enthusiastic participant, arranging the murder details and dispatching the victim himself. It is Neff who proposes that Phyllis take out a double indemnity insurance plan, to increase from $50,000 to $100,000 the amount of money the murderers can make from Mr Dietrichson's death. As the film progresses, however, sympathy is elicited for Neff's plight: he increasingly becomes the victim of Phyllis's manipulation and less convinced of what he is doing. Phyllis, on the other hand, develops into an increasingly unpleasant woman.

In these characterizations, Wilder presents an unwary man in the grasp of a scheming woman, seduced by her sexual wiles. He is essentially innocent, the film argues – powerless to control his sexual urges. He is the Adam to her Eve, led astray by a woman with no moral compass. Because he cannot master his impulses, the woman – the object of his desires – becomes the 'problem'. At first Neff understands that any sexual involvement with Phyllis is dangerous; yet he confesses that he could not let go of 'that red-hot poker'. When he confronts Phyllis with his conscience, she tells him, 'We're both rotten'. 'Only you're a little more rotten', he replies. Phyllis confesses in her dying moments, 'I'm rotten to the core'. Contemporary reviewers did not fail to grasp that it was 'the mercenary, nymphic [sic] wife' who had taken Neff to his doom.[40] The ingredients of murder, adultery and greed formed a prototype for Hollywood's more aggressive reformulation of attitudes to women in the 1940s. Wilder had led the way.[41]

Notes

1. The negotiations took place between 3 December 1945 and 26 February 1946; see Wanger, Box 91, 9.
2. Lang, letter to Michael Redgrave (14 September 1946), Wanger, Box 19, 10.
3. Wanger, letter to Edward Muhl (17 January 1946); Wanger, memo to Lang (17 January 1946); Ed Cooke, memo to Lang (1 April 1946); and Gang, letter to Wanger (3 April 1946); all Wanger, Box 47, 18.

4. Bennett's appearance was announced in June 1946 – Lang, wire to Wanger (22 June 1946), Wanger, Box 24, 14; she received the first 50 pages plus synopsis, along with Redgrave, in September; see Lang to Bennett, 20 September 1946, Wanger, Box 91, 15; Lang to Wanger, 30 October, 1946, Wanger, Box 47, 19.
5. The first draft screenplay was considered at a board meeting convened by Lang on 20 November 1946; see minutes of meeting, Wanger, Box 47, 16.
6. Lang, letters to Breen (12 December 1946 and 17 January 1947), PCA, Secret beyond the Door file (hereafter, Secret); Breen approved the script with virtually no objections. The final draft screenplay was delivered to Universal on 16 January 1947 – Gang, letter to Tannenbaum (22 January 1947), Wanger, Box 91, 12. Lang later told Wanger how he had cut 1000 words from the script before shooting started – Lang, memo to Wanger (10 March 1947), Wanger, Box 47, 20.
7. See Bennett, note (n.d.); Lang, letter to Wanger (30 October 1946); and list of suggested titles (28 August 1946); all Wanger, Box 47, 19. 'The' was dropped from the title in February 1947, as shooting commenced – Leonard Cripps, memo to various personnel (26 February 1947), Lang, Secret.
8. The *Redbook* 'novel' is in Wanger, Box 91, 14; a synopsis (3 December 1945) is in Box 91, 15. An extended version of the novel, retitled 'Museum Piece No. 13', was published in September 1946 – see Lang, letter to Wanger (11 September 1946), Wanger, Box 91, 9.
9. Higham and Greenberg, *The Celluloid Muse*, 118; Bogdanovich, *Fritz Lang in America*, 73. Bernstein, 'Fritz Lang, Incorporated', *Velvet Light Trap*, 22 (1986), 44–48, rightly documents Lang's enthusiasm for the project.
10. Report of meeting to discuss publicity for Diana (13 June 1946), 1–2, Wanger, Box 47, 18.
11. Report, 1–2, Wanger, Box 47, 18.
12. Report, 1–2, Wanger, Box 47, 18.
13. Richards, note to Wanger (22 April 1946), as briefing for a wire to Mason, Wanger, Box 91, 10.
14. Richards, briefing, Wanger, Box 91, 10.
15. Richards, briefing, Wanger, Box 91, 10.
16. Lang, informal minutes of meeting (5 November 1947), Wanger, Box 48, 1.
17. Lang, informal minutes, Wanger, Box 48, 1.
18. Selvin, letter to Wanger (8 April 1947), Wanger, Box 47, 20.
19. Selvin to Wanger (8 April 1947), Wanger, Box 47, 20.
20. Richards, letter to Jackson Parks (4 April 1947), Wanger, Box 47, 20.
21. Joan Bennett and Lois Kibbee, *The Bennett Playbill* (New York, 1970), 286.
22. Universal publicity release (13 May 1947), 3. Note too the publicity release (26 February 1947) which describes the older sister in the film as 'a domineering character who inflicts grievous mental scars on her younger brother' and how the film fits in with the recent Hollywood trend of portraying sisters as evil – 'Sisterly devotion is presently taking a beating ...'; both in, Universal, Secret.
23. Universal publicity release (13 May 1947), 1.
24. Lang, letter to Shurlock (23 January 1947), PCA, Secret.
25. The budget, schedule and weekly reports for the production are in Universal, Secret. The overspend appears from these records to be a little more than $172,000, but the minutes of a meeting of the Diana Board (23 May 1947) record the overspend as $90,000; Wanger, Box 47, 20. The acrimonious exchange followed reports to Wanger of Lang's 'excessive' rehearsals, lighting times and takes (Slater, letter to Wanger, 4 March 1947); Wanger wrote in mild terms to Lang

seeking an increase in the speed of production (5 March), but received an intemperate and intransigent reply (10 March) from Lang in which, among other things, he stoutly defended his script; see Wanger, Box 47, 20.
26. The Disney dream-pool commission is recorded in the cost report (w/e 23 August 1947), Universal, Secret; and in Gang, letter to Wanger (30 June 1947), Wanger, Box 47, 20.
27. The picture was scored by 2 September 1947 (Slater, letter to Wanger, 2 September, Wanger, Box 48, 1). The 3 September date of delivery to Universal comes from Selvin, letter to Mercader (28 January 1948), Wanger, Box 24, 16.
28. The preview results cards for 3 and 11 September 1947 are in Universal, Secret.
29. For the history of Universal's re-editing and the consequent battle over the film between Lang and Wanger, resulting in the final demise of Diana, see Wanger, Box 48, 1 and Box 24, 16. Lang's agitation is recorded, for example, in Lang, letter to Wanger (3 October 1947), Wanger, Box 48, 1.
30. The preview results cards for the third showing (4 November 1947) are in Universal, Secret.
31. Lang's informal minutes (5 November 1947), Wanger, Box 48, 1.
32. See Wanger's unsent memos to Lang of 12 and 14 November 1947, disputing the accuracy of Lang's informal minutes of 5 November 1947; Lang's minutes of 21 November 1947; and Wanger, letter to Gang (12 December 1947); the reference to the 'compromise cut' is from Gang, letter to O'Melveney (1 December 1947); all Wanger, Box 48, 1.
33. See previous note for the recriminatory exchanges. The delivery date of 9 December is from Gang, letter to Diana board members (8 December 1947); all Wanger, Box 48, 1. The actual delivery seems to have taken place on 18 December – Selvin, letter to Mercader (28 January 1948), Wanger, Box 24, 16.
34. Lang, letter to Leo Lania (10 December 1947), in Wisconsin Center for Film and Theater Research, University of Madison, Wisconsin, Leo Lania Papers.
35. Bercovici, letter to Wanger (7 October 1947), Wanger, Box 91, 15.
36. Cecilia Ager, *P.M.* (16 January 1948); Otis L. Guernsey Jnr, *New York Herald Tribune* (16 January 1948); Alton Cook, *New York World Telegram* (15 January 1948); all in Lang, Secret; Agee, *The Nation* (14 February 1948), in Agee, *Agee on Film*, 295. See also the reviews in *New York Daily News*, *New York Post*, *New York Sun* and *New York Journal American* (all 16 January 1948); all in Lang, Secret; and *The Commonweal* (30 January 1948), 400. The *New York Daily Mirror* (16 January 1948), however, liked it; see Lang, Secret.
37. *Daily Variety* (31 December 1947), PCA, Secret.
38. Bosley Crowther, *New York Times* (16 January 1948), 25. The West Coast reviews were more politely detached than overtly critical – see *Hollywood Reporter* and *Variety* (both 31 December 1947); PCA, Secret.
39. Higham and Greenberg, *The Celluloid Muse*, 246 and an interview with Wilder in *Cinema*, 4 (October 1969), 19.
40. The quote is from *Daily Variety* (24 April 1944); see also *Variety* (4 May 1944) for an objection to the last-minute attempt to humanize Phyliss; and Kate Cameron, *New York Daily News* (September 1944); PCA, DI.
41. Wilder's other films display the casual sexism of the period, but do not repeat or develop the attack on women evident in *Double Indemnity*. Gehman, 'Charming Billy', *Playboy*, 7 (December 1960), 70, observed that 'some critics have noted a strong anti-female undercurrent in many of Wilder's films', and there is further evidence of this noted in Sikov, *On Sunset Boulevard, passim*.

Chapter 5

The World Changes: Hollywood and International Affairs

Hollywood in the isolationist period: 1933–1941

When Hollywood chose to examine the affairs of nations other than the United States in the 1930s, it generally did so in order to throw into sharper relief the blessings of life in America. Europe of the past was routinely used to display the class-ridden corruption of the Old World from which the founders of America, and hence their descendants, had thankfully escaped. As discussed in Chapter 1, Roosevelt's foreign policy in the 1930s was largely aimed at promoting his American model of social reform to other countries. Hollywood joined in, espousing in patriotic fashion the virtues of New Deal American democracy. The United States was accordingly depicted as a place in which one could found a community, raise a family and find inner contentment.

Many of Hollywood's films set in Europe (and, to a lesser extent, non-European countries) were also set in the past, allowing a consideration of what Americans had left behind in founding their nation. Examinations of European history provided opportunities for positive statements about the fundamental ideals upon which the United States had been formed. France, for example, provided a reference point for the difference between the American Revolution, which had given the American people their democratic and egalitarian freedoms, and the French Revolution, which began in similar style but foundered and led to oppressive dictatorship. *A Tale of Two Cities* (Conway, 1935) remains a classic interpretation of the French Revolution. It records with due opprobrium the horrors of aristocratic tyranny and then, with equal disapproval, the reign of terror that followed. What begins as a commendable popular revolution degenerates into tyrannical dictatorship. The American Revolution is referred to in the film, to provide the ideologically correct model of social change. In the United States, a just revolt had established a just society, based not on political dogma but on a 'natural' social order of liberty and equality. The film's celebration of the storming of the Bastille is deliberately undermined by the subsequent farcical proceedings at the Revolutionary Tribunal, where men and women are arbitrarily condemned to death. One reign of terror has been replaced by another, with nothing to choose between them. By the time the doomed aristocrats are summoned to their execution, they have acquired a dignity of their own. *Marie Antoinette* (Van Dyke, 1938) took a similar approach to the French Revolution, applauding its genesis but decrying its development into tyranny. Accordingly, historians may register some surprise at the film's conclusion, where the once angry mob looks bashful and ashamed as the noble Marie Antoinette goes with grace to her execution. *Conquest* (Brown, 1937) took French history into the Napoleonic period, but found a similar moral in events there, charting Napoleon's transition

from liberator to autocrat. The ideals on which his revolution was based are perverted by his personal ambition. Napoleon's early talk of achieving a 'United States of Europe', run according to democratic principles, gives way to his later declaration, 'I am Europe'.

In contrast, England in the past was used not for lessons in revolutionary theory and practice, but for examples of a class-ridden society, in which an individual's prospects in life were restricted by the accident of birth. This was in stark contrast to the egalitarian, classless society found in America. *Souls at Sea* (Hathaway, 1937), set in the early nineteenth century, includes a sequence in which a passenger ship travels from England to America. On board, an 'upper crust' woman agrees to share her cabin with a lady's maid, who is fleeing the class restrictions of her home country for a new life in America. Her family, she explains, has been in service for generations – 'that's the way it is in England'. She is seeking opportunities in the New World, so that her daughter will be able to break free from the cycle of class bondage. In *Stanley and Livingstone* (King, 1939), the English establishment represents the stifling forces of reaction, pouring scorn on Stanley's geographical discoveries. Stanley makes an impassioned plea to this fraternity of 'armchair geographers' who have never discovered 'anything deeper than a plum pudding'. Similarly, *Hudson's Bay* (Pichel, 1940) shows the English administrators in Albany, New York opposing the entrepreneurial audacity of the early French–Canadian explorers. Too stubborn and fixed in their ways, the English colonialists cannot see the commercial possibilities of the trappers' scheme and will not support it; nevertheless, they are only too keen to levy taxes on the goods that the explorers later bring out of the interior. *Pride and Prejudice* (Leonard, 1940) also took the form of an amused concentration on English class barriers and the divisions created by snobbery and the rules of social conduct. *The Duke of West Point* (Green, 1938) wittily satirized English snobs training alongside American military cadets. The latter demonstrate democratic values and team spirit in their social structures. These films, of course, are concerned at one level with a discussion of class. The use of England as a bastion of elitism, however, was as much about the superiority of American democracy as it was about the English class system. Once again, the film industry provided powerful advocacy for New Deal liberalism.[1]

Hollywood and intervention in Europe, 1937–1941

Towards the end of the 1930s, Hollywood's thoughts on Europe increasingly turned to the threats to democracy posed by events in the Soviet Union, Nazi Germany and Fascist Italy and Spain. At first, Hollywood film-makers exercised restraint in expressing their interventionist tendencies. Films made before Hitler's invasion of Poland merely observed that Europe was in the hands of fanatical dictators, and that America was the last and best hope for the preservation of freedom. As early as 1934, for example, in *The House of Rothschild*, (Werker, 1934) some members of Hollywood thought it timely to speak out against the oppression of Jews in Europe. The film depicted anti-Semitic riots and discrimination against the Jewish Rothschild family. These scenes, together with the anti-Semitic diatribes put into the mouths of unsympathetic

characters, carried a topical message for Americans who were just becoming acquainted with Hitler's regime. Similarly, *The Prisoner of Zenda* (Cromwell, 1937), made two years before the invasion of Poland, seemed pointedly aimed at contemporary events abroad. Its claim to be set in turn-of-the-century Europe was a thin veil of disguise. The central character, Michael, who plots to seize the throne and declare martial law in the fictional country of Ruritania, bore more than a passing political resemblance to Hitler. In contrast, Hollywood seemed nervous about declaring an interest in events occurring in Spain. *The Last Train to Madrid* (Hogan, 1937) claimed in its credits sequence that the makers had taken a 'neutral' stance, depicting not the politics, but the people involved. As a result, the film floundered in search of a moral, attempting to present the conflict without taking sides.

Then Hollywood began tentatively to advocate American military intervention in Europe. This involved a significant reversal of the quasi-pacifist stance taken by Hollywood (and other) liberals prior to the rise of fascism in Europe. Before Hitler came to power, pacifism enjoyed a close relationship with liberalism, and Hollywood depicted warfare as destructive and dehumanizing.[2] After the rise of Hitler, however, liberals began to associate warfare with anti-fascism and to see conflict as a way to protect human rights – war could be an enobling activity. Following this political regrouping, pacifism – in the sense of non-intervention in European affairs – passed to the isolationist right. From around 1938 film-makers stopped looking to World War I as an inspiration for pacifist reflection; instead, the Great War became a model for American participation in a new world war. The departure from pacifism is perhaps first apparent in *Three Comrades* (Borzage, 1938). The film, set in Germany after World War I, tells the story of three young men and their lovers. Towards the end, one of the men is killed by Nazi thugs. His two comrades initially decide to run away to South America. But, by the end of the film, they have decided to remain in Germany: 'there's fighting in the city', says Otto. He and Erich turn from the graveyard where their friend is buried and, accompanied by his ghost, walk back to the fighting. It expresses a commitment to oppose the Nazis, at whatever cost.

Hollywood's product from 1938 onwards included a barrage of pro-interventionist films, reaching a peak in 1941. In this, Hollywood again allied itself with Roosevelt, in opposition to the isolationist Republicans and, indeed, to the majority of the American public. The slaughter of Americans in the 'European' conflict of World War I was still, for many, a painful memory. Hollywood's 'politics' were seldom more explicit than in its firm stand against isolationism, and it brought the film industry into direct conflict with Washington.[3] By 1939 it was quite common to find films portraying megalomaniacs who posed a threat to peace, freedom and democracy. These fanatics came in a variety of guises. In *Beau Geste* (Wellman, 1939), it was a band of evil Tuaregs who represented the challenge to traditional virtues, here symbolized by the defence of 'the flag'. *Gunga Din* (Stevens, 1939) portrayed the sect of Kali worshippers, men who 'kill for the love of killing', as their leader declares. His talk of an ambition to march across the country and conquer was a reference less to colonial India and the Thuggees than to events in contemporary Europe. Studies of fascist figures became more direct after the invasion of Poland. *Dr Cyclops* (Schoedsack, 1940) concerned a mad scientist, Dr Thorkel, whose ambition is 'to control life absolutely', by shrinking those who get in his way and feeding them to his cat.

The film's publicity billed the eponymous villain as 'a dictator', whose evil ambition had to be stopped. In *One Million B.C.* (Roach, 1940) the Rock People are a tribe of cavemen who live by violence, recognizing only the rule of strength. Weaker members of their society are not cared for; when an old man falls down a cliff, he is left to die. The tribe's leader is tyrannical and violent to all who stand in his way. A prologue to the film made it clear that the virtues of culture and education are acquired, not inherent – in other words, there is no scientific basis for a concept like the Master Race. The criticism of Nazi ideology was not difficult to see. That same year *The Son of Monte Cristo* (Lee, 1940) reprised *The Prisoner of Zenda*, this time with autocratic Gurko Lanen planning to oust a legitimate and benevolent ruler and take power himself.[4]

Arise My Love (Leisen, 1940, co-written by Billy Wilder) was a summons to America to awaken to the crisis in Europe and take a stand. Beginning with a sympathetic depiction of a soldier of fortune who fought on the Republican side in the Spanish Civil War, the film's story moves decisively towards a call to fight fascism. The soldier, Tom, and his girlfriend, Augusta, share an initial uncertainty about whether to oppose the Nazis. This is revealed as self-indulgent complacency. A French chambermaid, who envies their ability to find refuge from the Nazis in the United States, draws attention to the callous and selfish behaviour of Americans who would leave Europe to its fate. Tom and Augusta's vacillation is finally ended when their ship home is torpedoed by the Nazis. Although they had decided not to intervene in the conflict, 'God knew better and threw [that] right back at us'. *Escape* (LeRoy, 1940) sent American naïf Mark Ritter to Germany to locate his mother, who has been imprisoned by the Nazis. He meets an American widow who has remained in Germany after her husband's death, living far above the 'world's misery' on her mountain estate. At first she disdains to help Ritter, but she eventually rejects her Nazi lover. She then facilitates the rescue and escape of Mark's mother, at the cost of her own freedom. Her actions were an example of idealism in a passionate plea for American intervention in Europe. *Four Sons* (Mayo, 1940) was another film that set its story firmly in the contemporary conflicts in Europe. It tells the simple story of a Czechoslovak mother who loses three of her four sons as a result of the Nazis. The fourth flees to America. She finally joins him there – a haven from oppression and a base from which her surviving son can work on anti-Nazi propaganda. The film fiercely criticized the political cynicism that had ceded the Sudetenland to Germany without allowing the patriots to fight. It spared little in its depiction of the subsequent arrests and executions of the Czech nationalists. In one scene a troop of young boys in gas masks parades through the countryside. It effectively conveys the corruption and destruction of innocent future generations by unopposed Nazism.

In *A Woman's Face* (Cukor, 1941), the topicality is once again explicit. A thinly disguised Nazi ideologue, Baring, plots to murder an innocent child who stands between him and an inheritance. Having planned to ensnare Anna into carrying out the murder, he has to confront her when she balks at the crucial moment. This apparently straightforward murder story suddenly shifts into a battle of ideologies when Baring outlines the motives behind his plan. He criticizes Anna's new 'love for your fellow man' as a sign of weakness, an intolerable quality to Baring. He now reveals that his attempt to have the child killed was part of a plot to acquire power in order to dominate others. He renounces God and love, preferring to serve the Devil

and to do in nineteenth-century Sweden (where the film is set) 'what men are doing in other countries', a clear reference to fascist activities in contemporary Europe. When Anna kills Baring to rescue the child, she is saving future generations from the horrors of fascism.

World War I, once a symbol of the horrors of conflict and the basis for pacifist meditations, now became a lesson from history in the value of international intervention. *The Fighting 69th* (Keighley, 1940) was one such film that derived inspiration from this war, portraying the heroic exploits of the 69th New York Irish regiment. Their defence of 'the citadel of peace' – America – was invested with religious status. *Sergeant York* (Hawks, 1941), released before the attack on Pearl Harbor, found it timely to retell the memoirs of a sergeant in World War I who had reconciled his religious beliefs with a patriotic commitment to fight the Germans. Fully two-thirds of the film is spent preparing the ground for the battle scenes, focusing not on war itself, but on the moral issue of whether fighting and killing can be justified. The film concluded that warfare was in the tradition of American agrarianism, Daniel Boone and Christianity.[5] Contemporary critics remarked on the film's urgent and blatant calls for intervention. Pare Lorentz saw that the film was 'timely and important', while the *New York Times* critic remarked, 'The suggestion of deliberate propaganda is readily detected here'.[6] Otis Ferguson, not always the most perceptive of critics, thought the propaganda rather restrained, concluding, 'There is parallelism, of course – 1917 and 1941 – but it is not stressed'.[7]

Hollywood at war: 1941–45

Once the United States had joined the conflict, the pleas for intervention naturally subsided. During the war Hollywood turned its attention to depictions of the fighting abroad, and to the home front. This clearly simplified Hollywood's task in portraying foreign affairs for the duration of the war.[8] A handful of film-makers could not, however, resist the opportunity to remind the now-discredited isolationists of their folly. In *The Pied Piper* (Pichel, 1942), an Englishman, Mr Howard, discusses the war during the summer of 1940, as France falls. The dialogue is with a citizen of what would become Vichy France. The Frenchman becomes the mouthpiece for isolationist views, now sounding tantamount to treason and cowardice: '[France] should never have fought Hitler, we should've made terms; we're well out of it'. *To Have and Have Not* (Hawks, 1944) offered a belated story of an isolationist, Morgan, gradually committing himself to the cause of the Free French in Vichy Martinique in 1940. At one point the film makes a direct comparison between Vichy and the United States, describing both as being 'at peace with the world'. Morgan begins by disdaining commitment – 'I don't understand what sort of war you're fighting' – but slowly comes to help the freedom fighters. A Resistance leader tells him how he wishes it were Morgan's (and, by implication, America's) fight too, because the French need his sort. This once controversial message, however, appeared rather tame three years after America's entry into the war.

Another area of concern to Hollywood was Spain. Although reluctant to take sides before 1941, once fascism had been officially declared the enemy, Hollywood showed its hand.

For Whom the Bell Tolls (Wood, 1943) depicted the Spanish Republicans, fighting Franco's forces in 1937, as heroic freedom fighters. Their struggle, though doomed in the domestic context, would be taken up and carried on in the wider battle against fascism outside Spain. *Confidential Agent* (Schumlin, 1945) offered a powerful critique of the brutality of Spanish fascists. The confidential agent has various conversations with representatives of Spanish fascism as the film progresses, allowing him to explain to the audience what divides the Republicans from Franco's followers. The fascists are fighting for 'a private little government to protect your beautiful privileges', he tells one of his Spanish pursuers. Later, he is accused of being 'the righteous voice of the little people who hope to inherit the world', allying his cause with the New Deal ideal of protection for the weak. This strong endorsement of the anti-fascist movement in Spain, however, came long after the Republican cause was lost.

Hollywood and the consequences of war, 1944–48

The aftermath of the world conflict presented Hollywood with a serious dilemma. With liberalism in retreat at home and the threat of communism dominating America's foreign policy, Hollywood's overt support for New Deal values faltered. The increasing identification of New Deal liberals and international interventionists with communist sympathizers made many industry liberals suspect in Republican eyes. The appearance in 1946 of the House Un-American Activities Committee alarmed senior figures in the studios. HUAC's brief – to hunt out treacherous communists in American institutions – meant that it was not long before the Committee turned its attention to the enormously influential Hollywood film industry.

Anxieties and tensions about American life after the war were alluded to even during the conflict. In *Since You Went Away* (Cromwell, 1944), Tony offers the following remark about the young men currently fighting abroad: '[they're] expecting to come back to something like they left, only better. Hope they don't get too many surprises.' *Till the End of Time* (Dmytryk, 1946) explored what happened when the men did return. The main idea in the film was that the values that had informed American life in the 1930s could no longer complacently be relied upon. A new society needed to be formed that had learnt from the experience of the war. The film's last dramatic scene showed three war veterans embroiled in a fight with a sinister group of right-wingers known as the War Patriots. These representatives of the newly resurgent Right talk openly of their hatred of Roman Catholics, Jews and negroes. The period of dreaming was over. Those New Deal liberal values, so recently taken for granted, now had to be fought for. It was an uneasy adjustment.

A few films looked not at domestic issues, but at America's new international role. *Wilson* (King, 1944) was one of the first to do so. Made a year before the conclusion of the war, it drew upon the failure of the League of Nations in 1919, making the case for another attempt at international peacekeeping, led by America. Ostensibly a historical study of President Wilson, the film had obvious contemporary resonances. The presentation of Wilson's decision to intervene in World War I preferred topicality to historical accuracy. Wilson interviews

representatives of Germany and delivers a stern lecture on their theories of racial superiority and their 'discredited culture'. The kaiser is pronounced one of the greatest evils ever known; isolationists in America are denounced as allies of the Germans. All this in fact bore a closer relationship to Hitler's Germany and Roosevelt's America than it did to the period depicted in the film. After the Paris Peace Conference, Wilson reposes his trust in the American people's commitment to establishing a new moral order for the securing of world peace. That malicious senators and a complacent public undo him is seen as the cause of America's present involvement in World War II. Wilson reflects that the choice had been peace or to 'live with a gun in America's hand'. Future generations would have to pay for the rejection of his League of Nations plan. To emphasize where blame should lie, the film finished with Wilson's death and the arrival of Harding's Republican administration and Prohibition.

The need for America to take a leading role in establishing a moral world order from the ruins of Europe was stressed in another film, *The Master Race* (Biberman, 1944). The Allied liberators of a town in France explain that there is a distinction between ordinary Germans and their Nazi commanders. The American major tells a repentant ex-Nazi that although he will be tried for his past conduct, 'we want to make a decent world … we'll need decent Germans'. Von Beck, a Nazi living under an alias in post-war France, intends to frustrate the reconciliation efforts of the occupying Americans. First, he stirs up hatred of the Germans, to maintain an atmosphere of recrimination among the French. Then, he encourages the locals to express anti-American sentiments. He wants American public opinion to demand the return of their soldiers. If America will withdraw and leave Europe to its fate, the Nazis may have a chance to rise again. The film's message had obvious relevance to American audiences, whose preference for withdrawal from Europe was already becoming apparent.

Intrigue (Marin, 1947) developed for post-war audiences the notion of America's international moral purpose. The film self-consciously opposed the decline of morality and the resurgence of unscrupulous, selfish business methods. As seen in Chapter 3, *Key Largo* sounded a warning about the end of Rooseveltian liberal policies at home when it was released in 1948. *Intrigue* drew the same moral a year earlier in an international context. Set in China, the film uses the black market as a metaphor for the betrayal of the values fought for in the war. It charts the return to the worst excesses of the 1920s. The hero, Brad Dunham, must choose whether to participate in the easy profits of the black market and exploit the miseries of the poor, or instead fight the corruption. A friend reminds him that he used to be someone who stood up for 'the little guy who gets pushed around'. When Brad finally takes his stand and wrests control of the black market warehouses from the gangster's female leader, she tells him, 'don't dig up the past, it's over and forgotten'. She might be referring to the New Deal values of the 1930s, which Brad wants restored and against which are ranged the unscrupulous gangsters. Brad's first act when he gains control of the food supplies – a potential source of enormous wealth for him – is to open the warehouses to the starving people in an expansive gesture of social welfare. The film's message was clear: America had an international role to play. Its world leadership rested on exporting social welfare and protection of the weak. These were the values, created in the previous decade, for

which the war had been fought. *Intrigue*, with its international focus, provided an interesting complement to films that portrayed the same struggles for the preservation of idealism on the domestic front.

Notes

1. See also *The Corn is Green, Friendly Enemies, The Good Earth, How Green Was my Valley, The Keys of the Kingdom, The Lady Eve, Libeled Lady, The Little Minister, Kidnapped, Anna and the King of Siam, Captain from Castile, Reunion in Vienna, The Sailor Takes a Wife, The Black Swan, Camille, The Count of Monte Cristo, The House of Rothschild, Mary of Scotland, Saratoga Trunk* and *Son of Monte Cristo*.
2. Pacifist antecedents of greatest fame are *The Big Parade* and *All Quiet on the Western Front*. In the period under consideration, there were such films as *Only Yesterday, The Dark Angel* and *The Road to Glory*.
3. The Dies Committee was set up in 1938 to scrutinize pro-war propaganda and was chaired by Martin Dies, a Democrat from Texas. It had hardly commenced operations when Pearl Harbor made it an embarrassment to all concerned, and it was scrapped. It re-emerged in the late 1940s as the House UnAmerican Activities Committee, the precursor to the McCarthy hearings. See Richard Polenberg, 'Franklin Roosevelt and Civil Liberties: the Case of the Dies Committee', *Historian*, 30 (1968–69), 165–178.
4. For the idea that America is the best and last hope for democracy in a world dominated by dictators, see also *Conquest, Anna and the King of Siam, The Good Earth, The Keys of the Kingdom, Abe Lincoln in Illinois, Mr Smith Goes to Washington, Beau Geste, Gunga Din, Keeper of the Flame, The Son of Monte Cristo, The Prisoner of Zenda* and *Mr Skeffington*. Hollywood's opposition to totalitarianism was not confined to that of Germany: the Soviet Union was revealed as inhuman and oppressive in *Comrade X*, with the United States serving again as the final refuge for those seeking freedom and personal fulfilment.
5. For further examples of calls for America to intervene in the war, see *Gone with the Wind, The Long Voyage Home, The Prisoner of Zenda, Souls at Sea* and *His Girl Friday*. Examples of opposition to international intervention are rarer than films making the contrary point, as one would expect if my contention about Hollywood's liberalism is well founded. Some references can be found, however: see *Woman of the Year, Kings Row* and *The Wizard of Oz*.
6. Pare Lorentz, *McCalls* (September 1941), in Pare Lorentz, *Lorentz on Film: Movies from 1927 to 1941* (New York, 1975), 214–15; Bosley Crowther, *New York Times* (3 July 1941).
7. Otis Ferguson, 'In the Army, Aren't We All', *New Republic* (29 September 1941), in Wilson (ed.), *The Film Criticism of Otis Ferguson*, 385–86.
8. War films are rather one-dimensional, and I have not spent much time analysing morale boosting combat movies; but see, for a tiny selection, *Across the Pacific, They Were Expendable, Thirty Seconds over Tokyo* and *The Story of Dr Wassell*. *Cry Havoc*, considered further in Chapter 4, was a particularly effective tale of women at war, emphasizing the human drama rather than the action of combat. For a thorough analysis of Hollywood's relations with the Office of War Information, see Koppes and Black, *Hollywood Goes to War*. Shindler, *Hollywood Goes to War*, is not of the same scholarly distinction. For films about the home front, see in particular *Since You Went Away*. Everything else pales by comparison; but, for specific home front issues, see *The More the Merrier* and *The Doughgirls* (overcrowding in Washington DC); *Friendly Enemies* (the appropriate loyalties for German-Americans); and, for the vexed issue of GI brides, *The Miracle of Morgan's Creek, The Clock, The Sailor Takes a Wife, Deception* and *The Unfaithful*.

Case Study 5

'World Political Theater': Lubitsch and Foreign Affairs

Introduction
One might have expected European affairs to have had a particular fascination for all three of the émigré directors studied in this book. In fact, they made few films about the world outside America. Lubitsch almost invariably set his films in European locations – nevertheless, in doing so he was more often than not exploring American life. He used the foreign location as a distancing device, which enabled him to explore contemporary American life without appearing to criticize his new country. Lubitsch's sex comedies were designed to satirize American prudery, not to depict decadent European manners.[1] He probed further into the realm of direct political commentary in his comedy on communism, *Ninotchka* (1939). Subsequently, the exceptional circumstances of World War II placed Lubitsch and his two compatriots in a position where their adopted country was in conflict with their homeland. This produced a specific response from each of them. Lubitsch made *To Be or Not to Be* (1941), a very personal and highly controversial comedy about the Nazi occupation of Warsaw. Wilder left his most personal reaction until a few years after the war was over: *A Foreign Affair*, released in 1948, dealt with the complexities of the American presence in West Germany and in particular the military occupation of Berlin. This film is considered in Case Study 6. Lang's contributions of distinction dealt with Nazism (*Hangmen Also Die!* (1943)) and post-war international politics (*Cloak and Dagger* (1946)). These two films are considered in Case Study 7.

Lubitsch and European affairs
Lubitsch inserted passing references to his European heritage in many of his films. The camera scans a map of central and eastern Europe; a tiny state is just visible in the middle. But it is not until a magnifying glass is suddenly thrust over the spot that the viewer can decipher 'Marshovia'. Thus does Lubitsch open *The Merry Widow* (1934), deflating the pretensions of this mythical kingdom from the outset. Lubitsch satirized the pomposity of a European petty monarchy, a rural backwater with pretence to the gravitas of an international power. Its newspaper is 'The Morning Moo', 'a paper for table and stable', and eggs are used as currency ('keep the change', says one peasant, tendering a large egg for the paper). Lubitsch drew an ironic comparison between Marshovia and America's awakening labour radicalism. The king is warned that the shepherds are getting organized – there is talk of a Black Sheep movement – but is relieved to hear that it is only 'a few East Side shepherds'. 'Intellectuals!', he sneers, 'let 'em talk.' The introduction of the king allows further scope for wry comment on the European love of social order, hierarchy and class divisions. The camera reveals an enormous, expansive hall at the king's palace, with footmen at attention and portentous fanfares sounding, surely announcing the impending arrival of the monarch. But instead, tiny Donald Meek, playing the king's counsellor, walks into view, undercutting at a stroke Marshovia's aspirations to

grandeur. When, much later, the king prepares to flee the country, he wraps his crown in newspaper – a visual levelling of the conceit of monarchy. (This image was censored in fascist Italy, ever conscious of a challenge to the 'natural' authority of leaders.)[2]

In *Angel* (1937), Lubitsch satirized the English class system, depicting the arch snobbery of the servants. Denizens of a lower social order, they nevertheless ape their masters. Parochial snobs, the servants comment critically on the foreigners whom they have observed at a conference – the French had no manservants, the Russians were 'still dunking' and, to the amazement of the servants, actually had tailcoats. At the races, the butler tells his fiancée how a servant friend of his had to leave his master when the latter – an aristocrat – joined the Labour Party. Lubitsch returned to this idea in *Ninotchka* (1939), in which Leon's manservant declines to support revolutionary theory for fear of losing his savings. Again, in *Cluny Brown* (1946) the servants enforce on Cluny a code of extreme deference to their middle-class employers. In *Bluebeard's Eighth Wife* (1938), Lubitsch poked fun at the many Americans who found foreign affairs baffling. The hero tries to cure his insomnia by spelling Czechoslovakia backwards.

Lubitsch and communism: *Ninotchka*
Beyond these isolated examples of Lubitsch's references to his European roots, *Ninotchka* stands apart as his first significant treatment of foreign affairs. The Soviet Union's political system was in direct opposition to that of the United States, yet the dawning of the era of superpower politics made an understanding of it important. The USSR's rejection of capitalism made it an ideological (and cultural) enemy of the United States, even if it was soon to become a military ally in the conflict with Hitler. Lubitsch's achievement with *Ninotchka* was to offer an even-handed assessment of the Soviet system alongside a measured critique of capitalist rapacity. His conclusion was that the values that bind human beings together, no matter where they live, are more important than the political systems which divide them. Lubitsch satirized the excesses of Stalinist totalitarianism, while remaining respectful of the communists' genuine commitment to social equality and welfare. Similarly, while he made it clear that the personal freedom and decadence of the West was vastly preferable to the stultifying politics of the Soviet Union, he took care to criticize unprincipled capitalism and the old order in Russia. His overall aim was to show the triumph of human bonds over conflict; his metaphor was, as always, a love story.

The escalation of the European crisis during 1938 provided a note of urgency to Lubitsch's desire to promote the values of human accord over political conflict. Almost at the moment of *Ninotchka*'s completion, Hitler invaded Poland, an event that could only reinforce the topicality of Lubitsch's view.[3] He held up release for a few weeks to add a foreword to the film, 'because of the war situation'.[4] It announced his message of love overshadowed by divisions and conflict: 'This picture takes place in Paris in those wonderful days when a siren was a brunette and not an alarm – and if a Frenchman turned out the light it was not on account of an air raid!' The foreword was immediately censored in France.[5]

Leon and Ninotchka each stand for a flawed political system. During the course of the film, each makes a transition from extremism to moderation and, in so doing, discovers the

humanity within themselves. She must reject the inhuman aspects of Stalinist oppression. He must throw over his flirtation with the Countess Swana, bastion of White Russia, and abandon his brief to swindle the Soviet delegates out of their precious jewels. When Ninotchka and Leon first meet and return to his apartment, the attraction is mutual and spontaneous. Their natural, impulsive humanity is interrupted when she realizes that he is a political opponent, working to prevent the success of her mission. Their political differences prevent their 'natural' unity. Humanity takes second place to the conflict of ideologies. Later, she and Leon are reconciled and in love. Ninotchka makes a speech urging revolution – but not until she has had time to be happy with Leon. Now, political preoccupations have become secondary to the pursuit of human accord.

Lubitsch did not fear to offer direct political commentary and satire. Before his involvement with the project, the original author, Melchior Lengyel (source of Lubitsch's *Angel*), had stressed that the story's 'international background has no political implication'.[6] (The film's production history is analysed in Case Study 3.) Sidney Franklin, who was originally to have produced the film, took pains to reduce any overt political comment in the early script. He advised that Ninotchka's drunken speech 'mustn't be too communistic'; he cut the line, 'the Soviets have made a very good job for us [that is, Western capitalists]: they have shot their businessmen as "dangerous" '.[7] Lubitsch was not so coy. For him, the political dimension was a major factor differentiating his film from numerous other Hollywood romantic comedies. To reduce or eliminate that aspect would negate his primary purpose. He made the drunken speech a tribute to the Russian Revolution. He personally inserted a more subversive (and funnier) line to replace the one above: 'the last mass trials were a great success. There are going to be fewer, but better, Russians.'[8] He satirized Soviet repression: a Soviet travel agent denies that there is any political imprisonment in Russia, then knocks on wood for luck. When the three Soviet delegates first arrive in Paris, they are rapidly seduced by the pleasures of capitalist indulgence: Lubitsch fades out on a hatstand holding their peasant caps, and back in on the same stand, adorned now by two bowlers and a top hat. The satire of Soviet values is complemented by Lubitsch's respect for his heroine's ideology in other matters. Ninotchka's mission – to sell jewels to raise money to feed the starving Russians – is shown as a noble endeavour, contrasting with the indolent self-indulgence of the Countess Swana and her lackey, Leon. When Ninotchka first meets Leon, she asks him pointedly, 'what do you do for mankind?' After a pause, he can only reply, 'nothing'. Ninotchka tells Swana that the Russian people paid with their blood for the jewels which Swana claims are her private property. There are few clearer endorsements of collective ownership in 1930s American cinema. In the film's final scene, Ninotchka is lured away from Moscow and reconciled with Leon. Leon asserts that the export of Russian food and culture is the single most important diplomatic mission. The film ends with reconciliation. As the world went to war, Lubitsch was establishing points of contact between nations.

The critics remarked on Lubitsch's daring satire of Soviet politics. Nothing like it had been seen before. The satire was 'the most direct so far presented in an American film', confirmed *Variety*: despite the humour, 'there still remains the serious intent of comparisons between the political systems'.[9] The balanced political treatment was praised by another reviewer, who

noted both the 'good-natured' satire of Soviet Russia and the 'equally trenchant emphasis' on satirizing Swana's 'privileged life'.[10] It was the 'first movie ... to discover that Communists are people'; Ninotchka's 'cause takes a salutary ribbing but is not disgraced'.[11] Noting its controversial content, another reviewer observed Lubitsch's 'warmly human' response to Soviet Russia and the film's overall depiction of 'a simple ideal of human relationships'.[12] The *New York Times* writer best summed up Lubitsch's achievement: '[he] has expressed – through it all – the philosophy that people are much the same wherever you find them and decent enough at heart. What more could you ask?'[13] Lubitsch had tackled a difficult subject in making a film about the Soviet Union, but he had not been disrespectful of communist ideology, nor had he offered a eulogy of the American system. His message was more complex, less patriotic. It was the voice of a European determined to bring a more sophisticated understanding of foreign differences than Hollywood usually essayed.

Lubtisch and the Nazis: *To Be or Not to Be*
The crisis in Europe naturally had an urgency for the European directors that was more pressing than for many of their American counterparts. For a director such as Lubitsch, who refrained from commenting on the 'big' issues of the day, the onset of global war presented a problem. His ambivalence about responding to events abroad was complicated by the United States' continuing neutrality during the early years of the conflict. At one point it seemed that Lubitsch, who had revoked his German nationality as early as 1935, would follow his satire of Stalinism with something similar about the Nazis.[14] In March 1940 he announced plans to film 'Heil Darling', a story of two newsmen who pretend to act for Hitler but secretly undermine him.[15] Later in the year, however, he seemed to rule out articulating any response to international events pending a clearer indication of the United States' intentions. He told a New York paper that, 'Political events of today have terrific influence on the mood of an audience', but he wondered whether that meant audiences wanted 'timely pictures filled with the topics of today [or] escapist' stories. He concluded that, 'until it is more clear what part this country will take in the world political theater', he would continue to seek his inspiration in everyday stories.[16]

His reference to 'world political theater' turned out to be highly pertinent, for his eventual response to the Nazi threat was *To Be or Not to Be* (1942). Its central premise was that art, theatre and film had a vital role to play in resisting the ambitions of Hitler. Having apparently renounced political cinema in September 1940, Lubitsch was within a year casting a Hitler for his new anti-Nazi film.[17] He had decided to make a personal statement about the war without waiting for the United States to declare itself. He appears to have moved towards a more interventionist stance around the turn of 1940. Ironically, he was to suffer for this decision. By the time the film came out, America had joined the international conflict, and Lubitsch became the subject of a great deal of criticism for treating the war with humour. His sophisticated approach to the menace of the Nazis, incorporating farce as well as drama, went over the heads of the earnest American critics on the East Coast. They misunderstood Lubitsch's intentions in lampooning the Nazis and accused him of making fun of the Polish people. Nothing could have been further from what he was trying to achieve. *To Be or Not*

to Be was a courageous attempt to ridicule the ideology of Hitler, to bring to American audiences a taste of the sufferings of the Polish people and to explain to viewers the nature of resistance – albeit through the medium of comic drama.

The evolution of the story and screenplay is not well documented. It is known from the credits that Lubitsch himself co-wrote the original story, working once again with Melchior Lengyel, the author of *Ninotchka* and the source of *Angel*. Edwin Justus Mayer, a New York-born writer who had come to Hollywood in the 1920s, was assigned the job of turning the story into a screenplay (he worked on two other Lubitsch productions in this period). The files in the PCA archive appear to be incomplete. They record only the receipt of the 'final shooting script' in October 1941, followed by revisions later that month and final changes made at the request of the PCA the following January.[18] The film was previewed on the West Coast in February 1942, where it was well received and understood. Its release in the East the next month, however, provoked a storm of critical protest and accusations of bad taste. This deflected Lubitsch from his plans 'to kid the Japs' in a project called 'Typhoon', based yet again on a play by Lengyel.[19] Indeed, the outrage provoked by *To Be or Not to Be* may well have been responsible for Lubitsch's subsequent avoidance of 'political' films altogether.

In a number of key respects, Lubitsch's film pursued novel approaches to Hollywood's treatment of the conflict in Europe. First, he adopted the risky strategy of employing comedy to convey a serious message about issues that, at the time, were causing great anxiety in America. Next, he set his film in occupied Poland, preferring to discuss the impact of the Nazis in Europe rather than wait any longer for direct American participation in the war. Furthermore, Lubitsch made a point of highlighting Nazi anti-Semitism. His final novelty was to satirize the Nazis, rather than show them as evil and ruthlessly efficient.[20] It was an unusual film, uncompromising in its way and fundamentally at odds with American thinking at a time of international crisis. The film had been conceived before American intervention in the war, when commentators might have taken a more relaxed view of a satire on Nazi philosophy (as indeed they had done when reviewing Chaplin's *The Great Dictator*, on its release in 1940). But the appearance of *To Be or Not to Be* a couple of months after the attack on Pearl Harbor found a number of critics and other writers unable to share the joke.

The film tells the story of a group of actors in Warsaw who are drawn into the Resistance. Like Hamlet, they must decide whether to act or merely to contemplate events – to be or not to be. They learn that a Polish double agent, Siletsky, is due to arrive from England with details of the members of the Polish underground, and that he intends to give them to the occupying Nazis. The theatrical troupe is led by husband-and-wife team, Joseph and Maria Tura. They use their acting skills to undermine the collaborator's plans. First, they trick Siletsky into handing over his information to Joseph, who impersonates the Nazi commandant Erhardt. Then, when Erhardt asks to meet Siletsky, Joseph impersonates the spy and tricks the Nazi. Maria's thespian skills are required when she is called upon to seduce Siletsky. Finally, as plot complications pile up, the entire troupe has to impersonate Hitler and his personal bodyguard in order to escape from Warsaw. Throughout the often hilarious story, there is a running gag about Maria taking a lover. She devises a scheme for a young man in the theatre audience

to meet her in her dressing room when her husband is on the stage. The cue is when Joseph begins the famous soliloquy, 'To be or not to be'. The hasty departure of an audience member undercuts not only Joseph's command of his marriage, but also his theatrical prowess.

The comedy element in the film deserves analysis. The blending of grave events with comedy is announced in the film's opening scene. The group of Warsaw actors are preparing to put on an anti-Nazi play, 'Gestapo', just prior to the German invasion of Poland. They badger the director to allow them to incorporate humour. The actor playing Hitler enters to a barrage of *'heil Hitler'*s, but deflates the impact with a casual, *'heil* myself'. The leading lady, Maria Tura, playing a concentration camp inmate, arrives clad in a flowing ball gown. As the director reacts with horror to each of these incidents, a Jewish member of the company, Greenberg, keeps assuring him, 'it'll get a terrific laugh'. In these early scenes, Lubitsch prepared his audience for a serious comedy about the horrors of Nazism. Humour was not employed indiscriminately. The coming of the Nazis to Poland was handled without comedy and with an emphasis on anti-Semitism. The Jewish shops which appear in the film's opening montage of Warsaw life are later seen in ruins. Greenberg, surveying the destruction, quotes from Shylock's famous speech about the vulnerability a Jew shares with all humanity. The play 'Gestapo' has been banned by the Polish authorities in case it angers German feelings – but, notes Greenberg, 'there was no censor to stop' the Nazis invading Poland (perhaps a reference both to American isolationist complacency and to the PCA's complicity in this policy). Later, when the drama of the film reaches its climax in a daring escape by the actors (now turned underground fighters) from Poland, Greenberg gets the chance to recite the Shylock speech again. This time Lubitsch has him make his appeal apparently direct to Hitler (in reality, to one of the actors impersonating Hitler), in front of the Führer's personal bodyguards. It is a moving depiction of the Jewish plight in occupied Poland.

The Nazis are treated comically, belittling the image of power and mastery so effectively conveyed by the German propaganda machine. The evil Colonel Erhardt turns out to be a pompous buffoon, terrified of inadvertently offending Hitler and outwitted by the machinations of the acting troupe. The mindless cult of personality that attended Nazi ideology is underscored by Lubitsch's constant use of *'heil Hitler'* to comic effect. When Maria Tura feigns sexual ecstasy in the arms of Siletsky, she breaks off from his kiss to utter an anticipatory *'heil Hitler'*. Later, when she forges a suicide note from Siletsky, she finishes it with a flourishing *'heil Hitler'*. When Erhardt unguardedly tells a joke about Hitler, he stutters and mumbles confusedly until, in his panic, he can do nothing but bark out *'heil Hitler'*. It is a meaningless salute that takes the place of rational thought. Lubitsch's use of comedy led to complaints that he was content with 'superficially ridiculing the symptoms of Nazism [without attempting] to investigate the virus of the disease'. This critic compared *To Be or Not to Be* unfavourably with what he saw as Lubitsch's more analytical satire in *Ninotchka*.[21]

Lubitsch was anxious to do more than simply lampoon the Nazis. In a telling exchange between Maria and Siletsky, the latter tries to seduce her by explaining that Nazis can be human – 'sometimes very human'. She assents and he observes that she does so, 'as if you really meant it'. 'Oh, I do', replies Maria, rather abstractedly. Here Lubitsch conveys the point

that, while one may prefer to caricature the Nazis as inhuman beasts, this cannot explain the appeal of their creed to millions of ordinary Germans. The point was lost on contemporary critics. The Writer's Congress of October 1943, for example, could only criticize the film for 'belittling ... the serious nature of the enemy'.[22] Lubitsch attempted to explain his aim in the *New York Times* almost as soon as the film was released. He argued that, 'American audiences don't laugh at those Nazis because they underestimate the menace, but because they are happy to see this new order and its ideology being ridiculed'.[23]

Beyond the controversy of the film's comedy lies its discussion of art and politics. This was an issue of genuine concern to Lubitsch, who had agonized about the appropriate way for an artist like himself to respond to the international crisis. Lubitsch believed that entertainment was the best medium for conveying a message to the huge American audience. In 1940 he was clearly trying to reconcile his wish to offer diverting pieces to the public with the serious international crisis. In making his film, Lubitsch discussed the very issue of the artist's responsibility to society. The two stars of the Warsaw company – Joseph Tura and his wife Maria – are insufferable egomaniacs. Maria revels in the adulation of a young airman in her dressing room at the theatre. Joseph is mortified when the airman walks out during his soliloquy (to meet Maria). As Joseph returns to his dressing room, he is unaware that war has just been declared, and believes that the general lamentations are for this apparent insult to his acting, not for the future of Poland. Out of this seemingly barren soil, the seeds of Polish resistance grow. Lubitsch builds his theme carefully and comprehensively. When the preparations for 'Gestapo' are stopped, Lubitsch is emphasising theatre's potential for social criticism. Joseph, at first consumed with jealousy about his wife's infidelity, later commits himself to the Resistance, as does Maria. Using his acting skills now for a vital purpose, Joseph impersonates first Colonel Erhardt and then the spy Siletsky to protect the Polish underground movement. He is a ham actor ('what he did to Shakespeare, we are now doing to Poland', laughs Erhardt, in a line singled out as especially offensive by one reviewer),[24] but Lubitsch shows him graduating to heroism, almost in spite of himself. Once Joseph commits himself to the Resistance, he acts the most important roles of his life ,suggesting that within even the meanest of people lie the seeds of greatness in times of crisis. Siletsky tells Maria that she must choose the right role in real life: does she wish to support the Nazis or the Poles? Lubitsch emphasizes the distinction between the fantasy of acting in the theatre and the reality of the theatre of life.

Life imitates art in the film and art influences the course of history. Elements of the satire 'Gestapo' become real: Erhardt in real life behaves exactly as Joseph Tura had previously impersonated him, in the play, 'Gestapo'. Later, Erhardt tells the same joke against Hitler that had featured in the rehearsal for the play. The actor playing Hitler in the play has to do so for real during the escape from Warsaw. A reviewer noted that what begins as mere acting for the company is finally played out 'grimly for their lives'.[25] Siletsky is captured in the theatre and killed on the stage, a metaphor for the earnestness of this particular drama on the world's stage. Art has its role to play in the events of the moment: no artist can remain a detached bystander. As the film's title suggests, everyone must decide whether or not to play their part.

The West Coast critics responded as Lubitsch must have hoped, congratulating him on his skilful blending of comedy and melodrama. 'It is a farce of far deeper significance than ordinary', wrote one, 'daring to ridicule the practice of Nazism as only Chaplin's *The Dictator* [*sic*] has previously'; 'a trenchant satirical comedy' wrote another, which 'delivers a powerful wallop at the codes and regimented puppetry of the Nazi'.[26] Favourable audience responses were noted at the previews. Elsewhere, however, critics objected to the mixture of genres: 'comedy, no matter how purposeful, played out against a background of grim reality like the scarred skeleton of Warsaw, is apt to make you think more about the war than about the comedy', declared one.[27] The *New York Times* reviewer went further: to mix comedy, suspense and the Nazis was not possible; the subject was not funny. 'To say it is callous and macabre is understating the case'; Lubitsch had 'recklessly confused … comedy and grim excitement'. He concluded that: 'one has the strange feeling that Mr Lubitsch is a Nero, fiddling while Rome burns'.[28] Lubitsch's failure to produce a straightforward indictment of the Nazis was too radical for many critics, who could see only that the Nazis were no joke. His approach offended American morality. The film was like a cartoon, one writer argued, depicting a

> wish-fulfilment world which says in effect … 'If Nazis were only like this, they wouldn't be a genuine menace!' But we know they are a genuine menace. The daily sacrifices of the American people, at home and on the battlefield, are no laughing matter.[29]

This missed Lubitsch's point altogether. The observations made by these critics reveal the extent to which he had strayed outside the permitted boundaries of American humour. When the nation was at war, the critics decreed, only a serious response was acceptable. His estimation of the critical establishment's sophistication in these matters was over-optimistic, as it had been when he predicted a desire for more mature sex films in 1933.[30] He defended himself in the pages of the *New York Times*, dismissing criticisms of his decision to mix comedy and tragedy as irrelevant – 'I do not care and neither do the audience' – and rejecting suggestions that he undervalued the seriousness of the Nazis and the war effort.[31] He also had to explain that his comedy was not aimed at Polish people but at a group of actors and hams, 'in no way typically Polish, but universal' (indeed, neither of his two stars made the slightest effort to appear anything but American). Ultimately, Lubitsch placed his faith in the audience: if they liked it, his film could hardly be said to be in bad taste.[32] He returned to the fray five years later when, reviewing his later works, he declared that the film had been 'unjustly attacked'. He reiterated that it 'never made fun of Poles, it only satirized actors and the Nazi spirit and the foul Nazi humor'.[33] Nowadays, *To Be or Not to Be* is regarded by aficionados as a classic comedy.[34] Lubitsch never returned to the subject of the war, possibly shaken by the uncharacteristic hostility shown to him by the critics on the one occasion when he had tackled a political issue. Yet his contribution serves as a memorable example of the deeply personal response that events in Europe called forth at that time. No American tackled the subject with such conviction, nor with such a daring disregard for convention. But, as so often in Hollywood, there was little reward for innovation and dissent.

Lubitsch and old-world class structures: *Cluny Brown*

After the war Lubitsch made *Cluny Brown*. Released in the early summer of 1946, this film allowed Lubitsch to examine and comment on the social structures of class. (The film's production history is discussed in Case Study 3.) Although his final scene, as in the book, was set in the democratic and egalitarian promise of America, *Cluny Brown* was far from a simple celebration of American cultural superiority. Most of its energies and its time were spent absorbed in a very European analysis of the complexities of social class. The issue of conformity was directly relevant to American life after the war, but the film centred on an examination of English snobbery. It thus lacked Lubitsch's usual observations on American society. This may have reflected his belief that the key issue in the immediate aftermath of the war was European reconstruction. It is impossible to know Lubitsch's motives in making the film, not least because of the dearth of production material available. Our understanding of *Cluny Brown* has therefore to be derived largely from the evidence of the film itself.

A reviewer found *Cluny Brown* to contain 'some of the most amusing satire of English middle class life yet glimpsed on screen'.[35] Lubitsch showed the complacency of the English upper classes as Europe teetered on the brink of total war. As one critic observed, 'there is more talk about how well someone sits a horse than what Europe's political future will be'.[36] Lubitsch's point was not simply to draw attention to English insouciance during the Munich crisis, but to illustrate the upper classes' profound inadequacy in leading the country at a time of significant social change. He went on to observe the insularity of the upper-class family in the film, the Carmels, as further proof of their ignorance and detachment from world affairs. Talking over dinner with Cluny's admirer, Belinski, Lord Carmel confidently and unashamedly explains how he spoke only English throughout his recent world tour and how, in his view, people should stay at home. Lubitsch explored the carefully structured social hierarchy and its politics of deference. The Carmels stand at the tip – complacent, self-satisfied, indolent. Cluny's would-be husband, Wilson, is beneath them, a lower-middle-class shopkeeper – genteel, prudish, with limited horizons. Next come the servants, who ape their social superiors and affect a developed snobbery with regard to their employers' guests. At the foot of the ladder is Uncle Arn, Cluny's guardian, a working-class manual labourer, who talks not of revolution or subversion, but commits himself to 'knowing his place' and staying there.

Lubitsch's class satire is exemplified in the scene (not in the book) where Cluny first arrives at the Carmel country house to work as a maid. She is mistaken by her employers as a social equal and invited to tea. Cluny delightedly accepts and helps herself to scones and tea with three sugars. The mistake is discovered and the atmosphere instantly changes. Although remaining scrupulously polite on the surface, neither Lady Carmel nor her husband is charmed by the ingenuous girl's behaviour. Both unhesitatingly take their leave of her, Lady Carmel summoning the butler to escort Cluny below stairs. Her injunction to Cluny to finish her tea can hardly be followed beneath the glare of the head butler, and she is soon hurried out of sight. Once downstairs, she is inducted into the rigid hierarchy of the servants' quarters. She is now addressed as 'Brown'; she must not speak unless spoken to; the elaborate rules of deference regarding the Carmels are outlined; she has to call the

housekeeper 'ma'am' and the butler 'sir'; all will be easier to grasp, she is told, the moment she is in her uniform. Her brief equality with Lady Carmel at tea is revealed as nothing but a delusory interval; now the rules of English life reassert themselves with a vengeance.

Lubitsch wanted to do more than just satirize the English class system. He wished to intimate the coming of change, the demise of European social structures based on deference and inequality. The society depicted in the film, he was gently suggesting, could not survive unchanged by the momentous events of the war. His opening titles tell the viewer that it is London in 1938, with 'nothing exciting happening'. The film challenged this complacent aura by charting Cluny Brown's passage from class victim to liberated individual. Cluny is sent into service by her uncle to impose on her a suitably humble 'place'. Czech refugee Belinski is, however, struck by Cluny's nonconformity and advises her to maintain her individuality. Rules are to be broken, he asserts; if one wishes to feed squirrels to the nuts, rather than nuts to the squirrels, one should be free to do so. This unlikely inversion operates as code for an act or thought of rebellion. Belinski tells Cluny that her 'place' is wherever she can find happiness; this is the antithesis of Andrew Carmel's vexed realization that, 'we all behave too well. We never do the wrong thing at the right time.' *Cluny Brown* challenged the politics of deference and the barriers to individual fulfilment created by class structures. It criticized the complicity at all levels of the hierarchy that permitted the system to survive. Its message of individualism and egalitarianism was bound to strike a responsive chord in American audiences. Yet its dissection of the rules that underpin class hierarchies betrayed the hand of a director well versed in the intricacies of the Old World. It remained Lubitsch's most European film of this period.

Notes

1. See Carringer and Sabath, 'Critical Survey', in *Ernst Lubitsch*, 19–33, for a useful discussion of Lubitsch's European values clashing with American culture.
2. PCA, MW.
3. The film was screened for the PCA on 1 September 1939; PCA, Ninotchka.
4. The foreword was added at Lubitsch's request after the PCA had screened the film; Block, letter to Breen (8 September 1939), PCA, Nintochka.
5. Block, letter to Breen (8 September 1939), PCA, Nintochka.
6. See Charlie Greene Jnr's summary of Lengyel's foreword to the story (31 August 1937); in MGM, Ninotchka.
7. Conference notes (28 October 1938), 31, 18, MGM, Ninotchka.
8. The attribution was made by Brackett, 'A Matter of Humor', *Quarterly of Film, Radio and Television*, 7: it 'happens to be a line tossed into the script by Ernst Lubitsch'.
9. *Variety* (11 October 1939); in PCA, Ninotchka.
10. *Daily Variety* (7 October 1939); in PCA, Ninotchka.
11. Otis Ferguson, *New Republic* (1 November 1939), in Wilson (ed.), *The Film Criticism of Otis Ferguson*, 274–75.

12. James Shelley Hamilton, *National Board of Review* (November 1939), in Slide (ed.), *Selected Film Criticism: 1931-1940*, 174-76.
13. Frank S. Nugent, *New York Times* (10 November 1939), 27.
14. The revocation is described by Louella O. Parsons, *Los Angeles Examiner* (29 January 1935); in the Doheny Library, University of Southern California, Lubitsch personality file.
15. Parsons, *Los Angeles Examiner* (20 March 1940); in the Doheny Library, University of Southern California, Lubitsch personality file.
16. Lubitsch, 'What Do Film Audiences Want?', *New York Herald Tribune* (16 September 1940), 25.
17. Parsons, *Los Angeles Examiner* (25 August 1941); in the Doheny Library, University of Southern California, Lubitsch personality file.
18. George L. Bagnall, letter to Shurlock (7 October 1941); nine revised pages sent in on 16 October 1941; Alexander Korda's secretary, letter to Allan Lynch (29 January 1942); Lynch, letter to Korda (30 January 1942). The film was viewed on 21 January and certified on 27 January 1942, subject to the amendment recorded in the Korda–Lynch exchange of letters; all PCA, To Be or Not to Be file.
19. Parsons, *Los Angeles Examiner* (3 March 1942); in the Doheny Library, University of Southern California, Lubitsch personality file. Admittedly, politics was not Lubitsch's métier, and only the extreme circumstances of the Second World War had moved him to enter this sphere. Nevertheless, he might have made 'Typhoon' if not for the controversy over *To Be or Not to Be*.
20. See Koppes and Black, 'What to Show the World: the Office of War Information and Hollywood, 1942-45', *Journal of American History*, 64 (June 1977), 87-105; and their 'OWI Goes to the Movies: the Bureau of Intelligence's Criticism of Hollywood, 1942-43', *Prologue: the Journal of the National Archives*, 6 (Spring 1974), 44-59, for an account of the OWI's dissatisfaction with Hollywood's portrayal of the enemy.
21. Herb Sterne, *Rob Wagner's Script* (28 February 1942), in Slide (ed.), *Selected Film Criticism: 1941-1950*, 236-37.
22. Virginia Wright and David Hanna, 'Motion Picture Survey', in *Writer's Congress*, 403.
23. Lubitsch, 'Mr Lubitsch Takes the Floor for Rebuttal', *New York Times* (29 March 1942), VIII, 3.
24. Bosley Crowther, *New York Times* (7 March 1942), 13.
25. John T. McManus, *P.M.* (8 March 1942), in Slide (ed.), *Selected Film Criticism: 1941-1950*, 237-38.
26. *Hollywood Reporter* (18 February 1942); *Daily Variety* (18 February 1942); see also *Variety* (18 February 1942); PCA, To Be or Not to Be file.
27. McManus, *P.M.* (8 March 1942).
28. Crowther, *New York Times* (7 March 1942).
29. Parker Tyler, 'To Be or Not to Be, or the Cartoon Triumphant', (1944), in Tyler, *The Hollywood Hallucination* (New York, 1970), 214.
30. See the discussion of *Design for Living* in Case Study 3.
31. Lubitsch, 'Mr Lubitsch Takes the Floor for Rebuttal'.
32. Lubitsch, 'Mr Lubitsch Takes the Floor for Rebuttal'.
33. Lubitsch to Weinberg, in Weinberg, *The Lubitsch Touch*, 267.
34. See, for example, Leslie Halliwell, *Halliwell's Hundred: a Nostalgic Choice of Films from the Golden Age* (London, 1984), 487-491. The film was remade in 1983 under Mel Brooks' supervision.
35. *Daily Variety* (30 April 1946); in PCA, Cluny Brown file (hereafter, 'CB'). See also the comments in *Variety* (1 May 1946); in PCA, CB; and A. H. Weiler, *New York Times* (3 June 1946), 27; Weiler remarks that the film should be enjoyed by all but the landed gentry (and plumbers).
36. *Hollywood Reporter* (1 May 1946); in PCA, CB.

Case Study 6

'As corruptible as the others': Wilder on America and Europe

Early stirrings

Earlier in his career, while serving his apprenticeship as a screenwriter in Hollywood, Wilder was one of those who had urged American intervention in Europe. In the later 1930s he had co-written, with his regular collaborator Charles Brackett, *Arise My Love* (Leisen, 1940), described by a later journalist as 'a daringly interventionist film [which] evoked storms of protest from isolationist fans'.[1] But Wilder took time to develop the confidence to portray European matters with the lucidity and bite of Lubitsch. He avoided controversy when he first graduated to the director's chair, no doubt wishing to establish himself in the new role before taking risks. Thus, his first film as director, *The Major and the Minor* (1942), kept within the bounds of American patriotism. The film tells the story of a major in the US army who rejects his upper-crust fiancée. She wants him to spend the war at home, and so he deserts her in favour of an ordinary girl from Iowa, who supports his desire to participate in the conflict. There was nothing controversial about such a message in the summer of 1942. As one reviewer noted, the major's 'motives in having applied for more active service are entirely in key with the times'.[2] Wilder was merely displaying a rather conventional, and perhaps opportunistic, patriotism for his adopted country.[3]

His second film as director, *Five Graves to Cairo* (1943), was written sometime between December 1942 and February 1943. His co-writer was once again Charles Brackett. As was their custom, the script was produced in a piecemeal fashion over this period.[4] The film was previewed on the West Coast at the beginning of May and released by the end of the month. In many respects, *Five Graves to Cairo* is an unexceptional (although very well written) film, invested with an urgent topicality by the production team. Wilder was prepared, as Lubitsch had been, to risk blending a certain amount of comedy with serious drama, which resulted in some controversy. Juxtaposed with the reasonably sympathetic depiction of Rommel, the humour unsettled at least one contemporary critic. He wrote that it was 'out of key' with the rest of the picture, leaving a film with 'a little something for all tastes, provided you don't give a darn'.[5] As Lang was to do in *Hangmen Also Die!* (1943), Wilder used his heroine to depict a transition from the pursuit of personal interest to a realization of the wider issues at stake in war. Thus Mouche begins by trying to 'collaborate' with the Nazis so that her brother might be freed from a German prison. The film's hero, Bramble, learns of her reasons for flirting with the Nazis. He explains to her the wider cause for which the war is being fought and the need to subordinate personal motives to the pursuit of higher social goals: 'it's not one brother that matters, it's a million brothers. It's not just one prison gate they might sneak open for you, it's all their gates that must go.' Mouche changes her views as the film develops, so much so that she finally gives her life for the cause of freedom.

Other aspects of the film introduced ideas new to Hollywood's discussion of the war. The depiction of the Germans and Italians in the conflict caused some comment. Wilder used the character of Lieutenant Schwegler to convey a standard movie-Nazi, blonde and ruthless, who talks of killing the English just as easily as one swats flies in the desert. The characterization of Rommel was, however, more subtle. He was shown as a charming and humorous man. In one central scene, he entertains captured English officers over dinner with fascinating anecdotes about his strategy. The English respect and admire his brand of warfare. He does not exploit Mouche when she offers him her body. He tries to give her a fair trial at the end. By depicting him as human, rather than as a stereotypical brute, Wilder actually achieved a greater sense of menace: Rommel is dangerous because he is so talented, not because he is so evil. One reviewer commented, 'this portrayal is no unidimensional movie Hun, but a living impression of a living man'.[6] Another praised von Stroheim's performance, which conveyed 'a realism that chills the bones', not least because Rommel is not characterized as 'bluntly brutal'; he commands respect, the 'sort of German you can't laugh off'.[7] The Writer's Congress also endorsed the film's treatment of the Germans, although, surprisingly, Rommel was viewed as 'ruthless' by the relevant speakers.[8] Wilder's characterization of the Italian General Sebastiano also aroused comment. This 'priceless caricature of the plight of Italy in its collaboration with Nazi Germany' showed Wilder's innate sympathy for the Italians and his belief that the heart of that nation was not in the fight.[9] The humour also served to throw into sharper relief the grimness of the German war machine. When Rommel orders Sebastiano to stop singing, the Italian exclaims: 'can a nation that belches understand a nation that sings?' He anticipates the return of peace, when he can again listen to opera – 'and not Wagner!' At dinner, Rommel discusses strategy, while Sebastiano enthuses about risotto and describes food as the best international emissary. A withering look from the German silences him. The consequences for Italian culture can only be deleterious, suggests Wilder: Sebastiano explains that, 'when you lie down with dogs, you wake up with fleas!'

One should note, too, the film's muted political comment. Bramble scolds Mouche for her attempt to strike a deal with the Nazis, reminding her that the British tried to 'do business' with the Germans in the 1930s: 'we threw our arms around them … kissed them … went on a honeymoon … at Munich'. Later, Rommel is scathing about British complacency during the period when Germany was rearming, accusing them of taking their wives on holiday in 1935 while the Germans prepared for war. Here Wilder may have intended some criticism of America's isolation from European events in the 1930s. He even included a speech by Mouche in which she castigates the British for the debacle at Dunkirk, noted with approval by one reviewer.[10] Nevertheless, *Five Graves to Cairo* cannot be included with *To Be or Not to Be* nor with *Hangmen Also Die!* as an example of dissenting cinema within the Hollywood structure – Wilder's mature films were yet to come. His war film remains a diverting entertainment, with some points of interest but little more.

'More continental than American': *A Foreign Affair*

Wilder was in Berlin in August 1945, acting as the Films Officer for the Information Control Division (ICD) of the US army. The ICD were interested in his plans to make a film about the American occupation of Germany.[11] Wilder outlined his intention to produce an entertaining film which would serve as 'a superior piece of propaganda … cleverly devised to help us sell a few ideological items'.[12] This is the first reference we have to the seeds of an idea already germinating in Wilder's mind during this visit to Berlin: it would come to fruition over two years later as *A Foreign Affair* (1948). At this early stage, he was thinking in terms of a straightforward lesson to Germans regarding the superiority of American democracy. His theme, he explained, would be to awaken the German race to new hope in the post-war era – a realization that their nation could be rebuilt on the solid basis of democracy. An ordinary GI, not 'a flag waving hero or a theorizing apostle of democracy' but a man who was not even sure 'what the hell this war was all about', would meet a German woman.[13] Through their brief romance, she would resolve not to give up hope but to carry on and help construct a new Germany. The soldier would return to America, presumably to symbolize the need for Germany to go ahead alone on its confident road to recovery. It would be 'the best propaganda yet', claimed Wilder.[14]

If this sounded promising to the American military government in Berlin, it might have struck others as odd that Wilder should embark on such a simplistic celebration of American cultural values. He had referred to his wish to touch on 'fraternization, on homesickness, on black market', but that did not sound any alarm bells in the ICD.[15] When he returned from Berlin, Wilder told reporters that he would make a film 'in which some very definite ideas will be subtly conveyed'. He issued one note of caution, however: the Hays Office would never allow a 'true and realistic' depiction of life in Berlin, 'a modern Sodom and Gomorrah'.[16] It was not until May 1947 that Wilder began work on the German film, having co-written and directed a film in the meantime. It might have been partly because that film, *The Emperor Waltz* (1948), was such an overt tribute to all things American that Wilder's plans for *A Foreign Affair* began to change dramatically.

Important in the evolution of Wilder's ideas was the changing political climate in America. The increasingly conservative outlook and the rising anti-communist hysteria meant that perceptions of the true role of American diplomacy in Europe were shifting. A moral absolutism, which refused to recognize the realities of fraternization and black market economics, was hardly adequate to deal with the complexities of post-war German reconstruction. It must have occurred to Wilder that a celebration of American democracy would play into the hands of the resurgent Republican right. George Meader's 1946 report to the Senate War Investigating Committee on the US occupied zone in Berlin had revealed widespread misconduct on the part of American soldiers, including fraternization, black marketeering by officers and slack pursuit of de-Nazification. Republicans tried to use this evidence to argue against further American involvement in post-war Germany. Wilder, who seems to have based his film partly upon Meader's investigation, may well have re-conceived *A Foreign Affair* as a chance to oppose this Republican initiative. Even if this were not the

case, the issues were too important to be served by his initial idea of a 'superior piece of propaganda'. Nor was it the time for a liberal who cared about his cultural heritage to start selling 'a few ideological items'. The film began to take a very different shape from the scheme he had outlined in August 1945.[17]

Wilder kept his original idea of a romance between a GI and a German woman. He took from Irwin and David Shaw's unfilmed screen story 'Love in the Air' the additional plot element of a congresswoman who helps a soldier on the path to true love, thereby discovering her own sexuality and finding romantic fulfilment.[18] Wilder and his customary co-writer Charles Brackett were joined on this occasion by Robert Harari, whose specific role was to adapt the Shaws' original story. The trio began the task of blending the two plots together. In May 1947, when Wilder and his collaborators turned out their first treatment of *A Foreign Affair*, the outlines of the final story were already firmly in place.[19] The ending originally intended to offer a direct commentary on America's covert support for ex-Nazis, with Congresswoman Phoebe Frost attempting to disrupt a marriage between the GI, Pringle, and Erika, a known mistress of top Nazis. Frost was to make an impassioned speech, 'about Lincoln and the Bill of Rights, and if America meant to stamp out Nazism in Germany, certainly they didn't want to import the seeds of it into the United States'.[20] Moreover, this early script had Erika arrested not by the Americans, but by the Russians, an implicit reminder by the writers of America's debt to the Soviet Union in destroying Nazism.

When the film came to be made, however, it was no doubt the rising tide of anti-communism that gave Wilder pause for thought about such open support for the Soviets. The episode was altered. Phoebe's speech criticizing American indulgence of ex-Nazis was dropped altogether. Pringle's foreknowledge of his mistress's Nazi sympathies was changed, so that he realizes only late in the day just how closely involved she was with the Nazi high command. Work on the screenplay continued, with Harari dropping out and Richard Breen, a new scriptwriter, joining the team. By late November the first hundred or so pages of the script, provisionally retitled 'Operation Candybar', were available for PCA consideration. By now it was customary for Wilder to send his scripts to the PCA one section at a time. On this project he made the novel suggestion that, rather than supply a complete script, he visit Joseph Breen to tell him how the film would finish.[21]

The controversy aroused by the film on its release would have come as no surprise to Wilder. Even at an early stage in the film's preparation, the problematic elements were apparent. The response from the PCA, for example, was unusually long, running to five pages. Objections to the overt sexuality of Erika were to be expected, but this aspect paled into insignificance when compared with the script's wider targets: the American Army of Occupation and the Congressional Committee. The PCA could not object to the 'political' message of the film in itself, because this was not its function. There was therefore no comment about the script's implicit criticism of American diplomacy in Europe. Instead, the PCA had to concentrate its moral outrage on the individual elements that went to make up Wilder's critique. Accordingly, Breen focused on the satire of the military forces and members of Congress. On the surface, the PCA's objections – as with later criticisms of the

film – seemed to suggest simply that the American occupation of Berlin was not a matter for humour, but these objections masked a deeper sense of moral outrage. Wilder was daring to laugh at America's mission to preserve democracy in Europe, while simultaneously exposing American black marketeering and fraternization with Nazi women. Many Americans in 1948 did not want to have their national values examined on an impartial basis. Neither did they wish to hear that the situation in Europe was too complex to allow simplistic discussion of rights and wrongs, when the Cold War was being fought on exactly those terms. Wilder's strength of feeling about post-war Berlin ran directly contrary to national convictions about American foreign policy. It was a dangerously exposed position in which to place himself given the rising tide of anti-communist hysteria. But Wilder, by now, was more than ready to court controversy.

Stephen Jackson of the PCA recorded his hostility to Wilder's script. He wrote that, 'we believe this material presents a very serious problem of industry policy with regard to the characterization of the members of the Congressional Committee and of the members of the American Army of Occupation'. The letter solemnly continued, 'the portrayal of the Congresswoman, Phoebe Frost, getting drunk in a public night club of poor reputation, hanging from the ceiling and being arrested and carted off to jail in the police van' violated Code rules.[22] Jackson based his first objection on the rule requiring films to represent fairly the prominent people of all nations, although this rule had never been intended to inhibit satirical representations of fictional American politicians. Jackson's reliance on it demonstrates that the basis of his objection was not strictly Code-related, but rather a general sense of moral anger at the script's irreverence for American institutions. The letter went on to object to the black market activities of the occupation personnel and to the 'illicit sex' running through the script.[23] Nevertheless, although revisions followed between December and February, the film retained its irreverence for American institutions and its satirical bite. It was given a PCA certificate in March and was on general release by July 1948.[24]

Wilder used the formulaic romantic plot only as a framework for his dissection of American moral rigidity. As he told me many years later, his main aim was to show that 'we [that is, the Americans] were as corruptible as the others'.[25] Each of the characters presented in the film symbolizes an aspect of American values. Phoebe Frost is a frigid, assertive woman who discovers romance. The transition is mirrored by her development from moralizing Republican, determined to expose the corruption of Berlin, to one who understands the human aspect of Europe's problems. Wilder's own philosophy was embodied in the character of Colonel Plummer, a down-to-earth pragmatist with a strong sense of moral rectitude. Liberal, and realistic about Germany's difficulties in rebuilding itself, Plummer does not seek to impose rigid solutions based on ill-informed notions of American democracy's healing powers. For him, the presence of the black market and fraternization are part of the complex reality of post-war Berlin. They cannot be ignored, but neither can they be legislated out of existence. His solution to Germany's problems is to rebuild the shattered lives of the inhabitants, provide new schools and houses, decent food and services. Only in this way would the German people genuinely come to espouse democratic values.

Wilder found it comical that a group of American politicians should go to Europe to pronounce upon the future of democracy there, and he showed up their parochialism. He had the chairman of the Congressional Committee suffer from airsickness, 'indisposed ever since we took off from Washington', as one fellow congressman puts it. Their first glimpse of the ruins of Berlin from the air comes as a shock – they had previously had no conception of the devastation. Yet each congressional member quickly comes to see the visit to Germany as an opportunity for personal or national gain. One films the city, already planning 'The Incumbent Abroad', a movie for election time. Another demands that the German people be left in no doubt that it is the United States providing the food. Others bicker about the relative importance of re-establishing organized labour, business or agriculture. Later, when Miss Frost, masquerading as a Fräulein, reminds two soldiers of the gravity of Congress back home, they sneer contemptuously: 'so what's Congress? A bunch of salesmen that's got their foot in the right door!' The line stayed in the film despite the PCA's objections – the censors had already demanded the removal of its precursor, 'So what's Congress? A bunch of crooks that flunked out of law school'.[26] Wilder's combination of comedy and serious political commentary offended and confused the critics. 'Some may object to the light treatment given so [sic] serious problems as de-Nazification, fraternization, etc.', warned one prophetically. This particular critic admired the comedy but expressed 'only puzzlement concerning the more serious aspects of the film'.[27] Other reviewers were less circumspect: 'the picture indorses [sic] everything it has been kidding, and worse. A good bit of it is in rotten taste.'[28] The ICD, sponsors of the original project, changed their minds when they saw the finished product. The film was immediately banned from being shown in Berlin.

The debate about the merits of *A Foreign Affair* was still raging four years later. Herbert Luft, a German Jew who had been in a concentration camp before coming to America, found the film grossly offensive. Writing in 1952 he began, 'Survivors of Nazi concentration camps whose bones were broken in the dungeons must have been ... deeply hurt by the happy-go-lucky treatment of post-war Germany'. Wilder dealt 'with the aftermath of war with the luxurious cynicism of a sophisticate who has acclimatized himself to the ivory tower of Beverly Hills'. His version of Europe in 1947 was 'a superficial viewpoint bound to mislead an uncertain public', concluded Luft. [29] Yet, far from being misleading, Wilder's frank portrayal of events in Berlin had all too clearly shown the American public what was really happening there. Luft's objection was not, in truth, to the inaccuracy of Wilder's film, but to the effect that the truth might have on the American public.

Developing his theme that Wilder was betraying American values in his cynical film, Luft continued:

Our occupation forces appear undisciplined and ill-behaved. It is not funny to see Berlin's citizenry tyrannized by the same clique of Nazis whom we have cursed so often, or to view frauleins complacently ruling the destiny of American officers, or to realize that a huge black-market exists under the very eye of the military government.[30]

Again, Luft was troubled by the accuracy of Wilder's portrait of Germany, and the behaviour of its new masters – matters on which he would prefer Wilder to be silent and uncritical. He singled out Wilder's own foreign ancestry as the key to his un-American attitudes:

> Like many Germans, Wilder depicts only the weaknesses and shortcomings of the American people, ridicules their habits, but never senses the strikingly salubrious strength of this vibrantly young republic … He hasn't seen Americans as they are, or as they should be, but as he … was indoctrinated to conceive the 'Yankee' when he was still abroad … uncivilized, unconcerned … the savage of the Wild West who loves only money and owes allegiance to none … One can only conclude that Wilder's world is more continental than American.[31]

Wilder undoubtedly was reluctant to share in the uncritical celebration of American values. Luft's assessment was, in one respect, correct – Wilder had indeed seen the shortcomings and weaknesses of American life. He had, however, gone too far for many American critics. He had chosen a European subject that was obviously close to his heart. He had then pointedly contrasted America's professed cultural confidence and moral superiority with the corruption and self-serving behaviour of its military and political leaders.

Luft's article provoked yet further criticism of Wilder the following year. The next salvo came in 1953 from Stuart Schulberg, who was in the military government of Berlin at the time of the film's release. Having viewed the film to see if it was 'good orientation' for the Germans, he had been disappointed: 'our disappointment turned into resentment and our resentment into disgust … we could not excuse a director who played the ruins for laughs, cast Military Government officers as comics, and rang in the Nazis for an extra boff'.[32] For those Americans in Berlin at the time, Schulberg continued, the crux of the matter was this:

> [The film] treated a most crucial issue – the rehabilitation of Germany – **as nothing but a joke**. [Wilder] was simply irresponsible. At a time when sober American understanding of German problems seemed essential to our foreign policy, Wilder's slap-stick version of Berlin affairs struck us as an international disservice [original emphasis].[33]

Again, the issue was not the veracity of Wilder's vision of Berlin, but whether the unpalatable truth should be told. The real bone of contention was Wilder's failure to join the conspiracy of reassurance about the success of American diplomacy in the early Cold War era. His irreverent laughter at the expense of America's mission to save Europe from decadence and communism was tantamount to treason in some eyes. It is further evidence of the distance Europeans like Wilder maintained from American culture. Not every response to *A Foreign Affair* was unfavourable, however. Bosley Crowther, the *New York Times* reviewer, welcomed the film. He recognized that neither Congress nor the army would like it. Crowther shared Wilder's view that moral idealism was an inappropriate basis on which to construct the

government of post-war Germany: 'there is bite ... in the comment which the whole picture has to make upon the irony of big state restrictions on the level of individual give-and-take'. In other words, simplistic American solutions could not be imposed upon the people of Berlin in the confused circumstances of the time.[34]

A Foreign Affair was Wilder's most controversial and most personal film of this period. The state of affairs in Berlin, the city which had done the most to shape his own cultural outlook, had evoked a response from him that transcended commercial compromises. It was as if he had been provoked into a defence of his heritage by the combination of naivety and self-righteousness that pervaded American diplomacy at the time. Consequently, Wilder refused to accommodate American values and produced a powerfully dissenting work. Its criticisms of the army, of Congress and of American foreign policy culminated in a rejection of American moral idealism. For critics, Wilder had reached a low point in his cynicism and bad taste. For Wilder, it was a high point in his dissent from the American cultural consensus.

Notes

1. Barnett, 'Happiest Couple in Hollywood', *Life*, 17 (11 December 1944), 109. The film is analysed in Chapter 5.
2. *Hollywood Reporter* (28 August 1942); in PCA, The Major and the Minor file.
3. Compare this with Dick, *Billy Wilder*, 65; Dick sees Wilder as 'quintessentially American' and comments (under the subheading 'Yankee Doodle Billy') that Wilder 'regards the day in 1939 when he became an American citizen, as one of the most significant in his life' (126).
4. An early (but reasonably complete) draft (17 December 1942) is in Paramount. It was probably this draft which was sent to the PCA on 18 December 1942. Further fragments were sent on 19 and 23 December 1942; 21 and 28 January 1943; and 1, 8, 9, 11, 15, 18, 22 and 24 February 1943. There were some very minor points raised by the PCA, and a certificate was granted on 18 March 1943; see PCA, Five Graves to Cairo file (hereafter, 'FG').
5. Bosley Crowther, *New York Times* (27 May 1943), 21.
6. *Hollywood Reporter* (4 May 1943); in PCA, FG.
7. Crowther, *New York Times* (27 May 1943).
8. Wright and Hanna, 'Motion Picture Survey', in *Writer's Congress*, 405.
9. *Daily Variety* (4 May 1943); in PCA, FG.
10. *Daily Variety* (4 May 1943); in PCA, FG.
11. David Culbert, 'Hollywood in Berlin, 1945: a Note on Billy Wilder and the Origins of "A Foreign Affair" ', *Historical Journal of Film, Radio & Television*, 8 (1988), 311–12.
12. Wilder, 'Propaganda through Entertainment', memo to Davidson Taylor (16 August 1945), in Ralph Willett, 'Billy Wilder's "A Foreign Affair" (1945–1948): "the trials and tribulations of Berlin"', *Historical Journal of Film, Radio & Television*, 7 (1987), 13–14.
13. Wilder, 'Propaganda through Entertainment'.
14. Wilder, 'Propaganda through Entertainment'.
15. Wilder, 'Propaganda through Entertainment'.
16. Thomas Pryor, 'End of a Journey', *New York Times* (23 September 1945), II, 3.

17. Culbert, in 'Hollywood in Berlin, 1945', argues that the film was conceived from the start, with the full backing of the ICD, as 'the centrepiece of ICD plans to explain the realities of the occupation of Germany to Americans, while reminding German nationals that there indeed was a limit to moral absolutism as far as intelligent policy-makers were concerned' (*Historical Journal of Film, Radio & Television*, 8 (1988), 312). Culbert's analysis of the complexities which were to be explored by the film is indeed true of the film we have now, but he is almost certainly wrong to believe that this was the intention of the *original* ICD-sponsored project.
18. The undated story is in Paramount.
19. 'A Foreign Affair', treatment (31 May 1947), Paramount.
20. 'A Foreign Affair', treatment (31 May 1947), 35–40, Paramount.
21. Luraschi, letter to Breen (25 November 1947); PCA, A Foreign Affair file (hereafter, 'FA').
22. Stephen S. Jackson, letter to Luraschi (2 December 1947); PCA, FA.
23. Jackson to Luraschi (2 December, 1947); PCA, FA.
24. Script revisions were sent to the PCA on 16 December 1947; 5, 12, 15, 16 and 26 January 1948; and 5 and 6 February 1948; the certificate was issued on 22 March 1948; see PCA, FA.
25. Telephone interview with the author (31 August 1990).
26. See Jackson's letters to Luraschi (2 December 1947 and 6 January 1948); PCA, FA.
27. *Hollywood Reporter* (14 June 1948); in PCA, FA. See also the less critical, but still pertinent, comments in *Daily Variety* (14 June 1948) and *Variety* (16 June 1948); in PCA, FA.
28. Agee, *The Nation* (24 July 1948), in Agee, *Agee on Film*, 310–11.
29. Luft, 'A Matter of Decadence', *Quarterly of Film, Radio and Television*, 7 (Fall 1952), 61–62.
30. Luft, 'A Matter of Decadence', *Quarterly of Film, Radio and Television*, 7 (Fall 1952), 63–64.
31. Luft, 'A Matter of Decadence', *Quarterly of Film, Radio and Television*, 7 (Fall 1952), 64–66. Interestingly, Luft refers to Lang's *Fury* as another film critical of America. But he finds it acceptable, its honesty and realism about American failings moderated by 'a deeper belief in the innate decency of man'.
32. Stuart Schulberg, 'A Communication: a Letter about Billy Wilder', *Quarterly of Film, Radio and Television*, 4 (Summer 1953), 434–35.
33. Schulberg, 'A Communication', *Quarterly of Film, Radio and Television*, 4 (Summer 1953), 435.
34. Bosley Crowther, *New York Times* (1 July 1948), 19.

Case Study 7

'Propaganda can be art': Lang and International Affairs

Fritz Lang's commentary on foreign affairs constitutes one of his most important contributions to American popular culture of the 1940s. First, he made *Hangmen Also Die!* (1943) during the war, a deeply felt film in which he confronted viewers directly with the horrors of the Nazis. It was his first chance to put into practice his new ideas on 'affirmative resolutions' rather than 'happy endings' (as discussed in Case Study 1). Next, when the war was over, he attempted in *Cloak and Dagger* (1946) to make a controversial comment on America, post-war Europe and the atomic bomb. But Hollywood was not ready in 1946 for such a discussion. The film was edited without Lang's approval, and its shocking message completely neutralized. Once more Lang, like his fellow Europeans, was trying to expand the boundaries of American political discourse through the medium of mass popular culture.

Fritz Lang and the Nazis: *Hangmen Also Die!*
Hangmen Also Die! was a rarity among Hollywood films in its frank depiction of Nazi brutality and its uncompromising avoidance of the traditional 'happy ending'. It also refused to provide a conventional resolution to its romantic subplot. Lang had already directed *Man Hunt* (1941) for Twentieth Century-Fox, a frank anti-Nazi film written by Dudley Nichols before the attack on Pearl Harbor, but there had been no opportunity for the director to incorporate any of his personal views into the shooting script.[1] Lang himself regarded *Hangmen Also Die!* as the better film; he made it, he explained, 'out of a determined belief that the facts of this war must be made known to everyone'.[2] He made the film after a period of routine contract work at Twentieth Century-Fox. A film critic noted that Lang had finally escaped from Fox and, with *Hangmen Also Die!*, was again making more personal films: 'You get the impression that this director is no longer doing a job by the book … He is working from the inside. He knows what he is portraying and he feels it with violence.'[3]

The film began as an idea Lang had with Bertolt Brecht to write a screenplay articulating their joint response to the Nazi domination of Europe. According to an account he gave much later, he and Brecht met often and talked about the Nazis. During this period Czech refugee Arnold Pressburger, now an independent Hollywood producer, asked Lang to make a film with him. News came shortly afterwards that Heydrich, Reichsprotektor of Czechoslovakia, had been assassinated. Lang seized on this as the idea for the film and consulted Brecht. The latter agreed and in May 1942, according to Lang, the two of them dashed off a short outline of the story in only two days.[4] Although Lang was prone to tell tall stories in his later life, this account may well be accurate. The first surviving evidence of the film is a 39-page treatment, written in German. Enigmatically entitled '*437!! – Ein Geiselfilm*' (a hostage film) by Lang and Brecht (in that order), it was registered by Lang with the Screen Writers' Guild at the end of June 1942.[5] In July Lang contracted with Pressburger to produce and direct the

film. He was to have joint budget approval with Pressburger and the right to cut the film as he wished for its first preview.[6] He also secured the right to be consulted on all matters pertaining to publicity, a habitual obsession of Lang's that led to much bickering during the production (and during his later collaborations with Walter Wanger, detailed in Case Studies 1 and 4). Lang demanded sole producer credit rather than having the film billed as an 'Arnold Production'. And an argument blew up when Lang made adverse comments about his female star, Anna Lee, in a press briefing. Exasperated, Pressburger's publicity agent complained that,

> I'd like to spend 100% of my time publicizing the picture rather than waste any more of my time convincing Mr Lang that I can have only one interest at a time – to make this the best publicized picture of his career.[7]

Lang's contract with Pressburger specified that Lang would forfeit half his directorial fee in return for a 25 per cent share of the profits and a $5000 bonus. Within a week of Lang agreeing to these terms, Brecht sold his rights in the story – now entitled 'Never Surrender!' – to the director for $5000, agreeing to act as Lang's employee in its further development.[8] 'Never Surrender!', an expanded version of '437!!', running now to 95 pages and translated into English, was completed by 16 July 1942. It still bore the co-authorship credit of Lang and Brecht.[9] It is remarkably close in story outline to the finished film. Clearly, Lang and Brecht knew what they wanted from the film at the outset. The subsequent screenwriting process would be little more than the mechanical task of converting the story into dialogue and camera movements. Lang continued to work on the script from his house with Brecht and another writer, Milton Gunzberg, during early September, while casting decisions went ahead.[10] Lang failed to secure Joan Bennett and Dan Duryea for the film – they would both appear in his subsequent projects, *The Woman in the Window* (1944) and *Scarlet Street* (1945).[11] Thomas Mitchell rejected the part of the informer in a succinct telex: 'Tell Lang – no – wouldn't play a Quisling for all the tea in China'.[12]

At this point Lang brought in American playwright John Wexley, a sign perhaps that Brecht was not able to deliver what Lang wanted in converting the story into a screenplay. By early October Wexley and Brecht had produced the first 60 pages of polished script for Lang's approval, with Wexley apparently now acting as the senior collaborator.[13] Lang worked on this material, instituting 'various cuts and changes' over the ensuing weeks, until Pressburger was able to send the PCA in late October a script for his film, 'tentatively entitled NEVER SURRENDER'.[14] A month later, at the end of November, the 'final shooting script' (now called 'Unconquered') was available, credited to Wexley, from Lang and Brecht's original story. Shooting commenced sometime before 1 December 1942.[15] During these final months of script revisions, Lang had significantly reduced the sometimes long-winded exegesis. At some stage between his first ideas in May and the final script in November, he had made three important changes. First, the romantic subplot, in which the main female character, Mascha, sacrifices her reputation and her forthcoming marriage to protect Heydrich's

assassin, was originally more prominent. It has been observed that because Mascha 'reflects the cardboard traits of the typical Hollywood heroine', this subplot must have been Wexley's work, not Brecht's.[16] Yet, it is apparent that the story conceived by Lang and Brecht placed far greater emphasis upon the trite romantic story than did the eventual film. Moreover, Wexley and Brecht working together merely built up this part of the story into a fully developed theme.[17] It was therefore Lang who must have cut down the romantic element to its reduced level in the final film (even so, it remains one of the weakest elements in the movie).

The other two differences from the original story that the film displays are instructive. Lang and Brecht had wanted to draw parallels between Czechoslovakia's struggle for freedom and the revolutionary birth pains of the United States. Professor Novotny, Mascha's father, is taken hostage by the Nazis pending the arrest of Heydrich's assassin. In an early draft of the script he makes a speech to his fellow prisoners. He refers to the United States as 'the great sister republic of Czechoslovakia' and associates the two nations' struggles for independence against oppressors. In a later draft of the script by Wexley and Brecht, the professor is shown talking to his students about the American Revolution in its 'most desperate and hopeless state', instructing them on his arrest to 'work hard on the crucial chapters leading to Yorktown and to the ultimate convention in Philadelphia'.[18] Such clunking parallels and heavy-handed patriotic American sentiment were excised by Lang from the completed film. The third divergence was perhaps the most significant. In the film the Nazis execute Novotny in one of the very last scenes, a moment to shock any viewer accustomed to Hollywood's conventional resolutions. Yet the first idea had been to have the professor liberated and reunited with his family at the end.[19] Again, the decision to depart from Hollywood traditions was almost certainly taken by Lang, in the period *after* Brecht had made his main contribution.

Production, as usual on a Lang picture, was fraught. Pressburger feared that the script was too long and tried to persuade Lang to cut out certain scenes. Lang agreed to do so only on condition that he could reintroduce them subsequently if he deemed them necessary to the story. This proved a recipe for even more animosity as the production progressed.[20] As filming proceeded slowly, Pressburger became ever more agitated: Lang was shooting far too much material, alleged Pressburger, who could foresee a seventeen-reel picture emerging (a reel is around ten minutes long). Lang sneered at Pressburger's exaggeration about the length, calling the idea 'ridiculous' and saying that he had yet to edit the footage. The film would be about one hour 45 minutes in length, as agreed at the start of production, Lang assured him; in fact, it ran to over two hours and was widely criticized for being too long.[21] Lang sent Pressburger a note, blaming everyone but himself for the slow progress. The cameraman was too slow – an excuse he often used. He complained that the male lead, Brian Donlevy, would not work after 6 p.m. The female lead, Anna Lee, needed 'many additional hours' of work according to the director. Pressburger's request to eliminate certain scenes was refused – Lang had already 'proved [that they] were essential to this picture'. Lang concluded his characteristically bad-tempered note: 'The continuous harassing every day while I am shooting is very disturbing and tends to slow me up and accomplishes nothing'.[22]

While the film was being edited in January 1943, the 'vague' title of 'Unconquered' was reconsidered.[23] Suggestions for a new title ranged from 'I Killed Heydrich', 'I Killed Hitler's Hangman' and 'I Killed the Hangman' to Pressburger's own idea, 'Hitler's Henchmen'. By mid-February, however, *Hangmen Also Die!* had been agreed.[24] Pressburger now insisted that Lang stop shooting further inserts and refused permission for extensive re-dubbing. Although he loftily agreed with Lang that it was 'ridiculous to talk about such matters on a production such as ours', he was nevertheless grounded enough to rule that 'the time has come' to stop spending money on the film.[25] Accordingly, it was completed and previewed in late March 1943 and given its New York release in mid-April. Critics were divided about its socialist celebration of communal spirit over individualism, but nearly all praised its integrity, its power and its startling frankness. By July it had more than recovered its costs. Fritz Lang, reported Hedda Hopper, having 'gambled nine months of his time and maybe nine-tenths of his health', was ready for another independent production, so long as he could find the right partner.[26]

Hangmen Also Die! was in certain respects similar to *To Be or Not to Be*, although in mood and tone they could hardly have been more different. Both were films of the occupation, chronicling what it meant to be a member of the underground and to use violence for the good of the country, and what it meant to place one's community before one's personal interests. Both films used a collaborator to counterpoint the self-sacrificial endeavours of the Resistance with a figure who ruthlessly feathers his own nest at the expense of his country-folk. Both charted the transition of ordinary people from a preoccupation with selfish, parochial concerns to an understanding of the national, even supranational, needs that required the courage to oppose Hitler. Finally, both films seem to have been conceived as deliberate lessons for the American people in what the European experience of the Nazis actually meant. That Lang's was so stark and violent in comparison to Lubitsch's was symptomatic of the differences in style and temperament between the two directors. It also resulted from Lang's closer experience of what he called 'the brown pest', or the Nazi regime.[27]

Hangmen Also Die! tells the story of how one ordinary family in Prague becomes inadvertently involved in the underground's assassination of Heydrich. First the family offers the assassin protection as he flees the pursuing Nazis. Then the father is taken hostage by the Nazis as part of a scheme to intimidate the city into giving up the assassin. Uninterested in the struggle of the underground at the start of the film, the family becomes involved and then committed. We see this through the development of the daughter, Mascha. When her father, Professor Novotny, becomes one of 800 hostages, we see how the struggle embraces all the people of Prague, from all walks of life. Gradually, as the underground fights back against the Nazi reprisals and the work of Czaka, a treacherous collaborator, the whole city conspires to bring down the traitor, free the hostages and help the assassin escape. Lives have been lost in the struggle, including Professor Novotny's, but the fight for freedom goes on.

The foreword to the film introduced it as a tribute to the Czech underground, 'unhappy but undefeated'. Lang had sought to include a spoken foreword from Thomas Masaryk, leader of the Czech government in exile. Despite assistance from the Czech legation in

America, this was not possible. Neither was the second option achieved – showing footage of Masaryk's address before the Hall of Independence in Philadelphia.[28] Lang's intention was to bring home to his American audience the desperate plight of the Czech people and to convince them of the reality of his film drama. Writing five years later, Lang recalled that, 'I made [the film] primarily for Americans who then knew next to nothing of the nature of Fascism'.[29] He was equally clear on this issue at the time of the film's release, telling one interviewer that film, 'the great art of the people ... should be used to teach people the truth, particularly in times like these'. Asked what his next film would be, Lang talked of other matters: 'My main concern at the moment is to see a Second Front in Europe to bring Hitler to his knees'.[30] In a pre-release radio interview, Lang made similar points about the didactic and populist/democratic aims of his latest work. He explained that he wanted to show the effect the Nazis were having on 'the average people – the people I love ... not only professors and doctors, but also grocery-store women, and housewives'. Cinema, he went on, was, 'An art for the masses', the first real art for 'the common people'.[31]

Certainly, his film caused a stir on its release in April 1943. It was widely recognized as strikingly powerful propaganda, the like of which had not previously been seen from Hollywood. The War Production Board in Washington DC valued the film as useful propaganda, waiving their usual restrictions on the cost of sets and agreeing to help in other ways, as they always did for 'Motion picture companies doing propaganda pictures'.[32] On its release, the West Coast reviewers immediately appreciated the novelty of Lang's portrayal of events in occupied Europe. It was 'almost documentary drama', wrote one, 'almost completely free of the customary Hollywood studio manner'.[33] Another summed up the film's main point, simultaneously endorsing Lang's assessment of the possibilities of cinema: 'This is no period for America to indulge in ostrich complacency, and there is no better medium for wide public information than the screen'.[34] A third joined in the chorus:

> So forceful a document is it that it will incite the filmgoer to an intense hatred of the Nazi barbarian, and as such is probably one of the most effective pieces of propaganda to emerge from Hollywood ... [It proves] the fact that propaganda can be art.[35]

Lang had succeeded in drawing the critics into a discussion of cinema as propaganda, as educative, as the mass art for the American public. *Hangmen Also Die!* was not simply a melodrama, nor a wartime thriller. It was deliberately didactic – setting out to inform, as well as entertain, the American audience and to bring people to an understanding of what the conflict with the Nazis meant for Europe.

The central theme in the film is the evolution of commitment on the part of the ordinary people of whom Lang had spoken in his radio interview – the grocery-store women, housewives, young women on the threshold of marriage and a new life, taxi drivers and many others. Tied in with this idea was the urge to convince Americans that in such circumstances as occupation and underground resistance there was more at stake than one individual's rights. The furtherance of the cause meant at times that any one person – or,

in the case of the hostages in the film, hundreds of innocent people – would have to be sacrificed. The desire of the individual to lead a normal life, in which he or she need not be committed either way, was unsustainable in wartime, argued Lang. Everyone was either a freedom fighter when called upon, or a collaborationist. No one could stand on the sidelines and wait for the end of the war. This was a complex theme for Americans, who were not occupied by the Nazis and were likely to be distrustful of apparently socialist ideas. Indeed, Lang received a certain amount of criticism on the grounds that the theme of communal loyalty was unconvincing propaganda.

A central figure in the film is Professor Novotny. He is characterized in the early screenplays as 'an old revolutionary', in exile once 'with President Masaryk himself'.[36] Lang moved the character away from the elitist notion of an intellectual political leader. Instead, he chose to use Novotny as the archetype of a middle-class liberal, who accepts his role in the life and death struggle for freedom. When the Nazis come to arrest Novotny, to take him as a hostage, the assassin is in the room. Novotny knows this but chooses to keep silent, immediately understanding that the assassin's life is worth more as a symbol of Czech resistance than is his own. Ultimately, Novotny gives his life for the cause and the assassin lives on. His daughter, Mascha, begins as someone uninvolved in the conflict, passively opposed to the Nazi occupation but concerned more with her own marriage plans. Her fiancé, Jan, shows a similar lack of commitment, deploring the violence of Heydrich's assassination. He goes even further, however, virtually collaborating with the Nazis once he fears that Mascha may be romantically involved with the assassin.[37] As the film progresses, Mascha comes to understand the dangers of her complacency and the need to support the underground, even at the cost of her father's life. Her transition from complacent observer to active Resistance fighter requires her to subordinate personal concerns to the wider cause of Czech freedom. At first, Mascha demands that the assassin, Svoboda, give himself up, so that her father's life may be spared. Svoboda argues that if he is given up, the future of the Resistance will be undermined. The lives of the hostages are a price that must be paid: the communal sacrifice is worth more than the suffering of any one individual amongst the hostages.

In perhaps the most brilliant sequence of the film, Mascha goes to Gestapo headquarters to betray the assassin and release her father. On the way, a group of Czechs, who overhear her demands to be taken to the Gestapo, confront her with her selfish cowardice. On arriving at the headquarters, she sees torture victims being dragged past. Although she then changes her mind and invents a pretext for her visit, the Gestapo are suspicious of her. They therefore search the Novotny apartment and arrest and interrogate the entire household. An extraordinary montage follows. Lang cuts from one interrogation to another, faster and faster, showing the gruelling, repetitive terror of the interviews. The sequence culminates in Mascha's own imprisonment, during which she discovers in her cell the battered body of an old woman. She is a grocer who helped the assassin by sending his pursuers in the wrong direction. Mascha's selfish preoccupations have brought her whole family into danger. The old woman has accepted fatal torture rather than jeopardize the cause of freedom. Mascha

turns her face towards the light coming through the bars of her cell, as the realization of her proper role in the struggle begins to dawn upon her.

This powerful sequence is essential in convincing the viewer of the freedom fighters' case and the folly and selfishness of Mascha's behaviour. Lang knew the sequence was going to be important and fought hard to resist Pressburger's request that it be shortened by deleting the confrontation with the Czech crowd en route to the Gestapo HQ. Pressburger thought the scene an expensive luxury, while Lang contended that it would be 'one of the outstanding high lights [sic] of the picture' as well as 'practically the only scene in which we see the psychological reaction of the Czech people … If it were cut out,' he reasoned, 'the whole underground movement would become ridiculous and pointless.'[38] Lang told an interviewer that Mascha's evolution was meant to show how everything in life now had to be fought for, even love: 'We're fighting Hitler so that the ordinary things of life can go on in their ordinary way'.[39] Mascha is an average girl who learns an essential truth about this fight: 'like everyone else, she is forced to put her personal love second to her love of freedom'.[40] Lang used an analogy to illustrate his point. It was like a rich man holding a banquet, who need not concern himself with whether there is bread on the table. One day the man has to live without bread and so realizes how fundamental it is for survival. Even the most basic human freedoms and needs have to be fought for – they can no longer be assumed. Lang's analogy is recalled in the scene where Novotny dictates a letter for Mascha to convey to his son, explaining why the professor must die. 'Freedom,' he says, 'is not something one possesses – like a hat or a piece of candy. The real thing is fighting for freedom.' That, he explains, anticipating his fate, is why 'I died in this great fight'. From this moment on, the film moves from a chronicle of oppression and fear to one of active resistance, as the underground fights back.

The conflict between self-interest and self-sacrifice is further illustrated by the character of Czaka, the brewer who collaborates with the Nazis, 'for business reasons, for favours, for certain profitable military contracts'. He is the antithesis of Lang's advocacy of self-sacrifice for a communal good. He sells the Resistance fighters to their executioners for reasons of greed and profit. Here Lang tried to educate Americans about the nature and effects of collaboration with the enemy. Czaka is superbly portrayed as a cowardly, weak man whose urge for self-preservation knows no bounds. The underground (implausibly, it must be said) eventually conspire to frame him for Heydrich's murder, and he is shot trying to reach the sanctuary of a church. Juxtaposed against this contemptible figure are the brave men and women of the underground. One scornful Czech, appalled by the refusal to give up the assassin, complains about the underground fighters who get off 'scot-free'. Yet we see a group of them, victims of Czaka's treachery, being dragged off for torture and a horrible death. At the end of the film, as Czaka is shot, Lang cuts to Professor Novotny's unexpected execution. The message is clear: Novotny has not died in vain, but neither can the Czech people conquer the evil of Nazism without paying a price. Lang also uses the Czaka episode to illustrate the necessity – and the inspirational nature – of group solidarity against the common enemy. As citizen after citizen swears to a recollection of events that point to Czaka as the assassin, the

increasingly panic-stricken collaborator protests it is a plot to smear him. 'Are you trying to say that the whole city of Prague is conspiring against you?' sneers an incredulous Gestapo official. To Czaka and the Nazi forces, such communal identity of interest is unthinkable. To Lang and the viewer, however, it is the essence of the people's devotion to freedom and to conquering the enemy.

Americans did not easily understand the themes of sacrifice and communality. The *New York Times* felt that the film lacked the 'emotional power and conviction' to match 'its heroic theme'. The patriots seemed 'postured and insufficiently sincere, their words have the hollow ring of Hollywood'. Most tellingly, the critic felt that in justifying the underground's protection of the assassin, 'Mr. Wexley's moral reasoning seems both dubious and feeble'.[41] Another New York reviewer agreed, writing that the theme of not surrendering the assassin, 'often discussed, is somewhat difficult to understand'.[42] For another, the unconvincing 'stodgy heroism' was 'incredulously indecent'.[43] But not everyone was so confused or negative about this central theme. Ten leading American women's organizations congratulated Lang on emphasizing the theme of freedom over the destiny of any one individual, 'so that their personal tragedies seem of less importance than the ideal of freedom for which they sacrifice themselves'.[44] This was an unusual idea in a country and a film industry in which the individual was paramount in overcoming problems. Yet Lang's novel theme found other supporters. The reviewer for *P.M.* called it 'the first film treatment of European anti-Fascist resistance in which resistance as a cause – the utter necessity of it – is made to transcend all else, even the resisting heroes themselves'. Furthermore, Lang's aim of conveying the impact of Nazism on ordinary people succeeded for this reviewer, who commented that the Czechs were shown, not as 'poeticized light-opera Bohemians ... They are people very like you and me.'[45]

The most perceptive critical appreciation of the film's aims and intentions came from the communist writer Joy Davidman, in the left-of-centre journal *New Masses*. It merits a full summary. This, she began, 'may well be America's finest artistic comment on the war'. She explained the novelty whereby a few individuals had been used to tell the story of the lives of all the people. In this film the individual was not equated with an idea, was not romanticized, but represented an archetype of the masses in a context of historical realism. How favourably this compared with the usual war film that, she argued, could just as easily be located on Mars. The assassin did not represent, for example, the Four Freedoms, but merely himself – 'And therefore he comes to represent all men who fight for the people'. In the same way, the Gestapo agent is not evil personified but simply an ordinary, conscientious man: 'And thus he represents all those who acquiesce passively in fascism, all those who hope to safeguard their private lives by blind obedience'. (She could equally well have applied this to the Czechs in the film like Jan, who seek to live quietly without getting involved.) The Gestapo, she argued, were 'horrible precisely because they are human ... [T]heir crime is the human and suicidal one of taking the line of least resistance.' Davidman went on to note how the story built up from the events in one man's life, alone; then expanded to include a family of casual helpers; then, the underground leaders; and finally, the underground group as part of a vast movement embracing the whole city. Therefore, in the final analysis, the film was about 'a

man at the heart of a movement which is at the heart of a people'. The film was 'the screen voice of all men of good will'.[46]

Looking back at his film a few years later, Lang remembered it as the first in which he had articulated his 'affirmative resolution':

> In 1943, when I made 'Hangmen Also Die[!]' ... I ended the picture with the anti-fascist professor going to his death along with the other Czechoslovakian hostages. I did not want to tell Americans that Fascism would crumble at the first breath of resistance, and I did not think they would believe it if I had told them.[47]

But, Lang continued, it was not a negative or despairing ending. Instead, it showed 'man triumphant in himself, in his own sense of dignity'. This deliberately controversial ending, challenging Hollywood's conventionally optimistic resolutions, posed 'tremendous problems, but proclaim[ed] the solution through man's courage and sacrifice for those who live after him. This is not man as the victim of Fate or man dying for nothing'.[48] Reviewers noted that there was no 'easy' ending, no commando raid, national rebellion or devastating sabotage plot; as one remarked, 'Lang's direction has the march of doom in its momentum, but retains also that inspirational note which will hearten all fighters for freedom'.[49]

Lang glorified the worker in his film, from the victimized grocery-store woman (originally to have been played by Brecht's wife)[50] to the working man who composes a song for the people of Czechoslovakia, entitled 'No Surrender' (set to music by Hanns Eisler). Even more striking was Lang's novel depiction of the Nazis, particularly Gruber, the Gestapo agent, whose quiet power and efficiency evinces both terror and admiration. Reviewers noted the difference: 'Further, [the film] shows the Nazis in a new concept in films – not as blank-minded brutes, misguided fools or "officers and gentlemen" performing a distasteful function, but as an aristocracy of the bestial and depraved', wrote one. Another wrote that, 'You will notice that under Lang's direction the Gestapo men emerge from the commonplace anonymity of brutehood to the more refined and menacing appearance of highly personalized evil'.[51] The Writer's Congress, which had so criticized Lubitsch's humorous depiction of Nazi evil, heaped praise on Lang's film for its subtleties of characterization of the Nazis (and for using the word 'fascist').[52]

A number of critics thought *Hangmen Also Die!* was too long, 'too ponderous, too slow'. ('Thus far, resisting all well-intentioned advice, Lang is kee[p]ing his clippers completely out of sight' reported one pre-release article.)[53] Nevertheless, it put Lang in contention for the New York Critics' Award for Best Director and, for one voter, it was 'My personal idea of the very best picture of this past year'.[54] The film was a major contribution to the art of cinema propaganda and a step towards the maturation of Hollywood that Lang and his European contemporaries did so much to encourage in the 1940s. It was a unique perspective on the issues at stake in the global conflict. It was, too, a heartfelt statement by a man alienated from his own country, ill at ease in his adopted culture and searching for roots in the sufferings of a people he saw as his spiritual companions.

'An important, as well as a successful, picture': *Cloak and Dagger*

Fritz Lang's other major film about European affairs came after the war with *Cloak and Dagger* (1946). Lang intended the film to make an important statement about the world order in the atomic age, but events were to conspire against him. The release version turned out to be a fairly routine war thriller. It concerns the exploits of an atomic scientist, Dr Alva Jesper, who becomes a spy for the Office of Strategic Services (OSS) working in fascist Europe. There is nothing unusual or remarkable about the story or about Lang's handling of it. Indeed, as noted at the time, an OSS story, or indeed any war story, was, in mid-1946, somewhat dated.[55] Most reviewers assessed the film as an unexceptional, routine thriller, 'a "B" plot dressed up in "A" trimmings', 'the usual cops-and-robbers story', 'formula melodrama … hokum'.[56] Yet the film might have been very different had Lang been able to realize his intentions. The seemingly outdated wartime heroics would have been placed in a context of urgent topicality: the responsibilities of American world leadership in the new atomic age.

In later years Lang told interviewers that his sole reason for making the film was the original ending: a strong message about the need for collective security and international cooperation for peace, in an era when the superpowers possessed the knowledge to destroy the whole world. Unfortunately, Lang explained, the studio had cut out the entire last reel, removing what he regarded as the main purpose of the film.[57] Lang was prone in his later life to protest about how his lofty, artistic ideals had been compromised by the interference of philistine producers. More often than not, the evidence does not back up such claims but, in this case, the archival evidence supports Lang's story beyond any doubt. Lang may have exaggerated when he claimed that the lost ending was the *sole* reason he made the film, but he certainly envisaged it as a vehicle for a controversial message about the atomic age. As the film stands, and as it was released in September 1946, this key theme is so underdeveloped that it hardly engages the viewer's attention at all.

Lang's interest in the implications of countries possessing atomic power is, however, still detectable in the release version. At the start of the film, Dr Jesper is working on the Manhattan Project to develop the atomic bomb. He makes a significant speech about government priorities in science. Money is available, he notes, for work designed to increase mankind's destructive capabilities, but not for beneficial science. There are insufficient funds for research into cancer and tuberculosis; there is no money for hospitals, medical schools and universities. Instead, endless amounts are channelled into work that will enable human beings to destroy the whole world. Jesper picks up an apple. We will soon have the ability to deconstruct the atoms of this apple, he observes, releasing the awesome capacity to destroy; but, for all of our scientific advances, we still do not have the knowledge required to manufacture one small apple. Creativity is subordinated to destruction. This speech sets the context for the rest of the film. Jesper's subsequent espionage endeavours are aimed at preventing the Nazis from manufacturing the atom bomb. One of the film's points is that atomic knowledge is not evil in itself; it is the use governments make of science that determines its morality.

During his mission, Jesper makes contact with two scientists who are working under duress for the Nazis. He persuades them both to desist, appealing to one to remember his own pre-war ethos: 'only a free science in the service of all humanity can be a good science'. Lang constructs an image of a fraternity of scientists, stretching across the globe, committed to furthering the welfare of humankind. The issue is whether governments will work together in pursuit of peace or whether they will compete with each other in pursuit of power and destruction. It was a pressing question for the American people as post-war euphoria gave way to the Cold War. It did not make its way into the finished film, however. The atomic theme was left half-developed. The references to the atom bomb even appeared to one critic as opportunist, as though Lang had added them as an afterthought, to give a dated war film a specious timeliness.[58] The opposite was in fact true – the film's central message, foreshadowed in these early scenes, had been excised from the final product by hands other than Lang's. As the film's production history demonstrates, Lang had been instrumental in turning what began as a simple glorification of the OSS into a sober reflection on America's options for the post-war era.

Cloak and Dagger was a popular book by Corey Ford and Alastair MacBain, outlining the daring exploits of the OSS.[59] In autumn 1945 the noted director Mervyn LeRoy was preparing to cast and direct a film version of the book, in association with screenwriter-turned-producer Milton Sperling.[60] Their screenplay was being prepared, in customary Hollywood fashion, by an army of writers. First, John Larkin and Boris Ingster constructed an outline story. Their plot structure would survive right through to the final film, hardly changed except for the ending. Larkin and Ingster concluded their story with a warning about the premature disbanding of the OSS.[61] Sperling, who had just founded his own production company – United States Pictures (releasing through Warner Bros.) – hired left-wing writers Alvah Bessie and Ben Maddow to draw up the first screenplay, along with a military adviser, Sergeant Lester Koenig. Their unfinished treatment would, however, bear little resemblance to Lang's final film.[62]

By early December, LeRoy had dropped out and Lang had agreed to direct, excited by the chance to work with Gary Cooper. Cooper had been cast after James Cagney was considered but rejected.[63] In January and February 1946 Lang was 'testing an average of four girls a day' in his search for the actress to play Gina, the role ultimately taken on by Lilli Palmer (with whom he would fall out during shooting).[64] Meanwhile, two new screenwriters – perhaps appointed at Lang's request, given the timing – had begun to work on what would be the final screenplay. They were another pair of prominent left-wing writers, Ring Lardner Jnr and Albert Maltz.[65] They did not alter the story much, although they introduced Jesper's speech about the abuse of science for destructive purposes. At this stage the ending was simply a warning about the proliferation of atomic research sites.

Production began on 18 March 1946, with a budget of $1.6 million and a shooting schedule of 60 days.[66] The script was still being written as the shoot commenced. On 25 March, the Daily Report for the production recorded that, 'there's 20 more pages of script going through Stenographic this morning, and the balance of the script is to follow later'.[67]

By 2 April it was more or less finished: 'We received the balance of the script yesterday; there are no changes except in the dialogue'.[68] Once again, the production was tense and unpleasant under Lang's authoritarian regime. Lang had a 'mutual blowup' with Palmer on the forty-ninth day of shooting, because she could not handle a machine gun adequately.[69] Ten days later she refused to complete a location shoot because the sun bothered her.[70] Gary Cooper was asked about rumours of 'Fritz Lang throwing his weight around' on set, to which he replied diplomatically that Lang was one of the toughest directors he had worked with.[71] Palmer was less circumspect, telling a reporter after the film's release, 'I won't make another picture with Mr Lang unless I'm starving – and even then, I'd think it over first'.[72] As Lang fell further and further behind schedule in May 1946, Sperling intervened. He worked with Lang to reduce the overstretched romantic interlude between Jesper and Gina (even so, the sequence in the eventual film still drags).[73]

The uncertainty that had hovered over the production reached its climax when Lang came to film the ending. The initial ending had been inherited by Lang and his writers from the Larkin and Ingster story. It was controversial enough, even before the director and his team began to think in terms of their anti-war message. It contained an explicit warning about the dangers of atomic weaponry, which could have been interpreted as critical of American policy on this issue. Although Breen had raised virtually no objections to the script on Code-related matters, back in March he had alerted the production team to possible problems with 'political' censor boards.[74] Another PCA official, Geoffrey Shurlock, expressed his concern to Milton Sperling in April, who in turn passed the message on to Lang. Sperling explained that it was not a Code point, but 'primarily a word of caution on the tremendous responsibility we are assuming by doing the finish as it presently stands. [Shurlock] anticipates grave trouble on this matter, and I think we ought to spend five minutes with him hearing him out'.[75] Lang must have stood his ground and carried Sperling with him, for the ending was shot at the very start of June according to the then-existing script.[76]

Yet Lang remained dissatisfied with the ending, and he decided to make the anti-atomic message even more explicit. On 10 June, the seventieth day of shooting (already well behind schedule), Gary Cooper's illness gave Lang a break, which he used to rewrite the ending he had shot the previous week.[77] He reworked the script, which related how a deserted underground atomic plant was captured by American troops. Instead of the plant being wired for destruction, as the script suggested, Lang's new idea was that it had been stripped and moved elsewhere. Jesper and the soldiers, seeing this, realize it is only the beginning of the atomic threat:

CRONIN [*a soldier*]: Peace? There's no peace! It's year one of the Atomic Age and God have mercy on us all!

JESPER (*slowly*): No… no… God have mercy on us only if we're fools. God have mercy on us if we ever thought we could really keep science a secret – or ever wanted to. (*with passion*) God have mercy on us if we think we can wage other wars without destroying

ourselves. (*low-voiced*) And God have mercy on us if we haven't the sense to keep the world at peace.[78]

This was a radical addition to the project and one that fully realized the possibilities inherent in Jesper's early speech about science and the future of humankind. It openly criticized the American government's decision not to share the secrets of the atom bomb with the Soviet Union, and it also carried a powerful anti-atomic and anti-war message. In addition, Lang's script changes now named the countries that were continuing the fascist tradition established by Mussolini and Hitler. Jesper explained that the site had been relocated:

> Not to any other place in Germany where they know the show is over, but somewhere else where the Nazis have a foothold … The same scientists who were working for Germany are now still working against the Allied powers in some Fascist country.[79]

Lang had wanted Jesper to specify Argentina and Spain as likely locations. The point, Lang explained, was that the world had to be kept at peace to prevent its self-destruction by atomic warfare. But Sperling asked that the speech be filmed in such a way that the references to Argentina could be cut out for the South American market, while 'maintaining our principles in the rest of the world'.[80] Lang had thus introduced into the film a highly charged political statement with direct relevance to the tense post-war atmosphere in America. This radical new ending was then shot on location, with considerable loss of time. Finally, on 19 June 1946, Sperling took matters in hand and unilaterally brought shooting to a halt. The Daily Reports chronicled: 'Lang is opposing all of our efforts to eliminate anything or condense scenes. He was sulking last night because we told him we would have to finish on the location today'.[81] The production had been plagued by Cooper falling ill; Lang having gall bladder trouble; an editor who incurred Lang's wrath and was dismissed; the clashes between Lilli Palmer and Lang; constant script revisions; Lang yet again complaining about a slow cameraman; and Lang himself slowing down, inexplicably. It finally came to an end after 78 shooting days, eighteen days behind schedule.[82]

But the debate about the ending was not over. Sperling had had qualms about it since April. In July, with editing proceeding, Lang formally asked Sperling whether he was to have his customary right to the first cut of the film. He objected that Sperling was avoiding seeing him to discuss 'one or two cut reels'.[83] Presumably, Lang knew that he did not have contractual rights to a first cut, because he did not fight Sperling with anything like the tenacity he displayed on his next film, *Secret beyond the Door* (1948) (this dispute is detailed in Case Study 4). Indeed, he gave in with extraordinary good grace, suggesting that he was not so wedded to the ending as he later implied. In late August, with the film about to open, the *Hollywood Reporter* claimed that Lang was 'sizzling' at Sperling for having removed his ending.[84] But Lang told Sperling that this was not true. Reminding Sperling that the two of them had discussed the ending many times, Lang said he wished the film well. He went on, however, to explain why he supported the ending he had filmed:

[It] says something which is very important to say in these troublesome times. I sincerely believe that audiences throughout the world want to hear a plea for peace and, in my opinion, the original ending would greatly add to the stature of the picture so that it would be an important, as well as a successful one.[85]

In the event, Lang achieved only the second of his two objectives. The film was indeed successful – top of the new releases when it came out and taking 83 per cent over its cost in its first two weeks.[86] But its potential importance had been lost in the editing and, in general, the critics were lukewarm. Dissatisfied reviewers blamed the writers, as was often the case when Fritz Lang directed a formulaic piece.[87] One wrote that the 'value of [Jesper's] mission is never clearly shown in the development of the Albert Maltz-Ring Lardner, Jnr. script as filmed', while another suggested that, 'Mr. Lang, being wise and experienced, has not pretended to show any more than a romantic thriller, which is what his writers prepared'.[88] Neither the writers nor Lang were to blame for the film's failure to rise above its formulaic limits (although they must be held responsible for a great deal of its run-of-the-mill content, the weaknesses of which would not have been overcome by a stronger ending).

Critics did not entirely miss the significance of the atomic theme, even though some appeared to know that it had been heavily edited by Sperling.[89] In a witty and mocking review, Cecelia Ager accepted that, despite the film's shortcomings, it was refreshing to have Gary Cooper indignant, 'not because somebody stole his horse, but because billions are spent on destructive atomic bomb research while sick humanity waits'.[90] The *Los Angeles Times* reviewer noted that there was more depth to the film than was customary in thrillers, including 'some rather forceful commentary … about the atomic bomb menace'.[91] Another concluded:

And, although it embodies only a few fleeting lines of dialogue, this film also carries an important message through the words of Cooper. Without too much emphasis, he points out that if the amount of money allocated scientists to develop the atomic bomb as a [*sic*] instrument of death could also be made available to develop cures for cancer and tuberculosis, mankind would really benefit.[92]

Lang's attempt to participate in the debate about America's atomic responsibilities had been scotched by his producer's fear of the political repercussions. Sperling's caution may have been judicious, however; within a year, three of those who had worked on the script – Larnder, Maltz and Bessie – were facing contempt proceedings for refusing to cooperate with the House UnAmerican Activities Committee. Three years after that, they were all in jail for their beliefs. Lang had come dangerously close to getting embroiled in the anti-communist witch-hunts of Cold War America. Perhaps his uncharacteristically good-natured compliance with Sperling's judgement suggests that Lang lacked the courage of Billy Wilder when it came to direct criticism of American foreign policy in the tense times which followed the end of World War II.

Case Study 7 – 'Propaganda can be art': Lang and International Affairs

Notes

1. Smedley, 'Fritz Lang Outfoxed', *Film History*, 4 (1990), 296–97.
2. Lang, interviewed by Eileen Creelman (of the *New York Sun*); see the undated clipping in Lang, Hangmen Also Die file (hereafter, 'HAD').
3. Archer Winsten, *New York Post* (16 April 1943); in Lang, HAD.
4. Lang, letter to Prof. James K. Lyon (23 August 1971), 2, Lang, HAD. The extensive correspondence between these two arose when Lyon, a Brecht scholar, approached Lang seeking information about Brecht's involvement with the film. Discussion of *Hangmen Also Die!* has been largely overshadowed by argument over the extent of Brecht's contribution. Brecht later claimed that his best work on the film had been excised by Lang, and that there had been a conspiracy to remove his name from the credits. Lang denied any such intention, although it is perfectly true that Lang supervised Brecht's work and took the final decisions over the content of the screenplay, as one would expect of a producer–director. For all this, see the correspondence in Lang, HAD, particularly Lang's two long letters to Lyon (23 August and 5 December 1971). In this correspondence Lyon draws extensively on Brecht's diaries. Lyon later published an account of the controversy, in Lyon, *Bertolt Brecht in America* (Princeton, NJ, 1980), 58–71. For a pro-Brechtian, anti-Hollywood interpretation, see Reinhold Grimm and Henry J. Schmidt, 'Bertolt Brecht and "Hangmen Also Die"', *Monatshefte*, 61 (Fall 1969), 232–240. Rather as Lyon did in his first letters to Lang, these two regard Brecht as superior to the vulgar art of film-making. Eisner, in *Fritz Lang*, 221–238, devotes a large part of her chapter on *Hangmen Also Die!* to a discussion of the Brecht controversy, with a bias in favour of Lang's account. For an earlier, yet very similar, analysis, see Ben Brewster, 'Brecht and the Film Industry', *Screen*, 16 (Winter 1975–76), 16–33.
5. Lang and Brecht, '437!!', Lang, HAD.
6. John Peere Miles, memo to Pressburger, (3 September 1942), Lang, HAD. The contract, dated 9 July 1942, was signed on 11 August 1942; Lang, HAD.
7. The letters were – Pressburger to Miles (4 November 1942); Pressburger to Lang (29 January 1943); Lang's reply of the same date; Pressburger's reply (30 January); Lang's reply (2 February); and Pressburger's final salvo (3 February); all in Lang, HAD. There are numerous examples from Lang's period with Diana Pictures of his obsession with publicizing himself; in Wanger. See also Bernstein, *Walter Wanger* and McGilligan, *Fritz Lang, passim*.
8. Contracts between Lang and Brecht (14 July 1942), and between Lang and Pressburger (9 July 1942); both in Lang, HAD.
9. A copy is in Lang, HAD.
10. Pressburger, memo (2 September 1942); Lang worked at home with 'his writers', Brecht and Gunzberg; Lang, HAD.
11. T. W. Baumfeld, memo to Lang (3 September 1942), Lang, HAD.
12. Mitchell, telex (3 September 1942), Lang, HAD.
13. Wexley, letter to Lang (6 October 1942), Lang, HAD.
14. Pressburger, letter to Breen (26 October 1942), in which he reports that the script has been delayed by the cuts and changes. He does not mention Lang, but there can be no other person who would have been able to occasion the delay; see PCA, HAD.
15. Final shooting script (27 November 1942), Lang, HAD. A copy was belatedly sent to the PCA, after shooting had finished, on 27 January 1943 (Baumfeld, letter to Breen); see PCA, HAD. Disputes during shooting – detailed below in the text – demonstrate that production had already started by 1 December 1942.

16. Grimm and Schmidt, 'Bertolt Brecht and "Hangmen Also Die"', *Monatshefte*, 61 (Fall 1969), 235–39.
17. See the final draft script (16 October 1942, incorporating substantially amended pages of 28, 30 and 31 October, and 2 November 1942), Wisconsin Center for Film and Theater Research, University of Wisconsin, Madison, John Wexley papers (hereafter, 'Wexley'), Box 9, 6. Another copy is in Lang, HAD. Wexley wrote to Lang (6 October 1942), reporting on the progress he was making on the script, and specifically referred to Brecht's participation; Lang, HAD.
18. 'Never Surrender!', 83, Lang, HAD; final draft screenplay, 47, Wexley, Box 9, 6.
19. 'Never Surrender!', 94, Lang, HAD.
20. See Sam Jaffe (Lang's agent), letter to Pressburger (1 December 1942) and Pressburger's reply of the next day; and Lang, memo to Pressburger (9 December 1942), from which we can deduce the concerns regarding length which Pressburger must have expressed in his memo to Lang of 8 December 1942 (now lost); all Lang, HAD.
21. See the analysis of the reviews – below in the text.
22. Lang, letter to Pressburger (9 December 1942), Lang, HAD.
23. Baumfeld, letter to Breen (27 January 1943) explains that the film is now being cut; PCA, HAD.
24. See copy of wire from G. L. Sears (who worked in publicity) to Pressburger (26 January 1943), rejecting the 'vague' title 'Unconquered' and suggesting three alternatives; and Pressburger, letter to Lang (30 January 1943); both in Lang, HAD. Baumfeld, letter to Breen (13 February 1943) is the earliest reference I have found to the final title; PCA, HAD.
25. Pressburger, memo to Lang (28 January 1943), Lang, HAD.
26. The critical response is covered below in the text. The film had recovered $240,000 – 103.3 per cent of its cost – by 3 July 1943 (*Motion Picture Herald*, 3 July 1943); Hedda Hopper, syndicated in *St. Louis Globe-Democrat* (18 April 1943); both in Lang, HAD.
27. The phrase is from Lang's letter to Leo Lania (10 December 1947); in Wisconsin Center for Film and Theater Research, University of Wisconsin, Madison, Leo Lania papers.
28. See the various drafts of the foreword to be delivered by a Czech representative; the copy of a telegraph from the Czech legation to Pressburger (14 September [1942]) on the idea of securing Masaryk; and the letter (no author) to Lang (29 January 1943) on the unavailability of footage of Masaryk; all Lang, HAD. *New York Journal-American* (6 March 1943), 6, reports that the Czech government in exile helped Lang write the film, and that Masaryk's son, Jan, appears in a foreword; there is, however, no evidence that any such foreword was included on the film's release some weeks later, and certainly no foreword exists in surviving prints.
29. Lang, 'Happily Ever After', *Penguin Film Review*, 5 (1948), 27.
30. Lang interviewed by David Platt, *The Worker* (25 April 1943); in Lang, HAD.
31. Lang interviewed on Adelaide Hawley's *The Woman's Page of the Air* (17 March [1943]); transcript in Lang, HAD; see 3–5 especially.
32. *New York Journal-American* (6 March 1943), 6; Mary Yerke, memo to Baumfeld (15 October 1942), Lang, HAD. See also Koppes and Black, 'OWI Goes to the Movies', *Prologue: the Journal of the National Archives*, 6 (Spring 1974), 57, for the OWI's praise of the film's 'powerful presentation of the issues'.
33. *Daily Variety* (27 March 1943), PCA, HAD.
34. *Hollywood Reporter* (23 March 1943), PCA, HAD.
35. *Variety* (24 March 1943), PCA, HAD.
36. 'Hangmen Also Die!', final draft screenplay (16 October to 2 November 1942), 37, 42, Wexley, Box 9, 6.

37. Mascha's love for Jan is used to suggest her flirtation with the complacency of Czechs who would not get involved in the struggle against the Nazis; equally, her growing attachment to the assassin, and their enforced pretence as lovers, is associated with her growing understanding of his motives and his fight. Accordingly, the film veers dangerously close to conventional Hollywood romantic plots. However, as noted in the text, Lang did tone down this aspect of the Wexley–Brecht screenplay (see, for a good example of this, the final screenplay, 25–26, Wexley, Box 9, 6, where Mascha steers Jan off any participation in the Resistance, in order not to jeopardize her marriage plans; the scene does not appear in the final film). Neither did Lang opt for the predictable ending, in which Mascha would marry the assassin – a point noted by Joy Davidman, *New Masses* (4 May 1943), 28.
38. Lang, memo to Pressburger (9 December 1942), Lang, HAD. Pressburger estimated that the scene would cost at least $10,000 to $15,000.
39. Interview with Hawley, 6.
40. Interview with Hawley, 6.
41. Theodore Strauss, *New York Times* (16 April 1943), 24.
42. Eileen Creelman, *New York Sun* (16 April 1943); in Lang, HAD.
43. Agee, *The Nation* (1 May 1943), in Agee, *Agee on Film*, 35. See also Manny Farber, *New Republic* (3 May 1943), for an unfavourable review which criticizes, from a left-wing perspective, the film's failure to examine the ideologies of the people involved; in Lang, HAD.
44. See the summary sheet of the responses, Lang, HAD.
45. John T. McManus, *P.M.* (16 April 1943); in Lang, HAD.
46. Davidman, *New Masses*, 28–29. Davidman was a radical communist at the time she wrote this review, married to fellow communist sympathizer William Gresham. She subsequently moved to England, divorced Gresham and became a committed Christian. She married C. S. Lewis in 1956, and died of bone cancer 4 years later. Their relationship was fictionalized in *Shadowlands* (1993), directed by Richard Attenborough.
47. Lang, 'Happily Ever After', *Penguin Film Review*, 5 (1948), 27.
48. Lang, 'Happily Ever After', *Penguin Film Review*, 5 (1948), 27.
49. Alton Cook, *New York World-Telegram* (16 April 1943); in Lang, HAD; *Daily Variety* (23 March 1943); in PCA, HAD.
50. See the cast list, including 'Mrs Brecht' as Mrs Dvorak, the grocery woman, appended at the front of Wexley's copy of the final draft script; in Wexley, Box 9, 6. The role was in the event taken by Sarah Padden.
51. McManus, *P.M.* (16 April 1943); Winsten, *New York Post* (16 April 1943); see also his comments, *New York Post* (17 April 1943), that Lang's film is an exception to the repetitious portrayals of Nazis in Hollywood films; in Lang, HAD.
52. Wright and Hanna, 'Motion Picture Survey', in *Writer's Congress*, 406–7.
53. Strauss, *New York Times* (16 April 1943); Red Kahn's 'On the March' column, *Motion Picture Herald* (3 April 1943), 16; see also the comments in *Hollywood Reporter* (23 March 1943) and *Variety* (24 March 1943); in PCA, HAD.
54. Alton Cook, *New York World-Telegram* (18 December 1943); in Lang, HAD.
55. For example, see *Box Office* (14 September 1946); in the Doheny Library, University of Southern California, Warner Collection (hereafter, 'Warner'), Cloak and Dagger file (hereafter, 'CD'). See also *Hollywood Reporter* (5 September 1946), which talks of the 'disadvantages expected of attractions these days dealing with war themes'; in PCA, CD.
56. *Newsweek* (7 October 1946); in Lang, CD; *Variety* (11 September 1946) and *Daily Variety* (5 September 1946); in PCA, CD. See also the negative, or at best lukewarm, reviews (all 5 October

1946) by Howard Barnes, *New York Herald Tribune*; Eileen Creelman, *New York Sun*; Archer Winsten, *New York Post*; [no author] *New York Journal-American*; and Cecelia Ager, (n.d.) *P.M.*; all in Lang, CD; and Bosley Crowther, *New York Times* (5 October 1946), 13.
57. Bogdanovich, *Fritz Lang in America*, 69–70; Higham and Greenberg, *The Celluloid Muse*, 117; Eisner, *Fritz Lang*, 267–274, where she quotes extensively from a script of the missing portion of the film, but unfortunately provides no references for its date, authorship or location.
58. See the comment in *Daily Variety* (5 September 1946) that the film 'makes a play for timeliness' with the atomic bomb theme; in PCA, CD.
59. See the production notes prepared for the film's trade screening to be held on 9 September 1946; in Warner, CD.
60. LeRoy is reported as the director in the first of the daily production and progress reports (31 October 1945); he and Sperling's work on casting is reported in *Los Angeles Times* (2 November 1945); both Warner, CD.
61. Larkin and Ingster, 'Cloak and Dagger', incomplete outline for screenplay (8 December 1945), Warner, CD. A copy, sent to Warner Bros. by Pat Duff of United States Pictures (29 January 1946) is dated 24 November 1945; Warner, CD.
62. Bessie was a veteran of the Spanish Civil War and, later, one of the Hollywood Ten, imprisoned in 1950 for refusing to testify in 1947 about his Communist Party affiliations before the House UnAmerican Activities Committee. Maddow, a left-of-centre documentarist, had co-founded in 1936 'The World Today', a short-lived newsreel set up to counter the perceived conservative influence of 'The March of Time'. Their recruitment by Sperling is mentioned in an unidentified news clipping (n.d.); in Warner, CD. Their treatment (n.d.) is also in Warner, CD. The chronological filing of this material suggests a date of December 1945, which would plausibly fit in with the evolution of the project. An item in *New York Daily News* (n.d.) adds to the scriptwriting team the original authors, Ford and MacBain, story-writers Larkin and Ingster, and two OSS advisers, Michael Burke and Andreas Deinum (but misses out Bessie); in Warner, CD.
63. Lang was rumoured to be in mind for the director in *Los Angeles Times* (10 December 1945); in Warner, CD; he was reported as having been signed up in *Hollywood Reporter* (17 December 1945); see Lang, CD. Cooper's casting was announced in *New York Herald Tribune* (7 December 1945); in Warner, CD; James Cagney's potential involvement is mentioned in *Los Angeles Times* (23 October 1945); in Lang, CD. An unidentifed, undated news clipping reported: 'Never saw Fritz Lang in a happier mood than when he learned he had clinched the job of directing Gary Cooper in "The Cloak and the Dagger" [sic]'; in Warner, CD.
64. *New York Daily News* (8 February 1946); in Warner, CD. See also daily reports (25 January, and various dates in February, 1946), Warner, CD.
65. The earliest references to the involvement of these two are 10 January 1946 for Lardner and 7 February 1946 for Maltz – see the undated note added to the cover of the Larkin and Ingster outline (8 December 1945); R. J. Obringer sent three screenplays by Lardner and Maltz to Gerard Cahill (7 May 1946), as follows: temporary script (dated 27 February 1946), final script (dated 7 March 1946) and revised final script (dated 16 March 1946); all Warner, CD. The 'temporary script' went to Breen on 1 March 1946; see PCA, CD. The first two scripts are lost, but the revised final is in Warner, CD, incorporating various later revisions, including the crucial changes to the ending of 12 and 18 June 1946 – see below in the text for the significance of these.
66. The production is fully documented in the daily reports by Frank Mattison, the unit manager; the unbroken sequence of reports begins on 18 March 1946, the first day of shooting. The daily sheets record the schedule of 60 days and progress against it. The budget was set at $1.4 million on

18 December 1945, on the basis of the Larkin and Ingster outline, and revised upwards on 15 March 1946 on the basis of Lardner and Maltz's 7 March script; all in Warner, CD.
67. Daily report (25 March), Warner, CD.
68. Daily report (2 April), Warner, CD. The PCA received script changes on 19 and 29 March; 1, 4 and 9 April; 23 May; and 13 and 19 June 1946; see PCA, CD. The Lardner–Maltz revised final script has changes dated 8 April (the scene where Jesper first meets the Italian scientist, Polda), 22 May (the romantic interlude between Jesper and Gina), and 12 and 18 June (the ending).
69. Daily report (13 May 1946), Warner, CD.
70. Daily report (23 May 1946), Warner, CD.
71. Louella O. Parsons (n.d., no source); in Lang, CD.
72. *Des Moines* (5 February 1947); in Lang, CD.
73. Daily reports (9, 10 and 18 May 1946), Warner, CD
74. Breen, letter to Joseph Bernhard (4 March 1946), PCA, CD.
75. Sperling, memo to Lang (4 April 1946), Lang, CD.
76. See daily reports (2 and 7 June 1946), Warner, CD.
77. Daily reports (10 and 12 June 1946), Warner, CD.
78. Lardner and Maltz, 'Cloak and Dagger', revised final script, changed pages 109–110 (18 June 1946), Warner, CD.
79. The quotation is taken from Lang's working synopsis, 6, prepared after shooting on 10 July 1946; Lang, CD.
80. Sperling, memo to Lang (14 June 1946), Lang, CD. Sperling goes on to say that he wishes to discuss the ending with Lang. We know from the Lardner–Maltz script that both Argentina and Spain were named as the countries where the Nazis still had 'a foothold'.
81. Daily reports (18 to 22 June 1946, inclusive), Warner, CD.
82. For details of this list of problems, see the daily reports, Warner, CD. The final shooting day was Sunday, 23 June 1946.
83. Lang, note for the record (15 July 1946), Lang, CD.
84. Reported by Lang, in his letter to Sperling (29 August 1946), Lang, CD.
85. Lang, letter to Sperling (29 August, 1946); Lang, CD.
86. *Box Office* (n.d.), placing it top of the new releases; in Lang, CD.
87. See the reviewers' responses to *The Return of Frank James* and *Western Union*, for example; analysed in Smedley, 'Fritz Lang Outfoxed', *Film History*, 4 (1990), 299–300.
88. *Variety* (11 September 1946); in PCA, CD; Crowther, *New York Times* (5 October 1946).
89. *Box Office Digest* (September 1946) noted that Sperling, 'with credits aplenty in his own status as screenplay craftsman, must have given considerable [sic] to story guidance'; in Warner, CD.
90. Ager, *P.M.* (n.d.); in Lang, CD.
91. Edwin Schulbert, *Los Angeles Times* (n.d.); in Lang, CD.
92. *Motion Picture Daily* (9 September 1946); in PCA, CD.

Conclusion

In the 1930s there was a close relationship between American cinema and Rooseveltian liberalism. The reformulation of capitalist values under Roosevelt's leadership was a cultural, as well as a political, phenomenon. Serious novels and plays, pulp fiction and popular magazine literature, social commentators and highbrow thinkers – all participated in the reinterpretation of American society. Selfish individualism gave way to communal cooperation as an ideal. The expansionist urge was replaced by an emphasis on social justice and welfare. Hollywood gave convincing expression to these new values and articulated for a nation the goals of American idealism. Far from being conservative, as some film scholars have argued, Hollywood was at the forefront of the radical cultural regrouping that followed the New Deal.

The 1940s saw the gradual erosion of these liberal values, with a corresponding uncertainty about the place of idealism in American society. In Hollywood this confusion had particular significance. A decade of celebrating liberalism had come to an end, and a new role had to be found by the nation's leading cultural industry. Hollywood's response was to reiterate the need to preserve the country's ideals at a time of threat. Whether through fantasy or bleakness, the film industry called upon its audience not to forget the achievements of the high New Deal. Hollywood continued to ally itself firmly with the legacy of Franklin D. Roosevelt, as a repository of democratic liberalism. It is no coincidence that the film industry was an early target for what would become the House UnAmerican Activities Committee.

This liberal agenda, however, had no place for women's rights. Here, too, Hollywood was in harmony with the direction of Roosevelt's Democratic administration. The film industry's determined hostility to women provides convincing evidence that New Deal America fiercely resisted female emancipation. Although the increasing importance of women's economic role in time won them certain rights, nothing in Roosevelt's social policies recognized or supported their cause. The widespread cultural animosity towards independent women was given voice by Hollywood's consistent desire to denigrate the American woman, to contain her aspirations and to keep her in the domestic sphere.

In the field of foreign affairs, Hollywood once again expressed itself in terms remarkably close to the goals of the administration in Washington DC. The affirmation of American

democratic values in the 1930s served as an emblem from which other nations could seek inspiration. By the end of the decade, Roosevelt's desire to intervene in the European conflict found a willing partner in the American film industry. Hollywood's calls for American intervention brought the industry directly into the political arena, clearly signalling its internationalist affiliations. After the war, which was spent celebrating the fighting spirit of Americans at home and abroad, Hollywood lapsed into a strained silence about international events. The era of the Cold War, with its anti-communist witch-hunts, was a dangerous time for the expression of New Deal liberal views.

Hollywood's cultural engagement with the New Deal and the subsequent decline of liberalism was a remarkably homogeneous phenomenon, a coherent and comprehensive response to the challenges of the time. Yet, within this apparent homogeneity, there were important dissenting voices. The European directors studied in this book came from a different political tradition, one which influenced their reactions to America's consensus culture. Their values had been formed in a context of critical debate across a broad political spectrum. Yet their films had to be made in a culture of celebration, one which preferred to reformulate apparently timeless truths than to question the basis of those verities. Lang, Lubitsch and Wilder, in their different ways, chose to open critical lines of inquiry into American institutions and values.

Lang – when he had the freedom to do so – preferred to make films about some of the most important social issues in the United States. He discussed the meaning of democracy and populism, and their relation to social responsibility. He considered the case for a more sympathetic attitude to ex-convicts. He explored the issue of personal accountability in an era which seemed devoid of moral values. Lubitsch concentrated on the role of women in American life. He formulated a remarkable programme of dissent from the overwhelming antagonism towards feminine emancipation evidenced by most of the rest of Hollywood. Wilder appears at times more shallow than his two compatriots, yet he displayed great courage in tackling taboo subjects – whether alcoholism at home or American blundering in post-war Europe.

Three men came to America from Berlin. They arrived at different times, in different circumstances and achieved different measures of success and fame in their Hollywood careers. Yet, taken together, their work between 1933 and 1948 had a profound and enduring impact on Hollywood and on American culture. They made films which ranged across the burning social issues in America and the dramatic events unfolding in Europe. They were challenging, innovative, sometimes radical, more often than not controversial. They had the courage to address issues where others felt it best to remain silent. They stretched the boundaries of what was permissible in the mass market populism of Hollywood cinema. They speak to us now in terms as relevant and thought-provoking as when their films were freshly printed. American cinema and American life would be so much more impoverished without the unique, searching critiques undertaken in the films of Fritz Lang, Ernst Lubitsch and Billy Wilder.

Conclusion

In November 1947 Ernst Lubitsch died of a heart attack, at the age of 55. He was in the middle of production on *That Lady in Ermine*. The film was released the following year, with Otto Preminger taking over the final stages as director. Lubitsch left a legacy of often brilliant comedies of manners, but his fame today is confined to a small circle of cinéastes. His reputation is in serious need of reassessment.

Fritz Lang worked on for a considerable time after 1948, but he declined slowly into a B-picture director. Long gone were his glory days of might and power as the greatest director in Germany. He was never a force to be reckoned with in Hollywood. He struggled to maintain control over many of his films and failed to form lasting allegiances, all too often antagonizing producers, technicians and actors. In the end his inability to win friends – and his awesome ability to make enemies – got the better of him. In the 1950s he shifted down a gear, making a clutch of low-budget thrillers such as *The Big Heat* (1953), *While the City Sleeps* and *Beyond a Reasonable Doubt* (both 1956), along with unconvincing and overwrought melodramas, including *Clash By Night* (1952) and *Human Desire* (1954). Some of these are enjoyable films to watch today, but they are a far cry from his masterpieces of silent and early sound cinema in Germany.

Finally admitting defeat in America, Lang briefly but unsuccessfully went back to Germany in the late 1950s, perhaps seeking to recapture his glory days. He returned to a film project he had wanted to mount back in the 1920s, a two-part epic set in India – *The Tiger of Eschnapur/Der Tiger von Eschnapur* and *The Indian Tomb/Das Indische Grabmal* (both 1959). Back in the 1920s, Lang's screenplay had been appropriated by his producer, Joe May, who had chosen to direct the epic himself. Now it was Lang's turn, but the project was hopelessly old-fashioned and the two-part epic flopped. He had no more luck with his second attempt at reliving the past, the belated sequel to his two early Mabuse films, *The Thousand Eyes of Dr Mabuse* (1960). It was the end of the road for the erstwhile titan of European cinema. Lang settled into a long retirement in Beverley Hills, cultivating his reputation as a genius who had been misunderstood by the philistines of Hollywood. In time he found an audience eager to hear his anecdotes and willing to spread the myth of Lang's neglected brilliance. The French New Wave critics and film-makers adopted Lang as one of their 'American' heroes. Jean-Luc Godard cast him in *Contempt/Le Mépris* (Godard, 1963), as a giant of a film director whose artistic visions are frustrated by commercial pygmies. Much of the mythology so sedulously created by Lang during this period – the 1960s and 1970s – is only now being sceptically examined and his reputation being reassessed. Fritz Lang died in Los Angeles in 1976, aged 85.

Billy Wilder's career was just starting in 1948, as this study concludes. Already he had made a huge impact, particularly with the Oscar-winning *The Lost Weekend* (1945), but there were many more successes awaiting him during a career that lasted into the 1980s. He continued to display great wit and biting satire, and won himself an unassailable place in film history with such classics as *Sunset Boulevard* (1950), *Some Like It Hot* (1959) and *The Apartment* (1960), along with lesser-known masterpieces including *Ace in the Hole* (1951), *One, Two, Three* (1961), *The Fortune Cookie* (1966) and *Fedora* (1978). He directed

his final film, *Buddy, Buddy*, in 1981. Wilder, like Lang, busily cultivated his reputation as a Hollywood rebel, but did not have the bitterness of his compatriot. He had no complaints that he had been misunderstood and defeated in his grand designs. He enjoyed giving interviews throughout his long life, spinning numerous far-fetched, amusing yarns. (When I spoke to him about this study, I was delighted and surprised to hear the Germanic inflection in his telephone greeting, 'Vilter'.) There was no shortage of credulous, charmed listeners to write up Wilder's stories as gospel truth. There is still plenty of scope for film historians to revisit the extraordinary life and career of this Hollywood giant. He died in Los Angeles in 2002, aged 95.

Bibliography

(1) Primary sources

The Doheny Library, University of Southern California, Los Angeles:
Fritz Lang Collection
Twentieth Century-Fox Collection
MGM Collection
Universal Collection
Warner Bros. Collection
Edward G. Robinson Collection

The Margaret Herrick Library, Los Angeles:
Production Code Administration archive
Paramount Script Collection
Personality files on Lubitsch and Wilder

University Research Library, UCLA, Los Angeles:
Twentieth Century-Fox Collection

Wisconsin Center for Film and Theater Research, University of Wisconsin, Madison, Wisconsin:
Walter Wanger Collection
John Wexley papers
S. N. Behrman papers
Leo Lania papers
United Artists Collection

(2) Interview

Telephone interview with Billy Wilder, 30 August 1990

(3) Newspapers

Daily Variety
Film Daily
Hollywood Reporter
Los Angeles Daily News
Los Angeles Examiner
Los Angeles Times
Motion Picture Daily
Motion Picture Herald
New York Herald Tribune
New York Times
Variety

(4) Printed primary sources

Action (no author), 'Billy Wilder: Broadcast to Kuala Lumpur', 5 (November/December, 1970), 16–18.
Agee, James, *Agee on Film: Reviews and Comments by James Agee* (n.p., 1958).
American Cinematographer, (no author),[Untitled profile of Lubitsch], 19 (February, 1938), 56, 59–60.
American Cinematographer, (no author),[Untitled interview with/profile of Lubitsch], 28 (July, 1947), 238–39, 258.
Barnett, Lincoln, 'The Happiest Couple in Hollywood', *Life*, 17 (11 December, 1944), 100–112.
Beard, Charles A. and Beard, Mary R., *America in Midpassage* (London, 1939).
Bogdanovich, Peter, *Fritz Lang in America* (London, 1967).
Brackett, Charles, 'A Matter of Humor', *Quarterly of Film, Radio and Television*, 7 (Fall, 1952), 66–69.
Brackett, Charles and Wilder, Billy, 'A Symposium on Ernst Lubitsch', *The Screen Writer*, 3 (January, 1948), 14–20.
Cantril, Hadley (ed.), *Public Opinion 1935–46* (Princeton, NJ, 1951).
Cinema, (no author), 'Interview' [with Billy Wilder], 4 (October, 1969), 19–22.
Cohen, Elliott E., 'Letter to the Movie-Makers: the Film Drama as a Social Force', *Commentary*, 4 (August, 1947), 110–18.
Crowther, Bosley, 'The Movies', in Jack Goodman (ed.), *While You Were Gone: a Report on Wartime Life in the United States* (New York, 1946), 511–532.
Fadiman, William J., 'The Sources of Movies', in Gordon S. Watkins (ed.), 'The Motion Picture Industry', *Annals of the American Academy of Political and Social Science*, 254 (November, 1947), 37–40.
Fearing, Franklin, 'Influence of the Movies on Attitudes and Behaviour', in Gordon S. Watkins (ed.), 'The Motion Picture Industry', *Annals of the American Academy of Political and Social Science*, 254 (November, 1947), 70–79.
Fortune, (no author), 'Paramount', 15 (March, 1937), 86–96, 194–98, 202–212.
Gehman, R., 'Charming Billy', *Playboy*, 7 (December, 1960), 69–70, 90, 145–48.
Goodman, Jack (ed.), *While You Were Gone: a Report on Wartime Life in the United States* (New York, 1946).
Handel, Leo A., *Hollywood Looks at its Audience: a Report of Film Audience Research* (Urbana, Ill., 1950).

Bibliography

Hauser, Arnold, 'Can Movies Be Profound?', *Partisan Review*, 15 (January, 1948), 69–73.

Henderson, Brian (ed.), *Five Screenplays by Preston Sturges* (Berkeley, Cal., 1985).

Higham, Charles and Greenberg, Joel, *The Celluloid Muse: Hollywood Directors Speak* (London, 1969).

Hochman, Stanley (ed.), *A Library of Film Criticism: American Film Directors* (New York, 1974).

Hochman, Stanley (ed.), *From Quasimodo to Scarlett O'Hara: a National Board of Review Anthology, 1920-1940* (New York, 1982).

Houseman, John, 'Today's Hero: a Review', *Hollywood Quarterly*, 2 (January, 1947), 161–63.

Jones, Dorothy B., 'Quantitative Analysis of Motion Picture Content', *Public Opinion Quarterly*, 6 (Fall, 1942), 411–428.

Jones, Dorothy B., 'Is Hollywood Growing Up?', *The Nation* (3 February, 1945), in Gerald Mast (ed.), *The Movies in our Midst: Documents in the Cultural History of Film in America* (Chicago, 1982), 470–76.

Jones, Dorothy B., 'The Hollywood War Film: 1942-44', *Hollywood Quarterly*, 1 (October, 1945), 1–19.

Jones, Grover, 'Movie Magician', *Collier's* (21 September, 1935), 26, 33.

Kauffmann, Stanley (ed.), with Henstell, Bruce, *American Film Criticism: from the Beginnings to 'Citizen Kane': Reviews of Significant Films at the Time They First Appeared* (New York, 1972).

Koszarksi, Richard (ed.), *Hollywood Directors 1914-1940* (New York, 1976).

Koszarksi, Richard (ed.), *Hollywood Directors 1941-1976* (New York, 1977).

Lang, Fritz, 'The Freedom of the Screen', *Theater Arts* (December, 1947), in Richard Koszarksi (ed.), *Hollywood Directors, 1941-1976* , 137–38.

Lang, Fritz, 'Happily Ever After', *Penguin Film Review*, 5 (1948), 22–29.

Lawson, John Howard, 'Hollywood – Illusion and Reality', *Hollywood Quarterly*, 1 (January, 1946), 231–33.

Lee, Sonia, 'What's Wrong with the Movies', *Motion Picture Magazine*, 46 (September, 1933), 42, 90–92.

Liberty, (no author),[Untitled interview with/profile of Billy Wilder], 23 (4 May, 1946), 18–19, 59.

Life,(no author), 'The American Woman', 21 (21 October, 1946), 36.

Life,(no author), 'American Woman's Dilemma', 22 (16 June, 1947), 101–112.

Literature/Film Quarterly, (no author), 'Billy Wilder' [interview], 4 (Winter, 1976), 2–12.

Lorentz, Pare, *Lorentz on Film: Movies 1927 to 1941* (New York, 1975).

Lubitsch, Ernst, Letter to Herman Weinberg (10 July, 1947), in Herman G. Weinberg, *The Lubitsch Touch: a Critical Study* (New York, 1968), 266–67.

Ludwig, Emil, 'The Seven Pillars of Hollywood', *Penguin Film Review*, 1 (1946), 90–95.

Luft, Herbert G., 'A Matter of Decadence', *Quarterly of Film, Radio and Television*, 7 (Fall, 1952), 58–66.

Lynd, Robert S., *Knowledge for What? The Place of Social Science in American Culture* (Princeton, NJ, 1939).

Lynd, Robert S. and Lynd, Helen M., *Middletown in Transition* (New York, 1937).

Mast, Gerald (ed.), *The Movies in our Midst: Documents in the Cultural History of Film in America* (Chicago, 1982).

McDonald, John, 'Films' [a quarterly survey], *Public Opinion Quarterly*, 4 (September, 1940), 19–22, and 5 (March 1941), 127–29.

Mead, Margaret, *The American Character* (New York, 1944).

Mead, Margaret, 'What Women Want', *Fortune*, 34 (December, 1946), 172–75, 218–24.

Merrill, Francis E., *Social Problems on the Home Front: a Study of War-time Influences* (New York, 1948).
Meyer, Agnes, *Journey through Chaos* (New York, 1944).
Morris, Lloyd, *Not So Long Ago* (New York, 1949).
New York Times Film Reviews, Vols 2 (1932–38), 3 (1939–1948), 4 (1949–1958) and 6 (Appendix/Index) (New York, 1970).
Nichols, Dudley, 'The Writer and the Film', *Theater Arts* 28 (October, 1943), 591–602.
Playboy, (no author), 'Billy Wilder: the Playboy interview', 10 (June, 1963), 57–66.
Quigley, Martin, 'Decency in Motion Pictures' (1937), in Gerald Mast (ed.), *The Movies in our Midst: Documents in the Cultural History of Film in America* (Chicago, 1982), 340–44.
Raphaelson, Samson, *Three Screen Comedies* (Wisconsin, 1983).
Rosen, Robert, 'An Approach to Character 1943', in *Writer's Congress: the Proceedings of the Conference Held in October 1943 under the Sponsorship of the Hollywood Writers' Mobilization and the University of California* (Berkeley, Cal., 1944), 61–67.
Salemson, Harold J., 'A Question of Morals', *The Screen Writer*, 4 (April, 1946), 1–5.
Salemson, Harold J., 'Mr Capra's Short Cuts to Utopia', *Penguin Film Review*, 7 (September, 1948), 32–34.
Sarris, Andrew (ed.), *Hollywood Voices: Interviews with Film Directors* (London, 1971).
Schulberg, Stuart, 'A Communication: a Letter about Billy Wilder', *Quarterly of Film, Radio and Television*, 7 (Summer, 1953), 434–36.
Seldes, Gilbert, *Movies for the Millions: an Account of Motion Pictures, Principally in America* (London, 1937).
Slide, Anthony (ed.), *Selected Film Criticism: 1931–1940* (Metuchen, NJ, 1982).
Slide, Anthony (ed.), *Selected Film Criticism: 1941–1950* (Metuchen, NJ, 1983).
Snyder, W. L., 'Cinema and Stage', *Cinema Progress*, 4 (June-July, 1939), 11, 29.
Thorp, Margaret F., *America at the Movies* (New Haven, 1939).
Tyler, Parker, 'To Be or Not to Be, or the Cartoon Triumphant' (1944), in Parker Tyler, *The Hollywood Hallucination* (New York, 1970), 208–221.
Wanger, Walter, '120,000 American Ambassadors', *Foreign Affairs*, 18 (October, 1939), 45–59.
Watkins, Gordon S. (ed.), 'The Motion Picture Industry', *Annals of the American Academy of Political and Social Science*, 254 (November, 1947).
Wilder, Billy, 'Propaganda through Entertainment' (16 August, 1945), in Ralph Willett, 'Billy Wilder's "A Foreign Affair" (1945–1948): "the trials and tribulations of Berlin" ', *Historical Journal of Film, Radio and Television*, 7 (1987), 3–14.
13–14.
Wilder, Billy, 'The Case for the American Film' (unpublished) (1946).
Wilder, Billy, 'One Head is Better than Two', *Films and Filming* (February, 1957), in Richard Koszarski (ed.), *Hollywood Directors 1941–1976*, 271–72.
Wilson, Harry, 'The Genius of Fritz Lang', *Film Quarterly* (Summer, 1947), 11–20.
Wilson, Robert (ed.), *The Film Criticism of Otis Ferguson* (Philadelphia, 1971).
Woelfel, Norman, 'The American Mind and the Motion Picture', in Gordon S. Watkins (ed.), 'The Motion Picture Industry', *Annals of the American Academy of Political and Social Science*, 254 (November, 1947), 85–94.
Wolfenstein, M. and Leites, N., 'An Analysis of Themes and Plots', in Gordon S. Watkins (ed.), 'The Motion Picture Industry', *Annals of the American Academy of Political and Social Science*, 254 (November, 1947), 41–48.

Wright, Virginia and Hanna, David, 'Motion Picture Survey', in *Writer's Congress: the Proceedings of the Conference Held in October 1943 under the Sponsorship of the Hollywood Writers' Mobilization and the University of California* (Berkeley, Cal., 1944), 402–411.

Zanuck, Darryl, 'The Responsibility of the Industry', *Writer's Congress: the Proceedings of the Conference Held in October 1943 under the Sponsorship of the Hollywood Writers' Mobilization and the University of California* (Berkeley, Cal., 1944), 34–35.

(5) Selected novels and plays

Cain, James M., *Double Indemnity* (1935)
Chandler, Raymond, *The Big Sleep* (1939)
Chandler, Raymond, *Farewell my Lovely* (1940)
Chandler, Raymond, *The Lady in the Lake* (1944)
Fitzgerald, F. Scott, *The Beautiful and Damned* (1922)
Hemingway, Ernest, *To Have and Have Not* (1937)
Hemingway, Ernest, *For Whom the Bell Tolls* (1940)
Steinbeck, John, *The Grapes of Wrath* (1939)
Steinbeck, John, *Tortilla Flat* (1941)

(6) Films

In this part of the bibliography, the following abbreviations are used:

Columbia – Col
Paramount – Para
Twentieth Century-Fox – TF
Universal – Univ
Warner Bros. – WB

(i) Films directed by Americans

Abe Lincoln in Illinois (RKO 1939, John Cromwell)
Across the Pacific (WB 1942, John Huston)
The Adventures of Huckleberry Finn (MGM 1939, Richard Thorpe)
Ah! Wilderness (MGM 1935, Clarence Brown)
Alice Adams (RKO 1935, George Stevens)
An American Romance (MGM 1944, King Vidor)
Anna and the King of Siam (TF 1946, John Cromwell)
Anna Karenina (MGM 1935, Clarence Brown)
Anne of Green Gables (RKO 1934, George Nicholls Jnr)
Angel in Exile (Republic 1948, Allan Dwan and Philip Ford)
Arise my Love (Para 1940, Mitchell Leisen)

The Awful Truth (Col 1938, Leo McCarey)
Bad Man of Brimstone (MGM 1937, J. Walter Ruben)
The Barretts of Wimpole Street (MGM 1934, Sidney Franklin)
Beau Geste (Para 1939, William Wellman)
The Bells of St Mary's (RKO 1945, Leo McCarey)
The Big City (MGM 1937, Frank Borzage)
The Big Sleep (WB 1946, Howard Hawks)
The Black Swan (TF 1942, Henry King)
Body and Soul (Enterprise 1947, Robert Rossen)
Bombshell (MGM 1933, Victor Fleming)
Boom Town (MGM 1940, Jack Conway)
The Bowery (TF 1933, Raoul Walsh)
Break of Hearts (RKO 1935, Phillip Moeller)
The Bride Came C.O.D. (WB 1941, William Keighley)
Brigham Young (TF 1940, Henry Hathaway)
Bringing Up Baby (RKO 1938, Howard Hawks)
Bullets or Ballots (WB 1936, William Keighley)
Camille (MGM 1936, George Cukor)
Captain from Castile (TF 1947, Henry King)
Captains Courageous (MGM 1937, Victor Fleming)
Central Airport (First National 1933, William Wellman)
China Seas (MGM 1935, Tay Garnett)
Christmas in July (Para 1940, Preston Sturges)
Citizen Kane (RKO 1941, Orson Welles)
The Clock (MGM 1945, Vincente Minelli)
Command Decision (MGM 1948, Sam Wood)
Comrade X (MGM 1940, King Vidor)
Conquest (MGM 1937, Clarence Brown)
Confidential Agent (WB 1945, Herman Shumlin)
The Corn is Green (WB 1945, Irving Rapper)
The Count of Monte Cristo (Reliance 1934, Rowland V. Lee)
Craig's Wife (Col 1936, Dorothy Arzner)
The Crowd Roars (MGM 1938, Richard Thorpe)
Cry Havoc (MGM 1943, Richard Thorpe)
The Curse of the Cat People (RKO 1944, Robert Wise and Gunther Frisch)
Dance, Girl, Dance (RKO 1940, Dorothy Arzner)
Dancing Co-Ed (MGM 1939, S. Sylvan Simon)
The Dark Angel (Goldwyn 1935, Sidney Franklin)
The Dark Corner (TF 1946, Henry Hathaway)
David Copperfield (MGM 1935, George Cukor)
Deadline at Dawn (RKO 1946, Harold Clurman)
Deception (WB 1946, Irving Rapper)
Destry Rides Again (Univ 1939, George Marshall)
Devil Doll (MGM 1936, Tod Browning)
The Devil is a Woman (Para 1935, Josef von Sternberg)
Dinner at Eight (MGM 1933, George Cukor)

Bibliography

The Doughgirls (WB 1944, James V. Kern)
Dr. Cyclops (Para 1939, Ernest B. Schoedsack)
Drums along the Mohawk (TF 1939, John Ford)
The Duke of West Point (Edward Small 1938, Alfred E. Green)
The Enchanted Cottage (RKO 1945, John Cromwell)
Escape (MGM 1940, Mervyn LeRoy)
Farewell my Lovely (RKO 1945, Edward Dmytryk)
The Fighting 69th (WB 1940, William Keighley)
Footlight Parade (WB 1933, Lloyd Bacon)
For Whom the Bell Tolls (Para 1943, Sam Wood)
42nd Street (WB 1933, Lloyd Bacon)
Four Frightened People (Para 1934, Cecil B. DeMille)
Four Sons (TF 1940, Archie Mayo)
Friendly Enemies (Edward Small 1942, Allan Dwan)
The Fugitive (RKO 1947, John Ford)
Gentleman Jim (WB 1942, Raoul Walsh)
The Ghost and Mrs. Muir (TF 1947, Joseph Mankiewicz)
The Glass Key (Para 1942, Stuart Heisler)
Going my Way (Para 1944, Leo McCarey)
Gold Diggers of 1935 (WB 1935, Busby Berkeley)
Gone with the Wind (Selznick 1939, Victor Fleming)
The Good Earth (MGM 1937, Sidney Franklin)
The Gorgeous Hussy (MGM 1936, Clarence Brown)
The Grapes of Wrath (TF 1940, John Ford)
The Great McGinty (Para 1940, Preston Sturges)
The Great Man Votes (RKO 1939, Garson Kanin)
The Great Ziegfeld (MGM 1936, Robert Z. Leonard)
Gunga Din (RKO 1939, George Stevens)
Hail the Conquering Hero (Para 1943, Preston Sturges)
The Hard Way (WB 1942, Vincent Sherman)
Hellzapoppin' (Univ 1942, H. C. Potter)
His Girl Friday (Col 1939, Howard Hawks)
History is Made at Night (Walter Wanger 1937, Frank Borzage)
Hold That Co-Ed (TF 1938, George Marshall)
Honky Tonk (MGM 1941, Jack Conway)
House of Rothschild (TF 1934, Alfred Werker)
How Green Was my Valley (TF 1941, John Ford)
Hudson's Bay (TF 1940, Irving Pichel)
I Am the Law (Col 1938, Alexander Hall)
In Old Chicago (TF 1937, Henry King)
Intrigue (Star 1947, Edwin L. Marin)
It Happened One Night (Col 1934, Frank Capra)
It's a Wonderful Life (Liberty 1946, Frank Capra)
It's a Wonderful World (MGM 1939, W. S. Van Dyke II)
It's Love I'm After (WB 1937, Archie Mayo)
Ivy (Univ 1947, Sam Wood)

Jesse James (TF 1939, Henry King)
Keeper of the Flame (MGM 1942, George Cukor)
Key Largo (WB 1948, John Huston)
The Keys of the Kingdom (TF 1944, John Stahl)
Kidnapped (TF 1938, Alfred Werker)
King of the Turf (Edward Small 1939, Alfred E. Green)
King's Row (WB 1941, Sam Wood)
The Lady Eve (Para 1941, Preston Sturges)
The Lady from Shanghai (Col 1948, Orson Welles)
The Lady in the Lake (MGM 1947, Robert Montgomery)
The Last Train from Madrid (Para 1937, James Hogan)
Let 'Em Have It! (Reliance 1935, Sam Wood)
Libeled Lady (MGM 1936, Jack Conway)
Lillian Russell (TF 1940, Irving Cummings)
The Little Minister (RKO 1934, Richard Wallace)
Little Women (RKO 1933, George Cukor)
The Long Voyage Home (Wanger-Argosy 1940, John Ford)
Lost Horizon (Col 1937, Frank Capra)
The Lost Moment (Walter Wanger 1947, Martin Gabel)
Love Crazy (MGM 1941, Jack Conway)
Mad Wednesday! (RKO 1947, Preston Sturges)
Magic Town (Robert Riskin 1947, William Wellman)
Make Way for a Lady (RKO 1936, David Burton)
The Maltese Falcon (WB 1941, John Huston)
Man Alive (RKO 1945, Ray Enright)
Marie Antoinette (MGM 1938, W. S. Van Dyke II)
Mary of Scotland (RKO 1936, John Ford)
The Master Race (RKO 1944, Herbert J. Biberman)
The Mighty Barnum (TF 1934, Walter Lang)
The Miracle of Morgan's Creek (Para 1943, Preston Sturges)
Miracle on 34th Street (TF 1947, George Seaton)
The Moon and Sixpence (Albert Lewin/David Loew 1943, Albert Lewin)
The More the Merrier (Col 1943, George Stevens)
Morning Glory (RKO 1933, Lowell Sherman)
Mr. Blandings Builds his Dream House (RKO 1948, H. C. Potter)
Mr. Skeffington (WB 1944, Vincent Sherman)
Mr. Smith Goes to Washington (Col 1939, Frank Capra)
My Man Godfrey (Univ 1936, Gregory La Cava)
National Velvet (MGM 1945, Clarence Brown)
None but the Lonely Heart (RKO 1944, Clifford Odets)
Northwest Passage (MGM 1940, King Vidor)
Nothing Sacred (Selznick 1937, William Wellman)
Now, Voyager (WB 1942, Irving Rapper)
Of Human Hearts (MGM 1938, Clarence Brown)
One Million B.C. (Hal Roach 1940, Hal Roach and Hal Roach Jnr)
Only Angels Have Wings (Col 1939, Howard Hawks)

Only Yesterday (Univ 1933, John Stahl)
The Palm Beach Story (Para 1942, Preston Sturges)
Penny Serenade (Col 1941, George Stevens)
Personal Property (MGM 1937, W. S. Van Dyke II)
Peter Ibbetson (Para 1935, Henry Hathaway)
The Philadelphia Story (MGM 1940, George Cukor)
Piccadilly Jim (MGM 1936, Robert Z. Leonard)
The Pied Piper (TF 1942, Irving Pichel)
The Postman Always Rings Twice (MGM 1946, Tay Garnett)
Pride and Prejudice (MGM 1940, Robert Z. Leonard)
The Prisoner of Shark Island (TF 1936, John Ford)
The Prisoner of Zenda (Selznick 1937, John Cromwell)
Raw Deal (Reliance 1948, Anthony Mann)
Reap the Wild Wind (Para 1941, Cecil B. DeMille)
Red River (Monterey 1947, Howard Hawks)
Red Salute (Reliance 1935, Sidney Lanfield)
Return of the Bad Men (RKO 1948, Ray Enright)
Reunion in Vienna (MGM 1933, Sidney Franklin)
The Road to Glory (TF 1936, Howard Hawks)
Sadie McKee (MGM 1934, Clarence Brown)
The Sailor Takes a Wife (MGM 1945, Richard Whorf)
Saratoga Trunk (WB 1943, Sam Wood)
Sergeant York (WB 1941, Howard Hawks)
The Senator Was Indiscreet (Univ 1947, George Kaufman)
Since You Went Away (Selznick 1944, John Cromwell)
The Son of Monte Cristo (Edward Small 1940, Rowland V. Lee)
The Song of Bernadette (TF 1943, Henry King)
Souls at Sea (Para 1937, Henry Hathaway)
Stagecoach (Walter Wanger 1939, John Ford)
Stanley and Livingstone (TF 1939, Henry King)
Star Spangled Rhythm (Para 1942, George Marshall)
Station West (RKO 1948, Sidney Lanfield)
Stella Dallas (Goldwyn 1937, King Vidor)
The Story of Dr. Wassell (Para 1944, Cecil B. DeMille)
The Strawberry Blonde (WB 1941, Raoul Walsh)
Success at any Price (RKO 1934, J. Walter Ruben)
Sullivan's Travels (Para 1941, Preston Sturges)
T-Men (Reliance 1947, Anthony Mann)
A Tale of Two Cities (MGM 1935, Jack Conway)
They Died with their Boots On (WB 1941, Raoul Walsh)
They Drive by Night (WB 1940, Raoul Walsh)
They Were Expendable (MGM 1945, John Ford)
They Won't Believe Me (RKO 1947, Irving Pichel)
Thirty Seconds over Tokyo (MGM 1944, Mervyn LeRoy)
This Day and Age (Para 1933, Cecil B. DeMille)
This is my Affair (TF 1937, William A. Seiter)

Thirteen Hours by Air (Para 1936, Mitchell Leisen)
Three Comrades (MGM 1938, Frank Borzage)
Three Loves Has Nancy (MGM 1938, Richard Thorpe)
Till the End of Time (RKO 1946, Edward Dmytryk)
To Each his Own (Para 1946, Mitchell Leisen)
To Have and Have Not (WB 1944, Howard Hawks)
Tobacco Road (TF 1941, John Ford)
Tom, Dick and Harry (RKO 1940, Garson Kanin)
Too Hot to Handle (MGM 1938, Jack Conway)
Tortilla Flat (MGM 1942, Victor Fleming)
The Treasure of the Sierra Madre (WB 1947, John Huston)
Twentieth Century (Col 1934, Howard Hawks)
Tycoon (RKO 1947, Richard Wallace)
Unconquered (Para 1947, Cecil B. DeMille)
The Unfaithful (WB 1947, Vincent Sherman)
Unfaithfully Yours (TF 1948, Preston Sturges)
Union Pacific (Para 1939, Cecil B. DeMille)
The Valley of Decision (MGM 1945, Tay Garnett)
Vigil in the Night (RKO 1940, George Stevens)
Vivacious Lady (RKO 1938, George Stevens)
We Were Dancing (MGM 1942, Robert Z. Leonard)
The White Sister (MGM 1933, Victor Fleming)
Wife versus Secretary (MGM 1936, Clarence Brown)
Wilson (TF 1944, Henry King)
Without Reservations (RKO 1946, Mervyn LeRoy)
The Wizard of Oz (MGM 1939, Victor Fleming)
Woman Chases Man (Goldwyn 1937, John Blystone)
Woman of the Year (MGM 1941, George Stevens)
A Woman Rebels (RKO 1936, Mark Sandrich)
A Woman's Face (MGM 1941, George Cukor)
The Women (MGM 1939, George Cukor)
The World Changes (First National 1933, Mervyn LeRoy)
You Can't Take It with You (Col 1938, Frank Capra)
The Young in Heart (Selznick 1938, Richard Wallace)
Young Mr. Lincoln (TF 1939, John Ford)

(ii) Films directed by Lubitsch, Lang and Wilder

(a) Films directed by Ernst Lubitsch
Design for Living (Para 1933)
The Merry Widow (MGM 1934)
Angel (Para 1937)
Bluebeard's Eighth Wife (Para 1938)
Ninotchka (MGM 1939)
The Shop around the Corner (MGM 1940)

That Uncertain Feeling (Sol Lesser 1941)
To Be or Not to Be (Korda-Romaine 1942)
Heaven Can Wait (TF 1943)
Cluny Brown (TF 1946)
That Lady in Ermine (TF 1948)*

* Begun by Lubitsch but completed by Otto Preminger

(b) Films directed by Fritz Lang
Fury (MGM 1936)
You Only Live Once (Walter Wanger 1937)
You and Me (Para 1938)
The Return of Frank James (TF 1940)
Western Union (TF 1941)
Man Hunt (TF 1941)
Hangmen Also Die! (Arnold Pressburger 1943)
Ministry of Fear (Para 1944)
Woman in the Window (International 1944)
Scarlet Street (Diana 1945)
Cloak and Dagger (United States Pictures 1946)
Secret beyond the Door (Diana 1948)

(c) Films directed by Billy Wilder
The Major and the Minor (Para 1942)
Five Graves to Cairo (Para 1943)
Double Indemnity (Para 1944)
The Lost Weekend (Para 1945)
The Emperor Waltz (Para 1948)
A Foreign Affair (Para 1948)

(7) Secondary sources

(i) Books

Allen, Frederick Lewis, *Since Yesterday: the Nineteen-Thirties in America* (New York, 1940).
Ambrose, Stephen E., *Rise to Globalism: American Foreign Policy, 1938–1976* (Rev. edn, New York, 1976).
Andrew, J. Dudley, *The Major Film Theories: an Introduction* (London, 1976).
Andrew, J. Dudley, *Concepts in Film Theory* (Oxford, 1984).
Arnheim, Rudolf, *Film as Art* (London, 1958).
Babington, Bruce and Evans, Peter William, *Affairs to Remember: the Hollywood Comedy of the Sexes* (Manchester, 1989).
Balio, Tino (ed.), *The American Film Industry* (Wisconsin, 1976).
Balio, Tino, *Grand Design: Hollywood as a Modern Business Enterprise* (New York, 1993).
Banner, Lois, *Women in Modern America: a Brief History* (New York, 1974).

Baskerville, Stephen W. and Willett, Ralph (eds), *Nothing Else to Fear: New Perspectives on America in the Thirties* (Manchester, 1985).
Baxter, John, *Hollywood in the Thirties* (London, 1968).
Baxter, John, *The Hollywood Exiles* (London, 1976).
Bennett, Joan and Kibbee, Lois, *The Bennett Playbill* (New York, 1970).
Bergman, Andrew, *We're in the Money: Depression America and Its Films* (New York, 1971).
Bernstein, Matthew, *Walter Wanger: Hollywood Independent* (California, 1994).
Bernstein, Matthew (ed.), *Controlling Hollywood: Censorship and Regulation in the Studio Era* (New Brunswick, NJ, 1999).
Billington, Ray Allen, *America's Frontier Culture: Three Essays* (Texas, 1977).
Black, Gregory D., *Hollywood Censored: Morality Codes, Catholics and the Movies* (Cambridge England, 1994).
Blum, John Morton, *V Was for Victory: Politics and American Culture During World War II* (New York, 1976).
Boorstin, Daniel, *The Genius of American Politics* (Chicago, 1953).
Bowers, David F. (ed.), *Foreign Influences in American Life: Essays and Critical Bibliographies* (New York, 1944).
Bradbury, Malcolm and Temperley, Howard (eds), *Introduction to American Studies* (London, 1981).
Braeman, John et al. (eds), *The New Deal: the National Level* (Columbus, O., 1975).
Brookeman, Christopher, *American Culture and Society since the 1930s* (London, 1984).
Buxton, David, *From the Avengers to Miami Vice: Form and Ideology in Television Series* (Manchester, 1990).
Capra, Frank, *The Name above the Title: an Autobiography* (New York, 1971).
Carney, Raymond, *American Vision: the Films of Frank Capra* (London, 1986).
Carringer, Robert, and Sabath, Barry, *Ernst Lubitsch: a Guide to References and Resources* (Boston, Mass., 1978).
Cavell, Stanley, *The World Viewed* (London, 1979).
Chafe, William H., *The American Woman: her Changing Social, Economic, and Political Roles, 1920–1970* (New York, 1972).
Chandler, Charlotte, *Nobody's Perfect: Billy Wilder, a Personal Biography* (New York, 2001).
Coben, Stanley and Ratner, Lorman (eds), *The Development of an American Culture* (Englewood Cliffs, NJ, 1970).
Cook, Pam (ed.), *The Cinema Book* (London, 1985).
Cooke, Alistair, *A Generation on Trial: USA v. Alger Hiss* (London, 1950).
Crowther, Bosley, *The Lion's Share: the Story of an Entertainment Empire* (New York, 1957).
Curti, Merle, *The Growth of American Thought* (New York, 1943).
Cywinski, Ray, *Preston Sturges: a Guide to References and Resources* (Boston, Mass., 1984).
Dallek, Robert, *Franklin D. Roosevelt and American Foreign Policy, 1932–1945* (New York, 1979).
Davies, Philip and Neve, Brian, *Cinema, Politics and Society in America* (Manchester, 1981).
Deming, Barbara, *Running Away from Myself: a Dream Portrait of America Drawn from the Films of the Forties* (New York, 1969).
Dick, Bernard F., *Billy Wilder* (Boston, Mass., 1980).
Divine, Robert A., *The Illusion of Neutrality* (Chicago, 1962).
Divine, Robert A., *The Reluctant Belligerent: American Entry into World War II* (New York, 1965).
Doherty, Thomas, *Hollywood's Censor: Joseph I. Breen and the Production Code Administration* (New York, 2007).

Bibliography

Donovan, Robert J., *Conflict and Crisis: the Presidency of Harry S. Truman, 1945-1948* (New York, 1977).
Einaudi, Mario, *The Roosevelt Revolution* (London, 1959).
Eisner, Lotte H., *Fritz Lang* (London, 1976).
Ekirch, Arthur A. Jnr, *Progressivism in America: a Study of the Era from Theodore Roosevelt to Woodrow Wilson* (New York, 1974).
Eyman, Scott, *Ernst Lubitsch: Laughter in Paradise* (New York, 1993).
Eyman, Scott, *Lion of Hollywood: the Life and Legend of Louis B. Mayer* (New York, 2005).
Fermi, Laura, *Illustrious Immigrants: the Intellectual Migration from Europe, 1930-1941* (Chicago, 1968).
Fleming, Denna Frank, *The Cold War and its Origins, 1917-1960: vol. 1: 1917-1950* (London, 1961).
Fleming, Donald and Baillyn, Bernard, *The Intellectual Migration: Europe and America 1930-1960* (Cambridge, Mass., 1969).
Freeland, Richard, *The Truman Doctrine and the Origins of McCarthyism: Foreign Policy, Domestic Politics, and Internal Security, 1946-1948* (New York, 1985).
Frisch, Morton J. and Diamond, Martin (eds), *The Thirties: a Reconsideration in the Light of the American Political Tradition* (De Kalb, Ill., 1968).
Gardner, Gerald C., *The Censorship Papers: Movie Censorship Letters from the Hays Office, 1934-1968* (New York, 1987).
Gay, Peter, *Weimar Culture: the Outsider as Insider* (New York, 1968).
Gemunden, Gerd, *A Foreign Affair: Billy Wilder's American Films* (New York, 2008).
Giovacchini, Saverio, *Hollywood Modernism: Film and Politics in the Age of the New Deal* (Philadelphia, 2001).
Glatzer, Richard and Raeburn, John (eds), *Frank Capra: the Man and his Films* (Ann Arbor, Mich., 1975).
Gomery, Douglas, *The Hollywood Studio System* (London, 1986).
Griffith, Richard, *Frank Capra* (London, 1950).
Gussow, Mel, *Zanuck: Don't Say Yes until I Finish Talking* (London, 1971).
Halliwell, Leslie, *Halliwell's Hundred: a Nostalgic Choice of Films from the Golden Age* (London, 1984).
Hamby, Alonzo L., *Beyond the New Deal: Harry S. Truman and American Liberalism* (New York, 1973).
Handlin, Oscar (ed.), *Immigration as a Factor in American History* (Englewood Cliffs, NJ, 1959).
Hansen, Marcus Lee, *The Immigrant in American History* (Cambridge, Mass., 1942).
Hartshorne, Thomas L., *The Distorted Image: Changing Conceptions of American Character since Turner* (Cleveland, O., 1968).
Hays, Will H., *The Memoirs of Will H. Hays* (New York, 1955).
Hearn, Charles R., *The American Dream in the Great Depression* (Westport, Conn., 1977).
Higham, Charles and Greenberg, Joel, *Hollywood in the Forties* (London, 1968).
Hodgson, Godfrey, *In our Time: America from World War II to Nixon* (London, 1976).
Hofstadter, Richard, *Social Darwinism in American Thought* (Philadelphia, 1944).
Hofstadter, Richard, *The Age of Reform: from Bryan to F.D.R.* (New York, 1955).
Hofstadter, Richard, *Anti-Intellectualism in American Life* (New York, 1963).
Hofstadter, Richard, *The Paranoid Style in American Politics and Other Essays* (London, 1965).
Horowitz, David, *The Free World Colossus: a Critique of American Foreign Policy in the Cold War* (Rev. edn, New York, 1971).

Hughes, Stuart H., *The Sea Change: the Migration of Social Thought, 1930–1965* (New York, 1975).
Izod, John, *Hollywood and the Box Office 1895–1986* (London, 1988).
Jacobs, Lewis, *The Rise of the American Film: a Critical History* (New edn, New York, 1969).
Jarvie, I. C., *Towards a Sociology of the Cinema: a Comparative Essay on the Structure and Functioning of a Major Entertainment Industry* (London, 1970).
Jarvie, I. C., *Movies as Social Criticism: Aspects of their Social Psychology* (Metuchen, NJ, 1978).
Jenkins, Stephen (ed.), *Fritz Lang: the Image and the Look* (London, 1984).
Kaplan, E. Ann (ed.), *Women in Film Noir* (London, 1980).
Kaplan, E. Ann, *Fritz Lang: a Guide to References and Resources* (Boston, Mass., 1981).
Kazin, Alfred, *Starting Out in the Thirties* (London, 1966).
Kerr, Paul (ed.), *The Hollywood Film Industry* (London, 1986).
Knight, Arthur, *The Liveliest Art: a Panoramic History of the Movies* (New York, 1957).
Kolko, Gabriel, *The Triumph of Conservatism: a Reinterpretation of American History, 1900–1916* (New York, 1963).
Kolko, Gabriel and Kolko, Joyce, *The Limits of Power: the World and United States Foreign Policy, 1945–1954* (New York, 1972).
Koppes, Clayton R. and Black, Gregory D., *Hollywood Goes to War: How Politics, Profits and Propaganda Shaped World War II Movies* (New York, 1987).
Kracauer, Siegfried, *From Caligari to Hitler: a Psychological History of the German Film* (Rev. edn, Princeton, NJ, 1974).
Kuhn, Annette, *Women's Pictures: Feminism and Cinema* (London, 1982).
Lafeber, Walter, *America, Russia, and the Cold War 1945–1980* (4th edn, New York, 1980).
Lasch, Christopher, *The New Radicalism in America (1899–1963): the Intellectual as a Social Type* (New York, 1965).
Lasky, Betty, *RKO: the Biggest Little Major of Them All* (Englewood Cliffs, NJ, 1984).
Lasky, Jesse L. (with Weldon, Don), *I Blow my Own Horn* (London, 1957).
Leff, Leonard J. and Simmons, Jerold L., *The Dame in the Kimono: Hollywood, Censorship and the Production Code from the 1920s to the 1960s* (New York, 1990).
Leuchtenburg, William E., *The Perils of Prosperity 1914–1932* (New York, 1958).
Leuchtenburg, William E., *Franklin D. Roosevelt and the New Deal 1932–1940* (New York, 1963).
Leuchtenburg, William E., *A Troubled Feast: American Society since 1945* (Rev. edn, Boston, Mass., 1979).
Limerick, Patricia Nelson, *The Legacy of Conquest: the Unbroken Past of the American West* (New York, 1987).
Lyon, James K., *Bertolt Brecht in America* (Princeton, NJ, 1980).
McBride, Joseph, *Frank Capra: the Catastrophe of Success* (New York, 2000).
McBride, Joseph (with Wilmington, Michael), *John Ford* (New York, 1976).
McElvaine, Robert S., *The Great Depression: America, 1929–41* (New York, 1984).
McGilligan, Patrick, *Fritz Lang: the Nature of the Beast* (London, 1997).
Maland, Charles, *American Visions: the Films of Chaplin, Ford, Capra and Welles 1936–41* (New York, 1977).
Maland, Charles, *Frank Capra* (Boston, Mass., 1980).
Maltby, Richard, *Harmless Entertainment: Hollywood and the Ideology of Consensus* (London, 1983).
Maltby, Richard, *Hollywood Cinema* (Oxford, 2003).
Mann, William J., *Kate: the Woman who was Katharine Hepburn* (New York, 2006).
Marx, Arthur, *Goldwyn: a Biography of the Man behind the Myth* (New York, 1976).

Bibliography

Marx, Leo, *The Machine in the Garden: Technology and the Pastoral Idea in America* (New York, 1964).
Marx, Samuel, *Mayer and Thalberg: the Make-Believe Saints* (London, 1976).
Mast, Gerald and Cohen, Marshall (eds), *Film Theory and Criticism: Introductory Readings* (2nd edn, New York, 1979).
Metz, Christian, *Film Language: a Semiotics of the Cinema* (New York, 1974).
Moley, Raymond, *The Hays Office* (New York, 1945).
Monaco, James, *How to Read a Film: the Art, Technology, Language, History and Theory of Film and Media* (New York, 1977).
Monaco, Paul, *Cinema and Society: France and Germany during the Twenties* (New York, 1976).
Mosley, Leonard, *Zanuck: the Rise and Fall of Hollywood's Last Tycoon* (London, 1984).
Muscio, Giuliana, *Hollywood's New Deal* (Philadelphia, 1997).
Nash, Roderick, *Wilderness and the American Mind* (3rd edn, n.p., 1982)
Noble, David W., *The Progressive Mind, (1890–1917)* (Rev. edn, Minneapolis, 1981).
O'Connor, John E. and Jackson, Martin A. (eds), *American History/American Film: Interpreting the Hollywood Image* (New York, 1979).
O'Neill, William L., *Everyone Was Brave: the Rise and Fall of Feminism in America* (Chicago, 1969).
Palmer, Phyliss, *Domesticity and Dirt: Housewives and Domestic Servants in the United States, 1920–1945* (Philadelphia, 1989).
Paul, William, *Ernst Lubitsch's American Comedy* (New York, 1983).
Pells, Richard H., *Radical Visions and American Dreams: Culture and Social Thought in the Depression Years* (New York, 1973).
Perkins, V. F., *Film as Film: Understanding and Judging Movies* (New York, 1972).
Petrie, Graham, *Hollywood Destinies: European Directors in America, 1922–1931* (London, 1985).
Phillips, Gene D., *Exiles in Hollywood: Major European Film Directors in America* (London, 1998).
Poague, Leland A., *The Cinema of Ernst Lubitsch: the Hollywood Films* (Cranbury, NJ, 1978).
Polenberg, Richard, *War and Society: the United States 1941–1945* (Philadelphia, 1972).
Potter, Jim, *The American Economy between the World Wars* (London, 1974).
Powdermaker, Hortense, *Hollywood the Dream Factory: an Anthropologist Looks at the Movie-Makers* (Boston, Mass., 1950).
Ray, Robert B., *A Certain Tendency of the Hollywood Cinema 1930–80* (Princeton, NJ, 1985).
Richards, Jeffery, *Visions of Yesterday* (London, 1973).
Roddick, Nick, *A New Deal in Entertainment* (London, 1983).
Rollins, Peter C. (ed.), *Hollywood as Historian: American Film in a Cultural Context* (Kentucky, 1983).
Romasco, Albert U., *The Politics of Recovery: Roosevelt's New Deal* (New York, 1983).
Rosenberg, Bernard and White, David Manning (eds), *Mass Culture: the Popular Arts in America* (n.p., 1957).
Sarris, Andrew, *The American Cinema: Directors and Directions 1929–68* (New York, 1968).
Scharf, Lois, *To Work and to Wed: Female Employment, Feminism and the Great Depression* (Westport, Conn., 1980).
Schatz, Thomas, *The Genius of the System: Hollywood Film-Making in the Studio Era* (New York, 1988).
Schatz, Thomas, *Boom and Bust: American Cinema in the 1940s* (Los Angeles, 1997).
Schlesinger, Arthur M. Jnr, *The Crisis of the Old Order 1919–33* (Boston, Mass., 1957).
Schlesinger, Arthur M. Jnr, *The Coming of the New Deal* (Boston, Mass., 1958).

Schlesinger, Arthur M. Jnr, *The Politics of Upheaval* (Boston, Mass., 1960).
Schlesinger, Arthur M. Jnr and White, Morton (eds), *Paths of American Thought* (London, 1964).
Seidman, Steve, *The Film Career of Billy Wilder* (Boston, Mass., 1977).
Sennett, Richard and Cobb, Jonathan, *The Hidden Injuries of Class* (Cambridge, 1977).
Shindler, Colin, *Hollywood Goes to War: Films and American Society 1939–52* (London, 1979).
Short, K. R. M. (ed.), *Feature Films as History* (London, 1981).
Short, K. R. M. and Fledelius, Karsten (eds), *History and Film: Methodology, Research and Education* (Copenhagen, 1980).
Sikov, Ed, *On Sunset Boulevard: the Life and Times of Billy Wilder* (New York, 1998).
Sitkoff, Harvard (ed.) *Fifty Years Later: the New Deal Evaluated* (New York, 1985).
Sklar, Robert, *Movie-Made America: a Cultural History of American Movies* (New York, 1975).
Smith, Henry Nash, *Virgin Land: the American West as Symbol and Myth* (Cambridge, Mass., 1950).
Smith, Paul (ed.), *The Historian and Film* (Cambridge, 1976).
Smith, Wilson (ed.), *Essays in American Intellectual History* (Hinsdale, Ill., 1975).
Stempel, Tom, *Screenwriter: the Life and Times of Nunnally Johnson* (San Diego, Cal., 1980).
Susman, Warren (ed.), *Culture and Commitment 1929–1945* (New York, 1973).
Taylor, John Russell, *Strangers in Paradise: the Hollywood Émigrés, 1933–1950* (London, 1983).
Taylor, Philip, *The Distant Magnet: European Emigration to the USA* (London, 1971).
Thewelweit, Klaus, *Male Fantasies II: Male Bodies: Psychoanalysing the White Terror* (Oxford, 1989).
Thomas, Bob, *King Cohn: the Life and Times of Harry Cohn* (New York, 1967).
Thomas, Bob, *Thalberg: Life and Legend* (New York, 1969).
Thomas, Bob, *Selznick* (New York, 1970).
Tudor, Andrew, *Theories of Film* (London, 1974).
Vieira, Mark, *Hollywood's Dreams Made Real: Irving Thalberg and the Rise of MGM* (New York, 2008).
Wallis, Hal and Higham, Charles, *Starmaker: the Autobiography of Hal Wallis* (New York, 1980).
Wandersee, Winifred D., *Women's Work and Family Values 1920–1940* (Cambridge, Mass., 1981).
Warner, Jack L. (with Jennings, Dean), *My First Hundred Years in Hollywood* (New York, 1964).
White, Morton G., *Social Thought in America: the Revolt against Formalism* (New York, 1949).
White, Morton G., and White, Lucia, *The Intellectual versus the City: from Thomas Jefferson to Frank Lloyd Wright* (Cambridge, Mass., 1962).
Wiebe, Robert, *The Search for Order, 1877–1920* (London, 1967).
Willett, John, *The New Sobriety 1917–1933: Art and Politics in the Weimar Period* (London, 1978).
Willett, John, *The Weimar Years: a Culture Cut Short* (London, 1984).
Williams, William Appleman, *The Tragedy of American Diplomacy* (New York, 1952).
Willis, Donald C., *The Films of Frank Capra* (Metuchen, NJ, 1974).
White, David M. and Averson, Richard, *The Celluloid Weapon: Social Comment in the American Film* (Boston, Mass., 1972).
Wolfe, Charles, *Frank Capra: a Guide to References and Resources* (Boston, Mass., 1987).
Wollen, Peter, *Signs and Meaning in the Cinema* (2nd edn, London, 1972).
Wollenberg, H. H., *Fifty Years of German Film* (London, 1948).
Wood, Michael, *America in the Movies: or 'Santa Maria, it Had Slipped my Mind'* (London, 1975).
Wright, Will, *Sixguns and Society: a Structural Study of the Western* (Berkeley, Cal., 1975).
Yergin, Daniel, *Shattered Peace: the Origins of the Cold War and the National Security State* (Boston, Mass., 1977).
Zierold, Norman, *The Hollywood Tycoons* (London, 1969).

Zolotow, Maurice, *Billy Wilder in Hollywood* (London, 1988).
Zukor, Adolph (with Kramer, Dale), *The Public Is Never Wrong: the Autobiography of Adolph Zukor* (New York, 1953).

(ii) Articles

Altman, Charles F., 'Towards a Historiography of American Film', in MacCann, Richard D. and Ellis, Jack C. (eds), *Cinema Examined: Selections from Cinema Journal* (New York, 1982), 105-129.

Ambler, Eric, 'The Film of the Book', *Penguin Film Review*, 9 (1949), 22-25.

Bernstein, Barton J., 'The New Deal: the Conservative Achievements of Liberal Reform', in Barton J. Bernstein (ed.), *Towards a New Past: Dissenting Essays in American History* (New York, 1968), 263-288.

Bernstein, Matthew, 'Fritz Lang, Incorporated', *Velvet Light Trap*, 22 (1986), 33-52.

Bradbury, Malcolm and Temperley, Howard, 'War and Cold War', in Bradbury and Temperley (eds), *American Studies*, 243-266.

Brauer, Ralph, 'The Fractured Eye: Myth and History in the Westerns of John Ford and Sam Peckinpah', *Film and History*, 7 (December, 1977), 73-84.

Brewster, Ben, 'Brecht and the Film Industry', *Screen*, 16 (Winter, 1975-76), 16-33.

Brody, David, 'The New Deal and World War II', in Braeman, John et al. (eds), *The New Deal: the National Level* (Columbus, O., 1975), 267-309.

Buscombe, Edward, 'Notes on Columbia Pictures Corporation 1926-41', in Kerr, Paul (ed.), *The Hollywood Film Industry* (London, 1986), 44-63.

Campbell, Russell, 'Some Tentative Notes (Warner Brothers in the Thirties)', *Velvet Light Trap*, 1 (Winter, 1971), 2-4.

Chambers, Clarke A., 'The Belief in Progress in Twentieth-Century America', in Wilson Smith (ed.), *Essays in American Intellectual History* (Hinsdale, Ill., 1975), 422-437.

Countryman, Edward, 'John Ford's "Drums along the Mohawk": the Making of an American Myth', *Radical History Review*, 24 (Fall, 1980), 93-112.

Countryman, Edward, 'Westerns and United States History', *History Today*, 33 (March, 1983), 18-23.

Culbert, David, 'Hollywood in Berlin, 1945: a Note on Billy Wilder and the Origins of "A Foreign Affair" ', *Historical Journal of Film, Radio and Television*, 8 (1988), 311-12.

Curti, Merle, 'Human Nature in American Thought: Retreat from Reason in the Age of Science', in Wilson Smith (ed.), *Essays in American Intellectual History* (Hinsdale, Ill., 1975), 463-472.

Cutts, John, 'Great Films of the Century: "Ninotchka" ', *Films and Filming*, 8 (March, 1962), 21-23, 45.

Dempsey, Michael, 'John Ford: a Reassessment', *Film Quarterly*, 28 (Summer, 1975), 2-15.

Dickson, Robert G., 'Kenneth Macgowan', *Films in Review*, 14 (October, 1963), 475-487.

Dollimore, Jonathan and Sinfield, Alan, 'Foreword: Cultural Materialism', in each volume of Dollimore and Sinfield (eds), *Cultural Politics* series (Manchester, 1988 onwards).

Editors of *Cahiers du Cinéma*, 'John Ford's "Young Mr Lincoln" ' (1970), in Gerald Mast and Marshall Cohen (eds), *Film Theory and Criticism: Introductory Readings* (2nd edn, New York, 1979), 778-831.

Elkin, Frederick, 'The Value Implications of Popular Films', *Sociology and Social Research*, 38 (May-June 1954), 320-22.

Eyles, Allen, 'Films of Enterprise', *Focus on Film*, 35 (April, 1980), 13–27.
Farber, Manny (and Poster, W. S.), 'Preston Sturges: Success in the Movies', *Film Culture*, 26 (Fall, 1962), 9–16.
Fearing, Franklin, 'Films as History', *Hollywood Quarterly*, 11 (July, 1947), 422–27.
Fearing, Franklin, 'A Word of Caution for the Intelligent Consumer of Motion Pictures', *Quarterly of Film, Radio and Television*, 6 (1951), 129–142.
Frankel, Charles, 'John Dewey's Legacy', in Wilson Smith (ed.), *Essays in American Intellectual History* (Hinsdale, Ill., 1975), 389–401.
Friedman, Norman L., 'American Movies and American Culture 1946–70', *Journal of Popular Culture*, 3 (Spring, 1970), 814–823.
Gabriel, Ralph, 'Ideas and Culture in the Twentieth Century', in Cartwright, William H. and Watson, Richard L. Jnr (eds), *Interpreting and Teaching American History* (Washington DC, 1961), 312–328.
Gillett, John, 'Wilder in Paris', *Sight & Sound*, 6 (Winter, 1956–57), 142–43.
Goedecke, Robert, 'Holmes, Brandeis and Frankfurter: Differences in Pragmatic Jurisprudence', in Wilson Smith (ed.), *Essays in American Intellectual History* (Hinsdale, Ill., 1975), 402–414.
Gomery, Douglas, 'Rethinking US Film History: the Depression Decade and Monopoly Control', *Film and History*, 10 (May, 1980), 32–38.
Gomery, Douglas, 'The Popularity of Filmgoing in the US 1930–50', in MacCabe, Colin (ed.), *High Theory/Low Culture: Analysing Popular Television and Film* (Manchester, 1986), 71–79.
Grimm, Reinhold and Schmidt, Henry J., 'Bertolt Brecht and "Hangmen Also Die!" ', *Monatshefte*, 61 (Fall, 1969), 232–240.
Higham, John, 'Hanging Together: Divergent Unities in American History', in *Journal of American History*, 61 (June, 1974), 5–28.
Holt, James, 'The New Deal and the American Anti-Statist Tradition', in Braeman, John et al. (eds), *The New Deal: the National Level* (Columbus, O., 1975), 27–49.
Homberger, Eric, 'The American War Novel and the Defeated Liberal', in Higgins, Ian (ed.), *The Second World War in Literature: Eight Essays* (Edinburgh, 1986), 32–44.
Howe, Irving, 'American Moderns', in Arthur M. Schlesinger and Morton White (eds), *Paths of American Thought* (London, 1964), 309–325.
Hughes, William, 'The Evaluation of Film as Evidence', in Smith (ed.), *The Historian and Film* (Cambridge, 1976), 49–79.
Jacobs, Lewis, 'World War II and the American Film', *Cinema Journal*, 7 (Winter, 1967–68), 1–21.
Jarvie, I. C., 'Seeing through Movies', *Philosophy of the Social Sciences*, 8 (December, 1978), 374–397.
Jenkins, Stephen, 'Lang: Fear and Desire', in Stephen Jenkins (ed.), *Fritz Lang: the Image and the Look* (London, 1984), 38–124.
Jensen, Paul, 'Raymond Chandler and the World You Live in', *Film Comment*, 10 (November/December, 1974), 18–27.
Johns-Heine, Patrick and Gerth, Hans, 'Values in Mass Periodical Fiction, 1921–1940', in Bernard Rosenberg and David Manning White (eds), *Mass Culture: the Popular Arts in America* (n.p., 1957), 226–234.
Kazin, Alfred, 'The Freudian Revolution Analyzed', in Smith (ed.), *Essays in American Intellectual History* (Hinsdale, Ill., 1975), 383–88.
Kirstein, Lincoln, 'James Cagney and the American Hero', *The Hound and Horn*, 5 (April-June, 1932), 465–67.
Kluckhohn, Clyde, 'The Evolution of Contemporary American Values', *Daedalus*, 87 (Spring, 1958), 78–109.

Koppes, Clayton R. and Black, Gregory D., 'OWI Goes to the Movies: the Bureau of Intelligence's Criticism of Hollywood, 1942-43', *Prologue: the Journal of the National Archives*, 6 (Spring, 1974), 44-59.

Koppes, Clayton R. and Black, Gregory D., 'What to Show the World: the Office of War Information and Hollywood 1942-45', *Journal of American History*, 64 (June, 1977), 87-105.

Kristol, Irving, 'Ten Years in a Tunnel', in Morton J. Frisch and Martin Diamond (eds), *The Thirties: a Reconsideration in the Light of the American Political Tradition* (De Kalb, Ill., 1968), 6-26.

Lambert, Gavin, 'Fritz Lang's America', *Sight & Sound*, 25 (Summer, 1955), 15-21, 55-56 and (Autumn, 1955), 92-97.

Lawson, Alan, 'The Cultural Legacy of the New Deal', in Harvard Sitkoff (ed.), *Fifty Years Later: the New Deal Evaluated* (New York, 1985), 155-186.

Leuchtenburg, William E. 'The Achievement of the New Deal', in Harvard Sitkoff (ed.), *Fifty Years Later: the New Deal Evaluated* (New York, 1985), 211-231.

Lowenthal, Leo, 'Historical Perspectives of Popular Culture', in Bernard Rosenberg and David Manning White (eds), *Mass Culture: the Popular Arts in America* (n.p., 1957), 46-58.

Maland, Charles, 'Mr Deeds and American Consensus', *Film and History*, 8 (February, 1978), 9-13.

Marcus, R. D., 'Moviegoing and American Culture', *Journal of Popular Culture*, 3 (Spring, 1970), 755-766.

Mayer, Milton S., 'The Myth of the G-Men', *Forum and Century*, 94 (September, 1935), 144-148.

McConnel, Robert L., 'The Genesis and Ideology of "Gabriel over the White House" ', in MacCann, Richard D. and Ellis, Jack C. (eds), *Cinema Examined: Selections from Cinema Journal* (New York, 1982), 202-221.

Melling, P. H., 'The Mind of the Mob: Hollywood and Popular Culture in the 1930s', in Philip Davies and Brian Neve, *Cinema, Politics and Society in America* (Manchester, 1981), 19-41.

Mundy, Robert, 'Wilder Reappraised', *Cinema* , 4 (October, 1969), 14-19.

Narmore, James, 'Authorship', in Miller, Toby and Stam, Robert (eds), *A Companion to Film Theory* (Malden, Mass., 1999), 9-24.

Nieuwenhof, Frans, 'On the Method of Filmanalysis', in K.R.M. Short and Karsten Fledelius (eds), *History and Film: Methodology, Research and Education* (Copenhagen, 1980), 33-38.

Overby, David, 'Fritz Lang's Career Girl', *Sight & Sound*, 44 (Autumn, 1975), 240-44.

Pechter, William S., 'American Madness', in Richard Glatzer and John Raeburn (eds), *Frank Capra: the Man and his Films* (Ann Arbor, Mich., 1975), 177-185.

Phelps, Glenn Alan, 'The Populist Films of Frank Capra', *Journal of American Studies*, 13 (December, 1979), 377-392.

Polenberg, Richard, 'Franklin Roosevelt and Civil Liberties: the Case of the Dies Committee', *Historian*, 30 (1968-69), 165-178.

Polenberg, Richard, 'The Decline of the New Deal', in Braeman, John et al. (eds), *The New Deal: the National Level* (Columbus, O., 1975), 246-266.

Powers, R. G., 'J. Edgar Hoover and the Detective Hero', *Journal of Popular Culture*, 9 (Fall, 1975), 257-278.

Quart, Leonard, 'Frank Capra and the Popular Front', *Cineaste*, 8 (Summer, 1977), 4-7.

Roth, Mark, 'Some Warners Musicals and the Spirit of the New Deal', *Velvet Light Trap*, 1 (Winter, 1971), 20-25.

Sarris, Andrew, 'Lubitsch in the Thirties', *Film Comment* (Winter, 1971/72), 54-57 and (Summer, 1972), 20-21.

Sarris, Andrew, 'Billy Wilder: Closet Romanticist', *Film Comment* (July/August, 1977), 7-9.

Schwartz, Nancy, 'Lubitsch's Widow: the Meaning of a Waltz', *Film Comment* (March/April, 1975), 13–17.
Sklar, Robert, 'The Imagination of Stability: the Depression Films of Frank Capra', in Richard Glatzer and John Raeburn (eds), *Frank Capra: the Man and his Films* (Ann Arbor, Mich., 1975), 121–138.
Smedley, Nick, 'Fritz Lang Outfoxed: the German Genius as Contract Employee', *Film History*, 4 (1990), 289–304.
Smedley, Nick, 'A Foreigner's Affair: European Perspectives on American Social Change – Billy Wilder in the 1940s', in Hesling, Willem (ed.), *Billy Wilder: Tussen Weimar en Hollywood* (Leuven, 1991), 157–192.
Smedley, Nick, 'Fritz Lang's Trilogy: the Rise and Fall of a European Social Commentator', in *Film History*, 5 (March, 1993), 1–21.
Smith, J. E., 'The Spirit of American Philosophy', in Wilson Smith (ed.), *Essays in American Intellectual History* (Hinsdale, Ill., 1975), 473–79.
Staiger, Janet, 'Individualism versus Collectivism', *Screen*, 24 (July-October, 1983), 68–79.
Stowell, H. Peter, 'John Ford's Literary Sources: from Realism to Romance', *Literature/Film Quarterly*, 5 (Spring, 1977), 164–173.
Susman, Warren, 'The Thirties', in Stanley Coben and Lorman Ratner (eds), *The Development of an American Culture* (Englewood Cliffs, NJ, 1970), 179–218.
Welsh, James M. and Barrett, Gerald R., 'Graham Greene's "Ministry of Fear": the Transformation of an Entertainment', *Literature/Film Quarterly*, 2 (Fall, 1974), 310–323.
Willett, Ralph, 'The Nation in Crisis: Hollywood's Response to the 1940s', in Philip Davies and Brian Neve (eds), *Cinema, Politics and Society in America* (Manchester, 1981), 59–75.
Willett, Ralph, 'Billy Wilder's "A Foreign Affair" (1945–1948): "the trials and tribulations of Berlin"', *Historical Journal of Film, Radio and Television*, 7 (1987), 3–14.
Willett, Ralph and White, John, 'The Thirties', in Malcom Bradbury and Howard Temperley (eds), *Introduction to American Studies* (London, 1981), 220–242.
Willson, Robert, 'Capra's Comic Sense', in Richard Glatzer and John Raeburn (eds), *Frank Capra: the Man and his Films* (Ann Arbor, Mich., 1975), 83–98.

Index

Ace in the Hole (Wilder, 1951), 247
Adams, Ansell, 25
adult subjects, 125, 128–32, 160–1, 187
The Adventures of Huckleberry Finn (Thorpe, 1939), 74
affirmative resolutions, 93, 111, 128, 132, 225, 233, 237–8
Agee, James, 125
Ager, Cecelia, 238
agrarian myth, 24–5, 124
Ah! Wilderness (Brown, 1935), 74
alcoholism, 128–32, 146
Alice Adams (Stevens, 1935), 71
alienation, 8, 12, 53, 60
Allen, Frederick Lewis, 23
American occupation, 218
American values, 7, 19–28, 34, 127, 202–3, 218–23, 245–6 *see also* capitalist values; communal values/collectivism; individualism; New Deal values
Angel (Lubitsch, 1937), 163–5, 176, 206
Anne Boleyn/Deception (Lubitsch, 1920), 155
Anne of Green Gables (Nichols Jr, 1934), 74
anti-communism, 7–8, 26, 36, 79, 202, 218–19, 238, 246
anti-fascism, 34, 198–202, 208, 232
anti-intellectualism, 176, 178
anti-Nazism, 209–10, 225
anti-Semitism, 198, 209–10
anxiety, 27, 47, 78, 123
The Apartment (Wilder, 1960), 247
Arise My Love (Leisen, 1940), 148, 200, 216
Arliss, George, 49
atomic power, 13, 27, 36, 51, 225, 234–8
audiences, 51–3, 92

auteur theory, 13, 56, 123, 155
autonomy, 13, 52–3, 91–2, 107–8, 112, 123–4, 155, 158, 225
The Awful Truth (McCarey, 1937), 148

Babington, Bruce, 140
Baker, Graham, 99
Ball of Fire (Hawks, 1941), 122
banned films, 90, 103, 109, 130, 221
Barthes, Roland, 56
Battleship Potemkin (Eisenstein, 1925), 90
Baum, Viki, 172
Bazin, Andre, 56
Beard, Charles, 23
Beau Geste (Wellman, 1939), 199
Behrman, S. N., 170
The Bells of St Mary's (McCarey, 1945), 82
Bennett, Joan, 108, 112, 186–7, 189, 226
Bercovici, Leonardo, 190
Bergman, Andrew, 57–8
Berlin blockade, 37
Bessie, Alvah, 235, 238
Beyond a Reasonable Doubt (Lang, 1956), 247
The Big Heat (Lang, 1953), 247
The Big Sleep (Hawks, 1946), 80, 151
Black, Gregory, 52
Blitzstein, Marc, 106
Bluebeard's Eighth Wife (Lubitsch, 1938), 122, 167–8, 206
Bombshell (Fleming, 1933), 73
Bordwell, David, 57
Brackett, Charles, 122–4, 129–31, 167, 170, 216, 219
Brains Trust, 21
Break of Hearts (Moeller, 1935), 145–6

Brecht, Bertolt, 225–7
Breen, Joseph, 53–5, 96, 108, 111, 124–5, 131, 161–4, 167, 170–1, 174–5, 177, 186, 189, 219, 236
Breen, Richard, 219
The Bride Came C.O.D. (Keighley, 1941), 144
Brigham Young (Hathaway, 1940), 74–5
Bringing Up Baby (Hawks, 1938), 148
Britain, 19
Bryan, William Jennings, 20
Buddy, Buddy (Wilder, 1981), 248
Buscombe, Edward, 58
Bush-Fekete, Ladislaus, 168

Cagney, James, 235
Cahiers du Cinéma, 55
Cain, James M., 27, 124–5, 149
capitalist values, 19, 22–3, 27, 35, 105, 206, 245
 modified, 10, 19–20, 23
Capra, Frank, 49, 59, 72–3, 81–4, 143–4
career woman themes *see* independent women
Carney, Raymond, 49
Carringer, Robert, 14
celebratory approach, 50, 59, 124, 197–8
censorship, 9, 47, 50–5, 58–9, 92, 102–3, 108–9, 124–5, 128–31, 158–64, 167, 172–7, 206, 236
Chafe, William, 28
Chambers, Clarke, 23
Chandler, Raymond, 27, 80, 124, 128, 149
La Chienne (Renoir, 1931), 109
Citizen Kane (Welles, 1941), 78
Clash By Night (Lang, 1952), 247
class issues, 171–2, 198, 206, 213–14
classical tragedy, 110–11
Cloak and Dagger (Lang, 1946), 205, 225, 234–8
Cluny Brown (Lubitsch, 1946), 171–2, 206, 213–14
Cold War, 7–8, 11–12, 26–7, 37, 51, 220, 222, 235, 238, 246
Columbia, 124
comedy, 48, 58, 130, 148, 156, 166–7, 205–12, 216, 222–3
communal values/collectivism, 10, 22–4, 70–2, 82, 97–8, 152, 228, 230–2, 245
communism, 9–12, 27, 35, 37, 72, 144, 206–8, 232
Confidential Agent (Schumlin, 1945), 202

Conquest (Brown, 1937), 197–8
consensus culture, 12, 246
conservatism, 10, 12, 24–8, 53–4, 57–60, 122, 218
containment policy, 36–7
Contempt/Le Mépris (Godard, 1963), 247
controversial insights, 12, 128–9, 131, 216, 219, 221, 246
Cooper, Gary, 168, 176, 235–8
Cormack, Bartlett, 96, 98
Cornell, Katherine, 104
The Count of Monte Cristo (Lee, 1934), 70
courtship themes, 143–5
Coward, Noel, 159, 161
Crawford, Frederick, 32
crime/criminals, 99–103, 105–6
Crowther, Bosley, 82, 125, 129, 222
Cry Havoc (Thorpe, 1943), 147
Cukor, George, 70, 142, 145, 148, 200–1
Czechoslovakia, 225, 227–32

dangerous women, 148–9
Davidman, Joy, 232–3
Deadline at Dawn (Clurman, 1946), 80
Deming, Barbara, 60
Democratic Party, 9, 26, 29, 35
Design for Living (Lubitsch, 1933), 159–63
Deval, Jacques, 170
The Devil is a Woman (von Sternberg, 1935), 149
Dewey, John, 23
Dewson, Mary, 29
Diana Productions, 108–9, 186, 189–90
didacticism, 129, 140, 151, 168, 229
Dies, Martin, 34
Dietrich, Marlene, 108, 163, 165
Dinner at Eight (Cukor, 1933), 70
disillusion, 27–8, 77–80
Disney, Walt, 59, 189
dissent, 8–9, 12, 94, 148, 158–9, 172, 246
divorce themes, 142–4, 146, 148, 167–8, 176–7, 187–8
Dollimore, Jonathan, 56–7
domino theory, 37
Donlevy, Brian, 227
Donovan, Frances, 31
Double Indemnity (Wilder, 1944), 123–8, 190–1

Index

Dr Cyclops (Schoedsack, 1940), 199–200
Dr Mabuse der Spieler/Dr Mabuse the Gambler (Lang, 1921), 89
The Duke of West Point (Green, 1938), 198
Duryea, Dan, 226

Eisler, Hanns, 233
Eisner, Lotte, 13
émigré directors, 14, 90 *see also* Lang, Fritz; Lubitsch, Ernst; Wilder, Billy
The Emperor Waltz (Wilder, 1948), 124, 191, 218
England, 198, 206
Escape (LeRoy, 1940), 200
escapism, 12, 19, 50, 57, 77, 169
Eternal Love (Lubitsch, 1929), 156
European issues, 9, 11, 33, 36–7, 171–2, 197–201, 205–6, 213–14, 218–23, 234–8, 246
Evans, Peter William, 140
expansionism, 245
Eyman, Scott, 156

failure culture, 28, 109
Fair Deal, 26
fantasy, 12, 48–9, 53, 77, 80–4
Farewell, my Lovely (Dmytryk, 1944), 80, 149
Farnham, Marynia, 32
fascism, 8, 72, 198–9, 206, 229
FDR Roosevelt, Franklin D., 7–12, 20–2, 25–6, 33–5, 49, 53, 58–9, 69–70, 123, 157, 199, 245–6
Fearing, Franklin, 52
Fedora (Wilder, 1978), 247
feminism, 11, 28–33, 56, 140–2, 144–6, 160, 170, 173–4, 178 *see also* independent women; women's rights; women's roles
femmes fatales, 109, 124, 149–50
Ferguson, Otis, 49, 201
The Fighting 69th (Keighley, 1940), 201
film scholarship, 12, 55–60, 140–1
films noirs, 32, 60
Fischinger, Oskar, 189
Fitzgerald, F. Scott, 22
Five Graves to Cairo (Wilder, 1943), 124, 165, 216–17
Fodor, Ladislas, 165
Footlight Parade (Bacon, 1933), 59–60
For Whom the Bell Tolls (Wood, 1943), 202

Forbidden Paradise (Lubitsch, 1924), 156
Ford, Corey, 235
Ford, John, 25, 75–6
A Foreign Affair (Wilder, 1948), 123–4, 205, 218–23
foreign affairs, 7–13, 33–7, 202–3, 205–14, 218–20, 245–6
The Fortune Cookie (Wilder, 1966), 247
42nd Street (Bacon, 1933), 59–60
Fouchardiere, Georges de la, 108
Four Frightened People (DeMille, 1934), 74
Four Sons (Mayo, 1940), 200
France, 55–6, 197–8, 201, 206
Franklin, Sidney, 170, 207
Frau im Mond/Woman in the Moon (Lang, 1929), 89, 189
Friedman, Norman, 52
Fury (Lang, 1936), 91, 94–9, 113, 186

Garbo, Greta, 169
German cinema, 51–2, 88–90, 121, 155
Germany, 7, 11, 19, 198–9, 217–23
The Ghost and Mrs Muir (Mankiewicz, 1947), 83
The Glass Key (Heisler, 1942), 80, 150–1
Goebbels, Josef, 90
Goetz, William, 189–90
Gold, Michael, 24
Gone with the Wind (Fleming, 1939), 145, 147
The Good Earth (Franklin, 1937), 74
good-bad girls, 150–1
The Grapes of Wrath (Ford, 1940), 75–6
Great Depression, 7, 21, 23–4, 29, 58–9, 70–1, 93–5, 97, 102
Griffith, Richard, 82
Gunga Din (Stevens, 1939), 199
Gunzberg, Milton, 226

Hammett, Dashiel, 27, 149
Hangmen Also Die! (Lang, 1943), 91, 186, 205, 216, 225–33
happy endings, 92–3 *see also* affirmative resolution
Harari, Robert, 219
Harbou, Thea von, 88–9
The Hard Way (Sherman, 1942), 147
harmless entertainment argument, 58–60, 123, 169

Haskell, Molly, 140–1
Hawks, Howard, 80, 122, 148, 151, 190, 201
Hays Office, 53–4, 92, 102, 112, 124–5, 128, 130–1, 159–63, 174, 218
Hays, Will, 53–4, 175
Heaven Can Wait (Lubitsch, 1943), 168–9
Hecht, Ben, 159, 169
Hemingway, Ernest, 22, 28
Hepburn, Katharine, 145–6
Hilton, James, 171
His Girl Friday (Hawks, 1940), 148
Hitchcock, Alfred, 189
Hitler, Adolf, 7, 11, 35, 157, 198–9, 201, 206, 208–9
Hoffenstein, Samuel, 170–1
Hofstadter, Richard, 26
Hold Back the Dawn (Leisen, 1941), 122
Hollywood
 fantasy, 12, 48–9, 53, 77, 80–4
 isolationism/interventionism, 197–201
 politics, 47–60
 social change, 69–77, 79–80, 84
 women's rights, 140–52
 World War II, 201–4
Hoover administration, 20, 49
Hopper, Hedda, 228
The House of Rothschild (Werker, 1934), 49, 70, 198–9
House UnAmerican Activities Committee, 202, 238, 245
Houseman, John, 51
How Green Was my Valley (Ford, 1941), 76
Hudson's Bay (Pichel, 1940), 74, 198
Hughes, William, 52
Human Desire (Lang, 1954), 247
human relations, 128–32, 158–9, 208
Huston, John, 79–80, 122, 149–50, 203

idealism, 8, 10, 12, 20, 23, 48–50, 52–3, 70, 78, 82–3, 106, 245
 challenged, 93–9
 decline of, 107–12, 123–8
imperialism, 7, 10, 35, 37
independent women, 8, 31
 depictions of, 139–40, 145–8, 159–65, 169–72, 178
 hostility towards, 8, 32–3, 139–42, 148, 176, 190–1, 245–6

The Indian Tomb (Lang, 1959), 247
individualism, 10, 20, 23, 27, 60, 97–8, 228, 245
Information Control Division, 218, 221
Ingster, Boris, 235–6
innovation, 8, 246
internationalism, 7–13, 33–7, 202–3, 205–14, 218–20, 245–6
interventionism, 7–8, 11, 21, 34, 37, 54, 198–201, 216, 246
Intrigue (Marin, 1947), 203–4
isolationism, 11, 33–5, 37, 157, 197–8, 201, 217
It Happened One Night (Capra, 1934), 72, 143–4
Italy, 198, 206
It's a Wonderful Life (Capra, 1946), 81–2

Jackson, Charles, 128
Jackson, Stephen, 220
Jacobs, Lewis, 49–50
Johnson, Nunnally, 112
Jones, Dorothy, 50

Kaplan, E. Ann, 140
Kerr, Paul, 58
Key Largo (Huston, 1948), 79, 203
King, Rufus, 186–7, 198, 202–3
Kiss Me Again (Lubitsch, 1925), 156
Koenig, Lester, 235
Koppes, Clayton, 52
Kracauer, Siegfried, 51
Kraly, Hans, 172
Krasna, Norman, 96–7, 103, 105
Kuhn, Annette, 56, 140

La Cava, Gregory, 71
The Lady Eve (Sturges, 1941), 122
The Lady in the Lake (Montgomery, 1946), 80, 151
Lady Windermere's Fan (Lubitsch, 1925), 156
Lang, Fritz, 8, 12–14, 37, 51, 99–107, 128, 157, 246
 biographical details, 88–91
 under contract, 112–13
 European/German films, 88–90, 189
 Hollywood films: *Beyond a Reasonable Doubt* (1956), 247; *The Big Heat* (1953), 247; *Clash By Night* (1952), 247; *Cloak and Dagger* (1946), 205, 225, 234–8; *Fury* (1936), 91,

94–9, 113, 186; *Hangmen Also Die!* (1943), 91, 186, 205, 216, 225–33; *Human Desire* (1954), 247; *The Indian Tomb* (1959), 247; *Man Hunt* (1941), 225; *Scarlet Street* (1945), 96, 107–12; *Secret beyond the Door* (1948), 113, 186–90, 237; *The Thousand Eyes of Dr Mabuse* (1960), 247; *The Tiger of Eschnapur* (1959), 247; *While the City Sleeps* (1956), 247; *The Woman in the Window* (1944), 112–13; *You and Me* (1938), 103–7, 186; *You Only Live Once* (1937), 99–103
 on Nazism, 225–33
 philosophy of cinema, 91–3
Lardner Jnr, Ring, 235, 238
Larkin, John, 235–6
The Last Train to Madrid (Hogan, 1937), 199
László, Miklós, 178
Laughton, Charles, 108
Le Baron, William, 104
Lee, Anna, 226–7
left-wing thinking, 10, 12, 19, 34, 37, 50, 53, 123, 230, 232, 235
Legion of Decency, 58, 162–4, 175
Lehár, Franz, 172
Leigh, Rowland, 172
Leisen, Mitchell, 122, 147–8, 200, 216
Lengyel, Melchior, 163, 169–70, 207, 209
LeRoy, Mervyn, 58, 70, 145, 200, 235
Lesser, Sol, 176
liberalism, 8–12, 19–25, 34, 47–9, 53, 70, 106, 125, 161, 245–6
 decline of, 50–1, 77, 107–12, 123–8
 and fantasy, 12, 48–9, 53, 77, 80–4
Liliom (Lang, 1934), 90
Lillian Russell (Cummings, 1940), 146
Little Caesar (LeRoy, 1930), 58
Little Women (Cukor, 1933), 148
Lombard, Carole, 176
loner heroes, 27–8, 60, 77, 80
The Long Voyage Home (Ford, 1940), 76
Loos, Anita, 173
Lorentz, Pare, 201
The Lost Weekend (Wilder, 1945), 123, 128–32, 247
Love Crazy (Conway, 1941), 143
The Love Parade (Lubitsch, 1929), 156

Lowenthal, Leo, 27
Lubitsch, Ernst, 8–9, 12–14, 33, 55, 90–1, 108, 122, 148, 205, 233, 246
 biographical details, 155–7
 European/German films, 155, 247
 Hollywood films: *Angel* (1937), 163–5, 176, 206; *Bluebeard's Eighth Wife* (1938), 122, 167–8, 206; *Cluny Brown* (1946), 171–2, 206, 213–14; *Design for Living* (1933), 159–63; *Eternal Love* (1929), 156; *Forbidden Paradise* (1924), 156; *Heaven Can Wait* (1943), 168–9; *Kiss Me Again* (1925), 156; *Lady Windermere's Fan* (1925), 156; *The Love Parade* (1929), 156; *The Man I Killed* (1932), 156; *The Marriage Circle* (1924), 156; *The Merry Widow* (1934), 163, 172–6, 205–6; *Monte Carlo* (1930), 156; *Ninotchka* (1939), 169–71, 205–8; *One Hour with You* (1932), 156; *Rosita* (1923), 156; *The Shop around the Corner* (1940), 178; *The Smiling Lieutenant* (1931), 156; *So This is Paris* (1926), 156; *The Student Prince* (1927), 165; *That Lady in Ermine* (1948), 165–7, 247; *That Uncertain Feeling* (1941), 176–7; *Three Women* (1924), 156; *To Be or Not to Be* (1941), 176, 205, 208–12, 228; *Trouble in Paradise* (1932), 157, 162
 philosophy of cinema, 157–9
Luft, Herbert, 221–2
Lunberg, Ferdinand, 32
Lynd, Robert, 23–4, 26–7, 30–1

MacArthur, Charles, 169
MacBain, Alastair, 235
Madame DuBarry/Passion (Lubitsch, 1919), 155
Maddow, Ben, 235
Magic Town (Wellman, 1947), 84
The Major and the Minor (Wilder, 1942), 122, 124, 190, 216
Maltby, Richard, 58–9
The Maltese Falcon (Huston, 1941), 80, 149–50
Maltz, Albert, 235, 238
Man Hunt (Lang, 1941), 225
The Man I Killed (Lubitsch, 1932), 156
Manhattan Project, 234
Mankiewicz, Joseph, 83, 96, 99
marginalised heroes, 12, 77, 80–1

Marie Antoinette (Van Dyke, 1938), 197
marriage, 31, 142, 157, 160–1, 164–8, 176–7, 188–9
The Marriage Circle (Lubitsch, 1924), 156
Marshall Plan, 37
Marx Brothers, 58, 176
Masaryk, Thomas, 228–30
masculinity, 151–2, 163–5, 168–9, 173, 177, 188
Mason, James, 187–8
mass market, 12, 52, 92, 229, 246
The Master Race (Biberman, 1944), 203
materialism, 56–7, 71–2, 103, 125–7
May, Joe, 88, 122
Mayer, Edwin Justus, 209
Mayer, Louis B., 174
McCarey, Leo, 82, 148
McCarthy purges, 9–10, 12, 34, 238, 246
McElvaine, Robert, 23
McGilligan, Patrick, 14
Mead, Margaret, 30, 33
Meader, George, 218
Merrill, Francis, 25, 31–2
The Merry Widow (Lubitsch, 1934), 163, 172–6, 205–6
Metropolis (Lang, 1926), 89
Metz, Christian, 56
Meyer, Agnes, 32
MGM, 90–1, 96, 99, 124, 169–70, 172, 174–5, 178
Midnight (Leisen, 1939), 122
The Mighty Barnum (W. Lang, 1934), 71
Milland, Ray, 132
The Miracle of Morgan's Creek (Sturges, 1943), 148
Miracle on 34th Street (Seaton, 1947), 83–4
Mitchell, Thomas, 226
modified capitalism, 10, 19–20, 23
Moffitt, Jack, 49, 104–5
Monaco, Paul, 51–2
Montagu, Ashley, 32
Monte Carlo (Lubitsch, 1930), 156
morality, 27, 32, 47, 50, 70–1, 126–7, 160–1, 163, 234
 complex, 109, 111–12, 168–9, 172–4, 220
 conservative, 9, 53–5, 108, 157, 159, 175–6, 178
 in crisis, 51–3, 58–60, 78–80, 84, 112, 149, 203

Morris, Lloyd, 48
Mr Blandings Builds his Dream House (Potter, 1948), 84
Mr Deeds Goes to Town (Capra, 1936), 72
Mr Smith Goes to Washington (Capra, 1939), 84
Der Mude Tod/Weary Death (Lang, 1921), 89
musicals, 59–60, 156
My Man Godfrey (La Cava, 1936), 71
myth-making, 13

Nazis/Nazism, 12–13, 34–5, 90, 198–9, 203, 205, 208–12, 217, 219, 225–33, 237
Negri, Pola, 155
neo-formalism, 57
Nero Films, 89
New Deal, 8–12, 19–26, 29, 33, 52–3, 93–4, 245–6
 culture, 122, 124, 128, 139, 157, 202
 post-New Deal era, 10, 12, 77–80, 245
 themes, 84, 106
 values, 47–9, 57–60, 69–73, 144, 152, 203
Die Nibelungen (Lang, 1924), 89–90
Nichols, Dudley, 109, 112, 225
Ninotchka (Lubitsch, 1939), 169–71, 205–8
None But the Lonely Heart (Odets, 1944), 79–80
nostalgia, 73–6

Odets, Clifford, 27, 79–80
offender rehabilitation issues, 99–107
Office of Strategic Services, 234–5
One Hour with You (Lubitsch, 1932), 156
One Million B.C. (Roach, 1940), 200
One Two, Three (Wilder, 1961), 247
optimism, 26, 28, 77, 79–80, 82–4, 92, 106
Oscars, 132

Palmer, Lilli, 235–7
Paramount, 103–4, 122–5, 129, 131, 156–9, 161–3
Parsons, Talcott, 32
patriotism, 8–9, 11, 197–8, 216, 227
PCA (Production Code Administration), 9, 47, 53–5, 59, 96, 99, 103–4, 108–12, 124–5, 128, 161–2, 167, 175–7, 209, 219–20, 226, 236
Pearl Harbor attack, 11, 34, 209
Perelman, S. J., 176

Perkins, Frances, 29
personal accountability, 111, 246
pessimism, 77–80, 83, 102, 107–9, 111
The Philadelphia Story (Cukor, 1940), 145
Piccadilly Jim (Leonard, 1936), 145
Pickford, Mary, 156
The Pied Piper (Pichel, 1942), 201
Poland, 36, 121, 198–9, 206, 208–12
political contexts, 19–21, 34–5, 47–60, 218–19
political relevance, 12, 170–1, 206–8, 211–12, 236–7
Pommer, Erich, 88–90, 122
populism, 12, 94–9, 246
The Postman Always Rings Twice (Garnett, 1946), 149–50
post-New Deal era, 10, 12, 77–80, 245
post-war internationalism *see* internationalism
post-war tensions, 11, 54, 60, 81, 122–3, 202
Powdermaker, Hortense, 27, 55
Praskins, Leonard, 96, 98
Pressburger, Arnold, 225–8, 231
Pride and Prejudice (Leonard, 1940), 198
The Prisoner of Zenda (Cromwell, 1937), 199–200
progressivism, 20–1
propaganda, 218–19, 225–33
psychology, 56, 187–90
Public Enemy (Wellman, 1931), 58

Quigley, Martin, 54, 162, 175–6

race issues, 96 *see also* anti-Semitism
radicalism, 12, 23–4, 58–9, 129, 246
Raft, George, 108
Raphaelson, Samson, 156, 165, 168, 172–3, 178
realism, 107–8, 111
recession, 9–11, 21–2, 25
Red Salute (Lanfield, 1935), 144
Redgrave, Michael, 186–8
rehabilitation of criminals, 99–103, 105
Reinhardt, Elizabeth, 171
Reinhardt, Max, 155
Reisch, Walter, 170
Renoir, Jean, 109
Republican Party, 8–10, 12, 20, 26, 53–4
responsibility, 246

reviews
 Lang, 98–9, 102–3, 105–7, 109–10, 112, 187, 189–90, 221–2, 228–9, 232–4, 238
 Lubitsch, 163, 165, 168, 170–1, 174–5, 177–8, 207, 212–13
 Wilder, 125, 129, 132, 190–1
Richards, Silvia, 186–8
right-wing thinking, 10, 12, 26, 202, 218
RKO Studios, 162
Robinson, Edward G., 108, 112
Roddick, Nick, 58–9
Roosevelt, Eleanor, 29
Rosen, Robert, 50
Rosita (Lubitsch, 1923), 156
Roth, Mark, 59–60

Sabath, Barry, 14
Sadou, Victorien, 176
Salemson, Harold, 55, 83
Sarris, Andrew, 56
satire, 122, 124, 148, 167, 170–1, 205–14, 219–20, 222–3
Scarlet Street (Lang, 1945), 96, 107–12
Schanzer, Rudolf, 165
Scharf, Lois, 30
Schulberg, B. P., 103
Schulberg, Stuart, 222
Screen Playwrights' Body, 104
Screen Writers' Guild, 122, 225
scriptwriting process
 Lang, 91–4, 96–9, 101, 103–5, 108–9, 112, 186–7, 225–7, 235–7
 Lubitsch, 158, 165, 167–73, 178, 209
 Wilder, 122, 124, 219
Secret beyond the Door (Lang, 1948), 113, 186–90, 237
self-denial, 10, 152
self-help, 22
self-interest, 11, 19–20
self-publicizing, 14
self-sacrifice, 10, 19–20, 147, 231–2
Selznick, David, 90
semiotics, 56–7
Sergeant York (Hawks, 1941), 201
sexuality, 55, 108–10, 143, 151, 157, 159–61, 163–9, 171–7, 219
Sharp, Margery, 171

Shaw, Irwin and David, 219
The Shop around the Corner (Lubitsch, 1940), 178
Shurlock, Geoffrey, 236
Sidney, Sylvia, 104
Since You Went Away (Cromell, 1944), 147, 202
Sinfield, Alan, 56–7
Sklar, Robert, 58–9
The Smiling Lieutenant (Lubitsch, 1931), 156
So This is Paris (Lubitsch, 1926), 156
social change, 8–9, 12, 19–23, 34, 51, 69–80, 84
social comment, 8, 12, 37, 53, 58, 70, 92–5, 99, 106, 112, 122–3, 219, 246
social issues, 27, 49, 51, 103, 128–32, 245–6
Some Like It Hot (Wilder, 1959), 247
The Son of Monte Cristo (Lee, 1940), 200
Souls at Sea (Hathaway, 1937), 198
Soviet Union, 7, 9, 11–12, 26, 34–6, 198, 206–8, 219, 237
Spain, 11, 198–9, 201–2
Sperling, Milton, 235–8
Die Spinnen/The Spiders (Lang, 1919), 88
Spione/Spies (Lang, 1928), 89
Stagecoach (Ford, 1939), 75
Stahl, John, 163
Staiger, Janet, 57
Stalin/Stalinism, 11–12, 34–6, 206–7
Stanley and Livingstone (King, 1939), 198
State of the Union (Capra, 1948), 82–3
Steinbeck, John, 27
Stella Dallas (Vidor, 1937), 146–7
Sternberg, Josef von, 149
Stewart, Donald Ogden, 176
The Strawberry Blonde (Walsh, 1941), 144–5
structuralism, 56–7
The Student Prince (Lubitsch, 1927), 165
Sturges, Preston, 122, 148, 190
Success at Any Price (Ruben, 1934), 71
success myth, 27, 58, 60, 71, 77
suffragist movement, 28, 141
Sunset Boulevard (Wilder, 1950), 247

A Tale of Two Cities (Conway, 1935), 197
The Testament of Dr Mabuse (Lang, 1933), 89–90
Der Teufelsreporter/The Daredevil Reporter (Laemmle, 1930), 121
Thalberg, Irving, 172, 174–5

That Lady in Ermine (Lubitsch, 1948), 165–7, 247
That Uncertain Feeling (Lubitsch, 1941), 176–7
The Thousand Eyes of Dr Mabuse (Lang, 1960), 247
Three Comrades (Borzage, 1938), 199
Three Women (Lubitsch, 1924), 156
The Tiger of Eschnapur (Lang, 1959), 247
Till the End of Time (Dmytryk, 1946), 202
To Be or Not to Be (Lubitsch, 1941), 176, 205, 208–12, 228
To Each His Own (Leisen, 1946), 147
To Have and Have Not (Hawks, 1944), 201
Tobacco Road (Ford, 1941), 76
Tom, Dick and Harry (Kanin, 1941), 73
Too Hot to Handle (Conway, 1938), 148
topicality, 48, 50, 95, 99, 149, 202, 206, 208, 216, 234
Towne, Gene, 99
Tracy, Spencer, 98
Trouble in Paradise (Lubitsch, 1932), 157, 162
Truman Doctrine, 9–10, 26, 35–7
Twentieth Century-Fox, 50, 107, 168, 171, 225

Ufa film company, 88–9, 155
unAmerican/unpatriotic attitudes, 12, 26, 202, 222, 238, 245
United Artists, 156
United States Pictures, 235
Universal Studios, 108–9, 163, 186, 189–90
Upp, Virginia van, 103–5

Vajda, Ernest, 172–3
Vigil in the Night (Stevens, 1940), 147
violence, 96–7

Wall Street Crash (1929), 10, 22, 24, 48, 58, 70–1
Waller, Willard, 32
Wanger, Walter, 50, 99, 102, 104, 108–9, 186–7, 189–90, 226
Warner Brothers, 59, 124, 156, 235
We Were Dancing (Leonard, 1942), 143
Weill, Kurt, 103–5
Weimar culture, 14
Weinberg, Herman, 14
welfare systems, 7, 19–22, 203
Welisch, Ernst, 165

Welles, Orson, 78, 106–7, 122
West, Mae, 58
West, Nathanael, 27
Wexley, John, 226–7
While the City Sleeps (Lang, 1956), 247
Wife versus Secretary (Brown, 1936), 143
Wilder, Billy, 8, 12–14, 37, 90–1, 110, 148, 157, 165, 167, 170, 205, 216–23, 246
 biographical details, 121–3
 European/German films, 121
 Hollywood films (directing): *Ace in the Hole* (1951), 247; *The Apartment* (1960), 247; *Buddy, Buddy* (1981), 248; *Double Indemnity* (1944), 123–8, 190–1; *The Emperor Waltz* (1948), 124, 191, 218; *Fedora* (1978), 247; *Five Graves to Cairo* (1943), 124, 165, 216–17; *A Foreign Affair* (1948), 123–4, 205, 218–23; *The Fortune Cookie* (1966), 247; *The Lost Weekend* (1945), 123, 128–32, 247; *The Major and the Minor* (1942), 122, 124, 190, 216; *One Two, Three* (1961), 247; *Some Like It Hot* (1959), 247; *Sunset Boulevard* (1950), 247
 Hollywood films (scripting): *Arise My Love* (Leisen, 1940), 216; *Bluebeard's Eighth Wife* (Lubitsch, 1938), 122, 167–8, 206; *Midnight* (Leisen, 1939), 122
 philosophy of cinema, 123–4
Willett, Ralph, 60
Wilson (King, 1944), 202–3
Wilson, Woodrow, 20
Wingate, James, 162
witch-hunts, 9–10, 12, 34, 238, 246
Without Reservations (LeRoy, 1946), 145

The Wizard of Oz (Fleming, 1939), 74
Woelfel, Norman, 52
The Woman in the Window (Lang, 1944), 112–13
Woman of the Year (Stevens, 1942), 146
A Woman Rebels (Sandrich, 1936), 146
A Woman's Face (Cukor, 1941), 200–1
The Women (Cukor, 1939), 142
women's rights, 28–9, 33, 140–52, 245–6 *see also* feminism
women's roles, 7, 11–12, 28–33, 139–40, 147, 157, 245–6 *see also* independent women
 conventional, 186–91
 courtship themes, 143–5
 dangerous women, 148–9
 divorce themes, 142–4, 146, 148, 167–8, 176–7, 187–8
 domesticity, 28, 30–3, 139–42, 245
 femmes fatales, 109, 124, 149–50
 good-bad girls, 150–1
 and men's roles, 151–2
 as workers, 29–32, 139–40, 145–7
The World Changes (LeRoy, 1933), 70
World War I, 7, 11, 88, 164, 199–203
World War II, 7, 9–10, 22, 25–7, 31, 50, 122, 139, 201–2, 205, 216–17, 246
Writers' Congress, 233

You and Me (Lang, 1938), 103–7, 186
You Can't Take It with You (Capra, 1938), 72
You Only Live Once (Lang, 1937), 99–103

Zanuck, Darryl, 50, 166
Zukor, Adolph, 104